TOTALITARIAN ART

D1202713

TOTALITARIAN ART

*in the Soviet Union, the Third Reich, Fascist Italy
and the People's Republic of China*

Igor Golomstock

Translated from the Russian by Robert Chandler

OVERLOOK DUCKWORTH
New York • London

This edition published in the United States and the United Kingdom in 2011
by Overlook Duckworth, Peter Mayer Publishers, Inc.

NEW YORK:
Overlook
141 Wooster Street
New York, NY 10012
www.overlookpress.com
For bulk and special sales, please contact sales@overlookny.com

LONDON:
Duckworth
90-93 Cowcross Street
London EC1M 6BF
www.ducknet.co.uk
info@duckworth-publishers.co.uk

Originally published in a shorter form in 1990 by Collins Harvill

Cataloging-in-Publication Data is available from the Library of Congress
A catalogue record for this book is available from the British Library

Printed in the United States
1 3 5 7 9 10 8 6 4 2

HC 978-1-59020-317-0 (US)
HC 978-0-7156-4084-5 (UK)

PB 978-1-59020-670-6 (US)
PB 978-0-7156-4106-4 (UK)

Contents

TOTALITARIAN ART

Introduction

Totalitarianism is the concept which subsumes three such seemingly different movements as the Leninist-Stalinist stage of Bolshevism, Mussolini's Fascism, and Hitler's National Socialism. The deepest and most striking expression of the inner affinity of these three movements, all of which were directed against human freedom, is that they produced identical aesthetic conceptions and the same brand of official art.

Werner Haftmann, *Painting in the Twentieth Century*

There is a widely held view that similar governmental systems will produce similar art. Nothing could be further from the truth.

Berthold Hinz, *Art in the Third Reich*

On 27 May 1937, at the beginning of the talks on German–Soviet friendship, U. Schnurre, a senior official from the Reich Ministry of Foreign Affairs, made a statement to G. Astakhov, the Soviet representative in Berlin:

In spite of all the differences in our *Weltanschauung*, there is one common element in the ideology of Germany, Italy and the Soviet Union: opposition to the capitalist democracies. Neither we ourselves, nor Italy, have anything in common with the capitalist West. And so it seems somewhat unnatural to us that a socialist state should ally with the Western democracies.[1]

The Soviet representative did not find this idea in the least surprising or shocking. On the contrary, as we know, this shared ideological element soon led to the pact between Stalin and Hitler which, to all intents and purposes, unleashed the Second World War. In the area of culture this same shared element led to the unleashing of a purge against the art of the time; many valuable works were destroyed while their creators were arrested, banished or killed. At the same time, it contributed in both countries to the construction of a culture "of a new type".

For a long time the official art of the totalitarian regimes was seen as a "foreign element" within the context of twentieth-century art, "unworthy of

being the subject of research".[2] Works of art created by totalitarianism were hidden from the eyes of the inquisitive in dark museum storerooms; as though to emphasize their total exclusion from the world of art, they were even housed by such organizations as the Oberfinanzdirection in Munich and the "Military Collection" in Washington. "We are therefore quite well informed about the actions and measures taken by the government to suppress art ... But we know very little about the art promoted by the State",[3] wrote B. Hinz in the introduction to his book, *Art in the Third Reich.* This is still more true with regard to the other totalitarian regimes. In the Soviet Union the principal monuments of the Stalinist epoch have been blown up and destroyed, and what were once the most famous works of the Socialist Realists are now kept in inaccessible museum stores. In some publications about Fascist art, works of Italian artists painted towards the end of the Mussolini regime are reproduced with no indication of their present whereabouts or even their creators' names. Evidently they too have sunk into the waters of Lethe. It is also true that many of the most grandiose projects of Hitler, Stalin and Mussolini were never realized; in the ontology of culture, however, intentions have no less importance than their realization.

Only very recently has this official culture begun to emerge from oblivion – and even then only to reveal to the world a face from which the grin of totalitarianism has now faded. At the exhibitions "Art of the Third Reich" which toured West Germany in 1974, "Realisms" at the Centre Georges Pompidou in 1981, and the large exhibition in Milan in 1982, "The Thirties: Art and Culture in Italy", totalitarian realism, uprooted from its historical context, appeared harmless enough.

It is hard not to link this recent revival of interest with the general movement in Western art of the 1970s away from the extreme radicalism of abstract art towards a more traditional figurativism. As at all such transitional moments Art looks back, hoping to find support in the traditions of the recent past. And beyond the horizons of the shifting sea of the sixties and fifties, of an abstract art lacking in ideological content, it glimpses the solid cliffs of the life-affirming Socialist Realism of the forties and thirties. A nostalgia for Art's lost social role, for its purposeful organization, for its direct link with social and political life, casts a pessimistic gloom over appraisals of the contemporary scene, forcing many artists and critics to flirt, albeit unconsciously, with totalitarian aesthetics. As Peter Ackroyd wrote in *The Sunday Times* of 21 June 1981, "When Modernism in Western art is dying, it is impossible to reject the Soviet aspirations towards contact between Art and Life as though they were merely a political conspiracy."

Little, however, has yet been written on this subject. Hellmut Lehmann-Haupt's *Art under a Dictatorship* and Martin Damus's *Socialist Realism and National-Socialist Art* contain valuable information but draw only a few disconnected analogies between the arts of Hitler's Germany, Stalin's Russia and the German Democratic Republic. The term "totalitarianism" is now widely

used, with regard both to Hitler's Germany and Stalin's Russia, but the existence of a common style of totalitarian art is as a rule denied.

This book does not set out to define the nature of totalitarianism; that topic has already spawned a vast literature. Its authors tend either to search for its ideological sources in humanity's distant past – ancient Egypt, Diocletian's Rome, China, the Inca State, medieval Europe – or else to attempt to deduce it from the "historical verticals" of the countries that have been called totalitarian. Naturally, in the past of any country one can find any number of prophets, Messiahs and mass movements – from Joachim of Fiore to John of Leyden and from the Brothers of the Free Spirit to the members of the Munster commune who looked on themselves as bearers of truth and "vessels of the Holy Spirit", considering the rest of humanity merely as raw material in which to inculcate their ideas; the hapless masses have in all countries been only too ready to follow the preachers of social equality, to give up their valueless lives to the struggle for the establishment on earth of the "thousand-year kingdom" of social justice. "For it is the simple truth that, stripped of their original supernatural sanction," writes N. Cohn, "revolutionary millenarianism and mystical anarchism are with us still."[4] Thus Hitler's regime entitled itself the "Thousand-Year Reich", while the Soviet State anthem contained the words: "An indestructible union of free republics has been established *for ever* by great Russia".

Interesting though they are, these are only analogies. Ghengis Khan had no telegraph system; it is only in our day that such ideologies have found the necessary material and technological basis on which to establish themselves as stable political systems. "Historical verticals" are of less importance to the study of totalitarian culture than "geographical horizontals": the visual aspect of totalitarian cultures is determined not so much by their various national traditions as by the common processes of the social and intellectual climate of our time.

When writers do turn to these "horizontals", they often try to find characteristics of totalitarianism in such countries as Franco's Spain, Salazar's Portugal, Greece at the time of the Colonels, or even in today's Western democracies. This last is the equivalent of looking for the intention of ice in cold water. It is indisputably there; nevertheless, ice and water are two distinct conditions of matter. Similarly, totalitarianism and democracy are two distinct conditions of society. Even at a very low temperature a living body can move about in its environment, while human beings can analyse their relationship to their environment and either adapt the environment to themselves or vice versa. At a temperature below zero a body becomes a part of its environment and acquires its consistency, while the analytical and critical abilities of human beings either sleep or die. An ideal totalitarian state, if such a thing existed, would turn into an inorganic monolith – a congealed slab of historical time incorporating millions of frozen human intentions.

Nor is it worth looking to Plato's "ideal state", to the political and moral – or amoral – theories of Machiavelli, to Rousseau's "Social Contract" or to the chiliastic movements of the Middle Ages. It is perhaps Lewis Mumford, in *The Myth of the Machine*, who has come closest to a definition of totalitarianism. Describing various ancient civilizations of "The Time of the Pyramids", he wrote of what he termed the megamachine: "This was an invisible structure, composed of living, but rigid, human parts, each assigned to his special office, role, and task, to make possible the immense work-output and grand designs of this great collective organization."[5] Mumford sees the myths of religion (in ancient times) and of ideology (in our own time) as the fuel that feeds these megamachines, these myths that fuse disparate blocks and elements into one whole and direct this whole towards a universal goal. When fully fuelled, such a megamachine builds huge armies, empires, pyramids, monuments, canals, space ships and weaponry of enormous power; it perishes only if it meets another similar, but more powerful system (Germany in 1945), or if the fuel supply runs short (the Soviet Union today). The latter is just such a consummate megamachine, but now inadequately fuelled because of the exhaustion of Marxist-Leninist-Stalinist ideology.

In a totalitarian system art performs the function of transforming the raw material of dry ideology into the fuel of images and myths intended for general consumption. The precise nature of the raw material – whether it is the cult of the Führer or of the Leader, dogmas of race or of class, laws of nature or of history – is of no more importance than whether one uses beet or wheat when distilling alcohol: the raw material lends a specific flavour to a final product which is in essence identical. And it is not only the final product that is identical; the means of preparation (totalitarian aesthetics) and the technology of production (totalitarian organization) turn out to be equally similar.

The aesthetics and organization of totalitarian art will be discussed later, while the illustrations will give some idea of the works of art themselves. I have chosen works by the most important official artists of the thirties and forties, works that in their time were seen as the finest examples of the official style and so judged worthy of the highest government awards: the "State Prize" in Germany, the "Stalin Prize" in Russia and the "Cremona Prize" in Italy. It is impossible to explain the striking stylistic and thematic similarity between these works as the result either of coincidence (in that case we would find that other, very different, works had won equal prestige), or of shared cultural traditions (the traditions of Russia, Italy, Germany and China are simply too diverse). Nor can it be seen as the result of a strange similarity in the tastes of the arbiters of the arts in the different countries.

Although the Soviet theory of Socialist Realism was based largely on frag-ments of quotations from Lenin, he himself had no personal interest in art. In day-by-day diaries of his activities, there is not one mention of Lenin ever visiting

an art gallery or exhibition.[6] Stalin, according to his daughter Svetlana Alliluyeva, had only cheap reproductions of the Peredvizhniki (see pp. 160–62), torn from a magazine, on the bedroom walls of his dacha near Moscow; and in articles and anthologies under such promising headings as "I. V. Stalin on Art and Culture" we find not one judgement delivered by Stalin on an individual painting, sculpture or building. The ruling principles of Nazi art, on the other hand, were dictated by Hitler in person; dogged by the inferiority complex of a failed artist, he once declared that if Germany had not lost the First World War, he would have become "not a politician but an architect – as great an architect as Michelangelo".[7] His title "Der Schirmherr des Hauses der Deutschen Kunst", printed so splendidly on the catalogues of the exhibitions of Nationalist-Socialist art held annually in Munich, was no mere decoration; he himself selected the works to be exhibited. As for Mussolini, when he accompanied Hitler on a visit to the Uffizi Gallery he only had the patience to look at three pictures. Afterwards the Führer remarked tersely: "Where Art is concerned, the man's a fathead!"[8]

In their pronouncements on culture, however, these leaders were guided not by personal taste but by political instinct and the demands of the ideological struggle. As a result, for all their personal differences, their decisions were identical. Total realism was not the invention of any single one of them; it was a natural product of totalitarianism, as much so as the vast apparatuses of propaganda, organization and terror.

From the moment of its first appearance, the totalitarian state begins to construct a new culture according to its own image: i.e. according to the principle of the megamachine, with no parts that are not strictly functional, with a rigid programme and a universal aim. Anything that hinders its work is ruthlessly eliminated.

The foundations of totalitarian art are laid down at the same time and place as those of the one-party State:

(1) The State declares art (and culture as a whole) to be an ideological weapon and a means of struggle for power.
(2) The State acquires a monopoly over all manifestations of the country's artistic life.
(3) The State constructs an all-embracing apparatus for the control and direction of art.
(4) From the multiplicity of artistic movements then in existence, the State selects one movement, always the most conservative, which most nearly answers its needs and declares it to be official and obligatory.
(5) Finally, the State declares war to the death against all styles and movements other than the official ones, declaring them to be reactionary and hostile to class, race, people, Party or State, to humanity, to social or artistic progress, etc.

It is the process by which this megamachine is constructed, its concentration or diffusion in space and time, that determines the stages in the formation of

totalitarian art, its purity and degree of crystallization. But once the mega-machine is set in motion, however diverse the historical and cultural traditions of the countries in question, there arises a style that one can justifiably term the international style of totalitarian culture: total realism. For it is only by the imprint of racial, ethnic, geographical or other details that we can determine whether a work of art created under totalitarianism belongs to this or that country or people.

The classic examples of this style are Socialist Realism from 1932 to 1956 and the art of the Third Reich from 1933 to 1945. With the regularity of a physical law this same style began to reproduce itself immediately after the revolution in Communist China, and in the Soviet-bloc countries after the Second World War it determined the nature of the official art in direct proportion to the degree to which each country had been instilled with the ideology of the Big Brother (more in East Germany and Bulgaria, less in Poland and Hungary). In Russia this style developed gradually and only after a long prehistory. In Germany it emerged astonishingly quickly – during the three or four years immediately following Hitler's assumption of power. In Italy the process of its formation stretched out over two decades and was never fully completed; it was not until 1938 that Fascist culture ever came close to total realism. Nevertheless I have devoted considerable space in the first section of this book to Italian art during and immediately preceding the Fascist period, and also to the art of the Russian and German avant-gardes in the 1910s and 1920s.

Totalitarian art did not appear out of a vacuum. It was preceded by a long period when, in the crucible of the more radical artistic movements – Italian Futurism and the work of the Soviet avant-garde in particular – political ideas of total revolution and social transformation were translated into the precise formulae of a new art. Too conservative by its nature to generate new ideas, totalitarianism takes them ready-made, translates them into its own language, distorts their aesthetic nature, transforms them into their opposite and forges from them a weapon with which to destroy its enemies – including the very creators of these ideas.

As it existed until recently in the Soviet Union, the congealed skin of totali-tarian culture bore on it the ideological imprint not only of the reactionary thirties and forties, but also of the revolutionary twenties; deep inside it lay hidden powerful strata of the artistic tradition of the avant-garde and left art, a tradition that was violently broken off before being historically realized, a tra-dition that was driven underground but is still endowed with a potency which has begun to make itself felt since the death of Stalin. A Soviet museum was until recently a precise model of totalitarian culture: the public galleries were solemnly hung with the paintings of the Socialist Realists, while directly beneath them, hidden from the eyes of passers-by in reserve stocks and special stores, canvases by Kandinskii, Chagall, Malevich and Tatlin lay gathering dust. The

same model in reverse is applicable to some degree to the West: beneath a surface of free creativity lie strata of totalitarianism that have sunk deep underground – strata of who knows what potential power?

The theme of this book is not "art under totalitarian regimes", but "totalitarian art". Not all art created in Stalin's Russia or Hitler's Germany can be defined in this way – just as not everything created in the fifteenth century can be called a part of "Renaissance culture". The aim of this book is to show how, with the appearance of the totalitarian political systems of the twentieth century, there came into being a particular cultural phenomenon with its own specific ideology, aesthetics, organization and style. With the collapse of the Third Reich and fascist Italy, the totalitarian period of the cultural evolution in these countries came to an end, but in the Soviet Union it continued long after Stalin's death. A visible reaction against official art began in the mid-fifties and the next few decades saw the gradual erosion of the monolith of totalitarian culture. The opposition finally acquired an almost official character from the beginning of glasnost and perestroika.

This book was completed before the period of perestroika, so all the allusions it contains to the "contemporary" state of affairs in Soviet art refer to the time before 1985. Artistic life in the USSR underwent significant changes after this time, although it is difficult to say what this process will lead to. Will the megamachine of totalitarian culture now be destroyed completely, or will it simply be transformed into some new, post-totalitarian, phenomenon? For now, this remains an open question.

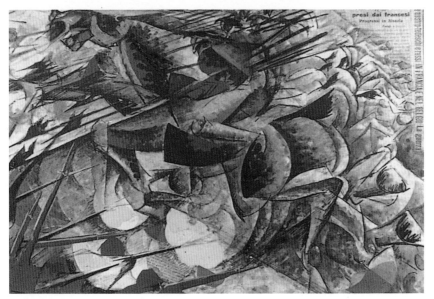

1. Boccioni: Cavalry Charge (1915)

The crucible of the revolutionary movements of the beginning of the century gave birth to an artistic ideology many features of which were later incorporated into the foundations of totalitarian art. Totalitarianism translated the ideas of the avant-garde into its own language and forged them into a weapon with which to destroy its enemies. The idea of struggle as the driving force of history and culture was expressed by the Futurists through the image of abstract "lines of force" and dynamic shapes (*Ill. 1*); in totalitarian art, however, this idea was embodied more concretely, through the image of war. War, the events of the past and everyday labour were all portrayed as a heroic struggle by man against inert Nature or the reactionary forces of History (*Ill. 2*).

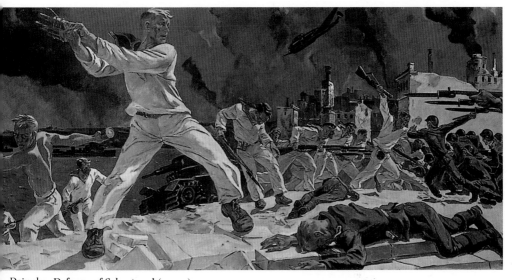

Deineka: Defence of Sebastopol (1942)

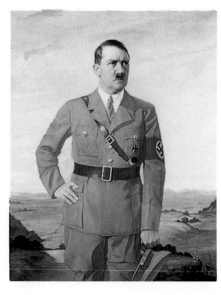

3. Knirr: Hitler

The ceremonial portrait of the leader (in painting and in monumental sculpture) occupied the most important position in the hierarchy of genres of totalitarian art. The majority of the most important State prizes were awarded to works in this genre, and it was their creators who filled the key positions in artistic life and constituted the artistic establishment of their countries. A comparison of early and late examples of the Soviet variant of this genre allows one to glimpse its stylistic evolution: from realism with a hint of romantic excitement, conveyed by the dynamism of the colours and the compositional structure (*Ill.* 5, 1930), to a solemn and frozen immobility that endow the image with the qualities of

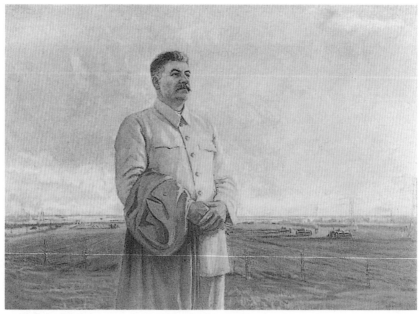

4. Shurpin: The Morning of Our Fatherland (1948)

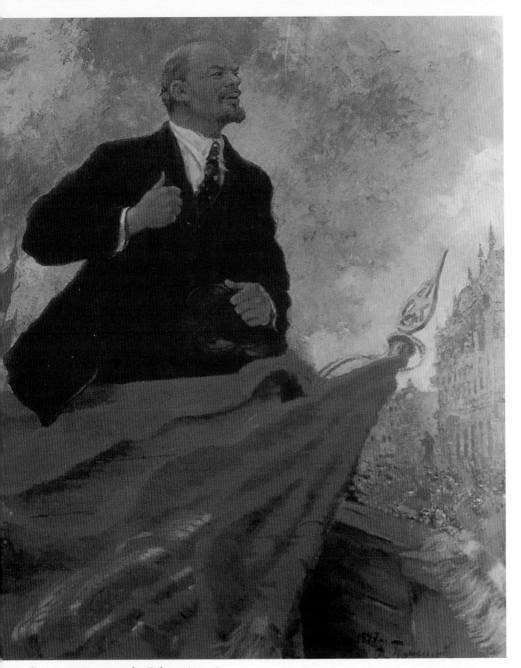

5. A. Gerasimov: Lenin on the Tribune (1930)

an icon (*Ill. 4*, 1948). This development from the realism of the Peredvizhniki towards an academic classicism is characteristic of Soviet art as a whole during its totalitarian period.

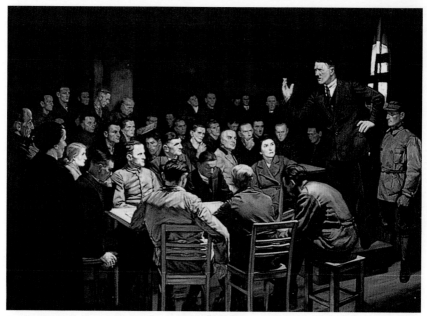

6. Hoyer: In the Beginning Was the Word (1937)

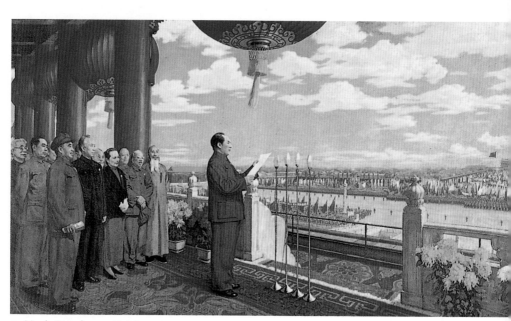

7. Mao's Speech on 1 October 1949

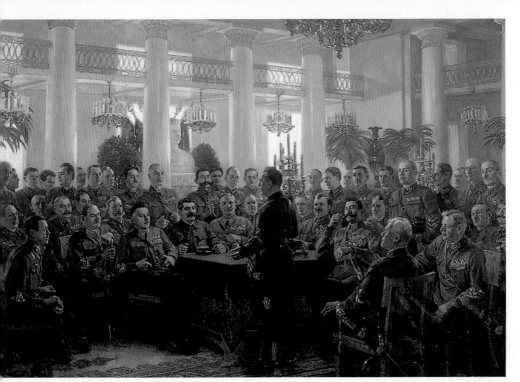

3. A. Gerasimov: Stalin at a Meeting with Commanders

The second most important genre of totalitarian art – the "historico-revolutionary theme" or "historical painting" – was also devoted primarily to portrayals of the leaders, this time as "creators of history" leading the revolutionary masses (*Ill. 7*). This genre also included portrayals of contemporary "historical" events directly involving the leaders (*Ill. 9*). The title of Otto Hoyer's painting (*Ill. 6*), depicting a speech given by Hitler at one of the first congresses of the National Socialist Party, is a direct quotation from the Bible. More often, however, the religious nature of these paintings is made apparent not so much by their titles as by their use of the compositional schemes characteristic of Christian iconography. The numerous paintings of meetings between the leaders and various sections of the population, for example, remind one of paintings of "The Appearance of Christ to the People".

9. Khmelko: Triumph of Our Fatherland

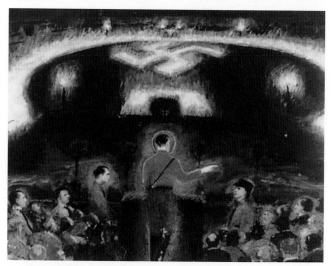

10. Taust: Hitler and God

There were few paintings of this nature in the art of Stalin's Russia and Hitler's Germany (they were more common in the early stages of development of totalitarian art, and in Mussolini's Italy in particular), but the tendency to deify the leader – here revealed only too clearly (*Ill. 10, 11 & 12*) – is an important characteristic of all totalitarian art. Here the leader loses all personal characteristics and is transformed into a figure of allegory: a warrior, a standard-bearer, a supernatural being in direct relationship with the deity.

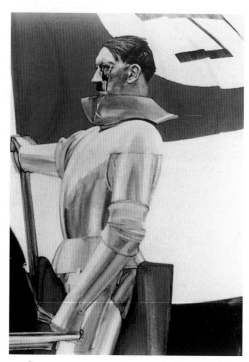

11. Lanzinger: Hitler

12. Iakovlev: Marshal Zhukov

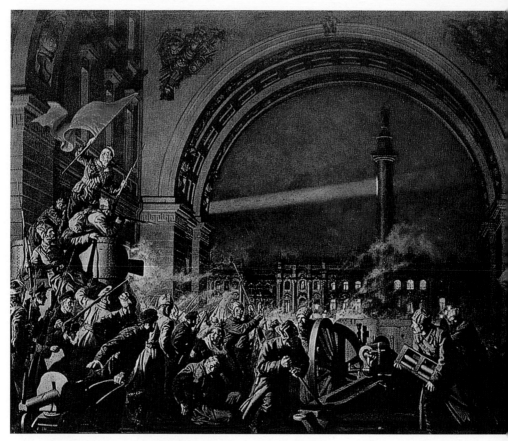

13. Sokolov-Skalia: The Salvo from the *Aurora*

One of the main functions of the historico-revolutionary genre, and indeed of totalitarian art as a whole, was the mythologizing of both past and present events. "The Salvo from the *Aurora*" and "The Storming of the Winter Palace" – the most common subjects of Soviet historical painting – are obvious examples. During the night of the 24/25 October 1917 the cruiser *Aurora*, moored in the Neva, supposedly fired a salvo at the Winter Palace; this supposedly led to the flight of the Provisional Government and the storming of the Winter Palace by the Bolsheviks. The Winter Palace was in fact guarded only by a women's regiment and a handful of poorly armed schoolboys; countless Soviet paintings,

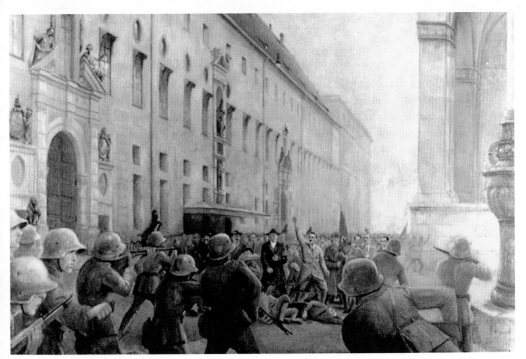

14. H. Schmitt: Hitler *Putsch*

however, portray the heroic storming of an almost impregnable fortress (*Ill. 13*). Hitler's heroic pose (*Ill. 14*) in this painting of the November 1923 *putsch*, considered one of the central events in the history of National Socialism, also owes more to myth than to historical truth. As the first shots were fired, Hitler fell to the ground; he then abandoned his dead and dying comrades and was carried to safety in a car that had been waiting for him round the corner.

Paintings of this nature were used as illustrations in historical textbooks; they were looked on almost as genuine historical documents.

Art of this kind includes few representations of events preceding the totalitarian revolutions: history in each of the totalitarian countries was considered to have begun with the coming to power of their respective totalitarian party, or perhaps with the beginning of its struggle for power. A truly historical Soviet painting first appeared only after the War, and it flourished during the last years of Stalin, at the time of Zhdanov's campaign against "rootless cosmopolitanism" and the revival of Russian nationalism. The battles which had established the Russian Empire were now considered to be as sacred as the battles to establish the Proletarian State. All Russian art, not just the realism of the Peredvizhniki, was now declared to represent a peak in world culture; this included old Russian icon-painting, the stylistic influence of which can be detected in many works by Soviet artists (*Ill.* 15).

15. Korin: Aleksandr Nevskii

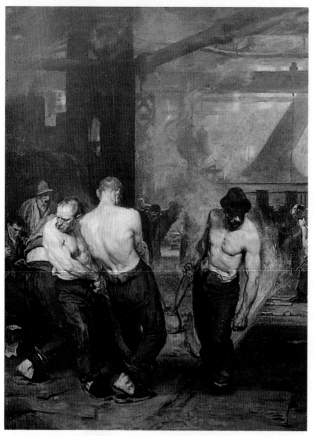

16. Kampf: Rolling Mill

17. Iablonskaia: Bread

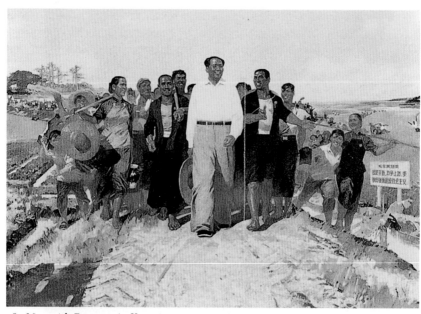

18. Mao with Peasants in Kwantung.

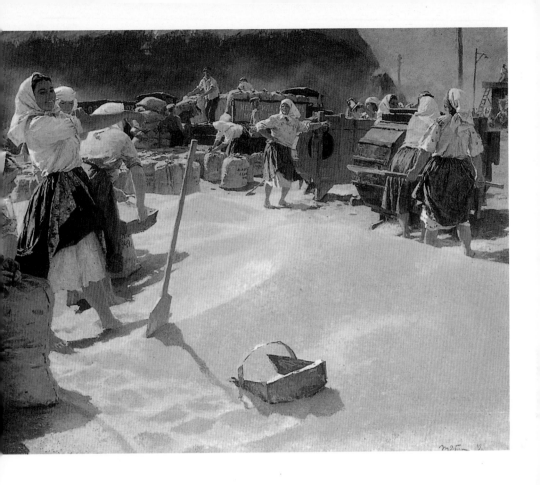

Although totalitarian art included many representations of the happy life of the people and their devoted labour, this genre occupied a considerably less important place in the artistic hierarchy. Labour, which under any totalitarian regime is essentially forced labour, was always portrayed either as a fierce struggle (*Ill. 16*) or else as a joyful festival (*Ill. 17 & 18*). Social optimism was the most persistent of all the leitmotifs of Soviet art, present in each stage of development of each of its national variants.

The most neglected genres in totalitarian art were landscape and still life. Even a landscape, however, was always treated in one of two ways: either as an image of the Fatherland, intended to inspire people with love for their country, or as an arena of social transformations – the so-called "industrial landscape".

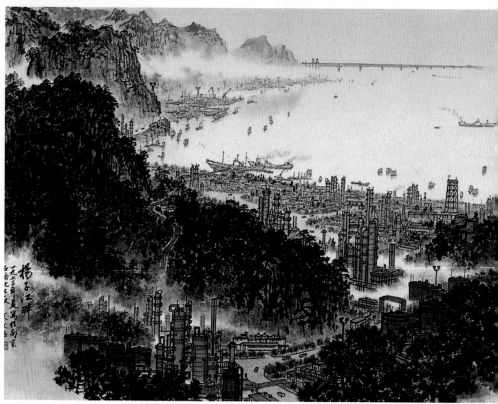

19. Industrialization on the Banks of the Yang-Tse.

During almost four thousand years of development Chinese art had never known painting in oils; the very idea of a framed painting hanging on a wall was deeply alien to its national spirit. After the Revolution, however, Chinese art was incorporated into the world of totalitarian culture – with all the consequences this entailed. In its first stage of development, following Mao's instructions, it imitated the Soviet model. The place of honour was given to the thematic painting: the ceremonial portrait of the Leader, the historico-revolutionary theme, etc. (*Ill. 18*). Later, Chinese art began to adapt the traditional techniques of painting with ink on silk (go-hua). With the most delicate brushes, dipped in coloured ink, Chinese artists now began to represent the image of the leader, to draw smoking blast-furnaces, huge cranes and the lines of high-voltage cables disappearing into the misty distance of hills and lagoons (*Ill. 19*).

Chinese art is a striking example of the universality of the mechanisms of totalitarian culture: wherever in the world they began to function, whatever national soil served as their foundation, whatever realities were reflected in their magic mirrors, these soils and these realities always took on one and the same aspect – that of the Socialist Paradise where there is no more pain or suffering, where happy people under the guidance of wise leaders construct a new life and harshly chastize their enemies.

Preface

Once, when I was employed at the Pushkin Museum of Fine Arts, someone discovered a copy of *Art of the Third Reich*, an official journal of Nazi Germany, among the rubbish behind the shelves in the library. Long, long ago, some book-lover had evidently stuffed it away to hide it from the numerous censorship committees – not, of course, out of love of Nazism and its art, but simply because, being a normal person, he saw something appalling in the destruction of the printed word. Now one of my duties at the time (the early sixties) was to lead discussion groups for senior schoolchildren, and during one of these groups I asked my pupils to tell me the names of the artists represented in these journals. The school-children saw the usual subjects, executed in the realistic style they knew so well: smoking blast-furnaces against the background of a symbolic dawn, zealous enthusiasm on the factory shop-floor, passionately motivated workers, muscular youths and heroic warriors, popular exultation, general prosperity, unanimous approval ... It seemed a very easy question and they immediately, each trying to be heard above the others, shouted out the familiar names: Gerasimov! Kotov! Mukhina! Tomskii! Vuchetich! Nalbandian! Their knowledge of the Soviet art of the preceding decades was indeed impressive.

One of the reproductions showed a working-class family listening raptly to a wireless.

"Laktenov!" my pupils declared almost unanimously.

"Look carefully."

The faces of the young art-historians took on an expression of extreme bewilderment: on the portrait above the heads of the listeners, instead of the half-smile concealed beneath the Leader's moustache, they had caught sight of the small Charlie-Chaplin moustache of the Führer.

It was then, in the bowels of the totalitarian system, "in the belly of the whale", that I first had the idea of this book: it arose from an intuitive sense of the strange closeness between two artistic systems that were separated by their high-flown phraseology and were, on the face of it, ideologically hostile to one another. Totalitarian aesthetics teaches that art is a mirror which reflects reality; in this mirror the two systems betrayed their true likeness and reached a near-absolute identity of style.

The book itself was written after I had emigrated. I am deeply grateful to

Andrew Nurenberg and to Maria and Andrei Sinyavskii, who persuaded me to undertake this work; to Inga Karetnikova and Leon Steinmets for their valuable comments on the text; to Igor Chelkovskii and Vladimir Papernii for their great help with the illustrative material and to my friends in Palo Alto and Oakland for their good advice and moral support during my stay in Stanford; finally I must express my special gratitude to the Kennan Institute of the Wilson Center in Washington and to the Hoover Institute of Stanford University for their material help; this enabled me to study the Washington "Military Collection" and the Hoover archives, and to work for one year in the libraries of Washington, Harvard and Stanford. Without the above individuals and organizations, this book could not have appeared in its present form.

Note on Transliteration

The system of transliteration used follows the Library of Congress system with the differences that an ë is rendered by an e, and both hard and soft signs are rendered by a single diacritical mark. The diacritical mark has been omitted entirely from the text, but is present in the footnotes and bibliography. In instances where this system of transliteration might make certain well established names such as Marc Chagall, Alexandre Benois, and El Lissitzky, unrecognizable, the familiar forms have been retained.

Preface to the Second Edition

The first edition of this book was published in the UK and the USA in 1990; it was also published in French and Italian translations. While I was working on the book, and when it was published, the mere use of the term "totalitarianism" with regard to the Soviet Union was seen as an ideological throwback to the years of the Cold War. Both social prejudices and political terminology made it difficult for many people to see the striking similarity, so very evident in their art, between dictatorial regimes that bore different names. Hannah Arendt, George Orwell and Arthur Koestler were among the few who saw this similarity – as was Vasily Grossman in the Soviet Union, who developed the idea of totalitarianism in his great novel *Life and Fate*.

German publishers declined to publish the book – and for a reason that is understandable. Germany – unlike Russia – had accepted the blame for unleashing the Second World War, and from a German perspective it seemed unacceptable to identify Hitler's regime with Stalin's. In Russia it proved impossible to publish the book until the collapse of the Soviet Union; it first appeared only in 1995. Apart from a couple of fairly hostile reviews, the book was little discussed there.

It appears, judging by the reviews, that the book was most warmly greeted in France and Italy. In England and the USA, on the other hand, I was accused of falsification, a selective approach to the facts, of Cold War propaganda and even (with Noam Chomsky's approval) of taking a Marxist approach to history. It was – I was told – my years of living and working in the Soviet Union that had led me to attempt to reveal certain universal laws of development of totalitarian art. Evidently, the concept of totalitarianism remains no more than a scholarly abstraction unless you have experienced for yourself the ideological pressure that can be brought to bear by such a regime.

During the years since the book was first published a great deal of material has been published – mainly in Russia but also elsewhere – from archives that were previously inaccessible. The problem of totalitarian art has been directly addressed, or at least touched on, in a substantial number of publications. There is much that could have enriched my arguments, but there is nothing, I believe, that in any way calls into question the book's central ideas. I have, therefore, made only a few small changes to the original text: a few minor additions, a few abridgements, a few stylistic changes.

My hope is that the changes that have taken place in the world during the last twenty years will make it possible for this book to be read with a new understanding.

—Igor Golomstock, *June 2009*

Each people is responsible for its own history. But only a consciousness unable to learn the lessons of the sorrows of our age can see Hitler merely as the representative of one nation, refusing to recognize that he represented the fulfilment of a powerful tendency that overshadowed the whole first half of the century.

Joachim Fest, *Hitler*

PART ONE – THE PROCESS

CHAPTER ONE

Modernism and Totalitarianism

(i) The artist and "the revolution of the spirit"

October. Whether or not to accept it? No such question
existed for me – or for the other Moscow Futurists. It was
my revolution. I must go to Smolny.

Maiakovskii, 1917

The coming to power of Fascism means the realization of
the Futurist minimum programme. The Futurists – the
prophets and forerunners of the great Italy of today –
are happy to salute a remarkable Futurist nature in the
person of our premier, a premier who has still not reached
the age of forty.

Marinetti, 1922

The harsh repression of contemporary art during the thirties, after which,
according to Isaiah Berlin, "Russian literature, art and thought emerged like an
area that had been subjected to a terrible bombardment, with some splendid
buildings still relatively intact, but standing bare and solitary in a landscape of
ruined and deserted streets,"[1] gave birth to a persistent legend of the "romantic
twenties" as a kingdom of liberated creative thought. These two decades appear
to be antagonistic epochs, divided by a blind wall of antitheses: freedom and
slavery, dynamism and stasis, development and stagnation, etc. It is indeed
true that there is no stylistic link between Tatlin's Monument to the Third Inter-
national and Iofan's tower of the Palace of Soviets, between Boccioni's dynamic
abstractions and portraits of the Duce by Cremona prize laureates, between the
inspired geometry of the products of the Bauhaus and the muscular strength of
Torak's and Breker's supermen. There does, however, exist a hereditary link: it
is not only the bright flowers of freedom of the spirit that sprang from the seeds
cast by the avant-garde into the heterogeneous ideological soil of the twenties.

In November 1917, several days after the proclamation of Bolshevik power,
the All-Russian Central Executive Committee invited the Petrograd intelligentsia
to Smolny in order to discuss the future collaboration of cultural figures with
the new government. Five well-known representatives of the artistic intel-

ligentsia came to this meeting: Vladimir Maiakovskii, the Russian Futurist leader; the poet Aleksandr Blok; the theatrical innovator Vsevolod Meyerhold; and two artists – Kuzma Petrov-Vodkin and the Futurist Natan Altman. On the day of Mussolini's coup, 24 October 1922, Italian Futurists, representatives of the most revolutionary wing of modernism, walked through the streets of Rome side by side with members of Fascist military units. Some time later these revolutionary artistic currents were to be marginalized in Italy and annihilated in the USSR. Hitler, on the other hand – like Mao Tse-tung after him – declared merciless war on all modernism the moment he came to power. The German and Chinese variants, however, represent a further stage in the development of totalitarianism: from the very beginning Hitler had before his eyes the results both of Mussolini's cultural policies and of the Leninist-Stalinist programme, while Mao took the model of the Big Brother as the basis for cultural changes from as early as 1942.

If one looks on these phenomena as parts of one historical whole, one can say that, although a totalitarian regime disguises itself in revolutionary garb during its first stage of development, the art engendered by it turns out sooner or later to be the result of the resuscitation of the most conservative and outmoded traditions. Shortly before the totalitarian revolution these traditions exist only on the cultural periphery, and their champions are not in the least disposed to welcome in political life the upheavals which have already been accomplished in spiritual life by their revolutionary colleagues. The latter, as a rule, see the triumphant progress of the revolution as an elemental flow sweeping away the social barriers that prevent free, independent creativity. Tommaso Marinetti saw Fascism as the realization of the "minimum Futurist pro- gramme".[2] Kazimir Malevich considered that "Cubism and Futurism were rev- olutionary movements in art, anticipating the revolution in economic and political life of 1917".[3] The Constructivist El Lissitzky saw Communism and its triumph as the direct result of Malevich's Suprematism,[4] and *The Newspaper of the Futurists*, edited by Maiakovskii, David Burliuk and Vasilii Kamenskii, began in 1917 to appear under the slogan "revolution of the spirit". Members of the German "November Group" – the most important avant-garde artists from Walter Gropius to Paul Hindemith and from Max Pechstein to Emil Nolde – had the same sense of themselves as "revolutionaries of the spirit" in 1918 when they welcomed the Russian Revolution and expressed their hope for the triumph of a similar revolution in their own country. This sense of the artist's kinship to the revolution is given clear and naive expression in the autobiography of Marc Chagall, then a Commissar for Arts in the People's Commissariat for Enlightenment (Narkompros): "Lenin turned [Russia] upside down the way I turn my pictures."[5*]

*In Paris in 1937 Chagall was to embody this metaphor in one of his paintings, portraying Lenin as a clown standing on his hands among a group of typical Chagall characters

By virtue of their revolutionary nature such artists appeared at the very epicentre of the social explosion, offering themselves to the revolution and aspiring on its destructive wave to the heights of creativity. It is for this reason that both the Bolshevik coup and Mussolini's were first welcomed not by those who were later to laud the great achievements of the totalitarian regimes – i.e. the realists and traditionalists – but by those revolutionary artists who were later either to be stifled and annihilated or else to be pushed aside to the periphery of artistic life. It is this historical paradox that appears to embody the logic of development of one of the main tendencies of twentieth-century art.

"The revolution of the spirit", the destruction of the foundations of the old culture, anticipated the social revolutions in both Italy and Russia. Art had developed considerably more slowly there than in France or Germany and so the longing for radical transformation was especially strong. The first decade of our century in Italy and Russia was marked by a rapid development of the most radical forms of art.

In February 1909 the *Founding and Manifesto of Futurism* was published in Paris, singing the praises of the polyphony of revolutionary tides, the beauty of great speeds and precise calculation, and the glittering horizons of the new machine age. Umberto Boccioni, Giacomo Balla, Luigi Russolo, Antonio Sant'Elia and Tommaso Marinetti quickly set about realizing this programme for the art of the future in the realms of painting, sculpture, architecture, music and poetry. In the following year the young Giorgio de Chirico, finding in the deepest layers of his unconscious an instrument with which to descry the invisible inner life of things, painted the first of the series of metaphysical paintings (*Pittura metafisica*) which were the direct precursor of Surrealism.

The pace of this development in Russia was still more impetuous. The future founder of Socialist Realism, Maxim Gorky, called the period from 1907 to 1917 "the most shameful decade in the history of the Russian intelligentsia". In actual fact Russian art had not known such a flowering since the days of Andrei Rublev and Theofanes the Greek. As early as 1907 Mikhail Larionov and Natalia Goncharova created in their so-called primitivism a national variant of what the German Expressionists in Dresden had arrived at two years earlier. At the same time, Chagall was creating his unique phantasmagorias; very soon, in the words of André Breton, an embodied metaphor was to descend from Chagall's Vitebsk paintings and begin its triumphant progress through European painting. In 1910 Vasilii Kandinskii created his first abstract paintings in Munich and finally, in 1913–14, Kazimir Malevich anticipated Piet Mondrian in proclaiming the principles of geometrical abstraction (Suprematism) while his spiritual twin, enemy and antithesis, Vladimir Tatlin, created the first "painterly reliefs" in the world.

Some time after French Cubism, but at almost the same time as Italian Futurism, there arose a peculiar synthesis of these two movements – Russian

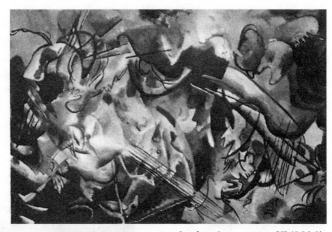

Kandinskii: Composition VI (1914)

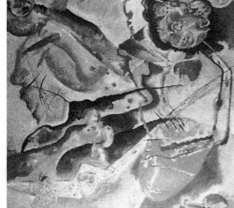

Kandinskii: Painting with a Red
Mark (1913)

Kazimir Malevich: Suprematism
No. 50 (1915)

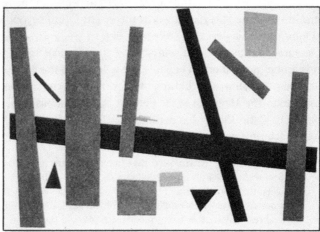

Cubo-Futurism. Later, together with Italian Futurism, this movement became
the most radical current within the European avant-garde.

Russian Futurism (or Cubo-Futurism) appeared after Italian Futurism, but
evolved extremely quickly during a short period. When Marinetti arrived in
Moscow and St Petersburg in January 1914 "as the head of the revo-
lutionary centre reviewing one of his provincial branches", the Russian Futur-
ists were little inclined to look on him as their leader or to look to his pompous
rhetoric for practical guidance. On the contrary, they considered that Velimir
Khlebnikov in poetry and Mikhail Larionov in painting had progressed much
further along the path of destroying the traditional approach towards form and
language.[6] Certainly this appraisal sprang partly from suspicion, arrogance and
even the envy of the provincial towards his colleague in the capital; nevertheless
a dramatic collision of attraction and repulsion, similarities and differences,
closeness and alienness, love and hatred, characterized the relations between
Russian and Italian Futurism from their birth until the middle of the twenties.

In the beginning there were more differences than similarities between these
two currents that bore the same name. Before the Revolution Russian Futurism
was a motley conglomerate of different literary, literary-artistic and artistic
groupings, bearing the most varied names – "Cubo-Futurism", "Ego-Futurism",
"Maisonine of Poetry", "Centrifuge" and so on. The post of leader of this
movement, held securely by Marinetti in Italy, remained vacant for a long time
in Russia, since neither Burliuk, Maiakovskii nor Larionov could lay claim to
the combined role of theoretician, ideologue and organizer. What united the
Russian and Italian Futurists was a common denial of the dark past and the
idea of building the culture of a bright future; their attitudes towards this future,
however, were very different.

The Italian Futurists saw the future as their own country, a country that
had thrown off the burden of the past and donned glittering clothes of steel and
glass. In his very first manifesto Marinetti appealed to the revolutionary crowd
and directed the Futurists towards the bright future beyond the horizons of the
coming technological era: "We will sing of great crowds excited by work, by
pleasure, and by riot; we will sing of the multicoloured, polyphonic tides of
revolution in the modern capitals; we will sing of the vibrant nightly fervour of
arsenals and shipyards blazing with violent electric moons".[7] In the second
manifesto, *The Manifesto of the Futurist Painters* published in 1910 by Umberto
Boccioni, Carlo Carrà, Luigi Russolo, Giacomo Balla and Gino Severini, this
future acquired definite social characteristics:

> Comrades, we tell you now that the triumphant progress of science makes
> profound changes in humanity inevitable, changes which are hacking an abyss
> between those docile slaves of past tradition and us free moderns ... In the eyes
> of other countries, Italy is still a land of the dead, a vast Pompeii, white with
> sepulchres. But Italy is being reborn. Its political resurgence will be followed

by a cultural resurgence. In the land inhabited by the illiterate peasant, schools will be set up; in the land where doing nothing in the sun was the only available profession, millions of machines are already roaring; in the land where traditional aesthetics reigned supreme, new flights of artistic inspiration are emerging and dazzling the world with their brilliance.[8]

In these manifestos aesthetics turns into politics, creativity takes on a practical slant, and the very terminology betrays its similarity with Party jargon; in the second manifesto the term "comrade" – later to become the official form of address between members of the Fascist, National Socialist and Communist parties – cements the people to whom it is addressed into a social order that is being called upon to transform the country. "I am a Futurist," wrote Giovanni Papini, "because Futurism means Italy, an Italy greater than the Italy of the past, more modern, more courageous, more advanced than other nations."[9]

This statement could not have been made by one of the Russian Futurists. Their denial of the past was stronger at first than their affirmation of the future. Their "slap in the face of public taste"[10] with its demands "to throw Pushkin, Dostoyevsky and others overboard from the steamboat of modernity" and "to batter the obtuseness of fat, overfed mugs with a lamp-post" corresponded to the insistence of the Italians that "Every day we must spit on the Altar of Art".[11] But between the aesthetic excesses on the literary platforms of Moscow and the politicized street-fighting in Milan lay the same difference as between Maiakovskii's famous yellow blouse and Marinetti's dinner-jacket. Their conception of

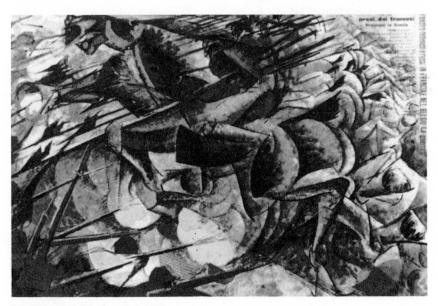

Boccioni: Cavalry Charge (1915)

the future they were named after, and for which they were fighting, was not so much a new Russia, with schools for the illiterate and factories equipped with the latest technology, as a utopian picture of the kingdom of eternal youth, with flying satellite cities inhabited by creators who constantly made the world anew. They saw Marinetti's zeal for social transformations merely as "base pragmatism", "opportunism" and "ideological acquisitiveness". Russian Futurism before the Revolution, as its theoretician Sergei Tretiakov stated, "was an aesthetic movement, the aspiration of a group of people whose main point of contact was not a positive task, not a clear recognition of their 'tomorrow', but a hatred for their 'yesterday and today', an unquenchable and merciless hatred".[12] Their yellow blouses and painted faces, their spoons in buttonholes, their demonstrations, their discussions and exhibitions which often ended in brawls, the pictures put together from the most common everyday objects and often accompanied by indecent titles, which they then dragged through the mud – all this contained in embryo the element of intentional scandal, of nihilistic denial of all cultural values that was to characterize the performances of the Dadaists a few years later in Europe and America.

Although war was hailed by Marinetti as "the world's only hygiene", the First World War placed the Italian and Russian Futurists in ideologically opposed camps: the former joined the protagonists of nationalist war whereas the latter were pacifists and internationalists. In this situation the Russian Futurists began to feel that what they called Futurism was now obsolete, and at the end of 1915 Maiakovskii proclaimed the death of Futurism along the lines of "Futurism is dead – long live Futurism!"

> The first part of our programme of destruction we consider to have been accomplished. That is why you should not be surprised if today you see in our hands not the clown's rattle but the architect's drawing ... Yes! Futurism as a particular group has died, but it has poured into all of us like a flood ... Today everyone is a Futurist. The people is Futurist. FUTURISM HAS GRASPED RUSSIA IN A MORTAL GRIP![13]

This was indeed a prophecy. No longer merely a movement of aesthetic rebellion, Russian Futurism merged with the destructive-constructive torrent of social revolution to become Futurism in the original, Italian meaning of the word; in the first years after the October Revolution it did indeed pour through the artistic centres of Russia like a flood.

(ii) Art and social revolution – Futurism under the red flag
at the service of two revolutions

I shall unfurl ... the red flag of Futurism.

Pratella, 1910

The future is our only religion.

Marinetti

Our god is speed.

Maiakovskii

"On 25 October [1917] we were already at work,"[14] Maiakovskii declared proudly in the first issue of his journal *LEF*. Marinetti could have named 23 March 1919 as a similar date: it was on that day, in the Circolo Industriale e Commerciale on the Piazza San Sepolcro in Milan, that Mussolini announced the birth of his movement, Fasci Italiani Combattimento – and Marinetti, the leader of Italian Futurism, was standing beside him. But in actual fact the collaboration of Italian Futurism with Fascism had begun two years earlier.

In April 1915 Marinetti and Mussolini were both arrested during a demonstration in Rome; the Futurists acclaimed the future Duce as "a man of truly futurist aspirations" and a personal friendship was born between the two leaders. In March 1919 Marinetti was elected to the Central Committee of the Fascist party, and in the autumn his name stood second, after Mussolini's, on the list of Fascist candidates for the parliamentary elections. In December 1918 and January 1919 the first Fascist-Futurist clubs opened in Rome, Ferrara, Taranto and Florence. Coincidentally, or by an irony of fate, January 1919 was also the date of the founding in Petrograd of the organization of Communist-Futurists. These "Komfuts", as they called themselves, placed themselves at the service of the Revolution as consciously and uncompromisingly as their Italian brothers. In the pages of the newspaper *Art of the Commune*, printed at that time by the art section of Narkompros but to all intents and purposes the main organ of the Futurists, the terms "Communist" and "Futurist" were used interchangeably. "The Futurists poured into the October Revolution with the same iron necessity as the Volga flows into the Caspian Sea."[15]

It is hard to explain the merging of Futurism with the ideologies of two parties, one in power, the other striving for power, except as a result of the similarity of the ideologies. "The springs of Fascism," writes the German historian Ernst Nolte, "were: the nationalists led by Enrico Corradini, the legionaries led by the D'Annunzio of the Fiume enterprises, and the former Marxists who had split off from the Socialist party and were led by Mussolini ... Of these three elements Mussolini's movement ... was by far the most important."[16]

The ideology of revolutionary Marxism was Mussolini's symbol of faith until the First World War. As a young man, he always carried in his pocket a nickel medallion with a portrait of Karl Marx, whom he looked on as "the greatest of all theorists of socialism".[17] The son of a blacksmith, Mussolini became the editor of socialist newspapers – first *Class Struggle*, and then *Avanti!* – in whose pages he proclaimed the principles of anti-imperialism and proletarian internationalism. (During the Fascist period *Avanti!* was equally unobtainable in Italian and, naturally, Soviet libraries.)

In 1912, opposing the approaching war and the upsurge of patriotic fervour of the time – unlike the Futurists themselves – Mussolini paraphrased Marx to write, "There are only two fatherlands in the world: that of the exploiters and that of the exploited."[18] After the outbreak of war, now in harmony with the Futurists, he repeated Lenin's slogan about the transition from an imperialist war to a civil war. Even after he had abandoned Marxism, Mussolini criticized the Bolshevik Revolution in Russia from a left-wing rather than a right-wing point of view. At the time he stated that Bolshevism was revealing "its capitalist – warlike, nationalist – face, and Lenin is the greatest of all reactionaries in Europe".[19] Marxism was far from being a youthful caprice of the Fascist Duce that disappeared without trace; as Nolte writes, "the *finalità* of Marxism continued to live in him, even if he was not aware of it".[20]

If Mussolini's movement was the main source of Italian Fascism, then Italian Futurism was one of the main sources of Mussolini's movement. After his sudden leap from revolutionary Marxism or, as he called it, "authoritarian communism", to Fascism, Mussolini had at first only a vague idea of the principles of his new movement. Fascism to him was not a dogma but a method or technique for attaining power, and he drew many of his ideas from the Futurists surrounding Marinetti who, between March and July 1919, "were the predominant element in the Milanese *fascio*".[21]

These ideas that were so easily transformed into methods, these methods that appeared in the guise of ideas, were shared by the two movements. Benedetto Croce has written about their continuity: "For anyone who has a sense of historical connections, the ideological origins of Fascism can be found in Futurism, in the determination to go down into the streets, to impose their own opinion, to stop the mouths of those who disagree, not to fear riots or fights, in this eagerness to break with all traditions, in this exaltation of youth which was characteristic of Futurism."[22] All this served as a means of attaining power – towards which Fascism and Futurism were now striding shoulder to shoulder. And so, on 15 April 1919, Marinetti personally led a raid on the editorial office of Mussolini's former paper, the Socialist *Avanti!* – an action described by Mussolini as "the first material achievement of the Fascist revolution".[23] And in October 1922, during the "march on Rome", the Futurists strode alongside the black-shirted Fascist *squadristi*.

The Italian Futurists saw Mussolini as the builder of their Futurist future, a crusader for the workers' cause who not long before had promised to hoist the red flag of revolution over the Potsdam palace; they saw in him the same ardent revolutionary as the Russian Futurists saw in Lenin. From their point of view, the revolutions in Italy and Russia had taken different paths but were following the same general goal of the destruction of the old order and had therefore engendered similar cultural phenomena.

"Every people had, or still has, its passéism to overthrow," wrote Marinetti. "We are not Bolsheviks because we have our own revolution to make."[24] Even though Italian Fascism had already been branded in the Soviet press as the world bourgeoisie's most extreme form of reaction to the proletarian revolution, though Mussolini himself was portrayed as a lackey and a puppet in the hands of the imperialists, the ideological and aesthetic kinship of the two futurisms was at the time admitted by both sides.

In 1920, during a speech to the Italian delegation at the Second Congress of the International in Moscow, People's Commissar Anatolii Lunacharskii referred to Marinetti as "the one intellectual revolutionary" in Italy. Antonio Gramsci, the founder of the Italian Communist Party, then mocked the Communists who were shocked by this application of the term "revolutionary" to a leader of the Fascist movement – "This unheard of, outrageous, colossal thing happened, divulgation of which threatens to wipe out all the prestige and credit of the Communist International . . . The philistines of the workers' movement are completely scandalized, and it's clear that to the old list of insults: 'Bergsonian, voluntarist, pragmatist, spiritualist', will be added a new and bloodier one: Futurist! Marinettist!"[25] It is clear that both Gramsci and Lunacharskii had no doubts about the revolutionary nature of Futurism; they saw any destruction of the bourgeois way of life, of bourgeois politics and culture, as the first stage of a proletarian revolution. Gramsci continued:

> The Futurists . . . destroyed, destroyed, destroyed without worrying whether their new creations were all in all superior to those they destroyed . . . this was their clearly revolutionary concept, and an absolutely Marxist one, when the Socialists were not even remotely concerned with such things . . . The Futurists in their field, the field of culture, are revolutionaries; in this field, in terms of creativity, it is unlikely that the working class will be able to do more than the Futurists for a long time.[26]

For his part, though he had absolutely no sympathy for Communism ("Communism can only be realized in the cemeteries"), Marinetti in 1920 hailed the achievements of the Russian Futurists:

> I am delighted to learn that the Russian Futurists are all Bolsheviks and that for a while Futurism was the official Russian art. On May Day of last year the Russian cities were decorated with Futurist paintings. Lenin's trains were decorated on the outside with coloured dynamic forms very like those of

Boccioni, Balla and Russolo. This does honour to Lenin and cheers us like one of our own victories.[27]

It is not by chance that the problem of the relationship of the Soviet avant-garde to Italian Futurism runs through all the literary and aesthetic polemic of the early twenties. One can sense the inner kinship of the two movements if only in the passion with which members of the Soviet avant-garde at times attempted to dissociate themselves from their Italian colleagues, denouncing them not as class enemies but as heretics, as dissenters from the true faith. They often tried to bolster their arguments by using the analogy of the relationship between the Bolsheviks and the Mensheviks. "We have had enough of the Marinetti question," wrote Tretiakov. "He is an enemy, even though he too bears the name of Futurist. He is no less of an enemy to Russian Futurism than Menshevism is to Communism."[28] In order to escape the undesirable association with Fascism, Maiakovskii attempted in 1921 to do away with the term Futurism as a designation of the revolutionary avant-garde. Unfortunately, however, it was not simply a matter of association; in that same year the zeal of the Soviet avant-garde for constructing a new future reached its peak – and most of their ideas corresponded to those of the Italian Futurists.

In 1923, in his efforts to withstand the new pressure of reactionary forces, Maiakovskii attempted to unite all the currents of the revolutionary avant-garde into what he called the "Left Front of Art", naming his new journal LEF to stand for those words. In the first issue he once again identified the avant-garde with Futurism: "Futurism has become the left front of art". In the second issue Mikhail Levidov extended Maiakovskii's definition to Futurism as a whole:

Fascism operates with materials that are potentially dangerous to it; one of these is Futurism. Italian Futurism is gambling on what is strong. Splendid! Today it is Fascism that seems strong; tomorrow it will be the revolution. Any movement in the world that has decided to gamble on strength, whatever its subjective aspirations, must objectively place its stake on revolution ... There is Soviet power in Russia – and the Futurists are with it! There is Fascist power in Italy – and the Futurists are with that! In Italy Maiakovskii would have been Marinetti, and in Russia Marinetti would have been Maiakovskii.[29]

The theoreticians of the Soviet avant-garde did not see the alliance Futurism made with Fascism as a deadly sin. Whatever the propagandist labels pinned at the time on Mussolini and his movement, they could not help but sense in him a destructive, revolutionary force, directed against the foundations of the old society, that was closely akin to their own zeal for class struggle. Both Lenin and Gramsci hurled abuse not so much at the Fascists as at the Socialists, Mensheviks, Social-Democrats and other "liberals" whom they saw as the principal obstacles to the victorious progress of the world revolution. (Stalin took the same position in 1933 when he forbade members of the German Communist Party to vote for the Social Democrats. It was this that secured the

triumph of National Socialism in Germany.) It was natural that the ideologists of proletarian culture should have seen as their enemy not revolutionary futurism but traditionalism – whether the leftist traditionalism of such artists as Chagall and Kandinskii or the rightist traditionalism of the representatives of the old pre-revolutionary realism. In affirming the unity of Futurism, in defending it as the most revolutionary current in art, they were affirming the purity of Marxist principles, not realizing that these principles were already in contradiction with the practical demands and the political ambitions of the Communist leaders.

It was from just such a position that the old Marxist theoretician, N. Gorlov, attempted to justify Futurism in his book, *Futurism and Revolution* (1924) – apparently the last such attempt in Russia. According to Gorlov, both the Russian Futurists and the Italian Futurists were engaged in the same revolution as "we Bolsheviks", but from a different starting-point, i.e. the realm of culture. "Marinetti spares neither religion, nor the family, nor the State. But these are the very pillars of private property! Marinetti takes up arms against all the hackneyed clichés of the Beautiful, the Grand, the Solemn, the Religious, the Bright, the Captivating. In only a few words he summarizes a whole programme of revolution in aesthetics."[30]

For this reason, Gorlov continued:

> People who think up two different Futurisms, placing them on opposite sides of the barricades, are deeply mistaken; but people who admit the ideological kinship and historical continuity between Russian and Italian Futurism and then, with an unequivocal nod towards Russian Futurism ("An apple never falls far away from the tree"), go on to discuss certain Italian Futurists, including Marinetti, who have besmeared themselves with Fascism – these people are no less deeply mistaken. But . . . has Marxism ceased to be a revolutionary ideology merely because our Mensheviks have attempted to accommodate it to the dictatorship of the White generals? Futurism will not cease to be a revolutionary aesthetic even if a certain number of Italian "Futurists" have attempted to accommodate it to Fascism.[31]

Gorlov added: "Futurism is a rebellion against the old way of life, it is revolution in art, it is the red flag hoisted over one of the citadels of the bourgeoisie. . . . This is why, in all countries, the bourgeoisie shies away from Futurism as if it were the plague."[32]

This fusion of revolutionary ideologies in the areas of politics and culture may well seem natural enough. In October 1922, however, when Mussolini implemented his coup, Marinetti – who was longing to implement the same coup in the area of culture – turned out to be a general without an army: by that date the majority of the Futurists had already left the movement. The situation of Russian Futurism after the October Revolution was very different; it was, indeed, a unique situation in the development of twentieth-century culture.

In 1923 L. Hirschfeld-Mack asked Fernand Léger why a France that was

intoxicated with victory, that was the centre for the most advanced forces of the world's artistic avant-garde, had failed to create any such avant-garde organization as the German Bauhaus. Léger replied that this failure was the result of the chauvinism, conservatism and reaction that determined the atmosphere of a victorious country, and that French artists were envious of the situation that had arisen in Germany: "to be able to build anew".[33] It was this very possibility, but to a much greater degree, that was granted to Russian artists after the victory of October. "To build creatively, burning one's path behind one"[34] – this slogan of Malevich's expressed the inner aspiration of the whole of Soviet culture during the first years after the Revolution.

The Revolution swept off the face of the earth all the "Tsarist" institutions that had previously been the foundation of Russian artistic life. The Imperial Academy of Arts disappeared, together with all the higher teaching institutions. All the museums and important private collections were nationalized. The institution of patronage, which had played an important role in Russian culture at the beginning of the century, naturally ceased to exist. More than this, by an unwritten decree of the dictatorship of the proletariat, the whole of the old culture, now declared "bourgeois", counter-revolutionary and hostile to the victorious class, was in effect abolished. The first people to fill the resulting vacuum were those who, in the rumble of the revolutionary avalanche, could hear the music of their own creativity; all the key positions in the country's artistic life during the first years after the Revolution were held by "left" and avant-garde artists. Anatolii Lunacharskii, who was – at least in Lenin's view – "sympathetic to the Futurists", was appointed head of Narkompros (The People's Commissariat for Enlightenment), formed in 1917. The artist, David Shterenberg, who was "close to the Futurists", was appointed head of its Department of Fine Arts ("IZO"). The majority of the members of the artistic board of Narkompros were Futurists and Constructivists: Natan Altman, Vladimir Baranov-Rossiné, Nikolai Punin, Maiakovskii, Osip Brik and others. Vladimir Tatlin became the head of the Moscow artistic board. Three years later the Institute of Artistic Culture ("INKhUK") was formed under the auspices of IZO; its task was to resolve problems in the theory and methodology of art and artistic education. Kandinskii was the first president, and Malevich was director of the Leningrad department from 1923. The Higher Artistic Workshops ("VKhUTEMAS"), formed on the basis of the former Petersburg Academy of Arts, Moscow College of Painting and Architecture and Stroganov College, were placed under the jurisdiction of INKhUK. The most influential teachers in VKhUTEMAS were such representatives of the most radical currents in art and architecture as Aleksandr Rodchenko, Naum Gabo, Antoine Pevsner, Liubov Popova, Anton Lavinskii, and Viktor and Aleksandr Vesnin.

During the first years after the Revolution, this system (Narkompros, IZO, INKhUK, VKhUTEMAS) completely dominated the whole field of artistic

Rodchenko: Workers' Club (1925)

ideology, education and administration; the artists who held executive positions
within this system were truly granted the power to "construct everything anew"
in accordance with their own theories. However, when the time came to place
art at the service of the reconstruction of society, "to replace the fool's rattle",
in Maiakovskii's words, "by the architect's blueprint", there turned out to be
no adequate building material in the storehouse of artistic methods of the avant-
garde in general or of Futurism in particular. The stylistic development of the
Russian avant-garde up to the appearance of Malevich's Suprematist com-
positions and Tatlin's reliefs had followed the course of development of Western
modernism, not one of whose currents had yet created any concrete methods
for the organization of life by artistic means. It was Constructivism that began
to develop such methods, after announcing its existence in 1920 through two
manifestos: *The Programme of the Group of Constructivists* by Aleksei Gan, Rodchenko
and Varvara Stepanova (initiated by Tatlin) and *A Realistic Manifesto* by Pevsner
and Gabo. In the main, the Russian Constructivists – who immediately split
into several independent and mutually hostile groups – concentrated on experi-
menting with the properties of utilitarian materials, their textures, tectonics,
colours and spatial relationships. They saw artistic activity as "nothing more
than the creation of new things". Their theories closely overlapped with the

conception of "life-building" which arose at almost the same time and served as a foundation for production art or Productionism. The adepts of the latter painted optimistic pictures of a future when "bourgeois" forms would have completely died away and the artist would have become not a creator of aesthetic objects, but a producer of utilitarian things. "No more 'churches' and temples of art" but rather "workshops, factories and colleges where in a common joyful process of production are created *treasure-goods*" – this was declared to be "the programme that must be followed by every Communist". Art was to be "the production of valuables that are necessary to the class and to humanity".[35]

A similar concept of art was held with slight variations by all the most avant-garde artistic groupings of the time. Their polemic zeal was directed towards the destruction of all the forms of art – but especially easel-painting – which had dominated European culture since the Renaissance and which were now consigned by the ferro-concrete adepts of Marxist theory to the category of "bourgeois". "A feeling has arisen that the painting is dead, that it is inseparably linked to the forms of the capitalist order and its cultural ideology ... Easel-painting is not only unnecessary to contemporary culture, but is indeed one of the strongest brakes on its development."[36] What they opposed to easel-painting was a collective art, created by the labour of the masses in a shared process that dissolved the creative identity of the artist, an art whose function was not the reflection or decoration of reality, but its radical reconstruction. In the grandeur of their elected tasks the Soviet avant-garde knew no predecessors.

In Russian post-revolutionary art, Futurism, Constructivism and Pro-ductionism were in effect one single phenomenon that appeared under different names. The differences between these movements are slight compared to the similarity of the goals they set themselves: the refashioning of the world through art, the construction of the material environment of the society of the future, and – as a consequence, or rather precondition – a clearing of space for this artistic-technical construction work by means of the destruction of all the traditional forms of culture. It is legitimate to look on these movements not as separate groupings, but as three stages in the evolution of a single revolutionary artistic avant-garde: the function of Futurism was to generate ideas, that of Constructivism was to establish a methodological basis for a shared ideology, while Productionism united the two in practical activity. They developed in parallel, and their mouthpieces were the same people and the same publications: Nikolai Punin's newspaper, *Art of the Commune*, then Maiakovskii's *LEF*, and then *Thing*, the journal published by El Lissitzky and Ilia Ehrenburg. The demar-cation line then lies not between the individual groupings, but between these groupings taken as a whole and those other artists who saw their bold inno-vations in formal matters not as a radical break with the past, undertaken with the aim of constructing the future, but as a continuation of the spirit of an eternally developing European cultural tradition. These two fiercely hostile

ideological currents, both engendered by the revolutionary epoch, can pro-visionally be designated "the art of the avant-garde" and "left art".*

(iii) The avant-garde and the left artists

Imitative art must be destroyed like the army of imperi-alism.

Malevich

I am always annoyed by the statement that I wish to overthrow the art of the past.

Kandinskii

Later, when the style of total realism was definitively established in both Germany and the USSR, Soviet and Nazi theoreticians began to look on this "transitional" stage in the development of the art of their respective countries as a struggle between "progressive" or "Aryan" realism and reactionary for-malism or modernism. In this they were rewriting history, projecting their own ambitions onto another period; in actual fact the hour of realism had not dawned and there was no argument whatsoever between its humbled adepts and the victorious "modernists". Nobody argued about whether it was the role of the new art to create new forms and concepts or to depict reality; the overwhelming majority of artists who accepted the Revolution saw it as obvious that this argument had already been decided by the march of history and that only inveterate conservatives and counter-revolutionaries could now attempt to summon back to life the shades of an already dead past. The only real argument was over whether art should be considered as a means for the ideological reconstruction of the world or as a laboratory for the creation of new forms, independently of ideology, in order to continue the European artistic tradition.

It is usual to gather together all the innovators of the beginning of the century under the term "avant-garde" or even "the revolutionary avant-garde". This is to bring together artists with opposite aims and aesthetic principles: fervent apostles of technology (Boccioni, Klutsis, Moholy-Nagy) and proponents of the spiritual principle in art (the German Expressionists, Kandinskii, Carrà), activists aiming to refashion the world in the name of a bright future (the Italian and Russian Futurists as a whole, Lissitzky, Hannes Meyer) and passive dreamers with their eyes turned to the past (Chagall, de Chirico), aesthetes (Gabo) and enemies of the aesthetic (Rodchenko).

If the development of art is seen simply as a continuous advance towards

* These terms, confusing though they are, have been used for so long that it is now impossible to do away with them or re-translate them. What must be emphasized is that the term "left art" was used extremely vaguely, and that it did not entail any specific political programme. [*Translator's note*]

more and more new stylistic discoveries, then it is legitimate to group together these very different artists. This is the view of those artists of the time who consciously placed their art at the service of the transformation of society, who renounced all the culture of the past and considered themselves to be the avant-garde of world progress. "We rebel against that spineless worshipping of old canvases, old statues and old bric-a-brac, against everything which is filthy and worm-ridden and corroded by time,"[37] wrote Boccioni, Carrà, Russolo, Balla and Severini, and they placed themselves by this logic in the avant-garde of the European movement in painting. But there were other artists who did not see themselves in this way, who were disposed neither to deny the past nor to appeal to the future, who had no wish to subordinate their art to the problems of constructing a new reality and who aspired only to do the same as their predecessors: freely to create new forms that are independent of ideological categories. Thus, in 1916, the founder of abstract art, Vasilii Kandinskii, wrote:

> Abstract art is not an obliteration of all previous art but an unusual and extremely important division of the old trunk into two main branches, without which the formation of the crown of the green tree would be inconceivable. I am always annoyed by the statement that I wish to overthrow the art of the past. I myself have never sensed in my work any destruction of already existing works of art; I have seen them only as a further growth of art, a growth which is both inwardly logical and externally organic.[38]

As for Chagall, he cried out in horror at the remorseless advance of a ferro-concrete culture: "Where are we going? What is this age that sings hymns to technical art and makes a god of formalism?"[39] Ideals that had been loudly proclaimed first by Italian and then by Russian Futurists, in manifestos that no one had had to read – these ideals acquired sudden authority when their proponents occupied key positions in the artistic life of the Soviet Union. In the eyes of the Futurists the very act of easel-painting was fundamentally opposed to "the State's point of view, the activities of government bodies in the field of art and to our activity as a circle of the party".[40] The author of this statement, Osip Brik – who, following Kandinskii, was the second chairman of the Institute of Artistic Culture – added that the institution he ran could never accept members of any "left" groupings: "For us, union with others, even left groups, is impossible".[41] Nikolai Punin, the chief theoretician of Futurism, spoke against the identification of left artists with Futurists, stating that " 'left art' where left is interpreted as a general commitment to materialism is also a myth".[42] This division, later forgotten, between "left artists" and "avant-garde artists" was seen at the time as a watershed between the two most important, mutually antagonistic, artistic movements during the first years after the Revolution.

In normal conditions different points of view do not prevent artists from sympathizing and even collaborating with one another. Before the Revolution Malevich was able to construct his "semaphores of space", striving to escape

"the ring of the horizon", "beyond the limits of earthly gravity", "beyond the zero of forms"; Tatlin was experimenting at the same time with "the painterly qualities of materials", preparing to apply them to the construction of useful objects. The Revolution telescoped these two poles. The most cosmic and exalted view of the world joined together with the most practical and earthbound; there was a brilliant flash, an explosion or take-off of creative potential accumulated over a decade. The revolutionary artists dreamed about vast spaces, precise calibrations and new materials, but all they could lay their hands on in a Russia that was ravaged and destitute was pieces of wood, scraps of tin and bits of wire and canvas. It was from these that they constructed their first spatial compositions and mobile constructions. They wanted to destroy the forms of easel-painting but, since no other possibility was open to them, they constructed brilliant examples of the particular language of twentieth-century painting. Their passion to build and create, their hope and optimism, shine through their paintings. It can be glimpsed in the vibrations of high speed fusing colour into a single mass, in the black and white of precise calculation, in the gleaming blades of never-before-seen machines; it is embodied in compositions imbued with the breath of the grandiose spaces of future factories, palaces and hangars. These abstract, strictly geometrical, rational forms were indissolubly linked in the minds of the avant-garde with the revolutionary *Weltanschauung*, while the old forms – that is, every kind of representational art – were seen as fetters that prevented progress, as a crime against humanity, as counter-revolution: "For us to reproduce beloved objects and corners of Nature is the same as for a thief to go into raptures over his fettered legs."[43]

As they moved from the platforms of discussions about aesthetics to the offices of newly-founded institutions, these disagreements turned into a battle for survival. Malevich and Chagall, Rodchenko and Kandinskii were infinitely more implacable towards one another than towards the heirs of the Peredvizhniki – whom hardly anyone now took seriously. Victory in this debate fell to the avant-garde, armed with its "love of danger" and its "dictatorship of taste".

In 1918 Marc Chagall was appointed director of the art school he had founded in his birthplace, Vitebsk. Soon, amongst others, he invited Malevich to work there. Malevich arrived in Vitebsk and caught sight of the blue horses and green cows with which his director had managed to adorn the town in celebration of the anniversary of the Revolution. Malevich did not hesitate; then and there he declared Chagall's work "incompatible with the spirit of the Revolution", had him dismissed from his post and appointed himself in his place as "guardian of the new art". None of this was a matter of personal ambition: Malevich was sincerely convinced that Chagall's figurative art was counter-revolutionary. In his view artistic form was an infallible indication of the artist's *Weltanschauung*.

An equally telling episode concerns Vasilii Kandinskii, the first head of the Institute of Artistic Culture, who attempted to structure its research programme according to the principles he had laid out before the Revolution in his treatise *On the spiritual in art*. His methodology for the study of artistic form – the main object of research for the Institute – had been elaborated not from the objective and scientific laws of the material but from spiritual or psychological laws relating to our perception of colour, line, volume, etc. His appeals to the spiritual sounded just as counter-revolutionary to the politicized avant-garde as Chagall's cows had seemed to Malevich; in 1921 he was dismissed. The new head of the institute, Osip Brik, a friend of Maiakovskii and his closest collaborator on the magazine *LEF*, celebrated his appointment by giving a lecture in which he suggested that artists abandon art and turn instead to production. In response to this lecture, twenty-five important artists stated that they considered their work as painters to be pointless.[44]

Naturally enough, this state of affairs led artists to begin to emigrate from Soviet Russia. The following is a far from complete list of the major artists who left Russia for good during the period 1919–23: Ivan Puni, Nikolai Roerich, Ivan Bilibin, David Burliuk, Leonid Pasternak, Vasilii Kandinskii, Marc Chagall, Antoine Pevsner, Naum Gabo, Filipp Maliavin, Konstantin Korovin, Aleksandra Ekster. If one adds the names of those who left before the Revolution and did not return (Ilia Repin, Leon Bakst, Mikhail Larionov, Natalia Goncharova, Chaim Soutine, Aleksandr Arkhipenko, Osip Zadkin) and of those who left after 1923 (Iurii Annenkov, Konstantin Somov, Mstislav Dobuzhinskii, Alexandre Benois and others), then it can be stated that this first wave of emigration carried away a significant proportion of the major artists who had made their names before the Revolution. But there is something else that is interesting about this list: it does not include even one of the champions of the radical transformation of the world through art. The only member of the avant-garde to leave Russia was Natan Altman, who emigrated in 1928 only to return in 1935; evidently the roots binding this "revolutionary of the spirit" to the country of the victorious revolution reached very deep.

It goes without saying that in 1917 the future members of the avant-garde were unable to see that a radical reappraisal of cultural values would begin five years later; that right would become left, bourgeois become proletarian, and counter-revolutionary become revolutionary; that the last remnants of creative freedom would be suppressed within a decade; that in the thirties Stalinist Socialist Realism would become indistinguishable both in theory and practice from the art of the Third Reich; and that in our own time the art of their grandchildren – the unofficial Soviet artists – would be destroyed by bulldozers and fire-engines. Still less could they foresee that the main instrument of tota-litarian aesthetics, an instrument used first of all against themselves, would be their own slogans: the mass-appeal of art, its class, ideological and revolutionary-

transformative nature, etc. Their social prophecies turned out to be a utopian dream. The "rubbish-bearing wind" of twentieth-century history carried the seeds they had sown away from their native soil and they sprouted in a new land that seemed to them to be alien and hostile. None of this, of course, could be foreseen by these revolutionaries of the spirit, these commissars of art, these idealists of materialism, these fervently believing atheists.

We shall never be able to understand the nature of totalitarian culture unless we examine its ideological sources in what it referred to with contempt as "modernism". Only time, only history, is able through the light of the present to reveal the events of the past in their true meaning. It would be wrong to approach the art of the twenties in any other way. The members of the avant-garde – like their enemies – worked consciously towards a "tomorrow" that has become our own "today"; the construction of the world of the future – our own world – was the principal driving force behind their work. Contemporary art and culture are still to a considerable degree the product of the ideological struggle of the 1910s and 1920s.

Without attempting to analyse this ideology in full, we shall single out the essential elements which, applied to different social conditions and wrapped in different verbal formulae, were chosen as the foundation for the megamachine of totalitarian culture.

(iv) The contribution of the avant-garde

Where barbarism rules, the fist and the bullet are the arguments which count.

From the manifesto of Italian Futurism, 1914

The collective art of the present day is the construction of life.

From *The Programme of the group of Constructivists*, 1921

If the principal characteristic of totalitarianism is that it proclaims its ideological doctrine as both uniquely true and universally obligatory, then it is the artistic avant-garde of the 1910s and 1920s who first elaborated a totalitarian ideology of culture. Only that art has the right to exist which is an effective instrument for the transformation of the world in the necessary direction, while everything else is counter-revolution or bourgeois reaction: to the revolutionary avant-garde this was an absolute and unshakeable truth.

In his first manifesto Marinetti sang the praises of struggle, aggression and love of danger; these he saw as fundamental characteristics of the new aesthetics.

Applied to politics, this implied a struggle for power in order to realize certain ideals. In 1914 the Italian Futurists appealed directly to the State, demanding that a code of laws be drawn up to protect the sphere of individual creativity from "shams". Until this happens, they wrote, "Futurist fists are logical and necessary – they fill the functions which in a civilized society are carried out by the law".[45] And when the Fascist revolution held out to the Futurists the possibility of real power, Marinetti – appointed by Velimir Khlebnikov as one of the 317 Presidents of the Terrestrial Globe in his ideal government – declared: "Yes! Power to the artists! The vast proletariat of gifted men will govern."[46]

Together with the red flag of revolution, the Russian avant-garde took from Italian Futurism this idea of aggressive struggle for power. The fourth (1918) issue of *Art of the Commune*, the main Futurist journal, began with an article by Nikolai Punin – the chief editor – under the title "Futurism as State Art", in which he stated: "We would not refuse if we were offered the use of the power of the State in order to realize our ideas." An answer to a question about the nature of these ideas was provided by Osip Brik, one of the main theoreticians of the avant-garde: "The answer is clear. The proletarianization of all labour, including artistic labour, is a cultural necessity ... And no amount of tears shed for supposedly vanished creative freedom will help."[47] The 1919 programme of the Petrograd collective of Communist-Futurists declared: "A Communist structure demands a Communist consciousness. All forms of everyday life, morality, philosophy and art must be restructured according to Communist principles. Without this any future development of the Communist revolution is impossible." From this theoretical basis they went on to demand that "the Soviet organs of culture and enlightenment shall be subordinated to the newly elaborated Communist ideology, and that in all spheres, especially that of art, we should firmly reject the numerous democratic illusions which mask bourgeois survivals and prejudices".[48] In a similar vein the first programme of the magazine *LEF*, drawn up by Maiakovskii, attacked "those who wish to replace the inevitable dictatorship of taste by the Constituent Assembly slogan of general elementary comprehensibility".[49] As in politics, so in culture; it was considered necessary to replace such concepts as "democraticness", "individualism", "tolerance", "free creativity", and "natural development" by strict ideological control on the part of the Party organs, "dictatorship of taste" on the part of artists, and a general organization of artistic life on the part of the State.

The necessity of the State organization of art and of ideological control was accepted by artists of the most varied creeds; Maiakovskii wished to impose "a dictatorship of taste", while Pavel Filonov, an outsider among the avant-garde, demanded that the State should respect all the various movements and judge them on the basis of the uniquely true, scientifically established and ideologically correct standpoint, i.e. Filonov's own standpoint of "analytic art".* In the words

* "The state must let art trends settle their own ideological and economic accounts. It should not support any

of Boris Arvatov, "the St-Just of the revolutionary avant-garde": "Once one has grasped Marxism, it is impossible to play for time and avoid taking sides, granting absolute independence to each of the contemporary artistic movements. The elemental quality of social development contradicts the interests of the working class."[50] The same idea was expressed very simply by Rodchenko: "As we see in the life of the RSFSR, everything leads to organisation. And so in art everything has led to organisation."[51] This was put more concretely by Filonov: "Just like heavy industry and the Red Army, art must be organized and made into an effective instrument that can be used as part of an integral State plan."[52] It is clear, in short, that the first calls for the strict administration and central administration of the arts came neither from Lunacharskii, the People's Commissar for Enlightenment, who at that time was entirely powerless, nor from the organs of the Party, then occupied by other problems, but from the artists and theoreticians of the revolutionary avant-garde themselves.[53]

The Soviet avant-garde can be said to have rewritten Marx's classic definition of the role of philosophy and applied it to art: "In the past artists depicted the world by various means, but the real task is to change it." This view of art as a means for the total refashioning of the world first appeared during the "pre-Marxist" stage of the development of the revolutionary avant-garde: in 1915 Giacomo Balla and Fortunato Depero published their *Manifesto for the Futurist Reconstruction of the Universe*, Sant'Elia in Milan said that it was necessary for each generation to build its own cities, and Malevich in Petrograd called for the destruction of old towns and villages every fifty years as part of the eternal renewal of humanity. In the conditions of post-revolutionary Russia, however, the members of the avant-garde were forced to descend from their utopias in the clouds to the sinful earth.

In this new stage the avant-garde theoreticians' understanding of the social function of art began to waver between two poles: the transformation of art into the construction by the worker-artist of "things necessary to the class" – the theory of the production-artists and Proletkult* – and the attempt to make it into an instrument for the education of the masses: "To catch live people ... to give blockheads a working-over ... to burnish brains with the file of language ..." – as Maiakovskii declaimed in 1917. "The problem of proletarian transitionally-representational artistic creativity is the problem of agit-art, of art that is propagandist not only in its theme but also in its methods of material formulation"[54] – so Arvatov formulated the problem in 1924. It is not surprising therefore that the members of the avant-garde were the first to address them-

one trend and should evaluate any work of any trend for its degree of analytical madeness (i.e. skill)." [N. Misler and J. Bowlt, *Pavel Filonov: a Hero and his Fate*, Austin, Texas, 1984, p. 231.]

*Proletarian Culture. The organization was founded in 1906, but became influential only after 1917. Its aim was to create a proletarian culture. Subordinate to Narkompros, it was finally dissolved in 1932.

selves to the so-called Lenin plan for monumental propaganda directed for the most part by the Futurists Altman and Shterenberg; it was they who, in accord with this plan, built most of the monuments to revolutionary figures in the squares of Moscow and Petrograd – monuments that were afterwards destroyed by the Soviet dictatorship; it was they who organized public celebrations and the agit-trains to which Marinetti responded with such enthusiasm.

One of the main accusations later to be levelled at the avant-garde by totalitarianism is that it was elitist, bourgeois and exclusive in its focus on formal and aesthetic problems, incomprehensible to the masses, and even anti-popular. It is difficult at this date to establish the response of the masses to the avant-garde. Soviet sources quote a number of incidents when indignant workers destroyed sculptures that they looked on as "Futurist scarecrows". It is possible that such incidents did indeed take place, still more possible that they were staged or inspired by the ideological enemies of the avant-garde. What in any case is indisputable is that the avant-garde did directly engage with the masses. Marinetti addressed his manifestos to revolutionary crowds, and Antonio Gramsci wrote in a letter to Trotsky: "Before the war, Futurism was very popular among the workers. At the time of the many Futurist demonstrations in the theaters of Italy's largest cities, the workers defended the Futurists against the young people – semiaristocrats and bourgeois – who attacked them. The review *Lacerba* [the main organ of the Italian Futurists], whose circulation reached 20,000, found four-fifths of its readers among the workers."[55] In the words of an eyewitness, before the war "Futurism roused the popular imagination to such an extent that Italian children played 'Futurists' instead of 'cowboys and Indians'."[56]

Russian Futurism only later acquired its mass audience – in the chaos of the Revolution and Civil War. It was with an eye to the masses that a search was then carried out for new forms, for a language that would have an immediate effect and could be relied on to instil a political idea into the consciousness of the people. "The most unambiguous and immediately recognizable forms are geometric forms. No one will confuse a rectangle with a circle, or a circle with a triangle"[57] wrote the Constructivist El Lissitzky. In such posters as "Beat the Whites with the Red Wedge!" (1919)* Lissitzky did indeed express a political idea clearly and simply through an arrangement of geometrical forms. His poster was evidently more comprehensible to the soldiers in the Civil War than the poster, "Did You Enrol as a Volunteer?", modelled on the well-known English poster from the First World War and later declared a classic. In this period of fracture the language of the avant-garde was close to the rebellious spirit of the masses, closer than any traditional or realistic forms of art. In the first place the Russian proletariat did not possess a figurative tradition, and everything

*For this and other examples, see Stephen White, *The Bolshevik Poster*, Yale, 1988.

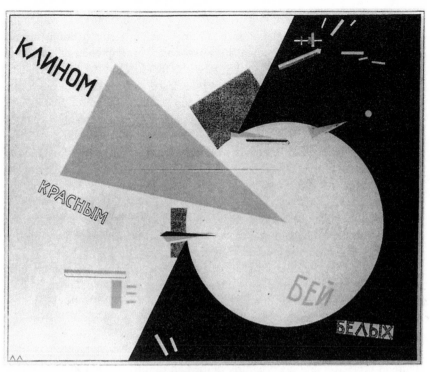

Lissitzky: Beat the Whites with the Red Wedge! (1919)

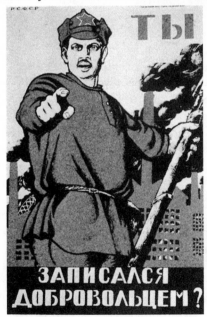

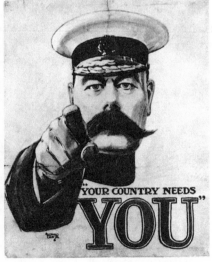

Moor (Orlov): Did You Enrol as a
Volunteer? (1920)

English Poster: Your Country Needs You
(1914)

traditional was firmly linked in its consciousness with the bourgeois way of life that was to be destroyed. Maiakovskii was right when, in a letter to Lunacharskii, he defended the avant-garde against accusations of incomprehensibility: "And is the old art comprehensible? Is that why the tapestries of the Winter Palace were torn up for people to wrap round their feet?"[58] In the second place, the richest popular or peasant tradition, stemming from icon-painting, had always accepted stylization, hyperbole, abstraction and the grotesque as a natural language through which to express its understanding of the world. It was this concern with mass art, this didactic and propagandist quality in the art of the avant-garde, that the left artists had in mind when they wrote: "Beneath the paint-strokes of the Futurists one can hear the accent of Repin and the Peredvizhniki."[59]

It was in this way that a theoretical foundation and a practical elaboration were developed by the avant-garde for the concept that was to be the basis for totalitarian aesthetics, the concept of *mass art.*

Unlike the Peredvizhniki, however, the avant-garde did not understand mass art as simply a matter of educating and enlightening the people. They saw it as something more than everyday political propaganda; the art of the victorious proletarian revolution should be a kind of "social engineering" or an instrument "for the construction of the psyche".

The phrase "social engineering" was first coined by Aleksei Gastev, a leading figure in Proletkult and the organizer of the Central Institute of Labour ("TsIT", founded in 1921). What he had in mind was the radical reconstruction through art not only of social life, but also of the human psyche. The whole sphere of elusive human emotions was to be subjected to a strictly mathematical understanding in order that it could be worked on by scientifically elaborated coefficients of "excitement", "mood", etc. (In the realm of the cinema means for constructively affecting the psyche were being developed by Eisenstein with his theory of "intellectual cinema".) All previous aesthetics were to be discarded and replaced by "the understanding of art as a means for emotionally organizing the psyche in connection with the tasks of the class struggle". "The art-worker must stand beside the man of science as a psycho-engineer, a psycho-constructor ... Propaganda towards the forging of the new man is in essence the only content of the works of the Futurists."[60] At a later date Stalin repeated almost literally these words of Tretiakov – who himself died in one of Stalin's camps – in his definition of the Socialist-Realist writer: "the writer is the engineer of human souls". The avant-garde concept of the construction of the New Man was later to become the esoteric mission of totalitarian culture.

The Futurists' image of this new man did not of course entirely coincide with that of the selflessly devoted, limitlessly courageous, muscular, fair-haired and blue-eyed figure, one with his people at the deepest level, who appeared in countless works of painting, sculpture, literature and cinema – in Germany

during the thirties and forties, in the Soviet Union mainly during the forties and fifties. Having helped to bring about the revolution, this representative of the new class was called upon to lead humanity forward and fashion it after his own image and likeness. The avant-garde saw this class as some kind of collective organism, each unit of which was subordinated to the common task of carrying out the productive process and the single aim of constructing the new society. The contradiction, "congenital to capitalist society", between compulsory labour and free leisure was entirely foreign to the existence of this unit. "Non-productive time is seen not as leisure in the sense of something antithetical to work, but as the period of time during which a man either performs a number of actions which are of indirect service to production ..., or else performs functions necessary to the class which are higher than that of production ... Everything known as 'private affairs' or 'personal interest' comes under the control of the collective. Each member of the collective sees himself as a tool, necessary to the collective, which must be looked after in the interests of everyone."[61] In the psychology of the proletariat these theoreticians perceived a "striking anonymity, which allows each individual proletarian unit to be designated as A, B, C, or as 325, 075, 0, and so on ... The manifestations of this mechanized collective are so devoid of personality, so anonymous, that the movements of these collectives or complexes are similar to the movements of things lacking any individual human face; there are only even, regularized steps, faces without expression, souls empty of lyricism, measured not by cries or laughter, but by meters and gauges."[62]

Such ideas, now reminiscent of the anti-utopias of Zamiatin, Orwell and Huxley, are perhaps characteristic only of the extreme of the avant-garde. They were put forward by the theoreticians of Proletkult (Gastev, Aleksandr Bogdanov), on the one hand, and by representatives of the most radical wing of the Futurists and *LEF* grouping (Sergei Tretiakov), on the other. Nevertheless, panegyrics to the "collective man" who has become one with the mass – together with demands to exclude from art all emotions, lyricism, psychology and individuality – appear either explicitly or implicitly on the pages of almost every document of the revolutionary avant-garde: in the manifestos of the Italian Futurists, in the early treatises of Malevich, in the programmes of the Russian Constructivists, Futurists and Production Artists. A second contribution of the avant-garde to the aesthetics of totalitarianism can therefore be given the name "Collectivism", understood both as the fundamental quality of the "new man" and as the artist's absolute subordination of his own creativity to the collective tasks of State construction.

> I do not live for years.
> I live for hundreds of years, for thousands of years.
> I have been living since the creation of the world.
> And I shall live for millions of years to come.
> And there is no limit to my career.

In these words the proletarian poet Aleksei Gastev identified himself with the life of his class, and the life of his class with that of humanity. The "class-personality" and the "nation-personality" – these two metaphors served as a point of reference for both the Russian and the Italian avant-gardes. In the fusion of the individual personality with that of the collective they found firm ground in the present and at the same time glimpsed a pledge of immortality in history. "His [the Futurist's] self-affirmation lies in his consciousness of himself as a screw that is essential to his productive collective. His true immortality lies not in the possible preservation of the arrangement of letters that forms his own name, but in the most widespread and complete assimilation of his product by other people."[63] The avant-garde saw themselves as standing on the threshold of a new era; the youth of the era was their own youth, the joy of awakening was their own joy. Art was to publish this joy in millions of copies, instilling it into the consciousness of the masses and stimulating them towards constructive labour. "The factory of optimism" was a name given to their art by the Russian Futurists, and Marinetti referred to his own as "an inspiring alcohol that makes the young into gods, multiplies tenfold the courage of the mature, and renews the old". *Social optimism* is the most consistent emotional dominant of totalitarian art, present in all its variants and at every stage of its winding path. This concept, too, was theoretically elaborated by the avant-garde and embodied in the language of their art; it was certainly not the least of its contributions to totalitarian culture.

In summary, it is hardly legitimate to speak – like certain anti-modernists – of "the avant-garde which opened the way for totalitarianism", or to say that "It was only one step from the anarcho-decadent aesthetic to the mock-restoration of classical art" [in totalitarian states].[64] It is equally illegitimate, however, entirely to deny the role of the avant-garde in the formation of the totalitarian artistic ideology, to consider any such assertion "as absurd as to blame the Western democracies for the dictatorships". It is clear that the artistic structure of these movements – like the political structure of the democracies of the time – contained a certain ideological component which helped the dictatorships during their rise to power, even if they later destroyed both the one and the other. Just as the words of Rousseau (in Heine's phrase) turned into the bloody machine of Robespierre, so – and only so – did certain aspects of the artistic ideology of the avant-garde become incorporated into the foundation of the megamachine of totalitarian culture.

Between Modernism and Total Realism

(i) When those who had fallen silent began to speak; the end of the avant-garde

> Why was it necessary to have a whole year of proletarian power and a revolution that embraced half the world in order for "those who had fallen silent to begin to speak"?
>
> Natan Altman, 1918

> Yes, I held out my hand to the "left artists", but the proletariat and the peasantry did not hold out theirs.
>
> Anatolii Lunacharskii

By the first stage of the formation of totalitarian ideology two of the main foundation-stones of the future megamachine of culture had already been laid. Firstly, both the Italian and Soviet avant-gardes had put forward the idea that art should serve the Revolution and the State; from here it was only a short step to the status art was granted under totalitarianism, that of an effective weapon in ideological struggle. Secondly, through the nationalization in the USSR of museums, private collections, systems of education and the media, a basis had been established for the Party or State monopoly of artistic life. Finally, in Russia after 1921, in Italy some time later and less decisively, a third foundation-stone was laid: the Party and State chose to back the artistic movement which, under the name of Socialist Realism or the Art of National Socialism, was to acquire official status in the totalitarian states.

The builders of these States, from Lenin to Stalin and from Mussolini to Hitler, looking on "artistic brawls" from the heights of political pragmatism, had always been critical of the avant-garde. They saw their vertiginous projects for the construction of a new reality not only as artistic gibberish but also as a dangerous interference in political matters, an intrusion on their own right to refashion the world according to *their* recipes. Lenin, who used the name "Futurism" quite indiscriminately for all the new movements in art, saw it as a rebellion of the "fastidious bourgeois intelligentsia". Trotsky, more au fait with cultural matters, saw the greatest achievements of the avant-garde simply as

"exercises in the verbal and sculptural music of the future"; he considered it "better that they should be left in the studios and not shown to the photographer".[1] The new regime had little time for art during its initial years, but as soon as the Civil War was over it began to pay careful attention to matters of cultural policy.

As early as the autumn of 1919, Grigorii Zinoviev – a favourite of Lenin and the all-powerful master of Petrograd – sharply criticized the avant-garde in a speech to a meeting of proletarian writers: "At one time we allowed the most nonsensical futurism to get a reputation almost as the official school of Communist art ... It is time to put an end to this ... Dear comrades, my wishes to you are that we should bring more proletarian simplicity into our art."[2] A year later, in "A letter on Proletkults" published in *Pravda* on 1 December 1920 – the first in a long series of similar documents – the same criticism was made in the name of the Central Committee as a whole:

> Proletkults have been inundated by elements socially alien to us, petty-bourgeois elements which have sometimes, to all intents and purposes, taken over the leadership. Futurists, decadents, proponents of an anti-Marxist idealist philosophy and, lastly, plain failures who have emerged from the ranks of bourgeois journalists and philosophers have taken complete control of some Proletkults. In the guise of "proletarian culture" workers have been offered bourgeois views in philosophy (Machism) and absurd, distorted tastes in art (Futurism).

Although it is Proletkults that are referred to, the main thrust of this letter is directed against the avant-garde as a whole, the representatives of which are declared "petty-bourgeois" and "elements socially alien to us"; the avant-garde's terminology is now being used against itself.

In 1923, with the outlines of this policy already fully defined, Maiakovskii and his comrades assessed the situation on the artistic front during the preceding period as follows: "The government, concerned with the fronts and the general devastation, paid little attention to artistic quarrels, attempting only to prevent the rear from making too much noise and to bring us to reason out of respect for 'the very distinguished'."[3] "The very distinguished" here means the realists, whom the Soviet regime had already decided to back.

At first, however, neither the Party leadership nor Lunacharskii – who was responsible for the execution of their artistic policies – had anyone to whom they could turn for support. In the words of Lunacharskii himself:

> The atmosphere of the Petrograd artistic world was bourgeois-democratic and hostile to us. All kinds of more or less subversive resolutions were carried at meetings of the Union of Artists ... This section of the intelligentsia, like every other section, was acutely dissatisfied with our policies ... In the realm of art our first priority was to destroy such essentially Tsarist institutions as the Academy of Arts, it was necessary to liberate the school from former "notable figures".[4]

Some of "the very distinguished", headed by Ilia Repin, the "Lev Tolstoi of Russian painting", had emigrated; others had lapsed into hostile silence. The most "progressive detachment" of Russian realism, the Peredvizhniki, were among the most intransigent, and anyway their conduct "during the 1905 Revolution left such a bad aftertaste that henceforth their critics invariably categorized the Peredvizhniki with those parties that sat on the extreme right of the Duma and at times even with the notorious Black Hundreds".[5] And when the first timid voices were heard from the realists in support of the new regime, the Petrograd IZO of the People's Commissariat for Enlightenment had every justification for saying in their official manifesto: "Now, when the victory of the working class is clear as the day, many of the artists who a year ago were grumbling and maliciously croaking about the swift collapse of Communism have come to apologize. Now they are ready to serve the 'socialist fatherland' on an equal footing with everyone else. Good luck, belated comrades!"[6]

In 1922 those who had fallen silent began to speak more loudly. In February the Peredvizhniki, after a long period of inactivity,* held their 47th exhibition. During the ensuing debate the Association of the Artists of Revolutionary Russia (AKhRR) came into being; in the hands of a regime that was now gaining strength, this soon became a convenient instrument for the reconstruction of Soviet art. The nucleus of the AKhRR consisted of former Peredvizhniki (Nikolai Kasatkin, Pavel Radimov and others), together with a number of young realists who at the time were unknown. Their first manifesto is notable for its grandiloquence and aggression:

> As citizens it is our duty towards humanity to engrave the greatest moment of history in its revolutionary surge. We shall depict the present day: the everyday life of the Red Army, of workers and peasants, of revolutionary figures and heroes of labour. We shall offer a true picture of events and not abstract fabrications that discredit our revolution before the world proletariat.[7]

This last phrase soon became a typical cliché of totalitarian attacks on the art of the avant-garde.

The chairman of the AKhRR was Pavel Radimov, the former chairman of the Association of the Peredvizhniki; its secretary was Evgenii Katsman. "A few days after the opening of the Peredvizhniki exhibition and the debate following Radimov's speech," Katsman wrote in his memoirs, "a group of realist artists decided to turn to the Central Committee of the Party and declare that we were at the disposal of the Revolution and that it was for the Central Committee to tell us artists how we should work."[8] This was probably the first time in the history of European art that painters had turned to Party leaders for instructions about their work. They did not have to wait long for these instructions – or indeed for the whole-hearted support of the State. In 1922 People's Commissar

* The Peredvizhniki had been through a crisis in the nineties.

Lunacharskii made an abrupt change of course and put forward the slogan: "Back to the Peredvizhniki".

Mere slogans, however, were of course not enough to turn the whole thrust of Russian culture away from revolutionary self-transformation and back to the portrayal of the everyday present. What was needed was a regulating mechanism with a single control panel. The credit for first constructing such a mechanism – as with other aspects of the organization of the totalitarian State – belongs indisputably to Lenin: "not only Stalin, but Mussolini certainly and Hitler (through the German Communists) indirectly, learned it from him".[9] Ideas for the comprehensive organization of culture had been expounded by Lenin as early as 1905, in "Party Organization and Party Literature". Although this short article was written in response to a particular occasion and appears to be addressed only to literature, it forms the basis of the entire cultural policy of Soviet Russia. Its ideas were widely circulated, and not only within the country of victorious socialism: this article was translated into German in 1924 and extolled by the German Communists; Mao Tse-tung turned to it for guidance during the first stage of his own cultural transformations; and Mussolini, a convinced admirer of Lenin during his youth, undoubtedly had a good knowledge of its principal theses. Lenin declared:

> Literature must be Party literature. As a counterweight to bourgeois morals, as a counterweight to the bourgeois entrepreneurial and commercial press, as a counterweight to bourgeois literary careerism and individualism, to "lordly anarchism" and the pursuit of profit, the socialist proletariat must put forward the principle of *Party literature*; it must develop this principle and realize it in the most complete and integral form. Away with non-Party men of letters! Away with supermen of letters! Literary activity must become a *part* of the general proletarian cause, "the cogwheel and screw" of one unique great social-democratic mechanism set in motion by the whole conscious avant-garde of the working class. Literary affairs must become a constituent part of a planned and systematic, united Social-Democratic Party activity.[10]

Lenin goes on to matters of concrete organization:

> Men of letters must enter Party organizations. Publishing houses and ware-houses, shops and reading-rooms, libraries and all the various forms of trade in books must be accountable to the Party and under its control. An organized socialist proletariat must check all this work and organize it; it must introduce into all of this work, without exception, a living stream of the living proletarian cause.[11]

At this date, 1905, Lenin added reassuringly that he was talking only about "Party" literature, and that "with regard to artistic literature as a whole, it was essential to provide a large area of space for personal initiative". From the very beginning, however, and with Lenin's energetic support, Soviet cultural policy was to apply the slogan "Party Spirit" to the whole realm of culture. In Trotsky's words, "the only question was where we should interfere first".[12]

In 1917 the People's Commissariat for Enlightenment (Narkompros) was established, together with its Department of Fine Arts (IZO); it was the function of the latter to organize everything relating to painting, graphics, sculpture and architecture. During its first years, a time of chaos and ruin, Narkompros had to struggle simply to stay alive, and IZO – whose activities were considered by the Party leadership to be ineffective and sometimes even harmful – was run mainly by "Futurists". It was for this reason that at the end of 1920 the long process of reorganizing Narkompros was set in motion, on orders from Lenin and with his own personal involvement. The aim of this reorganization was stated to be "the organic unification of the parts of Narkompros, which must become a single organism with a single head and a single will".[13] This aim, however, was not to be achieved for some time.

After prolonged discussions at the level of the Central Committee and Party Congresses, the management of art was divided between several Party and State organizations. The highest ideological organ for the management of the sphere of culture was to be the Central Committee's Section for Agitation and Propaganda (Agitprop); this was to continue to function, under various names, throughout the entire subsequent history of the Soviet State. Parallel to it was the Chief Administration of Political Enlightenment (Glavpolitprosvet), to whose jurisdiction IZO itself was transferred. In February Glavpolitprosvet was accorded "the right of veto from the political point of view" of all work currently being produced in the arts and sciences.[14] What remained under the jurisdiction of Narkompros was the academic world: artistic education, research institutes, museums, artistic periodicals and publishing houses, etc. Lastly, there is one organization which played a decisive role in the formation of the style of Soviet total realism: the Political Administration of the Red Army (PUR). With their huge resources, the Soviet generals were the main patrons of the AKhRR from the moment it was set up.

These several organizations, under the jurisdiction of various Party and State organs and often duplicating one another, might well seem a long way from the Leninist ideal of a single centralized apparatus for the control of art. This apparent contradiction, however, was resolved by the structure of the Soviet one-party system. Lunacharskii himself, whose artistic views had a certain breadth, was the first to take a hard line in subordinating all cultural activities to the will of the Party. This "liberal" commissar suggested restructuring his own Narkompros on the model of PUR, a purely military organization, and during a speech at the Tenth Congress of Soviets he said of the dual control of art by Party and State organs: "Comrades, there are often confusions which arise here from a Soviet/Party dualism – as if state and Party work must be marked out as if on a map; as if the boundaries where the Party fully transfers work to the state apparatus must be shown. That is wrong. The Party must be everywhere, like the Biblical spirit of God ... We must act through the Soviet

apparatus, which is the organ of the dictatorship of the Communist Party."[15] This idea of Party leadership, common to all forms of totalitarianism, was formulated far more strikingly by Mussolini: "The Party has the function of the capillaries in the body; it is neither the heart, nor the head, but those endings where the blood of Party doctrine, Party policy, and Party sentiment mingles with the rest of the body politic."[16]

This spirit of the Party was present in the main control centres of the country's artistic life – and not only in the invisible guise of Party dogma. It was incarnate in the persons of those who were at the very top of the administrative hierarchy: Agitprop was directly responsible to Lenin himself; the head of Glavpolitprosvet was his wife, Nadezhda Krupskaia; PUR was under the jurisdiction of Trotsky; Trotsky's wife was Lunacharskii's deputy in the Arts section of Narkompros; and the other important posts were shared between the wives, sisters and sisters-in-law of Dzerzhinskii, Kamenev, Zinoviev, Krizhanovskii, Bonch-Bruevich and other Party bosses. Through these blood-vessels and capillaries the will of the Party fed the diverse cultural organizations, binding them into one mechanism and transforming them into an inseparable part of the Party and State machine. The energy that fed this mechanism was Party ideology, and the control panel was located in the Leader's office. Only an analysis of the work of this mechanism, a mechanism created by Lenin, can shed light on the question of the end of the Soviet avant-garde, a question to which various answers have been given: was the avant-garde officially banned and forcibly annihilated, or did it simply exhaust its creative potential and quietly fade into the past together with the epoch that had engendered it? Was its end planned as a part of Lenin's cultural policies, or was it the result of a later, Stalinist, departure from Leninist norms, from his "broad and liberal" position on artistic matters?

Lenin himself understood better than anyone the social function of art in the State he was defending. He saw it primarily as a powerful propaganda weapon in the Party's, and the State's, struggle for power. It is not by chance that the first official decree relating to art that he himself signed was the Soviet of People's Commissars' resolution "On the erection of monuments to great figures of social and revolutionary activity" (published on 14 April 1918); this entered the official history of Soviet art under the title of "the Lenin plan for monumental propaganda". Despite all the demands on his time during the first years after the Revolution, Lenin entered into the minutest details of this plan, insisted on a rigorous observation of deadlines by Lunacharskii, and was present at the unveiling of the monuments themselves. The "Futurist scarecrows" that appeared on the squares of Moscow and Petersburg aroused his sharp criticism; he knew very well that art could only fulfil its social function if it was realistic, if it was addressed to the masses in a language they could understand. He demanded that the avant-garde be replaced by realistic artists. As early as December 1918 he demanded that Lunacharskii curtail Futurist publication in

the pages of *Art of the Commune*,[17] a journal that was closed down four months later.

Lenin's ideas and his methods of putting them into practice can best be deduced not from the texts of his speeches and Party documents, but from the "Leninist" style of leadership. In words Lenin declared that he was incompetent to make judgements on artistic matters and that administrative interference in such subtle questions was inadmissible; in actual fact he himself laid down the law. In 1921 the resolution which was adopted at a meeting of the Soviet of People's Commissars chaired by Lenin proposed to undertake urgent measures towards the reorganization of higher artistic education, taking care above all to ensure the possibility of the artistic development of realistic movements in art and sculpture. In the complex circumstances of the time, however, with most cultural figures strongly opposing such measures, Lenin preferred to impose his will not through official resolutions and declarations but through a control mechanism he had set up himself – through suggestions, telephone calls and official notes. Lenin's methods of struggle with political opponents can be illustrated by one of his notes sent in 1918 to the local Communist authorities of the town of Elts: "We cannot, of course, give you written authorization to oust Socialist Revolutionaries, but if you [do so], we in the centre … will only praise you for it."[18] The fate of the Socialist Revolutionaries is, of course, well known. Similar notes were sent by Lenin to those in charge of his various cultural organs. On 6 May 1921 he wrote to Lunacharskii's deputy M. N. Pokrovskii: "Kiselis, who people tell me is a 'realist' artist, has once again been put down by Lunacharskii, who supports the Futurists both directly and indirectly. Is it impossible to find any reliable anti-Futurists?"[19] P. Kiselis's only contribution to Soviet art was his speeches in defence of realism and his activities in AKhRR.

The removal of the avant-garde did not require the application of punitive measures or any direct attack with the weapons of ideology. The State already had a monopoly on all the resources of artistic life and was the only commissioner and consumer of art; all it needed to do was simply to close the supply channels. At the very beginning of 1922, for example, after Lenin's fierce attacks on Proletkult, this huge and many-branched organization lost its subsidies from the People's Commissariat for Enlightenment. And during the restructuring of the People's Commissariat for Enlightenment the "Futurist" David Shterenberg was dismissed from his position as head of IZO, which had until then been the only buyer of art and the distributor of State orders, subsidies, advances, rations and other material goods. Other representatives of the revolutionary avant-garde lost their posts at the same time, and the new leaders directed the resources of the State down other channels. All this considered, it seems doubtful that the end of the avant-garde was entirely natural.

It must be remembered that the fall of the avant-garde began immediately after its sudden upsurge: the theories of Constructivism and Production Art,

only formulated in 1920–1, were to continue for many years to generate artistic ideas within the German Bauhaus, the Dutch "Di Stijl" group, the English "Tekton" and many other avant-garde movements in Europe and America. Within Russia, however, the last major exhibition of the work of the avant-garde was in 1923, in Petrograd: "Artists of all tendencies 1919–23". After that it to all intents and purposes disappeared from exhibition halls, museum displays and Soviet publications: the avant-garde, which had played so active a role in the construction of the new culture, was its first victim.

The avant-garde met its end at the height of the New Economic Policy,* when, as a result of the partial restoration of the private sector, the cultural life of the country was growing somewhat more lively, when private theatres were being opened and private concerts arranged, when (in 1923) over three hundred commercial publishing houses were registered in Moscow and Petrograd and there was a demand for their products. But who, other than the State, could have commissioned Tatlin's Monument to the Third International or realized the architectural projects of Konstantin Melnikov and Ivan Leonidov? Who, for commercial motives, could have set up exhibitions of Malevich's Suprematist compositions or Lissitzky's Prouns?† All these had been created on the crest of a revolutionary wave, in the excitement of "the religion of the future". Now the avant-garde was being asked to rest, to reconsider its position. "The organizers of gigantic projects, like Tatlin, have been given a breathing space, in order that they should think more about a radical review and re-examination," wrote Trotsky in 1924. "For better or worse, circumstances offer him [Tatlin] a lot of time in order to find arguments in defence of his point of view."[20] Tatlin's breathing space was to last until his death in 1953.

The end of the avant-garde was as natural as that of a fish deprived of water; the State dammed the revolutionary stream and it suffocated in the stifling atmosphere of the new epoch. The State had no need to ban the avant-garde – it was enough to transfer it to a self-financing footing.

The second half of the twenties was marked by the bitter struggle of the artistic groupings hostile to the AKhRR. Their members accepted both the doctrine of realism imposed by the ideological apparatus and the accompanying directive that the heroism of the successful Revolution should be reflected within the forms of easel-painting. In their formal language, however, they attempted to preserve some remnants of creative freedom. This struggle was doomed to failure. Nevertheless, during the decade between the end of the avant-garde and the establishment of Socialist Realism, these groups created an art that reflected the "Romantic" atmosphere of the twenties and in many respects determined

* Lenin's plan to revitalize the Soviet economy, destroyed by the Revolution and the civil war, by means of introducing certain elements of capitalist economic relations into the socialist system.

† "Projects for the affirmation of the innovative"; Lissitzky gave this name to his geometrical abstractions.

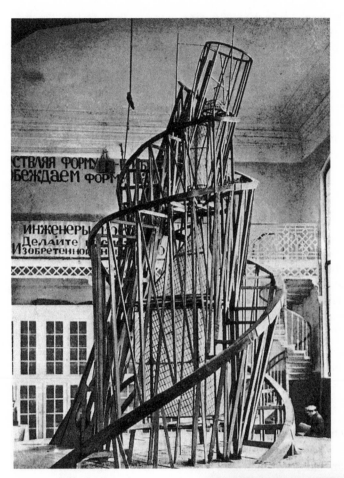

Tatlin: Monument to the
Third International (1919–
20)

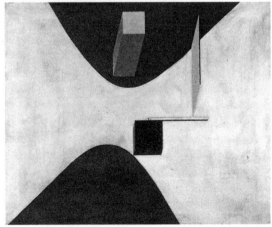

Lissitzky: Proun No. 6 (1919)

their style. In Italy, as well as in the USSR, art had to pass through this "heroic" style on its path towards total realism.

(ii) The interim style

The oldest of us is thirty, so we have ten more years in order to complete our work. When we are forty, younger and stronger men will probably throw us into the rubbish bin like useless manuscripts – and that is how we want things to be!

Marinetti, 1909

During the formation of totalitarian culture this optimistic prophecy from Marinetti's first Futurist manifesto was indeed fulfilled, tragically in the case of the Soviet avant-garde and with pathetic irony in the case of the Italian avant-garde. And those who replaced the young rebels were not younger and stronger, but older and more sober.

Marinetti's Futurist army threw itself into the Fascist Revolution with ranks that had grown considerably thinner. As supporters of nationalist war, many of the Futurists had left for the Front. Two of the most important – the sculptor and theoretician Umberto Boccioni and the architect Antonio Sant'Elia – had died on the battlefields. But Marinetti was losing supporters in ideological skirmishes as well, and with Mussolini's rise to power the flight from Futurism took on massive proportions. By the thirties "the only one of the first Futurists (the signatories of the manifesto) who still held to the tenets of the former heroic faith was G. Balla".[21] In Italy, however, the decline of the avant-garde occurred for different reasons and under different conditions than in Soviet Russia.

Unlike Russian Bolshevism, Italian Fascism was not at first a Messianic doctrine; it was intended for internal use and was not, in Mussolini's words, "goods for export".[22] Its political programme was simply the resurrection of Italy, her reattainment of her former greatness and special place among the other European states. In the realm of art, this doctrine was expressed through the term *italianità*, understood as a certain special quality of Italian culture and the people it had formed, a culture in which the solemn tread of ancient Rome and the Italian Renaissance had never ceased to echo. This affirmation of the primacy of the Italian sensibility is expressed in many Futurist manifestos, but it was only during the war that this sense of cultural exclusiveness took on its most fiercely nationalist tone. In his political manifesto, for example, Marinetti proclaimed that "the word Italy must overrule the word Freedom",[23] and in one of the last manifestos of their classical period the Futurists declared: "No artist in France, Russia, England or Germany anticipated us in perceiving anything similar or analogous. Only the Italian genius, which is the most constructive and architectural, could perceive the abstract plastic complex. With this, Futur-

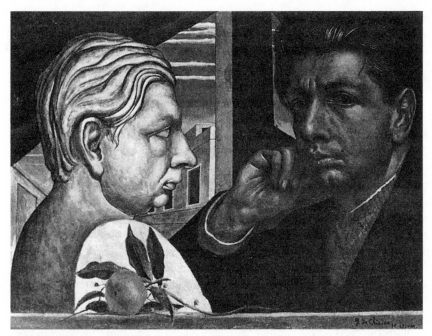

de Chirico: Self-portrait (1924)

ism has determined its style, which will inevitably dominate the sensibility of many centuries to come."[24]

But in order to assert one's national primacy one must be firmly based in tradition – and it was against all traditions that the rebellious enthusiasm of Futurism was directed. Futurism saw the traditions of Italian antiquity and the Renaissance as a dead weight that fettered Italy's movement into the future, and turned her into a "country of tombstones"; after Rome and her burden of the past it is not surprising that Marinetti saw London as the ideal city. The language of the Futurists was a dialect of the international modernism of the beginning of the century; it was not the masters of the quattrocento they saw as their forerunners, but the Impressionists – who had addressed contemporary themes and introduced elements of movement, transitional states and distortions of time. Impressionism is the thesis, Cubism the antithesis, and Futurism the synthesis of modern painting, proclaimed A. Soffici, the Futurist theoretician.[25] In the absence of any major representatives of Impressionism in their own country, they made an idol out of Medardo Rosso, an Italian sculptor who translated the achievements of Impressionism into the language of plastic forms.

The reality of war made many artists rethink their artistic views. In a military hospital in 1916 Giorgio de Chirico met Carlo Carrà, after Boccioni the most important and productive of the Futurists. De Chirico was at that time becoming

deeply disillusioned with Modernism. Three years later he published a kind of manifesto, *Back to Craft*, in which he attacked the 'alchemical, analytic and romantic art coming from the North, from France and Germany" and demanded "discipline, severity and structure" from the artist. He branded the Cubists, Futurists and, above all, the Surrealists – who looked on him, not without reason, as one of their spiritual fathers – as a bunch of degenerates, idlers and hooligans. Considering the answer to lie in a return to the classics, to academicism and the traditions of the quattrocento, he gave himself the title "Pictor Classicus". Influenced by these ideas, Carrà published a series of essays on Giotto and Uccello, whose art he saw as the most vivid embodiment of the Italian genius with its special sense of the plastic arts and the stability of material forms. His friend Gino Severini, who collaborated with him in writing the Futurist manifestos, published a book, *From Cubism to Neo-Classicism* (1921). Both title and content reflect the reappraisal of values which took place at this time in Italian art.

However, "one cannot be over-critical of the journalistic rhetoric of de Chirico and Carrà, since it was based on artistic ideas that were in themselves fruitful. The danger lay in the political and cultural level of those who took up their arguments"[26] – that is, Mussolini and the ideological circles surrounding him.

Both the Bolshevik coup and Mussolini's *putsch* – like any totalitarian revolution – led inevitably to an attack not on the traditions of the past but on the free, individualistic and dynamic spirit of the present, a spirit emancipated from both society and the State. It is not surprising that when Marinetti, the herald of this spirit of universal renewal, turned to his old friend Mussolini with a request for help, since political revolution must support artistic revolution, i.e. Futurism and all progressive artistic movements, he came up against the same wall that had destroyed the expectations of the Russian avant-garde. In their attempts to become the official art of the Communist and Italian regimes, the Soviet and Italian avant-gardes met defeat almost simultaneously.

In 1922, the year of the foundation of the AKhRR in Moscow, a group of artists in Milan, actively supported by Margherita Sarfatti, Mussolini's mistress and one of the most influential critics of Fascist Italy, laid the foundation of a new movement in Italian art – the "Novecento Italiano". The Novecento immediately opposed itself to Futurism, and its initial platform included a harsh criticism of modernism together with a demand for a purge of all foreign influences and a return to national sources. "Futurism was necessarily avant-gardist and aristocratic," the members of the Novecento declared in one of their early manifestos. "Novecentist art must make itself 'popular' and attract the 'public' . . . Unlike the Futurists, we have no admiration for the great development America has given to mechanical civilization."[27] Such "popular" artists gradually formed the nucleus of the Novecento and – as the mechanism of cultural control was established – came to occupy its key posts.

In February 1926 a ceremonial opening of the first Novecento exhibition was held in Milan. In his opening speech Mussolini confronted the artists with the rhetorical question: "What connection can lie between politics and art? ... Is it possible to establish a political structure between these two manifestations of the human spirit?"[28] For Mussolini himself there could be no argument about the answer. "Before man knows the need for culture, he feels the need for order."[29] In these words Mussolini elevated the central aim of totalitarian dictatorship to the status of an eternal human principle. What he, like Lenin, aspired to construct was not a bridging link between art and society but a single machine that would control both. Initially he and the other Fascist ideologues looked on the Novecento as the Communist ideologues looked on the AKhRR – as a convenient instrument for a refashioning of culture.

Parallels between the Novecento and the AKhRR, however, can only be drawn with considerable provisos. Firstly the Novecento included, as members or participants in its exhibitions, such important twentieth-century masters as de Chirico, Giorgio Morandi, Carlo Carrà and Gino Severini. Secondly, it did not preach any rigid aesthetic doctrine as the official style of Fascist culture. During the first stage of its development the prevailing influence was Neoclassicism – the legitimate child of their appeal to national tradition. Stylized figures in gladiatorial combat (de Chirico), monumental nudes (Carrà), heroic portraits of the Duce, allegories of citizenly virtues, landscapes that wandered into contemporary paintings and sculptures straight out of Roman reliefs and the backgrounds of the compositions of Paolo Uccello and Piero della Francesca – all this

de Chirico: School for Gladiators (1927)

Carrà: Lot's Daughters (1929)

Funi: Venus in Love (1928)

Samokhvalov: Girl in
Football Jersey (1932)

Samokhvalov: Girl Athlete (1933)

was the common currency of the Novecento of the twenties. Towards the end of the decade, as increasingly emphatic calls were made "to reflect Fascist reality more deeply", more and more painters of this movement began to link their work directly to contemporary life. The main themes were labour, sport, struggle and motherhood, and the principal content was the glorification of strength, courage and the physical perfection of the "new man" and the Duce who inspired his victories. Nevertheless, it was not until the end of the thirties that Realism became a defining characteristic of the Novecento. In their themes, emotional tone and breadth of stylistic range, the products of the Novecento are comparable not so much with those of the AKhRR as with those of the rival Soviet artistic groups of the time.

In order to oppose the intrusion of totalitarianism into the area of culture, artists in Italy and the USSR began to search for new forms of professional organization. During the twenties, the most diverse artistic groupings sprang up in both countries. In Italy there were the "Roman school", the "Turin Six", the Milan "Chiaristi Lombardi" – even the "Corriente" group which appeared towards the end of the thirties and was openly anti-Fascist. In Russia there were the "Moscow painters", the "Four Arts", the Leningrad "Circle of Artists", and others. The most radical and important of these rivals to the AKhRR were the "Society of Easel Painters" or "OST" (1926) and "October" (1928). All of these groups were to a greater or lesser degree opposed to the official artistic ideology.

By the end of the twenties such groups could only continue to exist in the Soviet Union on condition that they accepted, in word and deed, the official directives with regard to the construction of a broad panorama of heroic reality and its reflection within the forms of this reality. Such an orientation became an essential part of the programmes and manifestos of all the important artistic organizations of the second half of the twenties. The difference between them lay only in their interpretations of the concept of realism and their understanding of the permissible broadening or narrowing of its boundaries.

Many of the important Soviet artists who formed the nucleus of these organizations belonged to the younger generation (Aleksandr Deineka, Iurii Pimenov, Aleksandr Labas, Aleksandr Samokhvalov, Nikolai Denisovskii and others); in their enthusiasm for socialist construction, for the poetry of labour, for heroic legends about the days of the Revolution and the process of forging the "new man", they were the direct or indirect descendants of the revolutionary avant-garde. Despite the considerable infringements on creative freedom these artists held on to some of the achievements of contemporary art and attempted to use its language to express the "joyful, energetic and active" spirit of the time between the Civil War and collectivization, a time when an injection of free market relations somewhat enlivened the ruined economy of the country, when the appearance in the shops of a loaf of bread was seen as a sign of the coming general abundance, when a newly built stone hut was seen as the prototype of

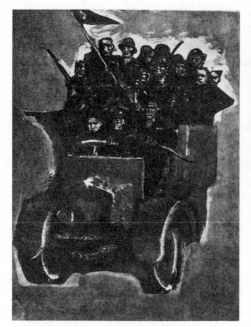

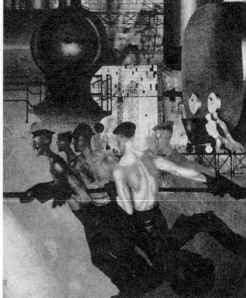

Sironi: Squadro Pimenov: Give to Heavy Industry (1927)

an architecture never before glimpsed and a newly smelted ton of steel was seen as one more crushing blow against world imperialism. These hopes were engendered by a decade of war, hunger and ruin, of social chaos and isolation from the rest of the world. A similar – only more relaxed – atmosphere of heroic enthusiasm, imbued with the same sense of the unparalleled achievements of the Fascist State in all areas of cultural and economic life, surrounded the artists of the Italian Novecento. Whether or not all this was an illusion, it felt real, it was the spirit of the culture of the period and it was appropriately embodied in the style of both Soviet and Italian "post-avantgardes".

This style could be called Constructive or Heroic Realism: its creators used real representational elements to construct the ideal world of their pictures, a world purged from old-fashioned (bourgeois) nuances of mood and permeated instead by a single powerful emotion – stern zeal (in scenes portraying labour), radiant exultation (in scenes portraying sport or motherhood), heroic resistance (in scenes of fighting), a world where nature appeared only in the form of a building site or the scene of a combat. In their monumentality and the heroic quality of their images, in their glorification of strength, labour and struggle, the works of the Soviet artists closely correspond to those of the Italian Novecento: Mario Sironi's members of Fascist military detachments are welded

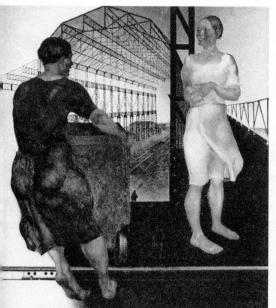

Deineka: On the Building of the New Factory (1926)

Petrov-Vodkin: The Alarm (1935)

into the same solid blocks as Iurii Pimenov's miners; the symbolic figures against the background of the ascetic townscapes or cold interiors of Kuzma Petrov-Vodkin or Carlo Carrà live the same "metaphysical life" and are endowed with the same degree of stylization (although this comes in one case from Old Russian icon-painting, and in the other case from the Italian quattrocento); the tense dynamism of Aleksandr Deineka's sporting scenes is almost indistinguishable from that of similar compositions by Achille Funi.* The principal difference is that the Italians' Neoclassicism was the language of their own national tradition, its forms bearing the imprint of their previous meanings, and that this imbued Fascist art as a whole with a quality of highly stylized pomposity. It is not insignificant that the most important form of official Fascist art was mural painting. The Russian artistic tradition, on the other hand, had not known a monumental style since the heyday of icon painting, and so the style of the Soviet artists was not so much a stylistic borrowing from the past as a translation of the abstract language of the avant-garde into the language of representational forms. This is the reason for the greater freedom of the Soviet painters in their approach to

*It would be possible considerably to extend these analogies, and also to introduce others regarding the similarity of phenomena on the periphery of this shared Italo-Soviet style.

the subject, the more realistic and contemporary spirit of their work, and their closer approach to a total identification between art and life.

But it was not merely a matter of different national traditions; what is more important is the different political structure of the two regimes. Although it was Mussolini who first coined the term "totalitarian state" and most succinctly defined its principles – "Everything within the State, nothing outside the State, nothing against the State" (*Tutto nello Stato, niente di fuori dello Stato, nulla contro lo Stato*) – his regime was in fact considerably further from realizing these principles than the similar regimes in Russia and – later on – in Germany. According to Ernst Nolte, "Of all the outstanding totalitarian personalities of the era, Mussolini was not the man with the deepest thoughts but he was probably the one with the most thoughts; he was not the most outstanding, but he was the most human; he was not the most single-minded, but he was the most many-sided. Thus to a certain extent he was the most liberal."[30] Italy was not permeated by the fear of political terror which in Russia embraced whole strata of society: the "privileged classes" at the time of the Revolution, the peasantry during collectivization and all the other classes from the beginning of Stalin's purges. It was only in 1926, after three attempts on Mussolini's life, that the death penalty was introduced in Italy, and from then until 1943 the courts pronounced only 25 death sentences, 21 of them on Slovene terrorists. (In contrast, the number killed by the Soviet Cheka from December 1917 until February 1922 is, according to the latest data, approximately 280,000.[31]) And Mussolini's secret police (the OVRA, established in 1927) had very little in common, either in aim or structure, with the Soviet Cheka or the Nazi Gestapo.

It was the same with regard to culture; the Duce proved considerably more tolerant than other führers or leaders. Whereas the Soviet State had, since the establishment of the AKhRR, encroached on the sphere of artistic language itself, the Italian authorities limited themselves to general ideological directions. "To remain loyal to culture was automatically to be anti-Fascist. To paint still lifes with bottles or write hermetic verses was in itself a protest," wrote Renato Guttuso of the days of his youth.[32] The opposition of the Italian artists was expressed first of all in their turning towards the "alien" traditions of Western modernism: to Fauvism, to German Expressionism, to the "hermetic" language of Matisse or Picasso's tragic distortions. With regard to their degree of realism, there was very little difference between the Novecento and its opponents (purely propagandist works aside). No one prevented Italian artists from painting still lifes with bottles, and in the most varied of styles. Beside the State feeding-trough stretched the broad sea of private enterprise, and artists were able peacefully to exhibit their works, publish them in journals, and offer them for sale on the free market, at home and abroad. It is another matter that the execution of State commissions took artists beyond the confines of their professional activity and into the sphere of ideology, and that this brought them money, titles, rewards

and a place in the New Fascist elite. In any case it was not through commissions that the most important members of the Novecento – e.g. Carrà, de Chirico and Severini – attained their position under the Mussolini regime; they had gained a considerable reputation before the revolution and through works of a quite different character.

Two of the most typical and active figures in the Novecento were Mario Sironi and Achille Funi. Before the war they had both joined the Futurist organization and in 1915, together with Marinetti, Boccioni and Sant'Elia, had enrolled as volunteers in the bicycle corps of the Italian army. Like Gropius in Germany and Lissitzky in Soviet Russia they had both dreamed of founding an association which would bring together the work of the artist and that of the artisan-labourer, developing through this cross-fertilization a new style of contemporary life. Glimpsing a possible realization of this dream in the plans of the Novecento, they played an active role in its establishment. Funi and Sironi executed the highest number of important commissions for the Fascist regime. In the words of one Italian critic, "Sironi created the Italian style of staging exhibitions, a parallel to which can be found only in the boldest achievements of the Russian avantgarde ... of the time of Vesnin, Melnikov, Tatlin, Lissitzky and Malevich."[33] In particular, Sironi designed the Italian pavilion at the 1937 International Exhibition in Paris, admittedly not in an entirely avant-garde manner. Funi's monumental murals on themes of labour and sport – glorifications of the achievements of the Fascist revolution – adorned the walls of many government offices. Both artists were members of the council of the Syndicate of Fascist Visual Art. If, however, one looks at the catalogues of their exhibitions during the course of the Mussolini regime, or at contemporary publications about them, one is struck by the complete absence of Fascist trappings. In the private sphere of artistic activity they both painted neo-classical still lifes or nudes, bold landscapes and gloomy portrayals of working-class districts of towns, completely lacking the pomposity and official optimism that characterize their commissioned works. The sphere of individual exploration and self-expression had not been stifled by the totalitarian machine, and it seems to have remained more important than the sphere of social service even to such official artists as Funi and Sironi. They were able to continue to find buyers for both aspects of their work.

In Russia this would have been quite impossible. From the end of the twenties, landscapes and still lifes "lacking in ideological content" aroused increasing suspicion. Party critics saw them as "attempts to distract the attention of the masses from the essential tasks of socialist construction"; a lack of realism in their treatment was seen as "a distortion of the image of our present day".

Soviet historians discussing this period of the Mussolini regime often attribute to it characteristics of the Stalinist epoch. "Over-importunate friends, people who reminded those in power about the time when they were still surrounded

by glamour and fame, more often than eternal gratitude received a bullet in the back of the neck. Bearing this in mind, it must be said that Marinetti got off lightly. If he had been less careful, he could at the very least have been sent to Linara island."[34] Soviet historians say this because that is what happened in their own country. It was not Marinetti but Maiakovskii who in 1930 was rewarded with a bullet, though admittedly in the heart rather than the back of the neck, and from his own hand rather than from those in power. Others were indeed rewarded with a bullet in the back of the neck. "The boat of love has been smashed against everyday life" and "I didn't have it out properly with Ermilov" – these two sentences from Maiakovskii's deathbed letter are like landmarks on his path to suicide.* Shortly before this, in contrast, Marinetti had become a member of the Fascist Academy alongside Fermi, Marconi and Pirandello, and had become head of the Union of Fascist Writers. These facts from the biographies of the two Futurist leaders symbolize the different fates of the movement in Italy and Russia.

After failing to become the official style of Fascism, Italian Futurism did not become opposed to the regime. Its heroic time remained in the past, but it adapted to new demands and its style degenerated into what, after the Fascist revolution, became known as the style of "the second Futurism". In 1929 Marinetti began a new Futurist movement which he called "aeropainting and aerosculpture". "Aeropainting started at the beginning of the Futurist movement with the first Futurists who were anxious to leave the earth with poetry, painting and sculpture and achieve a first, albeit vague aesthetic of flight and of aerial life," he wrote in his first manifesto, proclaiming the aim of this genre of art to be the creation in painting of the "optical and psychic sensations of flight".[35] In the works of the main representatives of this movement (Enrico Prampolini, Depero, Balla and others) the abstract aspects of Futurism were translated into the language of semi-representational forms. The dynamic lines of a large city seen from the cabin of a diving plane, the earth through a thick atmosphere permeated with coloured reflections – their works are reminiscent of illustrations in old science-fiction novels and can hardly be compared with the achievements of classical Futurism.

The political poster, however, was the main field in which Marinetti's followers found a way of serving the regime. The first to raise the poster to the level of high art had been such Russian artists as Klutsis, Lissitzky and Rodchenko, together with German Dadaists like John Heartfield and Hannah Höch. In the middle of the twenties these artists produced classic examples of the contemporary political poster, using techniques such as collage and photomontage that had been born in the creative laboratories of Cubism, Dadaism

* Vladimir Ermilov was one of the official literary activists and critics of the time. He played a major role in the persecution of Maiakovskii and went on to become an important literary figure, and a literary consultant to the KGB.

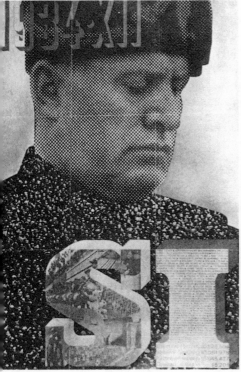

Poster: Mussolini (1934) Lissitzky: Poster of Lenin

and Futurism. The dynamism of Futurist collage, its capacity to express the throbbing life of contemporary cities, factories and dockyards, served to portray the energies of revolutionary crowds and the unifying will of the leaders; photomontage served in order to endow these clichés of totalitarianism with documental conviction. The Italian painters followed the Russians, used the same techniques, and as a result created images that are indistinguishable from the general interim totalitarian style. Smoking chimneys and spinning wheels; naval ships defending the fatherland with gaping gun-barrels; pistons and conveyor-belts, alternating like the lines of graphs and the figures of diagrams; festivals of sport; crowds composed of hundreds of thousands of faceless human units and formed up to represent the imperious gesture of Lenin's hand or the brutal profile of Mussolini; all this made up a heroic image of the State in the grip of revolutionary enthusiasm. The dynamic spirit of the making of totalitarianism, with its aim of bringing iron order to the human chaos, of reducing it to a common denominator in order for it to accord with an ideological dogma pronounced once and for all – this spirit demanded similar forms of embodiment.

Obedient to it, the Russian and Italian avant-gardes used fragments of an existing reality to construct an illusion – an illusion of the unity to come. The question of direct influences – which there indubitably were – is of secondary importance.

In accord with their old slogan – now the official Fascist doctrine – of bringing art and life closer together, the Italian Futurists found a place for themselves in the realm of such applied arts as illustration, commercial advertising and other forms of mass communication. A new generation, artists who had joined the

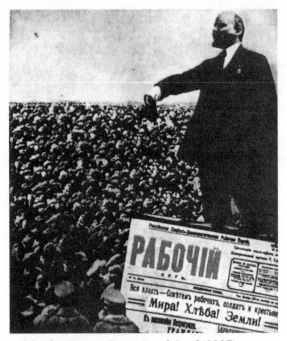

Rodchenko: Poster – Peace, Bread, Land (1937)

ranks of the Futurists at a later date or had simply been influenced by them, came to advertise the wines of the fatherland and articles produced by Olivetti in the same garish and simplified style that Rodchenko and Maiakovskii employed – after other areas of activity had been closed to the avant-garde – in order to advertise the products of Mosselprom (the Moscow Agricultural Industry). Unlike the Soviet advertisements, the Italian ones preserved a certain Futurist flavour right through the thirties.

All these similarities and differences were clearly revealed at the end of the twenties, when Soviet and Italian culture began to meet one another at the Venice Biennales, when they first looked one another in the face only to glimpse their own reflection.

(iii) Encounter in Venice

I think that the phenomenon of the Russian Revolution, which is akin to the Italian revolution in its hatred of the spirit of contemporaneity (represented for us by the spirit of the North-West and for Russia by the spirit of Europe) and its struggle against it, augments the phenomenon of the Italian Revolution. They both help one another in the common task of destroying contemporaneity, and one without the other is impossible, incomprehensible and illegitimate.

Curzio Malaparte

Mussolini was always glad to emphasize that he was the first of the Western rulers to recognize Soviet Russia – in the year 1924. "It occasionally crossed his mind that there was an approximation of communism to fascism in that both were opposed to liberalism, and others [his supporters] took note that the two regimes worked fairly harmoniously together, or even that fascism deliberately copied some aspects of communism. Mussolini had once belonged to the bolshevik wing of the Italian socialist party and still, in 1924, confessed admiration for Lenin, while Trotsky was quoted as saying that Mussolini was his best pupil."[36] "The best of relations" were immediately established between Soviet Russia and Mussolini's Italy, and these extended into the area of cultural links – though these were for the most part one-sided. Italy was the place where the new Soviet art was first able to appear before the world; from 1924 onwards the USSR participated regularly and on a large scale in the Venice Biennale. In the 1924 exhibition the Soviet section, which included work by Aleksandr Vesnin, Malevich, Popova, Matiushin, Rodchenko and Stepanova, had twice as many exhibits as either France or England (578, 259 and 250 respectively) and six times as many as Germany. The work of the avant-garde, however, was not shown at subsequent exhibitions.

The most striking meeting of Soviet and Italian art took place at the 1928 Biennale, when the foundations of the new art in both countries had already been laid. The central place among the 266 exhibits of the Soviet section was assumed by the groups hostile to the AKhRR: OST, the Four Arts, the Moscow Painters, etc. "It can be boldly claimed," wrote Boris Ternovets, a well-known Soviet critic of the time and one of the organizers of the exhibition, "that not one of the foreign pavilions exerts a similar power to attract and arouse ... The Fascist press has been compelled to admit the power of Soviet art, a power that lies in its unity and depth of content."[37] Ternovets then quoted a remark by the well-known Fascist critic Giuseppe Galassi: "Of the foreign pavilions it is the Russian which this year seems most worthy of attention." In the 1932 and 1934 Biennales the Soviet pavilions commanded the same degree of attention.

The Vicenza newspaper *Fascist Watch* (*Vedetta Fascista*) wrote with evident approval: "From the artistic point of view the USSR pavilion has taken a decisive step forward. It now, in the public eye, carries on political propaganda through its large paintings that are full of strength and saturated with colour. There is a tendency to decorativeness, but at the same time there is an awakening of strength and aggressive power. The art that stuns and ensnares."[38] Fascist criticism recognized the propagandist nature of Soviet art and its correspondingly realistic language as familiar; it felt the "breath of youth" emanating from these paintings; it heard in each of them "the sound of the bugle"; and it remarked on "the seriousness of form and design of this renaissance of Russian realistic painting, a painting that has certainly been disciplined in the service of the regime, that evidently aims to propagandize the events, types and characters of the new times, that is no longer lost in formalist and purely abstract explorations".[39] Galassi emphasized the same thing: "Stronger than the landscapes of their boundless motherland, the artists of the Bolshevik epoch have been able to sense the new life that is aspiring to transform, right down to the basic cells, the whole character of their society; they try to leave us an adequate and convincing representation. For this the Russians deserve our praise, all the more so since they seem almost alone in this attempt to bring together art and life."[40] Galassi concluded his review by noting stylistic parallels between the Soviet artists and the Novecento, noting especially the attempts of both "to reconcile old-fashioned and contemporary elements". The idol of the public in the 1928 and subsequent exhibitions, and the closest in spirit to the Fascist critics, was Aleksandr Deineka, represented by his newly completed masterpiece, "The Defence of Petrograd"; Margherita Sarfatti herself described it as conceived with genius in regard to both colour and line.

The comparison between Soviet and Fascist art, however, was seen as unfavourable to the latter. The confrontation of the two totalitarian artistic systems showed how much further Soviet art had progressed along the path of service to the Party and State, how much more controlled and disciplined it had grown, how to an incomparably greater degree it was now an inseparable part of its political system. Summing up the 1934 Venice Biennale, the 20 May issue of the newspaper *Matino* said:

> Only in the USSR pavilion is there vitality ... the renewed spirit of the nation that has broken age-old fetters and devoted herself entirely to the cause of her spiritual and economic renaissance ... The children of the Revolution, these artists sense that art cannot be separated from life, that artists must give all their strength to the renewal and elevation of the cultural level of the people, and that only by portraying and praising the outstanding people and events which surround them can they become worthy of the epoch in which they live.

Sensing these shared aspirations, the Soviet critics in their turn lectured the Italian artists from the height of their realized (or nearly realized) ideals:

Oppi: The Three Surgeons
(1926)

Deineka: Defence of Petrograd
(1928)

> The abstractness and formalism of [Fascist] art, its abstraction from vital social
> questions, its isolation from the interests of life rendered its propagandist effect
> on the masses one-sided and limited ... The inability of Fascist art to find a
> plausible, externally realistic form through which to express its false [sic!]
> ideals – this is the reason for the Fascist critics' dissatisfaction with these
> works.[41]*

While the Italian critics lamented the obvious superiority, with regard to
both style and content, of Soviet art, the Fascist administrators looked on it as
a model. It was what could be produced by the totalitarian cultural megamachine
that they themselves were trying to build.

Antonio Mariani, for example, the General Secretary of the XVIth Venice
Biennale, in an article "Art into Life", published in the Rome newspaper *Tribune*
on 24 December 1928, said of the Soviet system for the State encouragement
of art:

> Through these means the State has won over the artists, awakened their interest
> in the life of the country and created a collection of paintings which in ten or
> a hundred years' time will have an incomparable historical and perhaps artistic
> importance. Why can Italy not do the same for future generations? Why can
> art not engrave the life of these remarkable years? ... The means exist ... to
> direct and coordinate the work, to force art to become a powerful summons
> that will act on everyone. What is most important of all is to begin the work
> on a large scale, magnanimously, with a clear consciousness of our aims and
> the will to achieve them. Then the State can impart an incomparably greater
> stimulus to the bringing together of art and life than the usual miserable
> purchases at exhibitions.

Throughout the twenties artistic developments in Italy and the USSR followed
a similar course. A one-party State announced its historical right to be in control
of art, then gradually assimilated it until it became an organic part of its own
ideological structure. In both countries it set art a precise aim: to become a
powerful weapon in political struggle and "a powerful summons that will act
on everyone". In both countries a control apparatus was set up whose role was
to comprehend the whole of art and steer it in the necessary direction. This
megamachine of culture had not been entirely completed by the end of the
twenties, but its general plan had already been sketched out in political directives.

In both countries the first action of this machine was to dam up the springs
that had fed the energy of the revolutionary avant-garde and to promote a new
kind of art: "heroic realism", art of "the revolutionary surge", "of a new type".
The State looked on this art as the centre of the artistic structure it was building,
something to be encouraged through all possible means. But around this (still

* It is interesting to note that Goebbels came to a very similar conclusion: "The Italians have proved incapable
not only of achieving any in the least significant results in the military sphere, but even of creating anything
significant in the sphere of culture. One could almost say that the influence of Fascism on the Italian people has
been a sterilizing one." (V. Reimann, *Dr. Joseph Goebbels*, Vienna, Munich and Zurich, 1971, p. 319.)

only potential) centre played a rainbow of stylistic forms which was still the determining factor in artistic life. The Soviet and the Italian "interim" styles are similar in so far as they are both figurative movements, drawing from the common sources of Impressionism, Fauvism, Expressionism, etc.; the differences occur for the most part as a reflection of the specific realities of the two countries – of their artistic traditions and the nature of contemporary events. But what matters most is the general tendency of development: with the passing of time art reflected the concrete realities less and the determining ideologies more. In the twenties this ideological art in Italy and the USSR attained almost exact identity in two areas: in the "heroic realism" of the AKhRR and the nucleus of the Novecento and in the Soviet and Italian political poster.

By the beginning of the thirties Soviet art had reached the point where there could be no question of the existence of different styles, let alone of different ideologies. Italy began to approach this point only towards the end of the thirties. At their meetings in Venice the two systems of totalitarian culture not only looked one another in the face, but also, without doubt, exchanged experience.

(iv) The German avant-garde and "Kulturbolschewismus"

> If the age of Pericles seems embodied in the Parthenon, the Bolshevik present is embodied in a Cubist monstrosity.
>
> Adolf Hitler

> It is not for nothing that National Socialism finds an element of decadence in abstract art. But it is impardonable and disgusting demagogy to refer to the decadent product of bourgeois decline as "artistic Bolshevism".
>
> *Iskusstvo* (Art), 1934

> We were like sailboats flying our red, white or black sails against the wind. Some boats displayed the emblems of the United Front, others those of the Communists, the Nazis or the Stahlhelm. But viewed from the distance, all these flags looked alike.
>
> George Grosz

While Mussolini solemnly opened Novecento exhibitions and Lunacharskii instructed Soviet artists how to transform art into a "magic mirror" that would reflect the achievements of the Bolshevik regime, Hitler – who had by then exchanged his career as an unsuccessful painter for that of a politician – was still sitting in the Landsberg prison near Munich, recruiting supporters and writing *Mein Kampf*. In this book he for the first time defined the radical currents in contemporary art as "artistic Bolshevism" – a term that was to be altered by

Paul Schultze-Naumburg and Alfred Rosenberg to the broader "Kulturbolschewismus" and become of central importance to the cultural policy of the Third Reich and its struggle against modernism.

> Artistic Bolshevism is the only possible cultural form and spiritual expression of Bolshevism as a whole. Anyone to whom this seems strange need only subject the art of the happily Bolshevized states to an examination and, to his horror, he will be confronted by the morbid excrescences of insane and degenerate men, with which, since the turn of the century, we have become familiar, under the collective concepts of Cubism and Dadaism, as the official and recognized art of those states. Even in the short period of the Bavarian Soviet Republic this phenomenon appeared. Even here it could be seen that all the official posters, propagandist drawings in newspapers, etc., bore the imprint not only of political, but also of cultural, decay.[42]

This was written in 1924 when the art of the avant-garde was still associated with the ideology of the Bolshevik Revolution. But just as the conservatism of Lenin's artistic views at first provoked only a sceptical smile among true revolutionaries of the spirit, so Hitler's views were by no means universally shared among the German intellectual elite at the heart of the National Socialist movement. In the words of James Ritchie, the historian of this period of German literature: "National Socialists saw themselves as a movement of cultural revolution and some were tempted to align themselves with the radical avant-garde."[43]

As in Russia, so in Germany the avant-garde was a generator of artistic and political extremism. Its path led to revolution, but in the Germany of the twenties its members were faced with the choice between a red or a brown revolution. Both had an attraction for those who hated the existing bourgeois order and yearned to destroy its cultural and social foundations.

In *Mein Kampf* Hitler gave the following interpretation of the three colours of the German Imperial flag, which was retained as an emblem of State even during the Third Reich: "The red reflects the socialist, the white the nationalist ideas of the movement, the [black] Swastika symbolises the mission of the struggle for the victory of Aryan man and simultaneously the victory of the idea of creative work which itself has always been anti-semitic and will remain anti-semitic for ever more."[44] These are the three colours of all totalitarian ideologies, though in the Soviet Union – as we shall see – the black and the white appeared only in the second half of the thirties. In the National Socialist movement all three colours had equal rights from the very beginning: the Nazi flag, designed by Hitler himself, consisted of a black swastika in the middle of a white circle against a blood-red background. But if it was the black which drew the masses to Nazism, it was the red – the colour of the revenge of the oppressed and exploited – which drew the intellectual elite, yearning as they did for any revolution no matter what its colouring. In time this elite divided, those on the left becoming Bolsheviks while those on the right became National Socialists,

but during the twenties both tendencies were able to live peacefully under one roof, united by a common hatred of capitalism, democracy and the Weimar republic they had engendered.

The showroom of totalitarianism has never been short of ideological monsters. One such (apparently) unnatural hybrid was the German National Bolshevik movement, which experienced three surges of support, in 1919, 1923 and 1930; this movement has been described as a Prussian Communism, which hated Capitalism, hated the bourgeois West, and hoped to graft the methods of Bolshevism onto the warrior ideology of the Prussian nobility. This was supported on the one hand by Karl Radek, the Soviet representative of the Comintern in Germany, and on the other hand by such ideological leaders of Nazism as Ernst Jünger, Gottfried Feder the economist, and Josef Goebbels the future Führer of German culture. Both Communists and National Socialists had a common enemy and both were trying to win the hearts of the German proletariat; in spite of the ideological barriers that divided them, they were intuitively drawn to one another. The young Goebbels, for example, wrote in his diary: "And in the last analysis better to go down than live in eternal capitalist servitude ... I think it is horrible that we and the Communists bash in each other's heads."[45] And in his famous article "National Socialism or Bolshevism", written in the form of a letter to a "left-wing friend", he openly held out the hand of friendship to his ideological opponents, calling upon them to unite for a common struggle:

> No honest thinking person today would want to deny the justification of the workers' movements ... Grown out of need and misery, they stand before us today as living witnesses to our disunity and impotence, to our lack of national courage and will for the future ... We are both fighting honestly and resolutely for freedom and only for freedom; we want as final fulfillment peace and community, you that of the world, I that of the people. That this fulfillment cannot be attained in this system is entirely clear and evident to both of us ... You and I, we both know that a government, a system which is inwardly thoroughly mendacious, is meant to be overthrown ... You and I, we fight each other without really being enemies. In this way we splinter our forces, and we never reach our goal. Maybe the most extreme need will lead us together.[46]

(Goebbels, of course, turned out to be right: one such extreme situation, the partition of Europe in 1939, led to the Molotov–Ribbentrop pact.)

In artistic matters, Goebbels suffered from the same "Left Infantilism"* as many of his colleagues; eventually he was forced – like Maiakovskii – to "tread on the throat of his own song". A lively journalist who dreamed of a career as a writer, he was close in his literary works to German modernism, which at that time had taken on an Expressionist colouring. His play *The Wanderer* represented

* *On Left Infantilism:* V. I. Lenin (1918).

a fateful conflict between various faceless symbols drawn from the common stock of literary clichés of the time – the Capitalist, the Worker, the Baron of the Stock Exchange, the Prostitute, and Death; and in his main novel *Michael*, published only four years before the Nazis came to power, Goebbels gave direct expression to his artistic credo. Just as in 1915 Maiakovskii had proclaimed, "Today we are all Futurists!", so Goebbels – through the mouthpiece of his hero, a worker forcing himself into an intellectual mould – proclaimed: "Our decade is absolutely expressionistic in its inner structure ... We people today are all Expressionists. People who want to form the world from inside out. The Expressionist builds himself a new world within himself. His secret and his power is passion. His mental world usually breaks against reality ... Expressionist sensation is explosive ..."[47]

Expressionism, born in Germany at the beginning of our century and with a considerable national tradition behind it, was the first in time of the radical movements within German modernism. Unlike the Russian avant-garde, it had no interest in the idea of the rebuilding of society through art – either in its early stage, that of the Dresden "Bridge", or at the time of the later Munich "Blue Rider"; the radicalism of the movement lay instead in its emotional charge, "directed against reality". The Expressionists aspired to the renewal not so much of humanity as of the individual man, to a renewal that was spiritual rather than social and that was to be achieved through penetrating into the mysteries of the deepest layers of the individual and collective subconscious. The night-

Nolde: Legend of Marta Aegyptiaca: at the Port of Alexandria (1910)

mares of war and postwar chaos, however, brought the German artists down from their metaphysical heights and confronted them with the concrete problems of social life.

Shortly before the end of the war Germany was swept by a wave of Dadaism spreading from Zurich and Paris. This movement found fertile soil in the social conflicts of such industrial centres as Berlin, Cologne, Hanover and Stuttgart. The denial of all values of the past and present, the shocking of the bourgeois public, the assertion of the absurd – all this went to determine the purely negative social and aesthetic programme of German Dadaism, making it similar to that of the pre-revolutionary stage of Russian Futurism.

The only exception was the Berlin group of Dadaists, who immediately took up a political position close to that of the Soviet avant-garde. The title of their manifesto, released in 1920, was the question: *What is Dada and what does it want in Germany?*, and its first sentence gave the clear answer: "The international revolutionary union of all creative and intellectual men and women on the basis of radical Communism."[48] Over their great Berlin exhibition of that year soared the huge poster: "Art is dead. Long live the machine art of TATLIN!" And soon afterwards Hülsenbeck, the founder of this movement, declared: "Dada is German Bolshevism".[49] In the political sketches of George Grosz, in the photo-montages of Hannah Höch and John Heartfield, both members of this group, the face of the contemporary world, distorted by fear and hatred, is built up from elements of reality.

Grosz: Postwar Idyll (left) and Pimps of Death (right) from *The Face of the Ruling Class*, 1921

After 1923 "Die Neue Sachlichkeit" was born from the meeting of Dadaism and Expressionism; this was probably the most pointedly social movement in the art of its time. Of its three most important members, Georg Grosz had come to it from Dadaism, Otto Dix and Max Beckman from Expressionism. Just as National Bolshevism attracted political extremists, so this new stage of Expressionism attracted cultural radicals. Some saw in it the highest manifestation of the German or Nordic spirit, others were attracted by its aesthetic extremism, its refusal to accept bourgeois tastes and morality, and its open criticism of the capitalist system. Among those who sided with it were the Communists George Grosz and Hans and Lea Grundig, the Soviet sympathizers Käthe Kollwitz and Max Pechstein, together with Emil Nolde, the father of the movement and one of the first to join the National Socialist Party. Writers such as the Communists Berthold Brecht and Ernst Toller and such future Nazis as Ernst Jünger, Gottfried Benn, Hanns Johst and Arnold Brünner were quite undivided by matters of style.

From 1920 many of the Expressionists and representatives of the other revolutionary movements, regardless of their political views, were gathered around the journal *Der Sturm*; this was to remain one of the main outlets of the German avant-garde throughout the twenties. Its founder, Herwarth Walden – a musician, critic, publisher and collector – had joined the German Communist Party after the First World War. German Expressionism of the twenties, like Dadaism and Die Neue Sachlichkeit, was first and foremost a reaction against the war and its consequences. The members of these movements saw the war as an abstract power that had forced humanity into a senseless slaughter-house. To the old question of who was to blame, both left and right gave the same answer: the power of capitalism and its exploitation of the people, the power of liberal democracy to paralyse the will to resist, and the existing order as a whole, which had opened the way to the destructive elements in society and in culture. Another, very different, reaction to the war was embodied in the theories of class or race dictatorship, of the new State and ideology whose mission was to impose order and realize the eternal Utopia of the bright future. These two reactions are reflected by two different currents of modernist art: the one apocalyptic, alien and terrible, as in the nightmares of Grosz and Dix; the other utopian, magnificent and monumental, as in the *chef-d'oeuvres* of the court artists of Hitler and Stalin.

The positive and constructive elements in German art, which before the war had been latent in the architectural and design theories of Peter Behrens, Henry van de Velde and Gropius, came to the fore only after 1918. The November revolution and its overthrowal of the monarchy engendered joyful illusions among the German artists of unlimited possibilities of "building everything anew" – just as the October revolution had done among the Russian artists. Less than a month after the abdication of Wilhelm II, the "November Group"

was founded in Berlin "as a close alliance between mainly expressionist artists and the new, largely socialist German state".[50] Its members were the most important representatives of revolutionary German culture: Max Pechstein, Emil Nolde, Lyonel Feininger, Bruno Taut, Mies van der Rohe, Erich Mendelsohn, Walter Gropius, Berthold Brecht, Ernst Toller, Alban Berg, Paul Hindemith and others. In spite of their political differences, they all saw themselves as "revolutionaries of the spirit", and considered that revolution in art must inevitably be the precursor of social and political revolution. In their manifesto, "An Alle Kunstler" they declared:

> Painters, Architects, Sculptors, you whom the bourgeoisie pays with high rewards for your work – out of vanity, snobbery and boredom – Hear! To this money there clings the sweat and blood and nervous energy of thousands of poor hounded human beings – Hear! ... We must be true socialists – we must kindle the highest socialist virtue: the brotherhood of man.[51]

Two of the signatories of this first manifesto of the "November Group" were Walter Gropius and Lyonel Feininger, and these were the ideals on which Gropius founded the Bauhaus in 1919.

The red which coloured these appeals and manifestos was not exclusively that of proletarian revolution. The slogans of "true socialism" migrated from the banners of the Spartacists and the United Front to the standards of the National Socialist German Workers' Party; the "brotherhood of all men" was prophesied by both Communists and Nazis, though members of an alien race or class were of course excluded; and collective creativity in order to establish the building of the future was a dream not only of Russian Constructivists and Proletkultists – a model of such a "building" was described by Ernst Jünger in his early novel *The Worker*.

Later, in the thirties, Rosenberg referred indiscriminately to Expressionism, Dadaism, Die Neue Sachlichkeit and the Bauhaus as "Kulturbolschewismus"; at the same time Aleksandr Gerasimov, the head of the Soviet artists, branded the avant-garde of his own country as "Fascist rabble". Rosenberg and Gerasimov were both mistaken, but not to the same degree. The Russian avant-garde certainly had nothing to do with Nazism, but the German avant-garde had been allocated a role of some importance in the cultural policies of the Comintern.

From the moment they came to power, even before, the Communist leaders and theoreticians had seen Germany as the weakest link in the system of world imperialism, as the country where the next proletarian revolution would begin. In 1919, the year it was established, the head of the Third International – Grigorii Zinoviev – prophesied "the absolute inevitability of the triumph of Communism in Germany"; from there he believed the fire of revolution would spread across the entire world. In order to ignite this fire the Bolsheviks threw enormous material resources into Germany together with select Party cadres.

In spite of this the Hungarian revolution (November 1918), the Spartacist uprising in Berlin (January 1919), the (almost simultaneous) Bremen Soviets, and the Munich Soviet Republic (April–May 1919) all met disaster, opening the way for the Weimar Republic so hated by Communists and Nazis alike. At the Third International Congress of the Comintern, after three years of titanic efforts and fluttering hopes, Trotsky was forced to declare: "Now for the first time we can see and sense that we are not so close to our aim – to the conquest of power, to world revolution. Then, in 1919, we said to ourselves: 'it's a matter of months'. Now we say: 'it's a matter of years'."[52] For other Bolsheviks, however, it was still a matter of a shorter period of time. At the end of 1922 Zinoviev determinedly repeated his thesis: "Unless all tokens deceive, the path of the proletarian revolution leads from Russia through Germany."[53] Counting on economic chaos in the country and disorder in the German Reichstag, the Soviet Politburo (once again) scheduled the beginning of a revolution in Germany for 7 November 1923; what ironically occurred almost to the day (8–9 November) was an attempted coup in Munich by Hitler and Lüdendorf – the so-called beer-cellar *putsch* – which was immediately suppressed. Gradually losing hope of an immediate political revolution in Germany, the Soviet government put their money on the export of cultural revolution. "While the Comintern manipulated foreign Communist parties in order to realize the interests of the Soviet State, while the People's Commissariat of Foreign Affairs attempted to normalize relations with the West, a third dimension of Soviet foreign activity was flourishing: the cultivation in Western progressive circles of solidarity, sympathy and good will towards the Soviet Union."[54] In Germany this activity was closely linked with the name of Willi Münzenberg.

In 1921 Willi Münzenberg was instructed by Lenin to organize the Association of International Aid for Workers (the MPR). In Russia there was a terrible famine, and many important members of the Western intelligentsia agreed to work for this organization, some moved by human sympathy for the dying Volga peasants, others by political interest in the "Russian experiment". Alongside Albert Einstein, Bernard Shaw and Anatole France, the committee members included such artists as George Grosz, John Heartfield and Käthe Kollwitz; the secretary of the section for aid to artists was the German theatrical reformer Erwin Piscator and his deputy was Otto Nagel, later the President of the East German Academy of Arts and an honorary member of the Soviet Academy of Arts. By the middle of the twenties the MPR had been transformed into a powerful empire with daily and weekly political and satirical papers, its own clubs and theatres, its own "agitprop" group in Cologne, etc. On the surface Münzenberg's organization stood out only for its liberalism and humanism; its slogans – anti-imperialism, anti-Fascism, the defence of peace and culture, and the establishment of various links with Soviet Russia – were close to the hearts of many people. But its central aim was that of propagandizing the Soviet order

and recruiting supporters and members for the pro-Soviet Communist Party. A prominent Communist and a deputy to the Reichstag, in his speeches Willi Münzenberg emphasized the political independence of his organization in every possible way; in actual fact its activities were controlled by the Comintern and subordinate to Moscow.

> We exist for one purpose, to wage *the* broadest propaganda campaign for Soviet Russia ... It is up to us to make inroads into the broadest social strata, winning over artists and professors and exploiting the theaters and movie houses ... We all understand that MPR, which not only participates in these clubs but itself creates them in the first place, must use them to fashion paths of understanding between broad bourgeois circles and Russia. To this end the MPR can undertake measures that would be impossible to the political parties.[55]

Münzenberg's political neutrality was camouflage. The MPR had both secret and open links with a huge number of institutions and organizations, some purely political like the International Organization for Aid to the Fighters of the Revolution (MOPR), International Aid for the Workers, with its affiliated society Aid for Artists, International Red Aid and the League against Imperialism, others with avowedly cultural aims like the League of Revolutionary Proletarian Writers, the International Bureau of Revolutionary Literature, the Association of Artists of Revolutionary Germany, the International Union of Revolutionary Artists and many others. It also drew support from a number of "progressive" German publishing houses, art galleries and businesses which derived their own political or commercial advantages from links with the USSR. Willi Münzenberg* was behind the scenes of all the "progressive" international meetings and congresses, from the 1923 World Congress for Economic Aid and the Reconstruction of Soviet Russia to such anti-Fascist and pro-Stalin assemblies as the 1935 International Writers' Congress in Paris which resulted in the establishment of the International Writers' Association for the Defence of Culture. (The board of the latter included Gorky, Aldous Huxley, Shaw, Gide, Selma Lagerlof, Heinrich and Thomas Mann, Sinclair Lewis and Romain Rolland.) Though all these organizations and international forums ran threads which led to the Kremlin. "It is no secret to anyone that the Central Committee and Politburo of our party controls the Comintern," admitted Kamenev.

A considerable amount has already been written about the difference between the Soviet propaganda intended for internal consumption and that intended for foreigners; the history of Soviet "cultural links" with other

* In his memoirs, *Invisible Writings*, Arthur Koestler, who worked with him during the thirties in his Paris office, discusses the fate of this remarkable man. At the time of the Stalin purges Münzenberg was called to Moscow by the Party Central Committee, but, knowing what might lie in store, he refused to make the journey. In a French concentration camp at the beginning of the war, he was released, together with the other prisoners, shortly before the German occupation. He left the camp together with two comrades, but his corpse was soon discovered in a nearby wood, hanging from a rope. Evidently Münzenberg knew too much and his comrades had been sent by the NKVD. With his death, the main source of information about his empire disappeared; its role has still not been fully studied.

countries, however, has still not been fully researched. But there is no reason to be surprised that in this area too the Soviet leadership simultaneously pursued two diametrically opposed aims; from the beginning, what it suppressed within the country it gladly cultivated abroad. There are many lacunae in this story to be filled, and it is possible that some diligent historian will one day be able to draw on material from still inaccessible archives; the facts already published, logically arranged, read somewhat like a detective novel.

At the end of 1918 an International Section was set up under the auspices of Narkompros; its aim was to create links with the revolutionary artists of the West. Besides Lunacharskii himself, its governing body included the artists D. Shterenberg, Vladimir Tatlin, and (initially) Vasilii Kandinskii. The board of Narkompros, together with this International Section, sent out appeals and offers of collaboration to foreign cultural figures, most of them in Germany. One such appeal proposed calling a world congress of all the arts in order to construct "a world building for the arts and the working out of its designs".[56] This appeal was published in the March 1919 issue of the Berlin journal *Das Kunstblatt*; in the summer Moscow received a reply, signed by Walter Gropius, Bruno Taut, Cesar Klein and Max Pechstein, in which they agreed to work in collaboration with the board of Narkompros.[57]

The directors of Narkompros contrived to give an entirely practical meaning to the Futurist utopian dream of an all-world artists' State: that same summer the International Section announced that "ambassadors of art" were being sent to the West – "Comrade Kamp is travelling to Italy, and comrade Krayny to Germany and Austro-Hungary".[58] The pseudonym Krayny masked the art critic and Bolshevik Konstantin Umanskii who, on his arrival in Germany, energetically propagandized the achievements of Soviet revolutionary art and at the end of 1920 brought out a book in German under the title *The New Art in Russia; 1914–19*. This first book in praise of the avant-garde (especially Tatlin and the Constructivists), a valuable source of information for German artists, was never published in Soviet Russia. In 1921 El Lissitzky was sent to Germany in order to "renew contacts with the active figures in West European culture".[59] Here he met George Grosz who, in his capacity as a member of the MPR, was almost an assistant to Münzenberg in the area of cultural links. "I am not a bird who sings just for the sake of it," Lissitzky said of himself; and the same could be said of George Grosz. Little is known of their joint activity,* but undoubtedly it was through the channels of such one-sided "cultural links" that the ideas of the revolutionary avant-garde were transmitted from Russia to Germany.

When Hitler found out during the occupation of France that the Autumn Salon in Paris was full of "degenerate" works, he reacted very simply: "Are we

* In his autobiography *A Small Yes and a Big No*, written after he had emigrated to the USA, Grosz hardly speaks of his Communist past and makes no mention of Lissitzky or Münzenberg. Nor is Münzenberg mentioned in any Soviet sources.

to be concerned with the intellectual soundness of the French people? Let them degenerate if they want to! All the better for us!"[60] The same logic evidently underlay the activities of Lenin and the Comintern; their aim was to focus the destructive energy of the avant-garde, that had once helped to undermine the whole way of life of Tsarist Russia, against the liberal-democratic foundations of the Weimar Republic.

It would be no great exaggeration to say that from 1921 the centre of the Soviet avant-garde lay in Berlin rather than Moscow. Far more than any other artistic centre, Berlin in the twenties was a place of pilgrimage for Soviet artists. Tretiakov, Lunacharskii, Lissitzky, Ehrenburg, Maiakovskii, Brik, Gorky, Esenin, Tairov, Eisenstein and Dziga Vertov all travelled there to give lectures, to arrange joint exhibitions and to publish their books and articles. It was in Berlin rather than Moscow that Lissitzky and Ehrenburg began in March 1922 to publish their journal *Veshch* (The Object), which became the main organ for world Constructivism. Under the title "The blockade of Russia is coming to an end", the opening announcement of the first (double) issue contained the following passage: "Art is now INTERNATIONAL, even though certain of its attributes are still local. Between Russia, which has lived through the greatest Revolution, and the West, on its wearisome postwar Monday, regardless of differences of psychology, economics and way of life, the builders of the new craftsmanship are laying down a new link – *Veshch*, the meeting-point of two allied camps." The list of artists involved with *Veshch* includes Feininger, Le Corbusier, Fernand Léger, Theo van Doesburg and many other members of the Western avant-garde – as well as Maiakovskii, Malevich and Tatlin. El Lissitzky, the author of this manifesto, lived in Germany throughout the twenties, putting his ideas into practice by setting up Soviet pavilions and propagandizing the cultural and industrial achievements of the Soviet regime at exhibitions in Berlin (1923), Cologne (1927), Stuttgart (1929), Dresden (1930) and Leipzig (1930). These exhibitions were mounted in the Constructivist style which in Russia had already been branded as a manifestation of bourgeois decadence. Exhibitions of the art of the Soviet avant-garde were put on in Germany even after they had been severely curtailed, if not banned, in Russia itself.

The first and most acclaimed was the "First Russian Exhibition", which opened on 15 October 1922 in the van Diemen gallery in Berlin. During a visit to Moscow in November 1921, Willi Münzenberg submitted plans for the exhibition to Lenin, emphasizing its propaganda potential. In the first place, it was to be presented within the context of aid for the starving in Russia and so win the sympathy of the Western liberal intelligentsia; in the second place, it would neutralize the influence of émigré circles in Berlin by demonstrating the great achievements of Soviet art and the tolerance displayed by the Bolshevik leadership towards both the cultural heritage and the revolutionary movements in art. Lenin, who at the time was trying, through ideological prescriptions and

organizational changes, to diminish the influence of the avant-garde within Russia itself, willingly agreed to divert this influence to Germany, assigning 70 million roubles for the purpose. On 28 March 1922 a committee was set up, by decree of the Central Committee, with the sole aim of organizing exhibitions abroad; its chairman was Lunacharskii himself. Münzenberg took upon himself the role of intermediary in the negotiations in Berlin, and his Association for International Aid to the Workers guaranteed the exhibition financially.[61] In propaganda terms the exhibition more than justified itself; its effect on radical German artists was that of a bombshell. In an article published in *Izvestiya* on 2 December 1922, Lunacharskii noted numerous inadequacies in the organization of the exhibition, in particular its "leftish bent", but emphasized that all this was compensated for by its "effect as propaganda".

A similar excitement was generated by Malevich's one-man exhibition in Berlin, authorized by the Soviet government in 1927. It is characteristic of Malevich himself that, knowing the position of the Soviet avant-garde as he did and foreseeing its still more terrible fate, he entrusted his entire archives to his German friends, together with the approximately seventy works exhibited. His brief accompanying note, now known as Malevich's Testament, begins: "In case I die, or am innocently imprisoned . . ."[62] He went on to say that he wished to save his works "from destruction so that in time they may enter into cultural circulation".* Malevich's theoretical treatises, still unpublished in the Soviet Union, were published around this time in German by the Bauhaus.

In the light of the above, it would seem that the term "Kulturbolschewismus" has a certain rational content, rather than being merely a weapon in the Nazis' attempt to discredit modernism emotionally.[63] It is not surprising, then, that the Bauhaus itself should have been the setting for a backstage struggle in the course of which artistic ideas and their proponents were like pawns in a complex ideological game.

The Bauhaus – twin brother of the Soviet VKhUTEMAS and eventually one of the main centres of German cultural life – came into being on the crest of a revolutionary wave. In the year it was founded Walter Gropius wrote: "Since we now have no culture whatever, merely a civilization, I am convinced that for all its evil concomitants Bolshevism is probably the only way of creating the preconditions for a new culture in the foreseeable future."[64] Throughout its history the Bauhaus retained links – through Lissitzky, Malevich and Ehrenburg – with the Soviet avant-garde and one of the most important artists associated with it was Vasilii Kandinsky. In practice, however, Gropius attempted to stand aside from politics and to organize the Bauhaus as though it were a living organism. He gathered together the most diverse artists, from proponents of pure art such as Kandinskii, Klee, Feininger and Johannes Itten

* His fears were justified: in 1930 his property was confiscated and he was arrested as a German spy. Thanks to the efforts of his friends, however, he was soon released.

to heralds of the new technology like László Moholy-Nagy and Hannes Meyer. The former unveiled the pure "intuitive" sources of creativity, while the latter went on to teach a rational approach to function, construction and the material itself; through this cooperative effort the "Bauhaus style" came into being. Gropius's professionalism, broad-mindedness and political tolerance – qualities so in tune with the "spirit of Weimar" and so lacking in VKhUTEMAS – ensured the fertility of the Bauhaus and made it a magnet for the intellectual elite from Einstein to Schoenberg. Suddenly, however, in 1928 Gropius left the Bauhaus and handed over the reins to Hannes Meyer, the most politically and artistically radical of the entire collective. Historians of the Bauhaus still look on Gropius's action as an enigma.

At this time Hannes Meyer was an active member of ABC, the Swiss group of Constructivists founded after a visit to Switzerland by El Lissitzky. "ABC Demands the Dictatorship of the Machine"[65] – this slogan from their 1928 manifesto encapsulates the aesthetic, or anti-aesthetic, credo of Hannes Meyer himself. There are probably few members of the avant-garde who showed such zeal in their denial of art in the name of an industrial future, such undeviating purity in their adherence to functionalism: "Our knowledge of the past is a burden which weighs us down", "the unconditional affirmation of the present epoch demands an absolute denial of the past", "construction is a technical – rather than an aesthetic – process", and even such a direct borrowing from Le Corbusier as: "Ideally and fundamentally our house is designed as a machine for living".[66] A convinced Communist, Meyer not only redirected the Bauhaus along purely avant-garde and technological lines, but also fiercely politicized it. Under his control the Communist cell of the Bauhaus began to play an important role, its press began to print political leaflets, anti-Fascist demonstrations were arranged, etc. At a time of growing Nazi threat it was obvious that this would lead to the destruction of the Bauhaus. In 1930 Hannes Mayer unexpectedly emigrated, with a group of his students, to the Soviet Union. Here we meet yet another enigma: what he began to write in Moscow was diametrically opposed to his views of two or three years before.

> We Soviet architects must consciously and persistently study the methods of construction of the classics of all epochs. For us architects the classical heritage is of no less importance than the theory of counterpoint for musicians ... Finally, our attitude towards the latest Western architecture. As is well known, I do not agree with it ... In any case, any "basement" reproduced in *Pravda* seems to me a more important event, marking as it does the birth of socialist architecture, than Le Corbusier's elegantly-frivolous feuilletons.[67]

This was written when the Nazis were closing the already devastated Bauhaus and the Russian Communists were doing the same, almost simultaneously, to VKhUTEMAS, when Nazis and Communists alike were attacking the "bour-

geois boxes" of the new architecture and the very ideas which Meyer himself had so assiduously propagated at the Bauhaus.

Where for the engaged artist does the creative "I" end and the political "We" begin? Unfortunately such figures as Meyer rarely leave after them any account of the transformation of their own personality that is so necessary to the functioning of totalitarian society. All that can be said is that Hannes Meyer's swift metamorphosis coincides with a radical change in Soviet policy, both internal and external, towards the avant-garde and left art.

As Nazism took its place on the political stage and hope of a red revolution in Germany waned, the idea of transforming the world through revolutionary art began to lose its propaganda value in the eyes of the Kremlin leadership. Artistic policy was to follow new lines. Russia and Germany at the end of the twenties were to be the scene of a fierce battle for art, now seen by both right and left, by Communists and Nazis, by Hitler and Stalin, as a convenient instrument for catching human souls.

(v) The battle for art

A life-and-death struggle is taking place in art, just as it is in the realm of politics. And the battle for art has to be fought with the same seriousness and determination as the battle for political power.

Paul Schultze-Naumburg, 1932

Remember that all our agreements are only provisional. Do not forget that we Communists are fighting for world revolution. When this is triumphantly accomplished, the steel columns of Communism will drive over the bodies of the very people who are now hurrying to offer us their protection. This cannot be helped. It is an inevitable consequence.

Georgii Dmitrov

A determinedly serious attitude towards art and the identification of it with politics – this is the natural aspiration of any totalitarian regime as it attempts to assimilate art and make it an integral part of its own system. The ideas of the Nazi theoretician Schultze-Naumburg are in this respect no different from the slogans of Soviet Party decrees and resolutions from the mid-twenties until recent times. Art follows politics and is confronted with the same tasks. At the time of a turning point in the political game art changes its skin – or rather its skin is changed, new slogans and dogmas are painfully pulled over its body. Violence is the midwife not only of history, but also of the emerging forms of totalitarian culture.

The "battle for art" in both Germany and Russia was waged parallel to the

battle for political power. With the emergence of Nazism this struggle took on an extraordinary and paradoxical character. On the surface it was the supporters of Stalin and Hitler who were crossing swords, but Goebbels was not alone in questioning the authenticity of the fighting.

During the Fifth International Congress of the Comintern in 1924, Stalin outlined his view of Fascism and Social Democracy: "Fascism is a militant bourgeois organization which is enjoying the active support of social-democracy ... Objectively, Social Democracy is the moderate wing of Fascism ... These two organizations do not preclude one another, but rather complement one another; they are not antipodes but twins."[68] It was the more aggressive of these twins, however, that was the Leader's favourite – and this preference became increasingly obvious as Stalin reinforced his position and the Nazis drew closer to power.

Before the 1930 elections to the Reichstag, when few people doubted the impending triumph of Nazism, the Comintern and the German Communist Party were ordered by Moscow to direct their fire against the Social Democrats. It was the Social Democrats who became enemy number one, the incarnation of evil, the "chief support of world imperialism", the "main factor" preparing for war against the Soviet Union. Ernst Telman, the head of the German Communist Party, warned workers against "an exaggeration of the danger of Fascism".[69] Such propaganda, from both left and right, drew potential voters away from the Social Democrats and opened the way for Nazism. During the Reichstag elections of 14 September 1930 six million people voted for the National Socialists, making them the second biggest party in the German government.

Communists and Nazis alike considered the chief danger for Germany to lie not in the establishment of a totalitarian dictatorship, but in the liberal-democratic system of government. The Communist theoretical journal *The International* wrote: "A social democratic coalition, confronting a confused, divided and far from battle-worthy proletariat, would be a thousand times greater evil than a straightforward Fascist dictatorship opposed by a united, class conscious mass proletariat determined to fight."[70] The Communists themselves were of course simply mouthpieces for the immutable laws of historical development whose dialectic led to the conclusion: if Fascism is an inevitable phase on the path towards revolution, then why not help the Nazis to power? Theory determined practice; after 1930, although the Social Democrats, with 143 deputies, were the largest party in the Reichstag (the Nazis had 105 deputies, the Communists 77), they were to all intents and purposes paralysed, all their initiatives meeting the joint resistance of the Communist and Nazi deputies. This, of course, played into the hands of the Nazis. In the 1932 elections the National Socialists won an absolute majority in the Reichstag, and on 30 January 1933 Hitler became the Chancellor of Germany. All this was welcomed by the Communist International in its Executive Committee decree of 1 April

1933: "The establishment of an open Fascist dictatorship, which will destroy the democratic illusions of the masses and free them from the influence of the Social Democrats, will speed Germany on the path towards proletarian revolution."

Hitler too saw democracy as enemy number one and confessed: "I have learnt a great deal from Marxism ... National Socialism is what Marxism could have been had it freed itself from the absurd, artificial link with a democratic system."[71] The Führer explained that, unlike bourgeois politicians, who used exclusively intellectual weapons, "the Marxists 'united mind and brutal violence harmoniously'. The SA was to imitate them."[72]

Their slogans were interchangeable; Nazis and Communists used the same language and appealed to the same values. Hitler, for example, used to refer to himself with pride as a proletarian; his speech at the beginning of the Second World War – when the planes bombing English cities and the tanks invading France were both fuelled with Soviet fuel – is a fine example of Nazi rhetoric: "If everything in this war indicates that gold is now struggling against labour, capitalism against the people, reaction against the progress of humanity, then victory will go to labour, the people and progress."[73]

The communication of these ideas to the masses demanded new forms of artistic persuasion. Before the emergence of Nazism, the Soviet leadership could still look on the art of the avant-garde as a storehouse of revolutionary ideas intended for export, as a lure for Western intellectuals sympathetic to revolutionary changes but naturally inclined towards liberal democracy. This was the initial orientation of the activities of Münzenberg and his empire. Now, however, from the point of view of the Comintern leadership, such policies were a dangerous ideological anachronism. The slogans of the avant-garde, their abstract and often over-complex mode of appeal, were ineffectual as a means of influencing the masses, lacking as the latter were in revolutionary spirit. In the struggle for people's souls it was necessary to address the masses in a simple and accessible language. Goebbels, in spite of his own artistic tastes, soon demanded that German artists should construct works which would be comprehensible even to "the lowliest storm-trooper".[74] The Comintern "kulturträgers" received similar orders from the Kremlin – as did the machine of cultural control within the Soviet Union.

It was in the mid-twenties that the general thrust of the Soviet cultural policy initiated by Lenin received precise definition. Its final aim was formulated in a Central Committee resolution of 18 June 1925, "On the policy of the Party in the field of artistic literature" – a resolution seen by some historians as "liberal" or "Leninist" since it stated, among other things, that the Party could not at the present stage grant a monopoly to any of the existing artistic groupings. The gist of this resolution, however, is contained in the subsequent appeal by the Central Committee that writers and artists should construct an art that is

"comprehensible and close to the working millions", and that they should make use of all the technical achievements of the past in order to "elaborate an appropriate form that is comprehensible to the millions".[75] In the same year, at a meeting – the last of its kind – with artists, writers and scientists in the Large Hall of the Moscow Conservatory, Nikolai Bukharin, the theoretician and "Party favourite", said quite openly what the Party leadership was intending to do with the intelligentsia: "It is essential to us that the cadres of the intelligentsia should be ideologically trained in a definite manner. Yes, we will manufacture intellectuals, turning them out as though in a factory."[76] The intelligentsia simply gave their obedient agreement to this technical operation, which was carried out soon and with their help. In the same speech Bukharin declared that such concepts as "freedom", "the people", "the good", etc. were merely "a verbal shell". It would appear that the authors of the 16 June resolution looked on the main part of its content as "a verbal shell" – certainly the passages about "a protective attitude towards artists", about the necessity of allowing equal possibilities to the different artistic movements, about the inadmissibility of any one of them being granted a monopoly. In the visual arts, at least, such a monopoly had to all intents and purposes been granted already – to the Association of the Artists of Revolutionary Russia.

The appparatus for promoting the members of the AKhRR to the heights of power was simple enough. Guided by the principles of "Party spirit", "truth to reality" and "mass art", they travelled round factories and building sites, were admitted to the offices of Party leaders and military commanders, and painted portraits of Stalin, Voroshilov, Budennii, Kalinin and Menzhinskii. They portrayed these dignitaries on rostrums or going for walks, against a background of huge building sites or ecstatic masses of workers, talking to writers or declaiming fiery speeches. They covered huge canvases with scenes of the Revolution, the Civil War, and socialist construction, using the style and techniques of the Peredvizhniki or a turn-of-the-century salon and passing their works off as the new achievements of a revolutionary and heroic realism. Evgenii Katsman, the secretary of the AKhRR, wrote in his memoirs:

> Our political growth was aided by S. A. Unschlicht's studio in the Kremlin. At the time it was in the Winter Garden. Stefaniia Arnoldovna offered it to the members of the AKhRR. We had permanent passes to the Kremlin and were often able to see the leaders of the Party and government. I can say quite frankly that the achievements of Soviet figurative art are greatly indebted to K. E. Voroshilov, who spent time with us artists every day, helping us with the most valuable advice, ideological consultations or a friendly and comradely chat. Future historians of Soviet art will pause more than once over the enormous role played by members of the Revolutionary Military Committee in the art of the epoch.[77]

This is an important admission: the members of the AKhRR knew very well what they were doing when, in their first manifesto, they promised "faithfully

Avilov: Comrade Stalin's arrival at the First Cavalry Army

Brodskii: Voroshilov Skiing (1937)

to portray the present day" and in particular "the life of the Red Army". Their first exhibition, which opened in June 1922, was entitled "An exhibition of studies, sketches and drawings from the life of the Workers' and Peasants' Red Army". Trotsky himself, after a visit to their second military exhibition in March 1923, devoted to the Fifth Anniversary of the Red Army, left a joking inscription in the visitors' book: "Good, but I am forbidding the portrayal of generals for five years"[78] – a reference to the excessive number of portraits of military leaders.

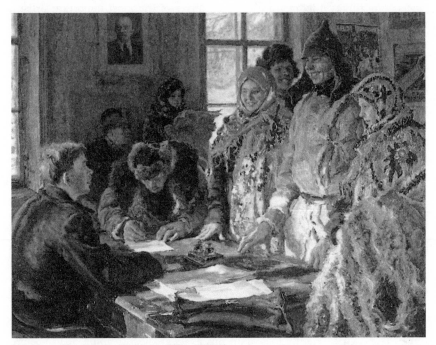

Moravov: The Country Registry Office (1928)

The sitters for these portraits were not ungrateful, providing for the AKhRR out of their enormous resources. It was Trotsky the Commander-in-Chief, the dashing Semen Budennii and the metal worker (later Marshal) Klim Voroshilov who were the first patrons of Soviet art. (As art curator for the Central Committee, Voroshilov continued to play this role until the mid-fifties.)

People's Commissar Lunacharskii gave his opinion of the quality of their work at the opening in February 1925 of the seventh exhibition of the AKhRR: "One's general impression is that if one took a good photograph and coloured it in more or less satisfactorily, then one would end up with exactly what they often give us instead of a painting."[79] In May 1926, however, when he opened their eighth exhibition, Lunacharskii was already remarking on "a significant

improvement in craftsmanship" and going on to explain that "The masses of workers ... want art through its magic mirror to reflect as broadly and concentratedly as possible, for the consciousness of the country, what the country itself stands for."[80] This change – from "coloured-in photograph" to "magic mirror" – reflected not so much the evolution of the AKhRR as a change in the official attitude. At this time, just after the Central Committee resolution of 16 June 1925, not only the military but also the main cultural organs of Party and State were rewarding this organization with constant attention. Evidence of this is a letter from representatives of the most important artistic organizations in which they ask the Central Committee "to do away with the situation in which one artistic grouping [the AKhRR] is granted all tangible marks of favour, expressed not only through the construction of a material basis for this grouping but also, more importantly, winning for it moral credit in broad circles of Soviet society which cannot be justified by the cultural-artistic level and achievements of one grouping".[81] This document, signed by the most important Soviet artists (David Shterenberg, Iurii Pimenov, Andrei Goncharov, Sergei Gerasimov and others) remained unanswered. Instead the prominent Party figure Emelian Iaroslavskii commented disapprovingly on the increasing number of attacks on the AKhRR: "The impression is created that almost the entire Soviet press is hostile to the AKhRR, as though it were something anti-Soviet".[82] It is indeed true that the best Soviet artists of the time were not only outside the AKhRR but increasingly antagonistic towards it – but majority opinion has never been an obstacle to the Soviet leadership. Lenin's widow, Krupskaia, branded the members of the avant-garde as "spokesmen for the worst elements in the art of the past" and – as head of the then powerful Glavpolitprosvet – offered extensive moral and material support to the AKhRR.[83] Finally, in 1928, Stalin himself, accompanied by the entire Politburo, visited the tenth exhibition of the AKhRR and praised their achievements in the highest terms. The AKhRR rightly looked on this as its greatest triumph; never before or after was an exhibition awarded the honour of a personal visit by Stalin himself.

At the same time the German Communist Party, through the Comintern, was arranging new links in its network of "international cultural ties". In March 1927 its Eleventh Congress in Essen resolved to set up Agitprop groups under the name "The Red Front of the Struggle for Culture". A year later the so-called Workers' Party for Communist Artists was founded, in which John Heartfield was a prominent figure. In 1928 the German Communist Party set up a special "Secretariat for Culture", responsible for the ideological supervision of these and other cultural institutions. During the same year two more powerful organizations were founded by Münzenberg's ideological empire: the Association of Artists of Revolutionary Germany (ARBKD) and the International Union of Revolutionary Artists. In 1930 the Centre of this International Union was

Gribel: Internationale

transferred to Moscow and the émigré Communist artists Béla Uitz and Alfred Curella were appointed its directors. If one considers that the German Communist Party was entirely dependent on the Kremlin, then the subordination of its cultural policies to the interests of Moscow is hardly surprising.

Most of these organizations were modelled on Soviet organizations of a similar type. The ARBKD in particular was an almost exact copy of the AKhRR. The paintings of its best-known artists (Otto Gribel, Kurt Kverner and others) were similar to the products of the more innovative members of the AKhRR; for the most part they were portrayals of workers' meetings, strikes and demonstrations, executed in a somewhat simplified manner with – initially – a slight flavour of Expressionism. Like the AKhRR, the ARBKD opened branches in different cities – seventeen by 1932. Although relations between the two organizations were complicated (in 1929 the ARBKD formally broke with the AKhRR), this was merely a reflection of the general struggle between the numerous groups and movements of the time, even within the AKhRR itself. In any case, the AKhRR directives with regard to Party spirit, national character, mass appeal, the cultural heritage and the struggle against formalism, were now equally obligatory for German Communists involved with cultural matters.

In the words of an autumn 1931 ARBKD report to the International Bureau of Revolutionary Artists in Moscow: "It is essential to move towards the creation of a mass organization ... We have now begun to accept all artists who show an interest in our association, whereas in the past we demanded that each applicant present work imbued with the spirit of the revolutionary class struggle ... It is absolutely essential to win over the most significant and authoritative of the left-wing artists."[84] The report also mentioned an extensive educational programme for new members, including "the study of Marxism as a continuous subject of instruction", "dialectical materialism", "construction in the Soviet Union", "strategy and tactics" and so on. As for the ARBKD's attitude to the avant-garde, this was discussed in Moscow by the artist Alex Keyl: "The Formalist movement of every possible 'ism' laid claim in Germany to a revolutionary role. But in actual fact, as in other countries, this movement was merely the expression of the ideological decay of a certain section of the bourgeois intelligentsia – a decay fomented by the impending revolutionary crisis."[85]

Formally the ARBKD was a non-party organization, but its neutrality was as much a camouflage as that of Münzenberg's other organizations. Hans Grundig, who ended his days as a staunch Communist in East Germany, describes in his autobiography the activities of the Dresden branch:

> Our only help was our conviction of the necessity to take part, by means of our art, in the class struggle. We took part in all the activities of the Party as a united group. I can no longer remember how many forceful demonstrations we organized a year. In each district there was a group of artists responsible for preparing drawings and posters for all the lorries and vans which took part in the demonstrations.[86]

On 26 February 1929, while branches of the ARBKD were springing up in cities throughout Germany, Alfred Rosenberg founded his "League of Struggle for German Culture". As far as can be judged from the few records that have been preserved,[87] its organizational principles and practical aims were little different from those of the ARBKD. It too claimed to be independent of political parties, but one of its tasks was "to instil nationalist ideas among circles of people who do not usually attend mass political meetings". The main object of its attacks was – inevitably – the modernists. Like the ARBKD, Rosenberg's league organized demonstrations, political meetings, and lectures on questions of national culture and art. The two competing organizations not only entered into conflict, but also each tried to win over the other. In the words of Hans Grundig, "During the first years of Nazism no one touched us. Maybe we were forgotten, maybe we were not taken seriously. It is possible that the Hitlerites saw us as dangerous opponents, but had hopes of winning us over to their own side. Anyway, it was rather strange. In 1934 the Nazi artists Gäsch and Waldapfel, above all Gäsch, wrote in the newspaper *Freiheitskampf* that the former ARBKD contained a number of artists whom they would like to see in their own ranks. Even now I

still feel the deepest shame at the thought that the overwhelming majority of artists did indeed make peace with the butchers. Yes, unfortunately, we witnessed such metamorphoses more than once; one barely had to look round before an artist who shared our views had betrayed himself and the Party."[88] There is no reason, however, to be surprised at such metamorphoses. Both the Association of Artists of Revolutionary Germany and the League of Struggle for German Culture held the same ideals, advocating a popular and ideological art, an art that appealed to the masses and drew on the cultural heritage. The only difference was that the former called this art "proletarian", while the latter called it "Nordic" or "Aryan". For a professional artist, however, such political distinctions were of secondary importance. The Russian Peredvizhniki, for example, despite their initial hostility to the Bolshevik coup, had been glad to stand beneath revolutionary banners as soon as they glimpsed the familiar slogans they bore – of realism, ideological content and popular spirit. Similarly, Josef Torakh, the most important sculptor of the Third Reich after Arno Breker, was still signing Communist proclamations on the eve of the Nazis' assumption of power.[89] Apropos of some similar instance, Hitler himself once remarked that one can make a good Nazi out of a Communist, but not out of a Social Democrat. This aphorism was embodied in an image from one of the most popular Nazi films: in the epilogue the hero's clenched Communist fist opens to give the Hitler salute.

With the rise of Nazism, members of Rosenberg's league penetrated organs of local government and began to take control of the centres of artistic life. Paul Schultze-Naumburg, an architect and prominent Nazi ideologue, was appointed head of the Weimar School of Applied Art in 1930 and immediately threw works by Ernst Barlach, Paul Klee, Vasilii Kandinskii and Oscar Schlemmer out of museum displays. In January 1932 the pro-Nazi municipality of Dessau closed down the Bauhaus. An increasing number of attacks began to appear in the German press on bourgeois, formalist and degenerate art – all identified with "Kulturbolschewismus".

These attacks were by no means exclusively in the Nazi press. From the late twenties Lenin's division of culture into "bourgeois" or reactionary and "socialist" or progressive became equally crucial to both Communists and Nazis. Both the League of Struggle for German Culture and the Red Front of the Struggle for Culture saw modernism – in the broadest sense of the word – as bourgeois and reactionary, and considered realistic art, based on the national or cultural heritage, to be socialist and progressive. The same ideological missiles now began to fall on "the revolutionaries of the spirit" from both left and right.

Die Rote Fahne, the main German Communist newspaper, warned workers at this time against Dadaist attacks on the cultural heritage, asserting that "such people have no right to call themselves Communists".[90] In 1928 the prominent German poet Johannes Becher, by then a Party functionary, declared the works

of Die Neue Sachlichkeit, the movement to which Georg Grosz belonged, to be reactionary in every sense. In 1931 reinforcements were sent from Moscow to the front line of the cultural struggle in Berlin in the person of Georg Lukács, the important Communist philosopher and activist who had played the same role in the theoretical foundation of Socialist Realism as Schultze-Naumburg in that of National Socialist art. Lukács at once became head of the Communist faction in the Association of German Writers and began sweeping attacks on "Formalism" in the Communist press, criticizing Willi Bredel for his distortion of language and attacking the principles of Ottwald's collages. At the same time, Alfred Kemeny,* the chief editor of *Die Rote Fahne*, accused Formalism – by which he meant "the art of 'isms' in general" – of a lack of contact with life and a contempt for the class struggle of the proletariat, referring to it as "an emanation of capitalism" which the latter gave off "every day, every hour, every minute". "We will not see an end to formalism," he wrote, "until capitalism is laid in its grave."[91]

At the beginning of the twenties German Expressionism, to which Kemeny was principally referring, had attracted radicals of both left and right. Some, not without reason, had seen it as a continuation of the national cultural tradition which stemmed from Gothic. Others, equally understandably, had valued its attacks on the bourgeoisie and its revolutionary quality. It is not surprising, therefore, that voices were now raised even among the supporters of Nazism in defence of the German avant-garde.

In November 1933 Gottfried Benn, an important poet and man-of-letters who supported the regime, described Expressionism as "the last upsurge of art in Europe" and argued that its irrational aspects and anti-liberal position were a contribution to the cultural programme of Nazism. Shortly before this a group of young artists, members of the Berlin National Socialist Union of Students, had organized an exhibition which attempted, through a display of work by Nolde, Pechstein, Karl Schmidt-Rottluff and Barlach, to show a direct link between contemporary art and Nazism. After three days this exhibition had been closed and the organizers expelled from the Students' Union, by decree of the Minister of Internal Affairs. A similar attempt by the Berlin National Gallery in the summer of 1933 led to the dismissal of its director. As for Gottfried Benn, even his impeccably German origin and reputation as one of the most prominent Nazi intellectuals did not prevent the Nazi press from branding him a degenerate, a Jew and a pederast. In 1937 he was saved from arrest only by the direct intervention of Himmler.

Goebbels himself, Minister of People's Enlightenment and Propaganda from March 1933 – like Lunacharskii in Russia at an earlier date – was relatively broad-minded in his view of the future of Nazi art. He declared the Nazi victory

* His pseudonym was Alfred Durus.

a "spiritual revolution" which would inevitably engender a "new feeling for style", and in one of his speeches he declared: "German art needs fresh blood. We live in a young era. Its supporters are young, and their ideas are young. They have nothing more in common with the past, which we have left behind us. The artist who seeks to give expression to this age must also be young. He must create new forms."[92] Goebbels was thinking mainly of Expressionism; he was still hoping, if not to make it into the official art of the Third Reich, at least to secure its right to continued existence. These views met with strong opposition in the official press. Schultze-Naumburg, however, warned menacingly against people who thought that Nazi art could become "the expression of a new or revolutionary era".[93] Controversy raged round such artists as Barlakh and Nolde. Goebbels supported them, but came up against the determined resistance of Rosenberg, a staunch advocate of popular and mass forms of art.

At this time Goebbels's influence was rapidly increasing; a favourite of Hitler, he was single-handedly building up the vast megamachine of totalitarian culture. Rosenberg's influence was equally rapidly declining; his lack of administrative talent and the heavy philosophizing of his *The Myth of the Twentieth Century* evoked only the tolerant contempt of the Führer and a yawn of boredom from members of the Nazi intellectual elite. In this conflict, however, the Führer firmly supported Rosenberg. In his Munich speech he referred to Expressionism as "degenerate art"; and in the 1937 exhibition entitled "Degenerate Art" paintings by the National Socialist Emil Nolde hung beside works by the anti-Fascist Otto Dix beneath such captions as "barbarous methods of representation" and "a tool of Marxist propaganda". Goebbels's personal ambitions had clashed with the iron laws of the development of totalitarian culture; like Maiakovskii and Marinetti before him, he met defeat.

One might well expect Hitler's attacks on Expressionism to have strengthened the movement's standing among the German Communists, but the logic of totalitarian ideology is more complex than this. In 1924 the First General Exhibition of German Art in Moscow (organized by Münzenberg's International Aid for Workers in response to the First Russian Exhibition in Berlin) earned the praise of Lunacharskii himself, while the only complaint of the well-known critic Tugenhold was that German Expressionism was not represented in its full glory.[94] In 1933, however, Georg Lukács, then in Moscow, officially excommunicated Expressionism from the Communist church. In "The Greatness and Fall of Expressionism", published in the German émigré press, he called Expressionism "the artistic form of mature imperialism, one which easily enters the service of Fascist demagogy".[95] Lukács's thoughts were further developed by his pupil Alfred Curella. An artist by training, a writer by profession and a politician by vocation, Curella played an active role in all three spheres, holding important posts in Soviet, German and international organizations for artists and writers. In 1928 he became a member of the artists' organization "October" (then the

main rival of the AKhRR) and incited fierce controversy in the Soviet press with his attacks on the AKhRR.[96] Nine years later he began another controversy, this time in the German émigré press, by publishing an article in which he accused Expressionism of "destroying the cultural heritage" and affirmed that the "spirit engendered by it" led directly to Fascism. The article was signed with the pseudonym B. Ziegler. At this time another Ziegler, the head of a commission specially established by Hitler, was making the rounds of German museums in order to remove works of "degenerate art". The German émigrés, scattered about the cities of Europe, racked their brains for a long time over two questions: whether the article had been written before or after Hitler's Munich speech, and which of the Zieglers was its author. One émigré, the writer Ernst Bloch, expressed anxiety in a private letter lest opponents of the Soviet Union detect "dangerous parallels between the official Nazi art functionary named Ziegler and the Nazi damnation of 'degenerate art', and the point of view of the Soviet Ziegler who considers Expressionism as a decadence".[97]

"Kulturbolschewismus" now appeared in a new guise. It threw off the yellow blouses of Futurism and the overalls of the Constructivists and Production artists and appeared, to the astonishment of many of its supporters, in the standard uniform of totalitarian realism. This uniform can be seen as a materialization or visual embodiment of the complex political, economic and cultural processes as a result of which "from 1929 Russia took its place in the ranks of totalitarian, fascist powers".[98]

From Words to Action

"In The Beginning Was the Word"

Title of a painting by Otto Hoyer of Hitler speaking
at a meeting of the Nazi Party

The final end of any revolution is the restoration of power.
Otherwise it would finally lead to chaos.

Goebbels (from his diaries)

The "battle for art" came to an end at the same time in both Russia and Germany. In Russia this was the result of fifteen years of Bolshevik cultural policies; in Germany it coincided with the Nazi assumption of power. In both countries we see the beginning of a new, final, stage in the development of totalitarian art.

Hitler's first gesture on his assumption of power was personally to lay the cornerstone of "The House of German Art" in Munich which was to become the main centre of the official art exhibitions of the Third Reich. Later he explained the symbolism of this: "When we celebrated the laying of the cornerstone for this building four years ago, we were all aware that we had to lay not only the cornerstone for a new home but also *the foundations for a new and genuine German art* [emphasis added]. We had to bring about a turning point in the evolution of all our German cultural activities."[1] The outlines of this "new and truly German" art were traced by Hitler in a number of speeches from 1933 to 1938 in which he developed ideas contained in embryo in *Mein Kampf* and now christened "The Führer's Principles".

The "battle for art" in the USSR was brought to a similar end by the Central Committee Decree of 23 April 1932, "On the restructuring of literary and artistic organizations". The text of this decree, which could be contained on a page of a school exercise-book, stated simply that the presence of various groupings in Soviet literature was a brake on its development; in view of this they were all to be abolished and replaced by a single union of Soviet writers. The third paragraph of the decree prescribed "similar changes with regard to other branches of culture".[2] Until recently official histories praise this decree as a "turning point" in the development of Soviet culture.

81

The period from 1932 to 1937 did indeed, in both Russia and Germany, mark a decisive move in the direction of totalitarian culture. It could be said that it was during this brief period that the megamachine was completed.

Firstly, the dogma of totalitarian art was given a definitive formulation: in the USSR it went under the name of "Socialist Realism", in Germany under that of "the Principles of the Führer". Secondly, a similar apparatus for the control of art was finally perfected in both countries. Thirdly, war to the death was declared against all artistic styles, forms and movements differing from the official norm. The artistic life of these countries, therefore, was now entirely determined by Hannah Arendt's three main characteristics of totalitarianism: ideology, organization and terror.

(i) Ideology: "Socialist Realism" and "the Principles of the Führer"

> Socialist art is a new and higher stage on the path of development of humanity's cultural activity. We stand on the threshold of a new Renaissance.
>
> *Iskusstvo,* 1937

> German architecture, sculpture, painting, drama and so on bear documentary witness to a creative period in art the swiftness and richness of which can be compared to little in world history.
>
> Hitler, 1938

No European political figure can have said so much about art as Hitler. His remarks may – as Vladimir Nabokov put it – have been only "as interesting as the snoring in a neighbouring room"; nevertheless, combined somehow or other into the theoretical treatises of Nazi ideologues and bearing the name of "the Principles of the Führer", they became incontrovertible laws governing the development of the art of the Third Reich.

On 23 March 1933 Hitler spoke in the Reichstag about the imminent radical changes in the cultural life of Germany: "Simultaneously with this political purification of our public life, the Government of the Reich will undertake a thorough moral purging of the body corporate of the nation. The entire educational system, the theatre, the cinema, literature, the Press, and the wireless – all these will be used as means to this end and valued accordingly."[3] On 11 September 1935, at a Party congess in Nuremberg, Hitler defined the role and function of art in the nation's life. Art, he stated is not a fashion, nor a meaningless alternation of ephemeral "ism" on the surface of the historical process, nor "the expression of any capitalistic tendency: all man's great

cultural creations . . . are the expression of the soul and the ideals of the community."[4] For this reason, "no age can claim to free itself from its duty to foster art", especially during times when a people has lost faith in its "higher values and thus in its mission". At such moments the task of art is once again to arouse this faith "by pointing to those evidences of the inner imperishable and highest values of a people which no political or economic distress can destroy."[5]

In the speech he gave at the opening of the House of German Art on 18 July, 1937 Hitler clearly indicated who was to occupy the top positions in the hierarchy of National Socialist art:

> Art does not create a new age, rather the general life of the people fashions itself anew and therefore also often seeks for a new expression. Clearly, that which in recent decades spoke of a new art in Germany, has in any case not comprehended the new German era. It is not the literary who are creators of a new era, but the fighters, that is, those who really shape and lead peoples and thereby create history ... it is not the function of art to step backwards from the development of a people, rather it can only be its function to symbolize this living development.[6]

Hitler not only put forward a view of art as "a form of reflection of reality" in its "living development"; he also pointed out the constructive forces which, as the most vivid manifestations of this reality, should be the main objects of its reflection in art – the leaders, fighters and creators of history. The true artist, according to the Führer, should make his art into an instrument of struggle for the future and place it at the service of the people.

> The artist does not create for the artist: he creates for the people and we will see to it that henceforth the people will be called in to judge its art ... an art which cannot count on the readiest and most intimate agreement of the great mass of the people, an art which must rely upon the support of small cliques is intolerable. Such an art does but endeavour to confuse, instead of gladly reinforcing, the sure and healthy instinct of a people. The artist cannot stand aloof from his people.[7]

Such "aloof" art was "a conspiracy of incapacity and mediocrity against better work of any age".[8] Those who denied this were "cultural vandals and criminals" who ought to "finish their days in a prison or madhouse".[9] "For such 'artists' the time is past ... And let no one talk of a 'threat to the freedom of art',"[10] Hitler declared, referring to all contemporary artists who failed to portray reality faithfully, depicting "fields as blue, the sky as green and clouds as sulphurous yellow". The Führer proposed radical measures in order to combat such unhealthy phenomena:

> Here are only two possibilities: either these so-called artists actually see things in this way and therefore believe in what they represent, in which case it need only be determined whether their defect of vision has occurred in a mechanical

manner or through inheritance. In the first case it is deeply pitiable for these unfortunates, in the second important for the National Ministry of the Interior, which must then take up the question, at least to prevent further inheritance of such a kind of ghastly defect of vision. Or else they themselves do not believe in the reality of such impressions, but they attempt on other grounds to harass the nation with this humbug; then such a transgression is a matter for the criminal court ...[11]

It was only with the help of the Party and State and under their direct leadership that it was possible for an artist to execute the tasks imposed by the epoch. Hitler more than once emphasized the necessity of direct interference in cultural matters, both through generous support of National Socialist art and through the use of punitive measures against its opponents. A historical justification of such interference was provided in his speech at the opening in Munich of the Third Exhibition of German art in July 1939:

> In times when victorious political or religious ideas develop gradually, artistic production naturally comes to take its place increasingly in the service of the dominant ideas. But in periods of rapid revolutionary development such an assimilation needs to be ordered and guided from above. Those who are responsible for the shaping of peoples in the sphere of politics or *Weltanschauung* must endeavour to direct the people's artistic forces – even at the danger of most rigorous intervention – upon the lines of their general *weltanschaulich* tendencies and demands.[12]

As well as putting forward the principle, already established in the Soviet Union, of the Party leadership of art, Hitler defined the aim of this leadership: something "above culture, above religion and even above politics" – the creation of a New Man. National Socialism, according to Hitler, was expending colossal energy in order to create new people and to make them "stronger and more beautiful": "And from this strength and this beauty comes a new sense of life. In this respect humanity has never approached so near to the classical world as today."[13]

Unlike the Germans, the Soviet people did not learn of the existence of Socialist Realism and its principles directly from their Leader. These principles matured somewhere in the upper regions of the Soviet Party apparatus, were explained to a select group of the creative intelligentsia at closed briefings and meetings, and only then, in measured doses, appeared in print. The term "Socialist Realism" itself first appeared on 25 May 1932 in the pages of the *Literaturnaia Gazeta*; its principles were put forward as the foundation of Soviet art during a secret meeting between Stalin and Soviet writers at Gorky's flat on 26 October 1932. This meeting, like similar meetings arranged by Hitler, was surrounded by an aura of black symbolism.*

* Its atmosphere has been reconstructed by Siniavskii from the words of M. Kolosov, a former Komsomol military journalist and a friend of the important Soviet poet Eduard Bagritskii: "His flat opened off the same landing as Bagritskii's, and they were close friends. One evening Bagritskii's telephone rang and the unknown voice of a security policeman ordered him to appear at twelve midnight at a certain address – and to keep this summons

Stalin himself never spoke publicly on matters of art and culture. Nevertheless, he was obviously the main author of the scenario according to which the principles of Socialist Realism were put into practice. We know that at one closed meeting Stalin spoke ten to fifteen times in defence of the term "Socialist Realism"; his opponents wished to name the fundamental method of Soviet art "dialectical materialist". It was generally thought that it was his brilliant foresight and iron will that lay behind all the turning points in cultural matters. He was credited with ideas – he himself claimed the credit for them – which had been put forward long before him, often by people he had himself destroyed. The famous "Stalinist" definition of the socialist-realist writer as an "engineer of human souls" was nothing other than a paraphrase of the avant-garde idea of the artist as a "psycho-engineer", formulated by the Sergei Tretiakov who perished in one of Stalin's labour-camps (see p. 26). From its birth, therefore, Socialist Realism was as firmly linked with the name of Stalin as the "Principles of the Führer" with that of Hitler.

Initially these two terms both said nothing with regard to style. It was clear only that each was the universally obligatory principle which must determine the character of the country's art, and that this art would be an art "of a new type" that would surpass all the previous achievements of humanity and inspire the masses to construct a new society. Gradually, however, these abstractions came to acquire a more definite content.

In August 1934, at the first All-Union Congress of Soviet Writers, Socialist Realism received its definitive – and still operative – formulation in a speech by Andrei Zhdanov, a functionary whose name was linked with all the main pogroms instigated against Soviet culture during the thirties and forties. Zhdanov presented it as a commentary to the wise instructions of Stalin:

> Comrade Stalin has called our writers the engineers of human souls. What does this mean? What obligations does this title impose on you? It means firstly that you must know life in order to depict it faithfully in artistic productions, to depict it not scholastically, not in a dead fashion, not simply as "objective fact", but to depict reality in its revolutionary development. At the same time the

secret even from members of his own family. In spite of their old friendship Bagritskii said not a word to Kolosov and obeyed his instructions to the letter. Kolosov, as a trusted Party figure, knew what was going on and took pleasure in dropping in on Eduard during the evening in question in order to see what he would get up to towards midnight. Towards eleven Bagritskii began to fidget and look at his watch; seeing that his guest wasn't going to leave, he sullenly announced that he was going to go for a walk. Kolosov laughed and offered to accompany him, all the more willingly since he had himself received identical instructions the day before and was merely testing the vigilance of his well-known friend. Then things really started up ... Bagritskii shouted out that he wanted to be left alone, in peace ... And an hour later they bumped into one another at Gorky's home – together with a large number of the most worthy men of letters who had been summoned by a similar telephone call for a meeting with Stalin. That night the Soviet literary world was issued with the new regulations, the new passport, of 'socialist realism' ... Imagine the scene yourself, dear reader: writers, 'the engineers of human souls', hiding from one another like thieves as they crept through Moscow one night around the beginning of the thirties, summoned by a telephone call from the police and not knowing the reason for such secrecy." (Abram Terts, "The literary process in Russia", Kontinent, No. 1, 1974, pp. 180–1.)

faithfulness and the historical concreteness of the artistic depiction must be combined with the task of the ideologically refashioning and education of labouring people in the spirit of socialism. Such a method of artistic literature and literary criticism is what we call the method of Socialist Realism.[14]

It is characteristic that, though he was addressing a group of writers, Zhdanov used the words "depict" and "depiction" four times in two sentences, though these words might seem less applicable to literature than to the visual arts. It is unlikely that this was a mere slip of the tongue.

German cultural policy during this decisive period was concerned primarily with the visual arts; in the USSR it was concerned mainly with literature. This was not simply a matter of the personal tastes of Hitler the failed artist, of Rosenberg the would-be architect or of the Stalin who wrote poetry in Georgian during his youth; it was, rather, a reflection of the general law of development of a totalitarian revolution. During its first stage particular importance is attached to direct methods of influencing the masses, and, in this respect, painting, drawing and sculpture have a certain advantage over literature. This is where Lenin began in 1918, making his plan for monumental propaganda the pivot of Soviet cultural policy. By the thirties, however, the visual arts had already been adjusted, in most respects, to suit the needs of the regime: a "faithful depiction" of Soviet reality had become the artistic credo of most Soviet artists long before Socialist Realism. It was now necessary to bring Soviet literature into line. It is not surprising, therefore, that it was at a congress of writers, rather than of artists or architects, that the universal method of Soviet culture was first proclaimed. The First All-Union Congress of Soviet Writers, held in Moscow from 17 to the 31 August 1934, was staged according to principles which became obligatory for all subsequent congresses and meetings. It was at this meeting that all the fundamental ideas of Socialist Realism were first articulated. It is worth examining in some detail.

The main business of the Congress was to honour the Leader. All the sweeping resolutions, all the lists of future directors of literature, all the agendas of the day were unanimously approved; throughout the duration of the Congress not one of the 600 delegates ever voted against anything, or even abstained. The principles of Socialist Realism, destined according to the main speakers to bring about a radical change in the whole of Soviet and – eventually – world culture, were above discussion; everything had already been laid down and ratified, and the role of the engineers of human souls was simply to raise their hands and to elaborate in their own speeches on the "wise instructions" of Stalin, Zhdanov and Gorkii. Speaker after speaker was interrupted by greetings from delegations supposedly embodying the writers' link with the people. To the accompaniment of drums, bugles and traditional instruments, miners and collective farmers entered the hall, followed by pioneers, Lapps from the Kolskii peninsula, workers and artists, construction workers on the Metro, foreign

Communists, reindeer-breeders, milkmaids ... Some brought the information that in the Samilkilskii reindeer-breeding state-farm 441 out of a planned 449 reindeer had calved, others proposed the immediate erection of a monument to Pavlik Morozov (see below, pp. 210–11), and they all instructed the writers to depict the heroism of their everyday life in new *chef-d'oeuvres*, to write in a comprehensible language and to avoid formalism.

The Congress elevated the cult of Stalin to unprecedented proportions. All the main speakers attributed to him the role of architect and helmsman in all areas of Soviet life, art and literature included. At the first sitting, in the name of all the participants a message of greetings was sent to Stalin which encapsulated the very essence of totalitarian aesthetics: "Our weapon is the word. We bring this weapon to the arsenal of struggle of the working class. We wish to construct an art which will educate the builders of socialism and instil boldness and confidence in the hearts of millions, which will serve as a joy to them and transform them into the true heirs of all world culture." It ended with the words: "Long live the class that gave birth to you and the Party that educated you for the happiness of the workers of the entire world."[15] Feelings of loyalty had reached such a pitch that even the Class and the Party were of significance only in so far as they had given birth to comrade Stalin and educated him.

Soviet literature needed its leader too, and this post was offered by the Party leadership to Gorky. In 1921, disagreeing with many aspects of Soviet policy, Gorky had left Russia. He had happily spent almost ten years in Mussolini's Italy, but from the end of the twenties had been invited with increasing frequency to return to his motherland. Gorky's fame in the West was then on the wane, editions of his books were decreasing in size and he was suffering serious financial embarrassment. In Russia he could look forward to editions of millions of copies and the attractive prospect of becoming an incontrovertible authority in cultural matters. At the time of the Congress Gorky was sixty-five years old, but he was seriously ill and his days were numbered. It was evidently for this reason that Stalin decided to make him into something like an incarnation of himself in the area of literature. Gorky's name was mentioned no less frequently during the Congress than Stalin's, and similarly heroic epithets were applied to him: "the greatest writer of contemporaneity", "great and beloved", "our precious old man" and even "the young warrior".

Gorky opened the Congress and then, after Zhdanov, delivered a long and magniloquent speech, talking of both himself and the Congress as a whole as though they were in a position to judge humanity from a position of absolute truth: "We are the judges of a world that is doomed to perish, we are the advocates of true humanism, the humanism of the revolutionary proletariat, the humanism of strength, called upon by history to free the whole world of labourers."[16] Clad in their judges' mantles, Gorky and Zhdanov pronounced the same stern verdict on contemporary culture as Hitler and Rosenberg. Zhdanov

referred to the condition of bourgeois literature (meaning modernism as a whole) as one of "decline and decay". Gorky attacked the Russian modernists, his old enemies from before the Revolution: "The period from 1907 to 1917 was one of utterly self-willed and irresponsible thought, full of 'freedom of creativity' for Russian men of letters. This freedom was expressed through propagandizing all the conservative ideas of the Western bourgeoisie ... As a whole, the decade 1907–1917 fully deserves to be called the most shameless and contemptible decade in the history of the Russian intelligentsia."[17] In this last sentence, which became a point of departure for all subsequent Soviet historical appraisals, Gorky was attacking the silver age of Russian poetry, the first creative burst of the avant-garde in the field of the visual arts, and – above all – the spirit of freedom, exploration and innovation with which, more than any other in Russian history, that decade was imbued.

It is characteristic that Hitler not only branded contemporary Western culture in similar terms, but also related its decline to the same "contemptible decade":

> It's striking to observe that in 1910 our artistic level was still extraordinarily high. Since that time, alas! Our decadence has merely become accentuated. In the field of painting, for example, it's enough to recall the lamentable daubs that people have tried to foist, in the name of art, on the German people ... On the subject of these daubs, people assert that it isn't easy to understand them, and that, to penetrate their depth and significance, one must be able to immerse oneself entirely in the image represented – and other idiocies from the same mill. In the years 1905–1906, when I entered the Vienna Academy, these hollow phrases were already being used – to give publicity to innumerable daubs, under the pretext of artistic experiment.[18]

The artistic ideology formulated at the Soviet Congress was in essence equally applicable to Socialist Realism or to "the Principles of the Führer". It was stated that this ideology contained the ultimate and definitive truth and was an "embodiment of historical reason, the fundamental, the triumphant, motive force of world history" (in the words of Nikolai Bukharin).[19] Standing on this "turret of the whole world" (Bukharin), the spokesmen of this ideology declared their historical right to judge humanity and pass sentence on it. Brute, one of the founders of National Socialist literature, pronounced in similar vein: "A German of our militant age achieves the most honourable fame when he steps forward as an accuser before the world, and lashes it for an outrage, an injustice, a fundamental criminal attitude."[20]

Zhdanov, Gorky, Bukharin and Radek, together with other important Soviet writers, poets and dramatists, all described socialist culture as the antithesis of the decadent culture of a doomed and criminal world. Rationally organized according to the objective laws of historical development, socialist culture would be a culture "of a new type" and "of the highest stage"; from its heights all the

preceding cultural activity of humanity would seem like prehistory. For this reason it must be imbued with an optimism that expressed the joy of the Stalinist epoch; for this reason every writer and artist must be guided in his work by a love of the people, the motherland, the Party and Stalin, and by a spirit of hatred towards their enemies. It was this combination of love and hatred that Gorky called true, socialist humanism.

From here it was a logical development to the central principle of totalitarian ideology – the principle of Party spirit, according to which an artist must look on reality through the eyes of the Party and portray it in the light of its "living" (in the words of Hitler) or "revolutionary" (in the words of Zhdanov) development towards its great aim. "Our Soviet literature," said Zhdanov, "does not fear the accusation of being tendentious. Yes, Soviet literature is tendentious, since during an epoch of class struggle there is no literature, and cannot be any literature, that is 'apolitical', that is not tendentious, not class-orientated."[21] "We are not objective, we are German,"[22] said Hans Schemm, the first Nazi Minister of Culture for Bavaria, putting forward the same principle in racial terms.

The realization of these principles would inevitably lead to a great flowering of culture, to a true Renaissance; for the present, however, these two ideologies saw themselves as islands of hope, bastions of progress, amidst an overwhelming sea of collapse and decay. In such a situation it was legitimate to demand that artists give of their utmost and to punish dissenters mercilessly. The great aim before them justified any means towards its attainment. This aim was the formation not only of a new society, but also of a new builder and a new inhabitant of this society, whose psychology, ideology, ethics and aesthetics were formed according to the laws of the only scientifically correct teaching; this was the ultimate goal, acknowledged or unacknowledged, of all totalitarian cultures. In the new society, literature "will cease to be merely fiction. It will become one of the most important tools for the sculpting of the new man."[23] Variations upon this formula were repeated throughout the Congress by dozens of speakers. In order to accomplish these tasks, the writer and artist were to live the life of their people, they were to play an active role in the construction of the new society and depict, in a simple and generally comprehensible language, the labours and achievements of the masses under the guidance of their leaders, the fighters, the creators of history. It was the unanimous opinion of Soviet writers – as expressed in the message of greetings to comrade Stalin – that literature must "become a faithful and accurate weapon in the hands of the working class at home and abroad". In the words of Robert Boettcher, the head of art education in Nazi Germany, the function of art was to be "a social cement", a tool in the class struggle. The division between the artist and the people must be liquidated: the artist must become "the servant of the people".[24]

A vivid illustration of the kinship of the two artistic ideologies can be found

in the speeches of the more informed of the Soviet writers present at the First Congress. In denouncing Nazi art they described it, consciously or otherwise, in terms of Socialist Realism:

> To the cult of the superman which is being developed in Germany ... we will oppose the image of the true proletarian leader, the calm, straightforward human leader. This can be done, this must be done. To the blindly obedient fanatical mass in Fascist books we will oppose a consciously progressing mass. We will find the correspondence: between the leader and the mass. If literature turns to this theme, it will make a great leap forward. (V. Vishnevskii)[25]

> For those who doubt the genius of the leaders and the wisdom of their policy, for those who are not deceived by the magical metamorphoses of German statistics ... there is no place in the Fascist Parnassus. Only chosen barbarians are admitted with swastikas on their sleeves. They are called upon to proclaim new ideas to the world, and a new art. (V. Kirshon)[26]

A detailed analysis of the artistic ideology of Fascism was carried out by Karl Radek. An important Comintern activist, he had lived mainly in Germany, setting up underground contacts, until Hitler came to power. From 1919 he had been the main Soviet advocate of the idea of National Bolshevism, that is, he had advocated a *rapprochement* with Nazism in the name of a combined struggle against Western democracy and world imperialism. According to some researchers it was he who prepared the way for the pact between Stalin and Hitler in 1939.[27] One section of his speech at the Congress was entitled "Fascism and Literature". In it he gave the following exposition of Fascist cultural policy:

> In the person of their theoreticians and leaders the Fascists say: "There is no literature outside struggle. You are either with us or against us. If you are with us, you must create from the standpoint of our *Weltanschauung*; if you are not with us, then your place is in the concentration camp ..." The Fascists make this demand on the writer: "Paint us a painting that shows how everyone under Fascism moves forward, grows and prospers."[28]

It is hard to guess what Radek was up to. In effect he was paraphrasing and ascribing to Fascism the Soviet slogan which had set the tone for the whole Congress: "Who is not with us, he is against us". Two important articles by Gorky bear the titles: "Whose side are you on, masters of culture?" and "If the enemy doesn't yield, then he is annihilated". Radek, however, went on to quote Goebbels himself, by name:

> It would be naive to think that the revolution will spare art, and that it can lead a kind of sleeping beauty existence somewhere alongside the epoch or at its margins ... At the moment when politics becomes a popular drama, the artist cannot say: "this has nothing to do with me". It has a lot to do with him. And if he misses the chance to take up a definite position through his art with regard to the new principles, then he must not be surprised if life rushes by him.[29]

Similar words had in fact been pronounced by Goebbels on 15 November 1933 in the hall of the Berlin Philharmonia on the day of the ceremonial opening of the Reich Chamber of Literature which brought together all German writers who accepted the Nazi regime. In any case, after the approval of the regulations and officers of the newly created Union of Soviet Writers, Gorky closed the Congress with a call to Soviet writers to "get down immediately to practical work – to the organization of All-Union literature as a single whole".[30] Similar creative unions were established at the same time, in both Germany and the Soviet Union, for other branches of the arts.

(ii) Organization: the megamachine of totalitarian culture

> Organization is the form of mediation between theory and practice.
>
> > Georg Lukács

> Organization plays a decisive role in the life of the people ... Only organization, correctly established and built up, can shorten and simplify the path to success (in some instances of course it provides the only path to success).
>
> > Goebbels

> In the conditions of the Soviet socialist regime, art, for the first time in the many centuries of its history, has become the object of State construction and State policy.
>
> > A. I. Nazarov (Chairman of the Council of People's Commissars' Committee for artistic matters), 1938

It is a common mistake to accuse totalitarianism of a barbaric contempt for culture, citing for this purpose the pithy saying attributed sometimes to Rosenberg, sometimes to Goering, sometimes to Himmler: "When I hear the word 'culture', I reach for my pistol". The truth is the opposite: in no democratic country has the State valued culture so highly and devoted such constant attention to it.

Art was spoken and written about by heads of government and Party leaders, by marshals and by chiefs of secret police. Martin Bormann called culture one of the "most important and meaningful instruments" of the Party.[31] Beria spoke of it as "a powerful tool for educating the masses in the spirit of Communism, in the spirit of Soviet patriotism and internationalism".[32] Sayings of the Führer – "Art is the only immortal result of human labour" and "No people lives longer than the monuments of its culture" – were inscribed on the walls of the House of German Art in Munich. And it goes without saying that the totalitarian state

did not grudge energy or expense towards the organization "as one whole" of the cultural matters to which it attached so much importance. If the avant-garde, from Futurism onwards, was inclined to look on the machine as an aesthetic touchstone, then totalitarianism aspired to organize both culture and life itself like a vast machine, with the control panel in the leader's hands. Only through the total organization of culture was it possible to subordinate it to ideology and so to the demands of the political struggle. This was Lenin's aim when he insisted in 1921 on the complete reorganization of Narkompros. The organizational system he set up served as a prototype, but one element was still lacking – that which would make it possible to control the creative process of the individual artist. The establishment of artists' unions in the USSR and Germany completed the process Lenin had begun.

On 13 March 1933, one and a half months after he came to power, Hitler established the Reich Ministry of Popular Enlightenment and Propaganda headed by Goebbels. Its sphere of responsibility was defined as follows: "The Reich Ministry of Popular Enlightenment and Propaganda is responsible for the entire area of spiritually influencing the nation, through propaganda on behalf of the State, through cultural and economic propaganda and through enlightening the people both at home and abroad; consequently, it is responsible for running all institutes which serve these aims."[33] Goebbels himself declared in the *Völkischer Beobachter* (10 May 1933) that the task of his Ministry was "to bring Germany to a state of spiritual mobilization", and that it "fulfilled the same functions in the sphere of the spiritual, as the War Ministry in the sphere of armament".

In order to realize these aims the Reich Chamber of Culture was established under the auspices of Goebbels's Ministry on 22 September. It was divided into seven specialized chambers: music, theatre, literature, the press, radio, cinema and the visual arts. The regulations of the latter listed the professions whose practitioners would become members: architects, interior and garden designers, sculptors, painters, graphic artists, commercial engravers, decorative artists, copyists, restorers, owners of art galleries, publishers of art books, etc. It was also stated that all previously existing organizations of the above professions "without exception are abolished and each of their members without exception is obliged to become a member of the Reich Chamber".[34] The realist artist Adolf Ziegler, an "unsurpassed master of still-lifes and nudes" whom Goebbels considered "so boring that he literally sends me to sleep" was appointed President of the Chamber of Visual Arts. [35] The whole centralized machine of culture was established and set in motion astonishingly quickly. By the beginning of 1936 the Chamber of Visual Arts already numbered 42,000 members. Its centre was in Berlin, and it had thirty-two branches in different cities of the Reich.

The Nazi revolution did not aim to destroy the existing mechanisms for organizing artistic life. It was simpler to adapt them to new aims. The Chamber

of Visual Arts, for example, was set up on the basis of the already existing Cartel of Visual Arts, the Chamber of the Press on the basis of the Society of German Journalists, the Chamber of Literature on the basis of the Association of German Writers, etc. All that was needed was to fuel these mechanisms with new ideological fuel and to replace the personnel. This was the first task of the Nazi regime in the sphere of culture. Firstly, special lists were drawn up of those who were useless to the regime and so to be expelled from artistic life – mainly Jews and modernists. Secondly, W. Frik, the first Nazi Minister of Internal Affairs, immediately set up within his Ministry an establishment of ideological inspectors known – just as in Soviet Russia during the twenties – as "Commissars for artistic matters" (Kunstkommissare). Recruited mainly from the members of Rosenberg's League of Struggle for German Culture, they were appointed to key posts where they watched vigilantly over the execution of "the Principles of the Führer".

Unlike the Nazis, the Bolsheviks destroyed the Tsarist cultural institutions. But even the forms constructed during the twenties, the new, "revolutionary" forms in the area of artistic activity, education, science, etc., soon ceased to meet the demands of Soviet cultural policy as it repeatedly changed course. The last such organizations had been done away with by the 1932 Central Committee decree. And when the time came to construct a single organization of unprecedented size, it had to be built on a site that was not merely empty, but had been dug up over and over again and was now obstructed with the fragments of previous cultural forms; the Soviet leadership had to pick up the bricks one at a time and restore what they themselves had destroyed. All this did not help the speed of construction.

The establishment of artists' unions in the USSR began immediately after the decree abolishing the various artistic groupings. On 25 June 1932 the establishment of the Moscow Regional Union of Soviet Artists was announced, and similar organizations gradually appeared in other towns and cities. At first the Union of Soviet Artists was merely a conglomerate of diverse republican, regional and city organizations with few links between them. It was only at the end of the thirties that the Organizational Committee was set up which became the Union's central organ of control. Its chairman from 1938 was the realist artist Aleksandr Gerasimov, a painter of portraits, still lifes and nudes.

Formally the Reich Chamber of Visual Arts and the Union of Soviet Artists were organized like professional unions, but in reality they had very little in common with unions in non-totalitarian states. The 1934 regulations of the Union of Soviet Writers, for example, which became a model for other such unions (artists, architects, composers, journalists), openly stated that the Union brought together writers who were "'on the side of Soviet power, who wished actively to participate through their creativity in the class struggle of the proletariat and in socialist construction", and that its aim and task was the "active

participation of Soviet writers through their artistic creativity in socialist construction, the defence of the interests of the working class and the strengthening of the Soviet Union through the faithful depiction of the history of the class struggle of the proletariat and the building of socialism in our country, and through the education of the broad working masses in a socialist spirit".[36] The regulations of the Reich Chamber of Culture declared its aim as being "to assist the development of German culture in the spirit of responsibility towards the people and the State". In the context of totalitarian ideology "the spirit of responsibility towards the people" and "the education of the labouring masses in the spirit ..." can be considered synonymous. Politics and culture were already fused.

The most sinister feature of these totalitarian unions was that they were obligatory: only as a member of a union did the artist have the right to practise his profession in his own country. The regulations of the Reich Chamber of Culture stated that anyone working in the field of culture, "independently of whether he is a member of this organization, comes under the jurisdiction of one or another of the specialized chambers" (paragraph 28), and that "Law-courts and administrative organs must offer juridical and administrative support to the Reich Chamber of Culture and its individual Chambers" (paragraph 29).[37] Nazi legislation included provision for prohibiting certain groups of artists – mainly Jews and modernists – from working at all; commissars for art, together with police agents, made sure this ban was observed, checking from time to time on the state of the artists' brushes and palettes. In the Soviet Union such legal measures were unnecessary: all essential artists' materials were in the hands of the State and could be distributed only amongst members of the Union of Soviet Artists – paints, canvas, paper, plaster, bronze and marble, not to mention lithographs which, like all means of mass reproduction, were strictly accountable to the State. Most of these were absolutely unobtainable on the open market, while the remainder could be found only with extreme difficulty. And in a society that functioned according to the principle "If you don't work, you don't eat" anyone who was neither working for the State nor a member of an artists' union was considered a parasite, and so liable to be sentenced and exiled to the most distant regions.

The Minister of Popular Education and Propaganda personally appointed the governing bodies of the Chamber of Culture and its individual Chambers. These bodies were responsible for the admission of new members and could turn down an applicant on the grounds "of his unreliability and unsuitability to the profession he exercised" (paragraph 10).

> By virtue of this "Führer principle", which had now been extended to the cultural sector, a central office could decide who would be accepted, rejected or expelled ... The government thus had a ready instrument for the exclusion of all those who were politically or philosophically "unreliable" or "unsuitable".

Such exclusion amounted in every case to a permanent disbarment from the profession.[38]

The above is equally applicable to the functioning of the Union of Soviet Artists. Constitutionally its governing body was elected; votes, however, were made not for actual people but for lists drawn up by the Party. It was as impossible to question these lists, especially during Stalin's time, as to question the policies of the Party, and the lists were always approved unanimously. The "elected" governing body then decided whom to accept as a member of the Union and whom to turn down or expel. As in Germany, "suitability for the profession" was a matter of political "reliability".

Through joining these unions artists placed themselves at the service of the State in the most direct and immediate way. Their only source of income was from State commissions, usually linked to important political events such as jubilees, anniversaries, great economic achievements or military victories. Works on a particular theme were then put together into exhibitions which toured different cities. The best were then chosen for the important yearly exhibitions or "views of the highest artistic achievements of the country" – the All-Union art exhibitions held first in the Tretiakov Gallery and then, because of their increasing size, in the vast Manège building, or the Great Exhibitions of German Art held in Munich. These exhibitions can be seen as vast sieves for sorting through the countries' artistic products and selecting the images most fully in accord with the spirit of Socialist Realism or the Principles of the Führer. Neither of these dogmas, however, contained any precise recipes or instructions as to how art should be produced. The totalitarian ideologues navigated not by philosophical theory, but by intuition and pragmatism. Theory was subservient to practice since, in Orwell's words, "The totalitarian state controls thoughts, but does not consolidate them. It lays down incontrovertible dogmas, and changes them from day to day."*

The standards of totalitarian art were refined as the cultural megamachine improved its functioning. In both Germany and the USSR the construction of these megamachines, of which the artists' unions were only one of the closely interdependent parts, was completed by the middle of the thirties.

On 17 July 1937, in the presence of Hitler, the government and the diplomatic corps, the first "Great Exhibition of German Art" was opened in the newly completed House of German Art in Munich. Exhibitions were then held annually until 1943. The exhibits for the first exhibition were chosen by Hitler himself, and his title – "Patron (*Schirmherr*) of the House of German Art" – adorned each

*This statement comes from a BBC broadcast of 19 June 1941, three days before the outbreak of war between Russia and Germany. Orwell continued prophetically: "Here is a straightforward and crude example: before September 1939 a German was supposed to look on Russian Bolshevism with horror and disgust – after September 1939 he was obliged to look on it with sympathy and admiration. If Germany and Russia go to war, we will see an equally sudden 180 degree turn."

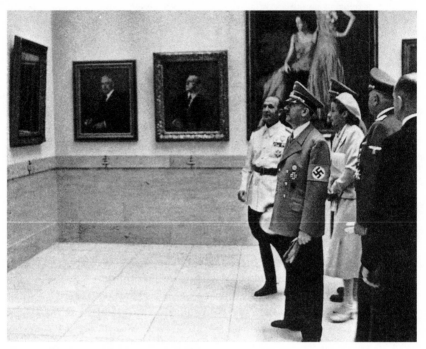

Photograph: Hitler Opening an Exhibition (16 July 1939)

year's catalogue. The Führer gave the following outline of his views: "I have inexorably adhered to the following principle: If some self-styled artist submits trash for the Munich exhibition, then he is either a swindler, in which case he should be put in prison; or he is a madman, in which case he should be in an asylum; or he is a degenerate, in which case he must be sent to a concentration camp to be 're-educated' and taught the dignity of honest labour."[39]

It turned out, however, to be far from simple to select 1,500 works for these "views of the highest achievements". According to Heinrich Hoffmann – Hitler's personal photographer, who was given the title "professor of art" and made responsible for the organization of the exhibition – the number of submissions for the first exhibition was 8,000. Twelve professors sorted through them, but Hitler was not satisfied with the final selection. He even intended to postpone the exhibition for a year, although he was persuaded by Hoffmann to change this decision.[40] Four years of Nazism had evidently not resulted in the production of worthy images for the arsenal of German art; it was necessary, therefore, to add another element to the megamachine of culture.

To encourage the most important artists the State prizes were inaugurated in Germany in 1937, and the Stalin prizes (later Lenin prizes) in the USSR in

1939. In Germany it was Hitler who had the last word as to who was awarded these prizes; in Russia lists of Stalin laureates were drawn up by the State Commission of the Committee for Arts of the Soviet of Peoples' Commissars (later the Ministry of Culture), confirmed by the corresponding department of the Party Central Committee, and finally approved by Stalin. The laureates were awarded the gold badge of the Stalin Prize First Class together with 100,000 roubles, or else the silver badge of the Stalin Prize Second or Third Class together with a smaller sum of money. In the complex hierarchy of the totalitarian elite these laureates were the guardians of the sacred principles of Socialist Realism or National Socialist Art. Later, in the USSR after the War, a still higher level was added to the hierarchy – that of Full and Correspondent Members of the Academy of Arts.

The existence of these academicians and laureates made it unnecessary to provide theoretical formulations or definitions of the nature and style of Socialist Realism or National Socialist Art; the standard was set by those who had been awarded the highest State titles and awards. It was for this reason that Goebbels, on 27 November 1936, imposed a ban on all art criticism, on any discussions or arguments about the nature of Nazi art:

> Because this year has not brought an improvement in art criticism, I forbid once and for all the continuance of art criticism in its past form, effective as of today. From now on, the reporting of art will take the place of an art criticism which has set itself up as a judge of art – a complete perversion of the concept of "criticism" which dates from the time of the Jewish domination of art. The critic is to be superseded by the art editor. The reporting of art should not be concerned with values, but should confine itself to description. Such reporting should give the public a chance to make its own judgments, should stimulate it to form an opinion about artistic achievements through its own attitudes and feelings.[41]

The *Völkischer Beobachter* (the chief mouthpiece of Nazism) further refined these statements of Goebbels: "The only possible criterion of judgment for a work of art in a National Socialist State is the National Socialist conception of culture. Only the Party and the State have the right to define standards in accord with the National Socialist conception of culture" (29 November 1936); "In future works of art will be reviewed only by those who devote themselves to this activity sincerely and in accord with the National Socialist *Weltanschauung*" (28 November 1936).

In the Soviet Union, on the other hand, the problem of art criticism – like many similar problems – was resolved administratively rather than through grandiloquent proclamations. Soon after the Central Committee decree of 26 April 1932 all the art periodicals linked to the different rival groupings were closed down, to be replaced in 1933 by the journal *Iskusstvo* (Art) – the organ of the Union of Soviet Artists, still published today. It goes without saying that

its art criticism was entrusted to those who devoted themselves to their work sincerely and in accord with the Marxist-Leninist-Stalinist *Weltanschauung.*

Art critics and historians were obliged in both countries to join together into unions: in the USSR they formed – and still form – the "criticism section" of the Union of Soviet Artists, in Germany they formed the seventh department of the Chamber of Visual Arts: "Art publications, sales and auctions". Criticism thus became a part of the totalitarian cultural machine.

Although criticism was not officially banned in the Soviet Union, its position differed little from that of its German counterpart. Works of Socialist Realism that had received the highest prizes and awards were outside its sphere of competence; all it could do was describe the events and characters portrayed, finding ever-new merits in their ideological content and artistic language. Any negative judgement was entirely out of the question.*

By assimilating artists the totalitarian machine both deprived them of freedom of choice and opened up before them a broad field of activity; it directed their work along the narrow channel of politicized art, but generously rewarded all who complied. Arno Breker, Hitler's court sculptor, for example, earned more from state commissions in 1938 than Goebbels himself in three years; and at one of the postwar trials of Nazi criminals the actor Emil Jannings showed the court his contracts for 1933, turned to the judge and said: "So allow me to ask, would you have refused such a sum?"[42] In 1937, at the joint congress of the Reich Chamber of Culture and "Strength through Joy"† Goebbels claimed:

> The German artist has his feet on a solid, vital ground. Art, taken out of its narrow and isolated circle, again stands in the midst of the people and from there exerts its strong influences on the whole nation.
>
> To be sure, the political leadership has interfered in this, and today it still interferes daily and directly. But this occurs in a way that can only work to the benefit of the German artist: through subsidy, the commission of works, and a

* The following extract from a speech by A. Zamoshkin, then the director of the Tretiakov Gallery, at the 1947 conference of the USSR Academy of Arts is a typical example of this kind of description: "The appearance of I. Serebrianii's picture 'At the Fifth [London] Congress of the RSDRP' [Russian Social Democratic Workers Party] is an event in our art. We have never before had such paintings on themes of the history of our Party. In this painting, conceived with complexity and depth and skilfully executed, the images of V. I. Lenin, I. V. Stalin, K. E. Voroshilov and A. M. Gorky are presented with historical truth and artistic conviction. We know that at this congress the Leninists, led by Vladimir Ilich, won an important victory in the workers' movement in their implacable struggle against the Mensheviks. In the foreground the artist presents a conversation between Lenin and Stalin. The image of Lenin is presented by the artist in a new manner, with realistic expressiveness. Vladimir Ilich, in a characteristically lively pose, is leaning forward with his right hand on the back of the chair, turning towards comrade Stalin and saying something to him with great conviction. The latter, sitting down, has turned his head towards Lenin with an energetic movement and is listening to him attentively. Between them sits Gorky, observing the conversation. Behind them the still young Voroshilov is leaning against the platform and craning forward, watching them in ecstasy." (*Thirty Years of Soviet Representational Art*, Moscow, 1948, p. 33.) Such "critical analyses" fill many pages of both the Soviet journal *Iskusstvo* and the German *Art of the Third Reich*. But then the ideological and artistic content of these paintings is indeed fully exhausted by such a description.

† The German Labour front, of which "Strength through Joy" was a part, was founded by Robert Ley (1890–1945) in 1933. It controlled trade union activity, industrial relations and mass leisure facilities.

patronage of the arts, whose generosity is unique today in the whole world ...
Germany marches ahead of all other countries not only in art but also in the
care which it showers upon artists ...

The German artist of today feels himself freer and more untrammelled than
ever before. With joy he serves the people and the state, who have accepted
him and his cause in such a warmhearted and understanding way. National
Socialism has wholly won over German creative artists. They belong to us and
we to them.[43]

Largely justified though it may be, this claim is, however, exaggerated: such
Soviet laureates as Aleksandr Gerasimov, Sergei Merkurov, Nikolai Tomskii and
Evgenii Vuchetich earned no less than their German colleagues and were no
less surrounded by the concern of the Party leadership. "The position of the
Soviet artist in a socialist state, the possibilities available to the artists' unions
of our country have no equals in the world. It is well known, for example, what

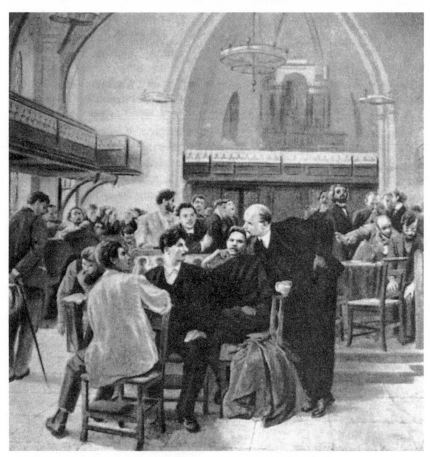

Serebrianii: The Fifth Congress of the Russian Social Democratic Party

a powerful material base they have at their disposal."[44] Unlike many of the clichés of Soviet propaganda, this statement from the ideological section of the Party Central Committee contains a degree of truth.

The nature of the relations between the artist and the totalitarian State can be most clearly understood through an examination of the workings of Soviet art over the fifty years following the Revolution. These relations are controlled by the work of a structurally complex ideological and administrative apparatus, but what lies at their foundation is a simple idea and aim: that State commissions should be the main, and eventually only, source of the artist's material livelihood, the only inspiration behind his work. The artists' union can then be seen as a mediator between the artist and the State.

The main routine task of the Union of Soviet Artists was the organization of the annual "theme" and "All-Union" exhibitions which defined the country's artistic life. Each of its departments included an exhibition committee which distributed commissions for pictures on a particular theme among members of the Union. The artists chosen received not only an advance, but also all possible help towards the successful execution of the commission. Many of them were sent, at the expense of the Union, on "creative missions" – in the footsteps of Lenin, to great battlefields or building sites, to northern fishing cooperatives or southern fruit-growing collective farms, in order to gather visual impressions and to find creative inspiration through contact with the working masses; on their return many of them went to "houses of creativity" belonging to the Union of Soviet Artists, situated in the most fashionable resorts, where they completed their work in a peaceful environment where all their needs were met. The completed work was shown to the exhibition committee who, after checking that it met their requirements, paid the remainder of the agreed sum. After that, many thousands of these products were exhibited to the public, to the critics and – most important of all – to the State Purchasing Commission of the USSR Ministry of Culture. The latter to all intents and purposes had a monopoly on buying works of art for all the country's museums as well as for its own reserves. As a rule, all works commissioned by the Union exhibition committees and shown at the main exhibitions were automatically bought by the State Purchasing Commission; State money was thus transferred to the Union funds at the same time as works of art became State property. Some of the products were given to the collections of the various (mainly provincial) museums, some were included in the countless touring exhibitions, but most of these miles of canvas and tons of marble and bronze, their propaganda function fulfilled, finished their ephemeral existence in the storerooms of the USSR Ministry of Culture, that huge graveyard of Soviet art.

A considerable length of time had been required in order to perfect the Soviet cultural machine; in seven or eight years (the process was slowed down by the war) the Nazi machine was unable to achieve such precision of functioning. The

systems were, however, remarkably alike. The main events in official artistic life were similar annual and "theme" exhibitions, above all the "Great Exhibitions of German Art" held in Munich. Hitler, who himself selected the works, was an important purchaser. It is known, for example, that he bought 144 of the 1,158 works shown at the second Munich exhibition in 1938, more than 13 per cent. His purchases were stored in the building of the Reich Chancellory of the Führer, and were intended for a gigantic cultural centre that Hitler dreamed of building in Linz, near his birthplace. This fact alone makes it possible to conclude that "the government was the major buyer in the House of German Art and set the standards for both form and content".[45] Hitler, however, was not the only purchaser. Some of the products of the Reich Chamber of Visual Arts were acquired by Goebbels's Ministry of Popular Enlightenment and Propaganda, by the various sections of Rosenberg's "ideological empire" and by various other military and civilian departments. And the largest consumer of German art was "Strength through Joy".

The task of "Strength through Joy" was to organize the leisure of the workers by involving them in official cultural activities. Its propagandist and ideological aims in many respects duplicated those of the Ministry of Popular Enlightenment and Propaganda, and for many years Goebbels and Ley argued over their respective spheres of responsibility.[46] Inspired by the theories of the Soviet avant-garde, especially those of Proletkult,[47] its activists brought art to the masses, together with the "great" ideas of National Socialism that were destined to form the new "spirit of the nation". Its main task was the organization of lectures, concerts, amateur theatricals, art competitions with such titles as "Art and the People Constitute One Whole", etc. In particular it organized the exhibitions of National Socialist Art which toured various cities and were held mainly in factories. The first touring exhibition of this kind was opened in Brunswick in April 1933, only a few months after the establishment of the new regime. In this too "Strength through Joy" was following the Soviet example: the AKhRR first organized similar touring exhibitions in 1922.

The work of this organization was evidently extremely effective. According to Hellmut Lehmann-Haupt, it is the absolute truth that before the war everyone in Nazi Germany was "continuously exposed to some form of officially sponsored art activity".[48] An equally total involvement in the sphere of official culture was – and still is – the ideal of the Soviet cultural machine, although this did not contain any such centralized organizations as the Reich Chamber of Culture or "Strength through Joy". The various realms of culture were shared between the artists' unions, the committees of the Soviet of Peoples' Commissars (later the departments of the USSR Ministry of Culture), and the republic and regional organizations. Touring exhibitions of Soviet art were arranged by the "Direction of art exhibitions and panoramas", a part first of the Soviet of Peoples' Commissars Committee for Matters of Art and then – from 1953 until the present

day – of the USSR Ministry of Culture. It performed this task on no less a scale than "Strength through Joy" and throughout the territory of the Soviet Union, from the Black Sea to the White and from the Carpathians to the Far East.

For all their external differences, both totalitarian systems had the same pyramid structure and were cemented together by the same "spirit of the Party" that Lunacharskii had compared to the "biblical Holy Spirit". The organizations of Goebbels, Ley and Rosenberg were under the direct control of the Führer, and the three main elements of the Soviet cultural megamachine – the Union of Soviet Artists, the Ministry of Culture and the USSR Academy of Arts – were crowned by the corresponding sections of the secretariat of the Party Central Committee, which themselves worked in close contact with the Leader. It was in the offices of the Leader and the Führer that the threads of the system of cultural control came together; it was here that decisions were taken; it was here that the principles of Socialist Realism and those "of the Führer" were formulated, and that measures were decided upon for putting them into practice.

These measures were dictated by one and the same "historical necessity": in order to open the way for the new art it was necessary to clear the field of culture of "the weeds of modernism", of all that totalitarianism referred to as decay, decadence and degeneracy, as the art of "Kulturbolschewismus" or of "Fascist rabble". It was for this reason that the process of intensive cultural construction went hand in hand with a no less intensive process of cultural terror.

(iii) Terror: totalitarianism against modernism

There is no law that everything repudiated for one or another political reason by Hitler (homosexuality, for example) must in itself be good ... Hitler persecuted modernism. And what of it?

Mikhail Lifshits, *Art and the Contemporary World,*
Moscow, 1978

In March 1933 the German newspapers published a kind of artistic manifesto under the title: "What German artists expect from the government". Amongst other things it stated:

They expect that from now on there will be one highway only in art ... It is a sacred duty to bring forward to the front line the soldiers who have already shown their valour in the battle for culture. In the realm of the visual arts this means: 1. That all artistic production which is cosmopolitan or Bolshevist in character must be removed from German museums and collections. First it should be gathered together and shown to the public in order to inform it how

much these works cost and which of the directors of cultural and artistic centres is responsible for their purchase. Then only one useful function should be reserved for these works of anti-art. They can serve as fuel for heating public buildings ... 5. That sculptures which offend national feelings and still defile public squares and parks should disappear as soon as possible, irrespective of the fact that they were created by such "geniuses" as Lehmbruck or Barlach. They must make way for artists who remained loyal to German tradition.[49]

In the cultural history of the totalitarian regimes this document is in no way unique. As early as 1922 AKhRR activists were turning to the Soviet government with similar manifestos. It is true that they did not at that time demand the physical annihilation of the modernism they accused of "discrediting the new reality". One of them, however, Aleksandr Gerasimov, who from the mid-thirties was a dictator with absolute power over Soviet art, stated:

> I have always thought ... there are so many bad paintings that it quite simply pains me that special stores should be filled with them. The storerooms of the Tretiakov Gallery, for example, are filled with stacks of "paintings" by Futurists, Cubists, and so on. One asks: what is the cost to the people of the preservation of these chef-d'oeuvres? How much paper has been used up on their account? How many people watch over this rubbish at a scientifically established temperature? One says involuntarily: "We're afraid for Man."[50]

In the mouth of the powerful guardians of the sacred national, popular, realistic and other traditions these were not empty words: cultural terror in both countries developed in accord with the demands of these and similar documents. It was as though Gerasimov and Kandinskii, Ziegler and Picasso, inhabited different historical epochs, incompatible aesthetic dimensions; for the former to exist, they had to destroy the latter.

The expectations of the German artists were soon realized. Later in 1933 an exhibition was opened in the city museum of Karlsruhe under the title "Official art from 1918 to 1933". Works by Impressionists and Expressionists were accompanied by mocking descriptions and their astronomical prices in inflated marks – an attack on the previous government for squandering the money of the people. This was followed by a series of similar exhibitions: "The Spirit of November; Art at the Service of Disinformation" in Stuttgart, "The Chamber of Artistic Horrors" in Nuremberg, "Signs of Decay in Art" in Chemnitz and Dresden, "The Eternal Jew" in Munich, and others. On 30 October 1936 the contemporary section of the Berlin National Gallery – the most complete collection of contemporary art in Germany – was closed down; and on 27 November Goebbels issued a special decree which proclaimed: "In accordance with the will of the Führer I authorize Professor Ziegler to select, for an exhibition of German degenerate art, any paintings or sculptures, beginning from the year 1910, that are to be found in the collections of the German Reich, in its cities and regions."[51] Ziegler's selection committee had four members: the "commissar for artistic

matters" G. Schweitzer, who chose as his pseudonym the old-German name Mjolnir (which could be translated into Russian as "Molotov"!), the SS officer Count K. Baudissin, the illustrator W. Willrich and the Nazi critic from the *Völkischer Beobachter*, F. Hoffman. Its role was not only to select, but also to confiscate works from museums. The commission toured the country during the years 1937–8; as a result 15,997 works by both German and foreign artists were removed from thirty-three museums. As well as the most important German modernists, the list of confiscations includes Van Gogh, Gauguin, Matisse, Picasso, Braque, Derain, Rouault, Kandinskii, Chagall, de Chirico, Vlaminck, Ensor, Lissitzky, Van Doesburg and many others. On 4 August 1937 Goering issued a decree "about the removal of all objects not corresponding to the aesthetics of National Socialism from all collections, both State and private";[52] and on 31 May 1938 a law was passed confiscating all works of "degenerate" art from all German collections. A special commission was then set up to decide how to utilize the confiscated works. The majority of them were sold abroad, Goering appropriated the finest of them, and the remainder (about 5,000 paintings, watercolours and drawings) were burned by the Berlin fire brigade. As a result of this cultural terror German museums sustained greater losses than in any other country.

This process was planned in the command centre of the totalitarian megamachine and then implemented by artists who had held firmly in their own work to the ideas of the preceding century and as a result had been relegated to the periphery of artistic life. They saw the triumph of totalitarianism as the moment to claim their place at the centre of official culture.

The Exhibition of Degenerate Art opened in July 1937 at almost the same time as the first Great Exhibition of German Art. Works of Nazi artists chosen by Hitler were exhibited in the main rooms of the House of German Art; the back rooms, normally used for storing archaeological copies and quite unsuitable for exhibitions, contained the works of the German modernists. The sculptures were without pedestals and the pictures were hung at random, some of them without frames, from floor to ceiling, lit by a dim light and furnished with mocking explanatory labels. This was supposed to demonstrate the poverty of contemporary art beside the bright and joyful art of the Germany that was now awakening to a new life. The exhibition catalogue divided the works into nine groups:

Group 1 presented a "general survey from a technical point of view of the barbarous methods of representation [and] of the progressive destruction of form and colour". This contained works by Otto Dix, Ernst Ludwig Kirchner, Oscar Schlemmer and others.

Group 2 was designated as "shameless mockery of religious conceptions" and was dominated by works of Emil Nolde.

Group 3 contained works of political content. The artists – mainly

Expressionists – were accused of "artistic anarchy" intended to incite "political anarchy".

Group 4 showed art as an example of Marxist propaganda, in this case directed against the army: pictures "depicting German soldiers as idiots, sexual degenerates and drunkards". It consisted of works by George Grosz and Otto Dix.

Group 5 consisted of art which depicted "the whole of reality as a vast brothel".

Groups 6 and 7 illustrated the "systematic undermining of racial consciousness" and the substitution of a racial ideal borrowed from the art of the Negroes. This consisted of Expressionist paintings and sculptures by Ernst Barlach.

Group 8 displayed "a selection from the infinite store of Jewish rubbish".

Finally, group 9 was entitled "general madness" and "the highest degree of degeneracy". This contained works by Constructivists and abstract artists.

There seems to have been no carefully thought-out plan behind the organization of this exhibition; ideological slogans and works exemplifying them were even repeated in different sections.

In his speech at the opening of the House of German Art Hitler summarized the totalitarian attitude to modernism: "Amateurs in an art that is contemporary today and forgotten tomorrow; Cubism, Dadaism, Futurism, Impressionism, Expressionism; none of this is of the least value to the German people ... Not one drop of talent; dilettantes who should be sent back, together with their scrawls, to the caves of their ancestors."[53] He continued:

> And what do you manufacture? Misformed cripples and cretins, women who could only inspire aversion, men who are more like beasts than men, children, who if such were to live, must instantly be considered the accursed of God! And this these completely inhuman dilettantes dare to present to our present world as the art of our time, that is to say, as an expression of that which the contemporary epoch forms and upon which it impresses its seal ... Here among the pictures sent in, I have observed many works, from which it must in fact be taken that to certain men the eye shows the object other than as it is, which is to say that there really are men who see the present representatives of our people only as depraved cretins, men who perceive or – as they perhaps say – experience meadows as blue, skies as green, clouds as sulphurous yellow and so on. I will not be drawn into an argument about whether or not those concerned really see and feel in this way; on the contrary I am inclined, in the name of the German people, to forbid that such deplorable unfortunates, who apparently suffer from defects of vision, should attempt to thrust the consequences of their failure of vision on their contemporaries as reality, and above all that they should present it as "art".[54]

In this medley of accusations one can make out three leitmotifs: (i) the accusation from an aesthetic standpoint that modernism distorted reality and was therefore decadent and degenerate; (ii) the political accusation of "Kulturbolschewismus"; and (iii) the racial and nationalist theme. The first two of

these motifs are also dominant in Soviet criticism after 1932 – except that "barbarous methods of representation" has acquired the label of "formalism", and "Kulturbolschewismus" has reversed its political content. The third, nationalist, theme flourished in Soviet art only after the war.

The Munich Exhibition of Degenerate Art has gone down in history as a symbol of the cultural barbarism and brutality of the Nazis. It is legitimate, in addition to this, to see it as the climax in the development of a totalitarian ideology that was common to both Germany and the USSR.

In the Soviet Union, analogous measures were taken earlier, although at first they took place without unnecessary pomp, and were concerned with organization rather than overt propaganda.

At the end of 1932 (a few months after the Central Committee's decision to liquidate artistic groups), an exhibition of "Fifteen Years of Soviet Art" opened in the Russian Museum in Leningrad. It presented an objective view of the development of various tendencies in the Soviet art of that period, and an extensive section was devoted to the revolutionary avant-garde, where the works of its masters proved to be all the more brilliant after a ten-year interval. The reaction of the artistic intelligentsia to this exhibition was enthusiastic and very hopeful. At that time it seemed that, after they had abolished the artistic groups and enrolled every artist in the artists' union, the Central Committee would adhere to a *laissez-faire* policy for artists of different movements. But apparently its organizers had other plans.

In June 1933, the same exhibition opened in Moscow. However, its content had been changed: the "formalist" trends were either absent or had been reduced to a minimum.

What took place behind the scenes between the two exhibitions can only be surmised. Assessing them both the journal *Iskusstvo* blamed the first on the ground of liberalism, and wrote as follows about the second:

> The Moscow jubilee exhibition is unusual, and almost without precedent in the practice of organizing large exhibitions. The past is presented here only so that it can be critically reassessed, in order to have a firmer footing in the next, higher state of development ... Directions to former artistic institutions have been rejected. These institutions used to exist, but now they do not, and there is no point in resurrecting them in the exhibition ... the Moscow exhibition sees formalism as the gloomy past, which still continues, but is no longer alive in the present, so to speak, and is not viable to us in the future. Similar exhibitions ... will become current in our artistic life not on an equal basis, but in preference over other kinds of exhibitions, since an experiment of a similar kind has shown to have striven more energetically towards the creation of a new Soviet style and the corresponding reorganization of existing mode of creativity in the visual arts.[55]

The "Fifteen Years of Soviet Art" exhibition became an example to all its successors; from then on, its history was cited exclusively in terms of the

establishment and development of Socialist Realism. What is no less important is that the avant-garde and formalist movements which were presented in its Leningrad version served as a concrete excuse for the beginning of the destruction of formalism by the government itself. In the realm of the visual arts, *Iskusstvo* became the main mouthpiece in this conflict from 1933, replacing all other art periodicals, which had been abolished along with all the artistic groups. The leading article of the first (double) issue stated that the formation of Socialist Realism "must accompany a merciless battle against formalism",[56] and the third issue opened with a leading article entitled "Formalism in Painting", in which this phenomenon was given an ideological basis:

> Formalism in any area of art ... is now the main form of bourgeois influence ... the struggle against formalism as the most harmful current in our painting, is at the same time a struggle on behalf of those formalist artists who are not hopeless from the point of view of the possibility of their reconstruction.[57]

It is not difficult to guess that the aim of the organizers of the exhibition of "Fifteen Years of Soviet Art" was the same as that of the exhibition organized by Hitler four years later to show to what decay and degeneration modernist artistic culture had fallen in the twentieth century.

A new stage of the struggle began after the First Writers' Congress proposed Socialist Realism as the fundamental and obligatory creative method for all Soviet artists. Early in 1936 *Pravda* published a series of articles attacking formalism in different artistic fields: "Chaos instead of music" (28 January), "Cacophony in architecture" (20 February), "On artist-daubers" (1 March), etc. Formalism (or modernism) was now cast in the role of the chief opponent of Socialist Realism, the class enemy standing in the way of artistic and social progress. "More Vigilance", the editorial of the first issue of *Iskusstvo* to appear after the writers' congress, put this more concretely:

> Any ambiguity or confusion, any hysteria, any formalist idiosyncrasies not justified by the content and not necessary for its expression are either methods of disguise for the class enemy or, by allowing a different reading, a different interpretation, can serve the interests of the class enemy against the author's wishes ... We must intensify the struggle for a genuinely realistic art ... We must fully unmask the remnants of the class enemies in art. And we shall accomplish this.[58]

The logic of totalitarian thinking under "right-wing" and "left-wing" regimes was astonishingly consistent, even with regard to terminology and verbal definitions. Formalism, the "art of decay and putrefaction", meant exactly the same in Russia as "degenerate art" in Germany, i.e. "Cubism, Dadaism, Futurism, Impressionism, Expressionism"; the same accusations – "destruction of colour and form", "barbarous methods of representation" – were levelled against each of them. "An intentional deformation of objects, a deliberate imprecision of

outline, harsh and quite unnatural combinations of colour, the over-soph-
isticated manner of painting with its painfully nervous worm-like smears made
his art inaccessible to the broad masses of viewers."[59] These words about Van
Gogh were written as late as 1962 by A. K. Lebedev – who had been for
many years the most high-ranking administrative figure in Soviet art. Similar
distortions by Russian artists were seen as an attempt to show Soviet people as
monsters and cretins, to deform the bright image of Socialist reality and so
inspire in the masses a hostile attitude towards the Soviet regime. The editorial
of the third issue of *Iskusstvo* in 1936, for example, posed a rhetorical question
that was entirely in accord with the spirit of Hitler's Munich speech:

> Imagine in theory what would happen if a future historian wished to form a
> conception of our time from the works of Shterenberg, Favorskii, Tyshler,
> Fonvizin, Frikh-Khar, Sandomirskaia, etc.... The historian would say first of
> all that these were people possessed by certain nightmares. He would, admit-
> tedly, add that the tension of these nightmares was not identical. For some they
> glimmered like a jelly-fish and turned the whole world into a play of colours;
> for others they were heavy, oppressive forms.[60]

The main thrust of this campaign was directed against the most important Soviet
figurative artists (Pavel Filonov, Aleksandr Drevin, Petr Konchalovskii and
others, in addition to the artists mentioned above) who not long ago had been
chosen, in exhibitions at home and abroad, as the exponents of the new realism.
As for Futurists, Constructivists and other abstractionists, they were considered
the "highest form of degeneracy". By this date, however, they had long since
been silenced.

Cultural terror in the Soviet Union gathered momentum together with
Stalin's political terror and culminated at the same time. Its peak was in 1937,
the year of the most widespread arrests and most terrible political trials in Russia.
Soon after the Exhibition of Degenerate Art in Germany, before their works had
even been transferred from the House of German Art to Hitler's commission for
their utilization, contemporary artists found themselves under attack in the
Soviet journal *Iskusstvo*:

> These clowns who wallow in different forms of defending the doctrine of "art
> for art's sake" are not so innocent. In the West, in the Fascist countries –
> Germany and Italy – these entertaining fellows have been very quick to find
> their way into the Fascist "cultural" hearts. Their supposed lack of ideology
> serves Fascism very well and very "ideologically". At home, these "leftist"
> clowns, who once laid claim to a monopoly on cultural leadership, are still
> getting under our feet.[61]

In this way, all contemporary art that departed from the standards of Socialist
Realism was damned with the most terrible of political labels; what had long
since, in Germany, been referred to as "Kulturbolschewismus" was now, in
Russia, given the name of "Fascist art".

Such political masquerades were not merely a tribute to the time. The assertion of a link between modernism and Fascism, Bolshevism, Imperialism, Jewry, Zionism, etc. was a persistent theme of totalitarian ideology. The soil and atmosphere necessary for the growth of this doctrine were provided by the sense of exclusiveness, of being socially or racially chosen, and so of being alone on an island of progress in a hostile world. This world apparently had only one aim: to stand in the way of progress, to prevent the liberation of humanity and to trample on the shoots of the new. With this aim it resorted to the most subtle and cunning forms of struggle – and one of the most dangerous of its weapons was art. Totalitarianism had learned to forge its own art into a powerful political weapon; it then ascribed the same function to all other art. Hitler evidently sincerely believed in the existence of a global Jewish-Imperialist conspiracy whose aim was to undermine the foundations of German life. Looking through the lists of confiscated German property, Hitler often found works by the nine-teenth-century German painters most dear to his heart. Their former owners were mainly doctors, lawyers and dealers, whose bourgeois tastes differed very little from those of Hitler himself. From this Hitler drew a paranoid conclusion: by supporting modernism and inflating its prices, the Jews had not only poured the poison of degeneracy into the healthy body of German culture but also lowered the prices of the old masters they then obtained for themselves.[62] Behind these "Jewish machinations" Hitler saw a still broader conspiracy, planned by the enemies of Germany. In his public speeches he gave this a political, rather than racial, interpretation: "Of the products of so-called modernism we would find less than five per cent in the property of German collections if politically and philosophically orientated propaganda, not concerned with art *per se*, had not controlled public opinion and, of course, had not foisted these works on the public through political machinations."[63]

At the same time the idea of a conspiracy against Soviet culture acquired a nightmarish reality in the Russian press. From 1934, the tone of the editorials of *Iskusstvo* grew more and more shrill, while the articles it published grew more and more saturated with such expressions as "the anti-Leninist policy of the former Narkompros", "the harmful activity of the leftist groupings", "ideals and feelings that are alien to us, implanted by artist-formalists", "ideological diversion", "Mikhailov's painting, terrorist-counterrevolutionary in content and form ... whose link with the Trotskyist-Zinovievite murderers is all too manifest" ...

The supposed evil against which any totalitarianism struggles is embodied in the image of its main enemy. In Soviet Russia before the Stalin–Hitler pact this enemy was National Socialism, referred to for obvious reasons as Fascism. From the summer of 1939 such words as "Nazism", "Fascism" and "Hitlerism" lost their derogatory tone and so ceased to be applied to modernism; in the same way the term "Kulturbolschewismus" disappeared from the vocabulary of Nazi

critics. In both countries the nature and sources of modernism were then seen to lie in the ideology of the Western democracies and world imperialism. During the war, however, and especially after it, comparisons between modernism and Fascism reappeared in Soviet criticism and have continued to the present day.* "The modernist disintegration of art is an analogy of the disintegration of social life embodied by Fascism ... As for the persecutions of artists [under the Nazi regime], they were called forth not so much by the aesthetic views of the artists concerned as by their nationality or socio-political position."[64] Nazi propaganda did indeed place its central emphasis on national origin and political allegiance, but V. Vanslov – the author of the above – is wrong to accept this at face value. In 1933, for example, the *Deutsche Kulturwach* wrote that all the contemporary art in the Berlin Kronprinzpalas – soon to be closed – was the work of Jews, although the German historian Franz Roh has estimated the Jewish contribution as not more than two per cent.[65] In the vocabulary of the Nazi *kulturträgers* the epithet "Jewish" – like "bolshevik" or "bourgeois" – was simply a hate-word, empty of meaning, applied to artists who were unwelcome to the regime. Lyonel Feininger, a "participant" in the Exhibition of Degenerate Art, complained in a private letter of 3 August 1935: "And in the background ... the necessity to prove my 'Aryan origin'. This was demanded of me, in its usual official language, by the Chamber of Culture. But we Feiningers, from time immemorial, have been 'pure Arians' and faithful Schwabian Catholics. Even for a million I couldn't find one 'non-Aryan' in the history of our family ... They also called Barlach a Jew, and Pechstein – on Nolde's denunciation – and other people."[66] As for Emil Nolde himself, neither his Aryan origin, nor his anti-Semitism, nor his denunciations, nor even the early serial number of his National Socialist Party membership card were enough to save him from the sad fate of representing "degenerate" art, together with Feininger, Barlach and Pechstein. It is only possible to make claims such as Vanslov's if, like most of the population of the Soviet Union, one has been subjected to a process of ideological numbing; until recently any objective information about the culture of the Third Reich remains strictly censored, in case it reminds Soviet citizens of their own cultural life.†

Behind this identification of modernism with Fascism or Bolshevism we can

*The champion of this idea until recently was the influential Soviet philosopher and critic Mikhail Lifshitz, a loyal student and follower of Georg Lukács who at the beginning of the thirties had linked Expressionism to Fascist ideology. In an article "Why am I not a modernist?" he managed to ascribe to contemporary art all the darkest attributes of Fascism. To the rhetorical question posed in the article's title he answered: "Because in my eyes modernism is linked to the darkest factors of our time – the cult of strength, joy in destruction, love of cruelty, hunger for a life without thought, for blind obedience". (M. Lifshits and L. Reinhardt. *The crisis of ugliness. From Cubism to Pop Art.* Moscow, 1968, p. 187.) He developed these ideas in more detail in *Art and the Contemporary World* (Moscow, 1973).

†It was precisely this reaction on the part of the viewers that caused *Ordinary Fascism*, a film by the Soviet director Romm, to be removed from the screens in the early sixties. The film contained frames from a Nazi documentary showing the opening of one of the official German exhibitions during the Third Reich.

glimpse one of the most terrible faces of totalitarianism: aesthetics is identified with political ideology, and an alien or incorrect ideology becomes a State crime and so subject to criminal law. If it was a matter of supposed Bolshevism or Fascism, then no measures could be too harsh. Originating in global, "uniquely true", "scientific" theories and gathering strength from the political slogans of the moment, totalitarian ideology always led to cultural terror. Under different systems it took on different forms; its essence, however, remained the same.

In Stalinist Russia during the thirties there was no need to remove modernist paintings from museums and private collections, to hold them up to public mockery and burn them on huge bonfires. All private collections had been nationalized immediately after the Revolution, and modernist paintings had been taken down from the walls of museums without the stimulus of State legislation. Works by modern Western painters were not, as in Germany, scattered throughout the museums of the country. The magnificent private collection, formed before the Revolution by Shchukin and Morozov and covering the period from Impressionism until 1914, had been turned into two independent museums after nationalization, and were then integrated to form the Moscow State Museum of Modern Western Art. It was only the fact that there had been no additions since 1914 which enabled the museum to survive at all; in 1947, however, it was abolished and arrangements were made to sell its exhibits abroad – a plan which, fortunately, was only partially executed.* As for the works of the Russian modernists, they had for a long time, in Gerasimov's words, "been lying in heaps in the stores of the Tretiakov Gallery" and other Soviet museums. The only difference between events in the two countries was with regard to time: the same process took three or four years in Germany and over two decades in Russia.

The monumental sculpture which "defiled public squares and gardens" suffered a worse fate. Weimar Germany had had little time for sculpture and few contemporary monuments had been erected. The fate of those which had, including works by Barlach and Wilhelm Lehmbruck, can be guessed only too easily. Barlach's letters during the thirties are full of the despair of the master contemplating the ruin of his creations: "On Hitler's birthday, with no great publicity, they broke up my "Crusader for the Victory of the Spirit" in Kiel. It was one of the works whose form was determined by the conditions of its site ... like the Magdeburg monument" (24 May 1937). "Meanwhile it has been decided in Hamburg to remove my work from the memorial ensemble. If that happens, all my most important works will have been taken away and destroyed – as though they had never existed in our time. In Magdeburg, Kiel, Lubeck, Gustov and Hamburg" (9 February 1938).[67]

In Russia immediately after the Revolution the erection of monuments "to

* The finest Van Gogh in the collection – "The Red Café in Arles" – is now in the Philadelphia Museum of Arts.

great people in the area of revolutionary and social activity" had been a central part of Lenin's general plan for monumental propaganda. In Moscow a July 1918 decree of the Soviet of People's Commissars called for the erection of fifty such monuments. In Leningrad seven monuments were unveiled in October and November 1918 alone: to Radishchev, Lassalle, Dobroliubov, Marx, Chernyshevskii, Heine and Shevchenko. During the first decade after the Revolution, dozens, if not hundreds, of such monuments were erected throughout the country – among them such important works as the grandiose model of Tatlin's Monument to the Third International and N. Andreev's Obelisk of Freedom in Soviet Square in Moscow. The plan for monumental propaganda, however, called for more than this; the first part of the title of Lenin's decree spoke of "the removal of monuments to the Tsars and their servants ..."[68] It was this, in essence, which unleashed the forces of destruction which in the thirties and forties swept away most of what had been produced in the twenties – and at the end of the fifties swept away nearly all the main monuments that had been produced in the Stalin era.

The steamroller of cultural terror passed not only over works of contemporary art, but also over their creators. Its passage through Germany has been described in detail, thoroughly analysed and documented: lists of works confiscated, sold and destroyed have been published, together with circulars from ministries and departments and biographies of the artists. The artists' fate is, on the whole, well known. The majority of the most important emigrated to the West. Ernst Ludwig Kirchner shot himself, despite having written not long before his death: "Events in Germany have deeply shocked me, and yet I am proud that those brown-shirted iconoclasts are also attacking and destroying my pictures. I would feel insulted if that kind tolerated me."[69] The bitterness of humiliation and of the destruction of his work evidently proved too strong. Hans Grundig, Otto Dix and Otto Freidlich all ended up behind barbed wire. Some of those who attempted to find sanctuary in Soviet Russia ended their lives in Stalin's concentration camps – including Herwarth Walden, the founder and inspirer of the "Sturm" movement, and the Communist artist Heinrich Fogeler.

A list of victims of Stalin's terror is still to be drawn up. Facts that began to percolate into the press at the end of the fifties were strictly censored again by the mid-sixties. It is clear, however, that this terror was – at the very least – no less fierce than Hitler's. Calls to do away with "the class enemy on the Art-front" were not merely rhetorical flourishes in newspaper editorials. In 1938, in a report to a session of the Union of Soviet Artists, Aleksandr Gerasimov summed up the period of bloodiest repressions: "Enemies of the people, Trotskyist-Bukharinite rabble, Fascist agents, who have been active on the Art-front and attempted in every way to brake and hinder the development of Soviet art, have been unmasked and neutralized by our Soviet intelligence service under the leadership of Stalin's Peoples' Commissar comrade Ezhov. This has made

the creative atmosphere more healthy and open the way to a new wave of enthusiam among the entire mass of artists."[70] Exactly who was neutralized by Ezhov's intelligence service is something we are not told by official sources.

Malevich had a clear understanding of the position of the Soviet avant-garde and he anticipated the difficulties he would face. In 1927, before returning to the Soviet Union after an exhibition of his work in Berlin, he entrusted his personal archive, along with all seventy of the exhibited paintings, to his German friends. He also left a will in which he stated that this was in order "to save them from destruction and in order that they should, in due course, enter cultural circulation." On his return to the Soviet Union, he was arrested as a German spy. Thanks to petitions made by his friends, however, he was soon released – these were "vegetarian times". Malevich died in 1935, just before the beginning of the Great Terror. Two of his close colleagues, Vladimir Sterligov and Vera Ermolaeva, had both been arrested in 1934; a third, Gustav Klutsis, would be arrested and executed in 1938. The artists Aleksandr Drevin and Konstantin Istomin were sent to the Gulag. Two of the most brilliant avant-garde theoreticians, Nikolai Punin and Sergei Tretiakov, died in the Gulag; and the mincing machine also disposed of the same P. Kiselis whom Lenin in 1921 had attempted to install as director of IZO . . . The members of the avant-garde who survived the years of persecutions and arrests lost faith in the value of their own discoveries and became unable to imagine that anyone could still be interested in their work. The legendary Tatlin withdrew into himself after the war, moving away from his friends and continually returning in conversation to old enmity with Malevich. Nothing interested him, and no one in Russia appeared interested in him.[71] Other founders of the new art were in a similar position and similar state of mind.

G. D. Costakis, the well-known collector of the Russian avant-garde, describes in his memoirs how during the forties he searched through Moscow cellars and attics where works by members of the avant-garde had been heaped up with piles of jink. Their owners thought it not only senseless but even dangerous to attempt to preserve them. Friends and relatives of the arrested artists immediately destroyed not only their archives, but also their works (this was how most of Drevin's work was destroyed). Less dangerous material was used for utilitarian purposes: paint was scraped off canvases to be used for new works, boards were used to stop up windows, stoves were heated with various wooden constructions, children constructed toys out of bits of metal and paper.[72]

Who knows how many artists, together with their creations, perished under Stalin without any legal enactments, ratified lists or public spectacles? And on what scales can one compare the burden of crimes of the different hues of totalitarianism? Nadezhda Iakovlevna Mandelstam – the widow of Osip Mandelstam, the great poet who died in one of the camps – passed through many circles of the Soviet Hell and summarized her experience as follows: "One has to live our life in order to learn one truth: while corpses are lying about on the streets and main roads, one can go on living. What is most terrible of all is when you don't see the corpses."[73] It is very possible that inhabitants of Germany who survived Nazism would not agree with this Russian aphorism

(iv) Italy on the path to total realism

> Mussolini is not a revolutionary like Hitler or Stalin. He
> is so closely tied to his Italian people that he loses the
> essential qualities of a revolutionary or rebel on a world
> scale.
>
> Goebbels

The hyperactive Italian Duce has been compared with a conductor attempting to play all the instruments of the orchestra, and with a powerful generating station functioning in order to light a single bulb. This last image could be applied to Italian totalitarianism as a whole – certainly in comparison with Stalinism or Hitlerism and their high-voltage incandescence.

In Mussolini's orchestra, after the decline of Futurism, the arts ceased to play the role of first violin. Although Mussolini remained faithful till the end to the ideals of the Futurists – their hatred of bourgeois culture, their cult of youth, strength and optimism, their love of danger, their belief in the future and contempt towards both past and present – he preferred to see these ideals embodied on the pages of a history he had himself created rather than on the canvases of his former comrades. Ideology in general served Mussolini as a means of attaining political goals, and he usually referred to it as "a luxury and for intellectuals only".[74] He was only too ready to turn the ideological map to suit the needs of the moment and spoke disparagingly of Hitler – for whom the ideological sphere was always of primary importance – as "an ideologue who talks more than he governs".[75] On the one hand he promised to realize the greatest of artistic revolutions in Italy as soon as he had time to resolve urgent political problems; on the other he complained that the excessively artistic nature of Italians was detrimental to their political maturity. On the one hand he appealed to the magnificent cultural heritage of Michelangelo, Raphael and Leonardo; on the other hand he said he would "prefer to have fewer statues and pictures in Italian museums and more flags captured from the enemy"[76] and insisted during the war that the country be defended "inch by inch" and "without any false sentimentality over its artistic heritage".[77] He called upon artists "to pour into art the expansive breath of the people which it now lacks"[78] and then suddenly, in 1934, defended contemporary architecture – then under fierce attack in both Germany and Russia – on the grounds that it was "absurd in our age to denigrate rational and functional architecture". Of the "Fascist city" Sabavdia, constructed in accordance with these principles, he said, "It is just what a city should be in the twelfth year of Fascism".[79] It is hard to make out any similarity between this stream of paradoxical bombast and the iron determinism of the Principles of the Führer or of Socialist Realism.

The fate of art in totalitarian societies, however, is determined not only by the will of Duces, Führers or Leaders; it is inevitably subject to the general laws

which govern such societies. With regard to both politics and culture the Duce was treading the same path as others – and he himself anticipated many of its developments. It is another matter that he was not endowed with the single-minded determination of the other dictators and so did not follow this path to the end.

The totalitarian conception of art as a "powerful weapon in the struggle ..." and as a way of "educating the masses in the spirit ..." was gaining ground in Italy – and not only as a result of the ties developed with Germany around 1938; perhaps more important was the Duce's constant interest in everything that happened in Russia. Mussolini had welcomed the Bolshevik Revolution from the very beginning, and in 1939 he was a fervent supporter of Stalin's entry into a Triple Alliance. He felt an inner kinship with the Soviet dictator, and "some of his followers wondered if the two movements [Fascism and Stalinist Communism] were coming so close as to be no longer easily distinguishable; he himself considered such an approximation to be at least a possibility".[80] A symbol of this can be seen in the presence during the last days of the regime, as Mussolini's right-hand man and the "grey cardinal" of the Salò republic, of Nicola Bombacci, once a leader of the Italian Communist Party. It was under his influence that Mussolini, with the aid of German bayonets, attempted to realize the socialist ideals of his youth, calling his nightmarish Salò regime "the only truly socialist government in existence – with the possible exception of Soviet Russia".[81] Socialist pretensions of this kind took Mussolini still further away from the artistic concepts of modernism and encouraged him in his instinctive tendency to move towards "something similar to the socialist realism found in Russia".[82]

The year 1932, which saw the abolition of artistic groupings in the USSR, was the tenth anniversary of the Fascist revolution in Italy. Under totalitarian regimes such celebrations are a convenient opportunity to proclaim the ideals which direct State policy along a new channel or else speed its movement along present channels. Mussolini would have been untrue to himself if he had failed to take advantage of this anniversary. In October, during a speech before the National Conference of the United Fascist Syndicates of Free Arts and Professions, he spoke of the impending unification of culture and public life:

> There was a time when it was thought that Fascism and Culture, Fascism and theory were mutually antagonistic. Such antagonism is indeed a fact if culture is understood as dry erudition, a mechanical accumulation of knowledge without warmth or life, if the intellect takes on the likeness of a sack of facts from which nothing can be extracted. Fascism does not participate in such culture but despises it, just as it nurses no sympathy towards the ivory tower of the various kinds of abstract and neutralist intellectual philosophizing which often mask an incurable spiritual sterility. Culture and university diplomas do not give their possessors the right to stand aside from the life of our day and our epoch; on the contrary, they call upon us all to live a full life, to be people of our

time, to avoid sterile egotistic isolation – for we cannot stand aside from the stupendous and intense experience of the magnificent period of birth throes and efforts in which we live. In this our common Fascist State all intellectual forces working in the area of consciousness and spirit must be multiplied and instilled deep into our national life. Only then will Rome once again lead the world.[83]

Mussolini's global ideas were taken up by the Fascist ideologues, interpreted and applied at various levels and in various spheres of culture. The forum for putting his ideas into practice in the sphere of the representational arts was the 1932 exhibition in Rome, "Art of the Fascist Revolution". Dino Alfieri, the organizer of this exhibition and head of the Ministry of Popular Culture, described it as the first grandiose display of the greatest achievements of Fascism in the area of culture and as a demonstration of the beating of a certain higher will, the inspiring, creative will of the leader which gathers together all the mysterious powers of the race. Porlibeni, the general inspector of fine arts, demanded truthfulness and reality of representation; C. E. Oppi, the president of the National Syndicate of Fascist Visual Art, called upon artists to create monumental canvases like open books to the masses;[84] Giuseppe Bottai, the Minister of Education, insisted that "art must cease to be the exclusive privilege of the bourgeoisie"; and the well-known critic R. Papini – as though repeating the arguments of official aesthetic discussions in Russia before the establishment of Socialist Realism – wrote of the collectivism of the new art, which was opposed to bourgeois individualism and was not only the goal, but also the means for propagating ideals and facts. All these high-ranking functionaries, like their colleagues in Germany and the USSR, held firmly to a belief in a propagandist art that praised the achievements of the epoch; brochures with such titles as "Fascist Art is the Art of the Masses"[85] were widely distributed by Mussolini's propaganda apparatus.

Slogans and appeals, however, are not enough to create a new type of art, and it is unlikely that the Fascist leaders were satisfied with the ideological products that were supposed to represent their greatest achievements. After ten years of Fascism, and again after twelve, the Italian press compared the Soviet and Italian pavilions at the Venice Biennale and sadly admitted:

What enormous things have been achieved in Italy during the last ten years in the area of land improvement, restoration and construction – why have so many labours, so much courage, so much political and technical wisdom not found any reflection in Italian painting? ... To blazon Fascist art abroad till one's ears ring, and then do nothing or almost nothing in order to reflect the constructive power of Fascism that is envied by the whole world – such a situation is deeply sad and astonishing. I cannot but remark on this, especially in comparison with the spiritual unity which inspires the Soviet artists. It is essential to remember that we are living in the twelfth year of Fascism.[86]

What was lacking in Mussolini's Italy was a fully completed cultural machine; without this the fuel provided by ideological slogans was wasted.

The idea of organizing culture as a single whole was a logical development of Fascist doctrine and, in particular, of Mussolini's classic definition of the totalitarian state as an aesthetic and spiritual union of government and people. A people, not fused into one whole with the State, was according to Mussolini not a people, but a crowd; when asked how this fusion could be achieved, his interpreters replied:

> This is the answer of Fascism: by means of the organization of people into groups in accordance with their useful activities, groups which will be grateful to their leaders – the captains of tens, hundreds and thousands of men – as they construct something similar to the pyramids, whose base is formed by the masses and whose apex is the State. No groups outside the State, no groups against the State, all groups within the State. The organization of practitioners of the free arts and professions into registered professional unions [sindicati] is the most specific and outstanding achievement of the Fascist regime.[87]

General totalitarian aspirations were given their most precise formulation by Mussolini and his comrades; in this instance, however, as so often in Fascist Italy, words were never embodied in concrete forms of social life.

The Fascist Academy was founded in 1926, and the National Syndicate of Fascist Visual Art a year later. The centre of the latter was in Rome and it had eighteen departments in the provinces. Its president was the artist Cipriano Oppo, a realist. Its stated aim, like that of all such institutes, was firstly the State support of artists, which would free them from the power of "the money-bag" – from private patronage, which "degraded the worth of the nation" – and secondly the encouragement of artists' links with life, the transformation of art into "a factor for improving and elevating the life of the people".[88] With these aims in view, the Syndicate not only organized up to fifty exhibitions a year in different cities, but also set up new forums for Fascist art: the Rome Quadrinnale (from 1931), the Milan Triennale, etc. In the early thirties the Venice Biennale was reorganized, exhibits being selected more strictly. Membership of the Syndicate gave artists definite advantages with regard to receiving State commissions. The Syndicate also had the right to a deciding vote in the appointment of artists to positions of responsibility within the system of cultural control.

Antonio Mariani, the general secretary of the Venice Biennale, gave the following description in the English journal *Studio* of the workings of the Syndicate:

> The aim of this institution is clear. It is meant to create in the artist a sense of responsibility, a consciousness of his place in the life of his country ... if the spirit and feelings of artists as citizens could be improved, their work would reflect this change and become healthier and happier ... Each one of the Interprovincial Syndicates has to promote a yearly exhibition of its members in the chief town of the region ... The artists who show their capacity ... can

be admitted to the National Exhibitions which are held every two years in Rome and in other great cities. Those who are best in these National Exhibitions are invited to participate in the great International Exhibition of the *Biennale* of Venice ... Last but not least, for the Masters who deserve the highest recognition, Fascism has created in the Royal Academy of Italy a class reserved to the painters and sculptors which confers on those elected conspicuous rank and salary. Thus the career of the artist, first as a student, later as a member of the Syndicate and finally, if he grows to real fame, as an Academician, is always accompanied by the State.[89]

Later, two more essential elements were incorporated within this ideal model of the Italian totalitarian megamachine: State prizes and regular exhibitions on a particular theme. The "Cremona prizes", established in 1937 "in order to encourage the best works of Fascist art", were set up before the Stalin prizes in Russia and the State prizes in Germany. As for the exhibitions, Mussolini himself chose their themes, together with such titles as "The Battle for Corn", "The Fascist Youth of Italy", "They listen to the Duce's Speech on the Radio", etc. It It was only at this time that the Fascist cultural machine began to function entirely in accord with the general laws of totalitarianism. Artists received commissions, embodied the set themes in a strictly realistic form and turned out a product which "was as close to the Socialist Realism of Stalinist Russia as the Russian art of the period of the Bolshevik Revolution was close, in Marinetti's opinion, to Italian Futurism".[90] The organization "Dopo Lavoro", responsible for propagandizing Fascist culture among the workers, brought this art to the masses in the same ways as the Nazi "Strength through Joy" and the Soviet Directorate of Artistic Exhibitions and Panoramas. The artists most devoted to the regime were rewarded with the highest State prizes and titles.

The names of these Fascist laureates have been literally erased from the pages of art history. Even at the vast 1982 Milan exhibition "The Thirties: Art and Culture in Italy" their work was represented only by poor photographs glued on to two cardboard panels and hung outside the main exhibition with no indication of the names of the artists or the whereabouts of the originals. At the end of the thirties, however, they stood on the very pinnacle of the Fascist artistic hierarchy, and it was their work that was held up as an example to Italian artists as a whole. Dino Alfieri, the Italian Minister of Culture, a favourite of Hitler and a close friend of Goebbels, was only summarizing the general mood when, in 1939, he quoted almost word for word a well-known statement of Lenin's to the effect that "art must be comprehensible to the broadest masses of the people"; "Art must be, in these times of noticeable social betterment, art for the people and by the people; such art as shall exalt the people and which the people, advancing towards higher aims, will understand."[91]

It might seem from Antonio Mariani's picture of the role of the artist in the Fascist State in 1936 that the appeals he made in 1928 – that art should be as efficiently organized in Italy as in the Soviet Union – had indeed been realized;

Longoni: The Battle for Corn

Anon.: Italy
(Cremona Prize)

Anon.: Fascist Youth
(Cremona Prize)

nevertheless, for all the similarities with Stalinist Russia and Hitler's Germany, one extremely important link in the system was still missing. On joining the Syndicate of Fascist Visual Art, an artist, like any other State official, had to vow loyalty to the regime; he did not, however, have to vow loyalty to its aesthetic dogma – and so was not incurring any serious obligations with regard to his work. Most important of all, unlike in Germany or Soviet Russia, it was not essential for artists in Italy to be members of a professional body in order to practise; they were free to acquire the necessary material and instruments, to exhibit their work in private galleries, to offer it for sale on the commercial market and to publish in the press. In Germany and the Soviet Union Party censorship penetrated into every cell of social and individual consciousness; in Italy it extended at an administrative level only to the daily press, otherwise concerning itself only with the preservation of morale and the excision of direct attacks on the Duce.

Totalitarianism as a whole effected its control of art through the use of both the carrot and the whip. Italian Fascism, however, used only the carrot: its cultural policy was executed through encouraging supporters rather than through destroying opponents. It is true that Van Gogh was declared a madman and Picasso a charlatan, that German Expressionism and French Fauvism were seen as bearers of a "North-Western spirit" that was hostile to a truly Italian perception of the world; nevertheless modernism was not subjected to any large-scale witch-hunt, nor was there anything that can be called cultural terror. For all its demands for truth to life and realistic form, in practice Fascism reconciled itself to the widespread existence, throughout the thirties, of both Tatlinesque Constructivism and more organic forms of abstract art. Much of what was created during these years by such artists as L. Veronesi, F, Melotti and F. Grigani was the subject of further development after the War, in particular in Op Art. The reason for all this lay not only in the relatively "vegetarian" character of Italian Fascism.

During the twenties Mussolini was proud of having preserved previous organizational forms under the new regime, explaining the chaos in Russia as the result of the destruction of such forms; during the Second World War, however, he tended to ascribe the Russian victories to the fact that Stalin had in essence preserved "only one newspaper and one radio station".[92] Mussolini was unable – or did not wish – to carry out the complete nationalization of all museums, private collections, exhibition halls, systems of artistic education and means of mass communication. It is for this reason that the new ideological institutions he established – the Fascist Academy (1926), the National Syndicate of Fascist Visual Art, the Ministry of Popular Culture, the Government Section of Contemporary Art (1942) – failed ever to become organic parts of a single apparatus for the control of art. Without such a foundation, without the control of cultural life in all its forms and on all its levels, i.e. without a State monopoly,

the totalitarian cultural machine was unable to function effectively.

Ideology, organization and terror, fused into one whole and nourishing one another, were the essence and foundation of the totalitarian regimes in Stalin's Russia and Hitler's Germany. In Italy a powerful generating station for ideological propaganda functioned without the necessary driving belts to connect it to the mechanisms of the country's cultural life. In Italy the construction of the totalitarian triad was an unrealized ambition, one that had been present from the very beginning, had been reinforced in the late thirties, and then came to nothing with the collapse of the regime.

(v) Appendix: the Chinese variant

The new culture and the reactionary culture are now engaged in a battle to the death: there is no construction without destruction, no liberation without limitations and no movement without breathing. With regard to the new culture, it is a reflection of the new politics and the new economics and is at their service.

Mao Tse-tung

Unlike the Italian variant, the Chinese could be taken for an ideal model of totalitarian culture with regard both to the purity of its stated principles and to the consistency of their application. It is probable that there is nowhere where

Chinese poster: Art Comes from the Struggle

the demarcation line between the old and the new, the progressive and the conservative, the revolutionary and the counter-revolutionary, was as sharply defined as in China. In 1940, in *The New Democratic Culture* Mao Tse-tung wrote:

> The new political, economic and cultural forces in China are revolutionary forces and they contradict the old politics, the old economics and the old culture. The old order consisted of two parts: one was the native Chinese, almost feudal, politics, economics and culture, the other was the imperialist politics, economics and culture – and it was this latter that had the dominant role in the alliance. All this is evil and must be entirely destroyed. Reactionary culture serves imperialism and the class of feudal lords, and it must be swept off the face of the earth. Until it is destroyed, it is impossible to construct any new culture.[93]

The "new culture" was defined by Mao Tse-tung as "a powerful revolutionary weapon of the people".[94] Inexperienced in dialectical subtleties, the Chinese mentality tended to take the statements of its revered leaders literally, and the principles of Mao, whenever and wherever they were stated, were immediately put into practice.

The Chinese variant would indeed be an ideal model of totalitarian culture if it were not second-hand. "The Chinese Communists followed in the footsteps of the USSR, and the literature and art of Communist China are in effect a part of Soviet literature and art"[95] – these words of Chung Chao, a writer who broke with the regime, convey the official orientation of the Chinese leaders during the first stage of their cultural policy. In his famous speeches at the meeting of literary and artistic figures in Yangyang on 2 and 23 May 1942, Mao Tse-tung stated directly that "the experience of the USSR" in general, and the principles of Socialist Realism in particular, must be an example for the culture being constructed in China.[96] From then until the present day the culture of Communist China has followed this path unswervingly, making its own variations on the experience of the Big Brother but all in all repeating it – in spite of the deep ideological divergences between the two regimes which have become increasingly accentuated since the mid-fifties.

Mao's Yangyang speeches laid the foundation for Chinese cultural policy and in official documents are grandiloquently referred to as "The Compass of the Great Proletarian Cultural Revolution". The needle of this compass pointed to the usual key ideological points. According to Mao the allotted role of art was to be a weapon in the class struggle; its aim was to expedite victory in this struggle; its method was to instil the ideas of this struggle into the consciousness of the masses through a language that was universally accessible. The most powerful magnetic pole for all compasses of this kind was the conception of the identity of culture and ideology, of the inseparability of artistic activity and political tasks. Mao's statements on this matter are far from original:

> In actual fact there is no such thing as "art for art's sake", an art that stands above the classes, which stands aside from politics or is independent of it. Proletarian literature and art are only parts of the single whole of the proletarian

revolution;* as Lenin said, they play the part of cogs and wheels in the general revolutionary machine. What we demand is the unity of politics and art, the unity of form and content.[97]

Mao could just as well have quoted Goebbels or Hitler. His one original contribution was to take the common totalitarian dogma to a still further extreme: by speaking in the same breath of "the unity of form and content" and "the unity of politics and art", he was in effect proclaiming art to be merely a form of politics, with no other content. The consequences of this identification were soon manifest.

Following the same logic, Mao named literature and art the cultural front ("the front of the pen" alongside "the front of the rifle"), going on to state: "If popular literature and art go into decline, then the revolution will be unable to continue and we will not achieve victory."[98] (Hitler was thinking the same thing when he spoke of the necessity of decisive intervention in cultural matters during periods of revolutionary development – see pp. 83–4.) By "popular" Mao meant not the Chinese people's traditional forms of creativity, but the "mass" language of the official culture he was attempting to construct. In his address to writers and artists at Yangyang, copying the verbal mannerisms of Stalin he posed the rhetorical question – "What is a mass style?" – and answered: "It means that the thoughts and feelings of our writers and artists must fuse with the thoughts and feelings of workers, peasants and soldiers. How can literature and art speak if you find the very language of the masses is incomprehensible? If you wish the masses to understand you, if you wish to be one with the masses, you must prepare yourselves for a long and even agonizing path of fusion with the masses".[99] Having fused with the masses and learnt their language, artists must then reflect life not directly, not as "objective reality", but in its movement towards the social ideal: "Life, as it is reflected in art, can and must be elevated to a higher level, must be more intense, more concentrated, more typical; it must stand closer to the ideal and so be more universal than everyday life. Revolutionary literature and art must construct a multiplicity of characters taken from everyday life and help the masses to move history forward."[100] In this passage Mao is simply paraphrasing the Zhdanov–Stalin definition of Socialist Realism with its emphasis on the reflection of reality "in its revolutionary development". Like Hitler in his Munich speech he said that the moving forces of this development were the main objects to be reflected in art: "What about those who create history in this world, why should they not be glorified? What about the proletariat, the Communist Party, the leaders of the new democracy and socialism, why should they not be objects of glorification?"[101]

In its resolution on the meeting of literary and artistic figures in Yangyang, the Chinese Communist Party Central Committee noted that "this speech by

* Mao is repeating totalitarian clichés so slavishly that he uses the phrase "proletarian culture" even though he understands his own revolution as being fundamentally a peasant one.

comrade Mao lays the foundation for Chinese government policy in the area of literature and art at the present stage. The whole Party must study this document."[102] The Party and intelligentsia did indeed continue until recently to study this document as zealously as, in their time, speeches by the Führer and the Leader were studied in Germany and the USSR. The Chinese variant of total realism was thus from the very beginning as firmly linked with the name of Mao Tse-tung as Socialist Realism with the name of Stalin and National Socialist Art with the name of Hitler.

The necessary organizational machine for applying these principles in China was also a copy of existing totalitarian models.

In January 1949 Mao announced the formation of the Chinese Peoples' Republic with himself as head of both Party and State. In June of the same year the All-Chinese Association of Workers in Literature and Art was formed in Peking; this immediately began preparations towards the convocation of an All-Chinese conference of creative workers. Soon 824 delegates from different branches of art gathered in Peking for a conference closely modelled on the First Congress of Soviet Writers; like the latter, it lasted exactly two weeks, and it ended with the formation of the All-Chinese Federation of Literature and Art. In its structure this was, admittedly, more reminiscent of Goebbels's Chamber of Culture than of the Soviet artists' unions, being divided into separate associations of representational arts, literature, theatre, music, dance, art history, etc. Also, just as the Chamber of Culture was subordinate to the Ministry of Education and Propaganda, so the All-Chinese Federation was under the jurisdiction of the Ministry of Culture, which was in turn subordinate to the State Soviet headed by the Chairman himself. The Ministry of Culture also included the Chief Academy of Arts, which had a monopoly on all artistic education within the country. The "general programme" adopted at this conference included the chief demand that every totalitarianism makes of its culture; paragraph 15 of chapter 5 states: "Literature and Art must serve the people, awaken its political consciousness and reinforce the enthusiasm of the workers. Outstanding works of literature and art should be supported and encouraged."[103] With the introduction of compulsory membership of the All-Chinese Federation for all artists and of academic titles and State prizes for the most successful, a new elite was created among the Chinese intelligentsia of guardians of the sacred principles of Mao. The first issue of the main organ of the Federation, the journal Art, was published in January 1954. According to Chung Chao, "it was only after the All-Chinese Conference of Artists and Writers in July 1949 that full control of culture was finally achieved".[104]

Alongside organization, the natural and inevitable means for achieving such control is terror. Mao was dealing with almost a billion people and had an Asiatic indifference to the value of the individual human life, making no exception, at least in his youth, for his own. Even the threat of an American invasion and the

destruction of most of humanity in a nuclear war was proclaimed by Mao to be no more than a child's toy, a "paper tiger". And when Nehru first visited Peking in 1954, Mao explained his position as follows: "If the worst happens and half of humanity perishes, then the other half will remain. Imperialism will have been razed to the foundations and the whole world will become socialist. With the passing of time another two billion and seven hundred million people will appear, and perhaps still more."[105] He obviously did not consider this price too high, and he himself modestly estimated the number of his own victims between 1949 and 1954 as eight hundred thousand.

In China, as in the USSR, the curve of cultural terror both rose and fell. In 1956 Mao unexpectedly put forward a slogan which appeared to contradict the whole of his previous cultural policy: "let a hundred flowers bloom" (in art) "and a hundred schools in philosophy". He explained that "it is dangerous to impose or forbid any particular style in art and philosophy through administrative measures" and that such measures should be replaced by the method of "painstaking clarification".[106] He even accepted the possibility of criticism of Party decrees, saying that under their blows Marxism, like a boxer, would only strengthen its muscles. "Hot-house flowers are hardly notable for their robust health," he declared, and the masses "will themselves distinguish fragrant flowers from poisonous weeds". Mao did admittedly propose six conditions which art should observe and which he suggested the masses could use as criteria for distinguishing between weeds and flowers: it should strengthen the unity of the Chinese nation of many peoples, aid socialist construction, reinforce the popular democratic dictatorship, reinforce democratic centralism, reinforce the leadership of the Communist Party, and help to bring about international socialist solidarity and the solidarity of the peace-loving peoples of the whole world. The most important of these concerns were the socialist path of development and the leadership of the Party. "Of course," Mao wrote, "one also needs other appropriate categories in order to judge the truth of scientific theories or the aesthetic value of works of art, but these six political criteria are applicable to all areas of activity in art and science."[107]

Such deviations from the highway are not unique in the formation of totalitarian cultures. It is enough to remember the reassuring decree of the Bolshevik Party Central Committee (18 June 1925), "On the policy of the Party in the area of artistic literature", which also spoke of the need for an attitude of care towards artists, of the inadmissibility of administrative measures, and an impartial attitude on the part of the Party leadership towards all existing artistic movements. Seven years later a new Party decree abolished this theoretical diversity and opened the way to cultural terror. In spring 1966, all that had flourished during the nine years since Mao's liberal assurances was brutally uprooted as Mao began his Cultural Revolution.

In the words of the Chinese Communist Party Central Committee resolution

of 8 April 1966, "The aim of the great proletarian cultural revolution is to revolutionize the ideology of the people, and as a result to achieve significant, rapid, better and also more economical results in all areas of working activity."[108] Six million students and senior schoolchildren were united for this purpose into detachments of "Red Guards" or – for the youngest – "Young Pioneers". They ran amok on the streets, tearing European clothes off passers-by, burst into temples and museums where they destroyed everything they saw as a product of the "feudal past" or Western modernism, and accused their teachers of all possible bourgeois sins. Their destructive activities were directed by Mao's closest comrades and in particular by his wife Chiang Ching – a former actress who had been appointed to the Central Committee. Mao's Yangyang speeches, now republished by the central press, no longer seemed abstract or metaphorical: many thousands of writers and artists were exiled from the cities to workers' communes in order to undergo the "long and exhausting process of fusion with the masses".

Paintings and books were burnt under the socialist regimes of Stalin and Hitler – both openly in public squares and secretly according to lists provided by censors; their creators disappeared in labour camps under both regimes, but, as a rule, they disappeared quietly. In China, however, not only were pictures spat on in public, but so were the faces of their creators; artists were beaten, led between ranks of frenzied Red Guards, marched down streets in dunces' caps and then made to repent before the crowd of their evil plans or simply of failing to understand the wise policies of the leader of the Chinese people. But by the second half of our century such features of proletarian and cultural revolutions had ceased to astonish – they were thought of merely as Eastern embellishments of familiar totalitarian melodies and march rhythms.

What can arouse legitimate astonishment is the attitude of China's new culture to her own cultural heritage. To anyone wishing to study the mechanisms which developed the international style of total realism, the Chinese variant is especially instructive.

Throughout the almost four thousand years of its development, Chinese representational art had known neither oil painting nor sculpture in the European sense; the very idea of a painting inserted in a frame and hanging on a wall was deeply alien. European influences had penetrated Chinese painting only at the beginning of our century. Only since then had European modernist easel-painting begun to coexist with the traditional Chinese method of drawing in ink on rolls of silk or paper – so-called go-hua painting. Mao was equally hostile to both of these traditions, seeing the first as a product of Western Imperialism and the latter as a continuation of the native feudal culture. Although he followed Lenin in saying that it was essential to take care of the national heritage, and that "we must distinguish in the culture of the past between the scum of the feudal governing class and truly popular elements

which are democratic and revolutionary in character",[109] Mao could not, for all his wishes, have found anything in the Chinese past except "feudal scum": the Chinese representational tradition knew neither the peasant-revolutionary motifs of Albrecht Dürer, nor the monumental heroism of the artists of the Italian Renaissance, nor the social awareness of the Russian Peredvizhniki. The only resort left to the Chinese leaders was to turn to Soviet Socialist Realism. A resolution of the Second Congress of the All-Chinese Federation of Literature and Art (October 1953) demanded that "energetic measures be undertaken to

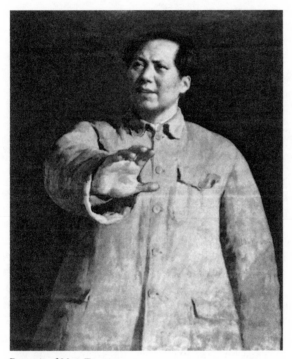

Portrait of Mao Tse-tung

study the mature experience of the USSR in the area of literature and to strengthen cultural interpenetration between China and the USSR".[110] For its part, the Soviet Union was only too willing to share its experience with its Chinese comrades. Students at art academies began painstaking copies of antique marbles and Michelangelo's "David", they studied the canvases of Aleksandr Gerasimov, the monuments of Evgenii Vuchetich and the drawings of Boris Prorokov; having mastered the techniques, they began to use oil and marble to glorify those who were worthy of glorification, i.e. "the proletariat, the Communist Party and the leaders of the new democracy and socialism".

see p. 319 (below)

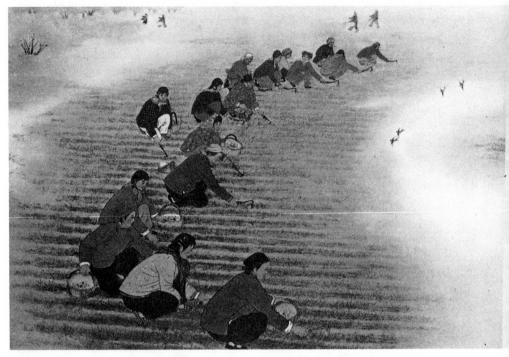

Peasants in the Fields (1958)

"In practice, the overcoming of the colonial and the feudal meant that certain artistic genres were banned. Nudes disappeared and still lifes were few and far between; landscapes were tolerated only as a background to depictions of industrial construction. The dominant genre was the portrait. Huge portrayals of Mao were installed in public markets and squares. The means of Party control of art was the Union of Art Workers, which distributed commissions, planned details, and checked on their execution. 'Backward' artists were subjected to criticism; one, for example, was criticized for 'devoting more attention to a horse than to a soldier'."[111] The stylistic similarity between the Chinese and Soviet products became absolute. Li Chang-ching's once-famous painting "The East Grows Crimson", for example, was an almost exact copy of Feodor Shurpin's "The Morning of Our Fatherland", the only difference being that Mao held his cloak in his left hand and Stalin in his right.

For all this, the problem of the national heritage was not so easily resolved. The March 1954 issue of the journal Art (the Chinese rather than the Soviet version) published an article "Stalin on Art" which quoted Stalin's well-known definition of Socialist Realist art – "national in form, socialist in content". Mao himself in his 1940 article "On the New Democratic Culture" had slightly varied

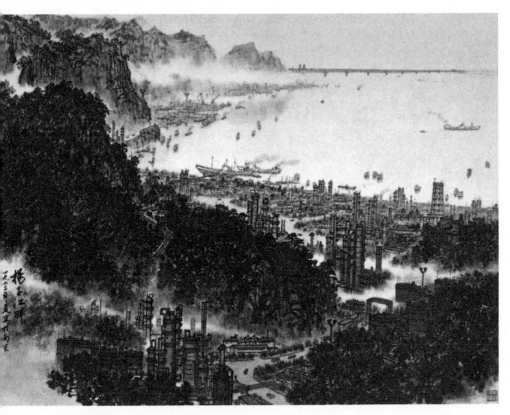

Industrialization on the Banks of the Yang-tse

this formula – "national in form, new democratic in content".[112] But the Chinese ideologues responsible for art had evidently had no idea whatsoever how to combine this formula with the calls of their Chairman mercilessly to uproot all "feudal" forms of the national past. It was only the art of the mature period of Stalinist Socialist Realism that suggested the correct resolution, that one could use the severe faces of icon-painting in order to praise the glory of the Russian armed forces – as Pavel Korin did in his mosaics for the Komsomolskaia metro station – and that one could use national forms of ornamentation to portray the general flourishing of peoples under socialism – as in the pavilions of the various Soviet republics at the Exhibition of Economic Achievements in Moscow.

After 1954, traditional go-hua painting, which till then had been kept down, began once again to blossom among the hundred flowers. With the most delicate brushes, dipped in coloured ink, Chinese artists drew smoking blast-furnaces and huge cranes, hurtling trains and the lines of high-voltage cables disappearing into the misty distance of hills and lagoons. All that was left of "national in

form" was a technique, gentle shifts of perspective and sometimes the vertical format of the traditional roll; everything else belonged to the category of "socialist" or "new democratic in content" total realism. Go-hua painting of this kind was not weeded out like others of the hundred flowers, but survived the Cultural Revolution and, in parallel with the orthodox varieties of totalitarian art, continues to flourish to this day.

In this way, the new Chinese culture, at first merely a part of Soviet culture, was comprised in the general universe of totalitarian culture, with all the consequences this entailed. From the very beginning it had a completed model before its eyes and, creating itself in its likeness, it began to turn out products which in style, social function and ideology were hardly distinguishable from those of the other totalitarian systems. Chinese representational art is indeed a striking example of the universality of the mechanisms of totalitarian culture: in whatever point on the globe they begin their functioning, whatever national soil serves as the foundation for their construction, whatever realities are reflected in their magic mirrors, these soils and realities always take on one and the same aspect – that of the socialist paradise where there is no more pain or suffering, where happy people under the guidance of wise leaders construct a new life and harshly chastise their enemies.

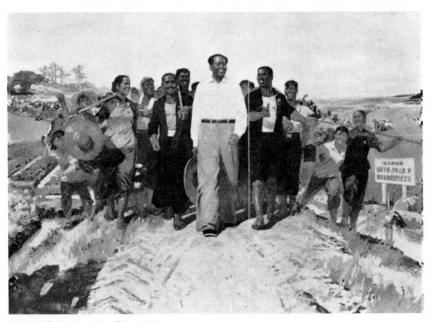

Mao with Peasants in Kwantung

PART TWO – THE PRODUCT

Encounter in Paris (1937 and beyond)

In 1936, sensing the icy breath of totalitarianism and foreseeing its coming night, Ernst Barlach entitled a new sculpture "The Tragic Year 1937". It was a small figure, huddled up against the cold, with the face of Käthe Kollwitz – an artist who, like Barlach himself, had been expelled from the Prussian Academy. Barlach's intuition did not deceive him. In Germany this year was marked by the Munich exhibition of "Degenerate Art", in Russia by the climax of Stalin's show trials and purges. In both countries the very date has become a symbol of cultural and political terror.

Amid the chaos of cultural pogroms the official artistic style of the two totalitarian regimes developed with new strength and optimism. It was in 1937 that National Socialist Art revealed its heroic face at the First Great Exhibition in Munich. It is to the same year that we owe such classical examples of Socialist Realist Art in the USSR, imbued with the spirit of youth and faith in the triumph of their ideals, as Vera Mukhina's group sculpture "Worker and Collective Farm Woman". According to Soviet criticism, both past and present, this "has the right to be considered an epoch-making work of art, expressing the content and the most advanced ideals and tendencies of our age ... World art had never seen popular images of such striking grandeur."[1] And it was in the summer of 1937, at the International Exhibition of Arts, Crafts and Sciences in Paris, that the two warring systems first met and displayed themselves to the world.

The exhibition, opened in May by the French President, consisted of 240 pavilions from 42 countries. The world press gave wide coverage to the event, describing it as representing the "triumph of modernism". The pavilions of most countries – Britain, Belgium, Czechoslovakia, Sweden, and Japan among them – were designed in a "rational" style, and the works of art they contained were in harmony with the contemporary architecture. The Pavilion of Electrification was adorned with vast panels 660 metres square painted by Raoul Dufy – constituting the biggest picture by one man, as was proudly pointed out at the time. The French Pavilion contained Chagall's "Revolution" together with a huge painting by Miró, neither of which has been preserved. The younger generation showed examples of the various styles of abstract art which were then flourishing. The Pavilion of Republican Spain included Picasso's newly

finished "Guernica", a response to the first large-scale bombing of a civilian population. A number of painters embodied their premonition of the coming nightmare in Surrealist and Expressionist images. A large Van Gogh retrospective in the French pavilion served to demonstrate both how the art of the thirties was linked with tradition and how it departed from it. In this context the Soviet and Nazi pavilions seemed like manifestations from another planet.

In recognition of the immense significance they both attached to the appearance of their pavilions, the USSR and Germany were allocated places of honour beside the Eiffel Tower, on either side of the main boulevard leading from it to the Seine. "What is on show at this exhibition," said Doctor Ruppel, the organizer of the Nazi pavilion, "can be summed up in a very few words: the projects and designs of the Führer's great constructions which are destined to change the character of German life."[2] The Soviet pavilion, in the words of Boris Ternovets, the organizer of a number of international exhibitions, "clearly expresses the idea of efficiency and powerful growth, of the invincible movement of the Soviet Union along the path of conquests and victories".[3]

The Soviet pavilion was planned as a synthesis of architecture, sculpture see p. 365 and the other arts. It was designed by Boris Iofan as a large streamlined block, crowned on its main western façade by a tower eight storeys high. The 35-metre pilasters of the tower emphasized the upward thrust of the entire building. The tower performed a second role as a pedestal for a vast group-sculpture one-third of its own height – the previously mentioned "Worker and Collective Farm see p. 366 Woman": two huge figures, seeming to move from east to west and carrying in their upraised hands a hammer and sickle, the symbol of the Soviet State. The meaning of the pavilion was explained in a special brochure: "The style of the Soviet pavilion bears the definite imprint of the artistic method we call Socialist Realism", and "the most important quality of the Soviet pavilion as a work of architecture is the fullness of its imagery, its ideological completeness."[4]

The German pavilion stood directly opposite. Five hundred feet high, it too see p. 364 was completed by a tall tower crowned with the symbol of the State – an eagle with a swastika. Intended to be left standing as "a piece of sacred German earth", it had been built "exclusively from German iron and stone" and was the costliest building at the exhibition; ten thousand tons of material had been transported by train from Berlin. It too had been planned as a synthesis, the sculpture being an "integral part of the architecture". The architect, Albert Speer, describes in his memoirs how the idea of the complex first came to him:

> While looking over the site in Paris, I by chance stumbled into a room containing the secret sketch of the Soviet pavilion. A sculpted pair of figures thirty-three feet tall, on a high platform, were striding triumphantly towards the German pavilion. I therefore designed a cubic mass, also elevated on stout pillars, which seemed to be checking this onslaught, while from the cornice of my tower an

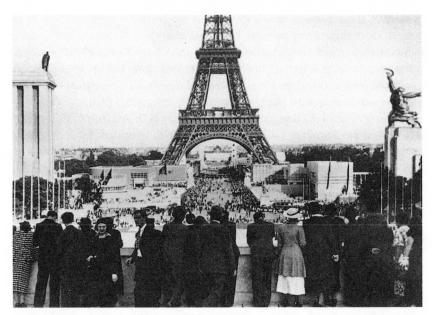

Photograph: Panorama of the Champs de Mars (Soviet and German Pavilions)

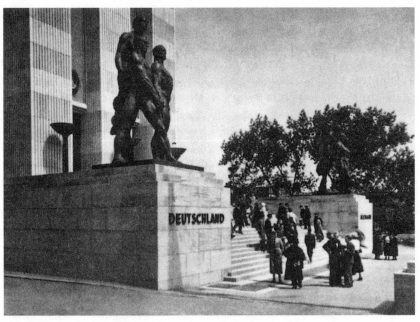

Entrance to the German Pavilion with Comradeship by Thorak

eagle with a swastika in its claws looked down on the Russian sculptures. I received a gold medal for the building; so did my Soviet colleague.[5]

It was not only the outspread wings of the eagle that checked the advance of the hammer and sickle; at the foot of the building Speer placed Thorak's sculpture "Comradeship" – a group of huge figures, twenty-two feet tall and *see p. 367* with the chests of supermen. It is interesting to compare official contemporary descriptions of the Nazi and Soviet sculptures: "Powerful figures standing side by side and full of strength ... marching in step, united by a common will, moving forward, sure of themselves and sure of victory";[6] and "moving forward with the same powerful movement ... long powerful strides, the majestic folds of clothing, the bold youthful faces of these people looking bravely into the distance, into the sun and wind – all this strikingly embodies the fervour of our epoch, its aspirations for the future".[7] In Speer's confession and in these descriptions we can see the similarity of "artistic" criteria more clearly even than in the buildings themselves. A "fullness of imagery" expressing an "ideological completeness" has, in both countries, become the main criterion of artistic evaluation.

When they decided to place the Soviet and Nazi pavilions opposite one another, the organizers of the International Exhibition were probably hoping to underline the contrast between the two warring systems. The actual effect, however, was the opposite. Ten years later, the Italian artist Gino Severini, who had himself experienced the nature of totalitarianism, reminisced: "One was struck at once, in looking at the whole, by the obvious intention of making *size*, of making immense, pompous size. The same gloomy rhetoric was also to be found in the German pavilion which stood exactly opposite the Russian – and we find it, alas, in Italy and a thousandfold in Rome: an architecture of propylaea well fitted for bourgeois cemeteries."[8] The magazine *Art Digest* commented at the time:

> The finest pavilions are those of Japan and the smaller countries, those which aren't striving for prestige. In contrast, the German building with its frighteningly vast tower can only be seen as an expression of Fascist brutality. Russia is represented by another construction in the same spirit and the Italian pavilion also produces a surprisingly similar effect, this time achieved by more contemporary means.[9]

While drawing attention to such shared characteristics as brutality, pretentiousness and pomposity, serious critics defined the style of the two pavilions as neoclassical. An orientation towards the forms of classical antiquity had indeed already become the official slogan of totalitarian culture – in Germany, Italy and the USSR alike – in its search for universal roots and national traditions. It is therefore not surprising that the similarity between the two pavilions did not escape the architects and designers themselves. Both sides, however, saw the neoclassical pretensions of the enemy as merely a cunning ideological

camouflage. A Nazi critic called the style of the Russian pavilion "barbaric formalism" beneath a thin veil of classicism, while referring to the Nazi pavilion as purely "Nordic".[10] The Paris exhibition was hardly discussed in the Soviet press – except for mentions of the success of the Soviet pavilion; but one critic, in a discussion of "Fascist" art, remarked: "This 'ideological harmony' is merely a camouflage for the discord of real social relationships. For this reason it is sterile and false; in practice the slogans of Fascist 'neoclassicism' serve only to camouflage the irrationality of the content beneath a 'rational' form."[11]

In general, however, the works of the Soviet, Nazi and Fascist artists were almost lost in the vast ocean of visual art on display. Few people paid any attention to the mosaic by Mario Sironi, "Labour and Industry", which adorned the Italian pavilion, to the Soviet panels portraying comrade Stalin amid crowds of ecstatic workers, or to the factory scenes on display in all three pavilions; the press itself hardly mentioned them. Gino Severini's recollection of the Soviet pavilion is one of the few detailed accounts we have:

> I remember perfectly the inside of that pavilion, the two big pictures which decorated the vestibule of the main entrance and were entitled "1917–37" together with many other pictures in the last section in which Stalin was always portrayed in the centre surrounded by generals or workmen – all of them, especially himself, "terribly life-like". Other pictures were about the transformation of Moscow and Leningrad. Others were inspired by a glorification of youth or by popular festivals. Indeed, from the point of view of inspiration and treatment they were identical with the well-known Fascist pictures of the exhibitions of Rome or Milan. The works of sculpture, among which stood out a group of Lenin and Stalin together, were on the same level.[12]

From the point of view of all three totalitarian ideologies these themes and styles, this "closeness to real life", were signs of a true blossoming of art. They all considered that by achieving "identity with life" art had already attained the level of the highest peaks of world culture and was now ready to surpass them. Adolf Ziegler, the chairman of the Reich Chamber of Art, gave the following résumé of the state of German art in a speech about the German pavilion:

> Under the powerful influence of this new surge of life there is no longer any place for artistic schools or intellectual "isms" ... For the most outstanding German artists have now grouped themselves around the Führer and his comrades ... This explains why it is that an outside observer will discover a new creative spirit and a true Renaissance all over Germany, in all areas of culture – architecture, sculpture and painting. The Reich Chamber of Arts, of which all German artists are members, is striving to disseminate this new spirit as widely as possible ... In the course of a few decades this natural development, under the leadership of Doctor Goebbels ... will cause future decades to consider the works of this period the German Renaissance.[13]

At the same time, Soviet criticism, inspired partly by the success of the Soviet pavilion, put forward a final definition of Socialist Realist Art, one which was

to be repeated again and again in works on Soviet aesthetics: "Socialist art is a new stage, the highest stage in the development of humanity's artistic activity. We are standing on the threshold of a new Renaissance."[14]

At the Venice Biennales Soviet art had appeared, in the words of Galassi (see pp. 51–2) "almost alone" in its aspiration to link itself to real life and to express the majesty of the epoch; at the Paris exhibition, however, it found a worthy partner. There the two totalitarian systems met as enemies, both claiming the dominant role in the contemporary world. In the Soviet Union magazine covers and the front pages of newspapers were adorned with the slogan: "Proletarians of the World Unite". All over the Third Reich German youth sang: "Today Germany, Tomorrow the World!" The magic mirrors of Soviet and Nazi art reflected in essence the same image, but the two cultures still refused to recognize this. Events after 1937, however, appeared to be developing towards such a recognition.

Two years after the Paris Exhibition, at a meeting of Soviet representatives with U. Schnurre in Berlin, words were said about a common element in the ideologies of Germany, Italy and the Soviet Union – their opposition to the Western democracies. Six months later, after the signing of the Nazi–Soviet non-aggression pact, Stalin pronounced his famous toast at a meeting in the Kremlin: "I know how much the German nation loves its Führer; I should therefore like to drink his health." Ribbentrop informed Hitler afterwards that during this meeting "he felt more or less as though he were among a group of old Party comrades".[15] Later still flags bearing the swastika and the hammer and sickle were to be hoisted side by side during the combined parade of German and Soviet forces to celebrate the crushing of Poland. And in 1940 Molotov sent a special telegram to the German Führer, warmly congratulating him on his brilliant victory over France.

The Nazi–Soviet non-aggression pact contained an article about cultural exchanges. In the event these remained largely unrealized, probably because people brought up on anti-Nazi and anti-Soviet propaganda were not considered ready to appreciate the cultural achievements of their newly declared friends. Nevertheless, at the very top, cultural links were being developed. At the beginning of October 1939, for example, von Schulenburg, the German ambassador in Moscow, informed Hitler that Stalin was personally interested in German architectural designs. Soon after this an exhibition of models of Nazi architecture was shown in the Kremlin. While keenly following Soviet architectural developments, however, Hitler ordered the most important German designs to be kept secret – "so as 'not to give Stalin any ideas' ". Soon, Speer writes, "Schnurre ... informed me that Stalin had liked my sketches."[16] Not a word was said in the Soviet press about this secret exhibition, but the fact that it took place shows that at the highest levels moves were indeed being made towards a cultural *rapprochement*. Who knows? – but for the war, Muscovites might have had the

chance to gaze in the halls of the Tretiakov gallery at portraits of Hitler and Goering in their full state regalia.

After 1939 not much new was added to the cultural and social life of Germany.[17] Nor is there much to be said about cultural life in the USSR after this date. The next changes came after the Second World War, when another wave of cultural terror was to raise Soviet art to new and still greater heights. But by the beginning of the war a complete model of totalitarian culture had been constructed in both the USSR and Germany, and Italian culture was following close on their heels. The ideology had been defined, the organizational megamachine had been set up, the cultural terror had reached its peak and was even on the ebb; these three closely interrelated elements had already begun to produce what in both countries considered itself "an art of a new type". In its structure, in its social functions, in its style and artistic language, this art was indeed radically different from all the preceding art of our century. Until the mid-thirties we have been considering totalitarian art in its development and formation; now we can consider it as something fully formed.

The Present, the Past and the Future (inheritance and traditions)

(i) New heights

Our art has achieved great successes, being by rights the
most progressive, the most ideological, the most popular
and revolutionary art in the world, being a beacon for all
of advanced and progressive humanity.

Iskusstvo, 1949

On 15 November 1939 Goebbels wrote in his diary: "I watch the new weekly
newsreel with the Führer ... Apart from on these occasions, the Führer scarcely
has any time to concern himself with the arts. Worries and responsibilities
occupy his entire time."[1] As the Führer switched his attention to military
matters, National Socialist art lost the main force behind its development.
Goebbels, the head of the propaganda system which included the Chamber of
Culture, looked on the cinema as the main means of influencing the masses. He
paid little attention to the fine arts and did not share the Führer's radical views.
The 20–30 pages of the monthly *Kunstkammer,* the official organ of the Chamber
of Art, consisted mainly of neutral material to do with the artistic heritage
and the applied arts and can hardly be seen as a channel for propagating the
ideas of National Socialism. This journal was admittedly closed down in 1936
and replaced by *Art of the Third Reich,** published from 1937 to 1944 under the
editorship of Alfred Rosenberg. Nevertheless differences between Rosenberg
and Goebbels on matters of artistic policy, together with arguments about the
respective spheres of responsibility of the Ministry of Propaganda and Robert
Ley's Workers' Front, of the Chamber of Culture and the departments of the
Wehrmacht responsible for art, did not help to crystallize what had been devel-
oping so rapidly during the first five years of the Nazi regime. This situation in
Germany is somewhat reminiscent of an earlier stage in the development of
Soviet art, when the newly reorganized Narkompros, Agitprop, Glavpolitprosvet
and PUR attempted to impose on artists a general line that was not always
consistent in detail.

*In 1939 the title was changed to *Art of the German Reich.*

139

More importantly, the war, which lasted for almost half the history of the Third Reich, slowed down the development of totalitarian culture and weakened the system of control. In 1943, for example, German artists officially congratulated Edvard Munch on his eightieth birthday – someone who not long before had helped to represent degenerate art at the exhibition in Munich. There is evidence that works by the banned artists Emil Nolde, Karl Schmidt-Rottluff and Max Pechstein surfaced again at exhibitions held during the war.[2] In exactly the same way, the Soviet intelligentsia, left for a while without supervision, allowed itself in 1942 to exhibit works by Pavel Filonov, Vladimir Tatlin and Liubov Popova in an abandoned Moscow; we know of this, however, only from accounts by eyewitnesses.

But if the collapse of the Third Reich put an end to the development of totalitarian culture in Germany, the Soviet victory heralded the beginning in Russia of "its new and highest stage". The period from 1946 to 1953 in the Soviet Union can be considered with absolute justification as the most achieved, productive and "classical" period in the development of totalitarian art as a whole. It was during these years that the megamachine of culture was perfected; the dogmas of Socialist Realism, sketched out by Lenin and honed down during the harsh ideological struggle of the twenties and thirties, were now elaborated in detail by vast new special institutes, painstakingly formulated, and then summarized into the "code of laws" of Soviet aesthetics, philosophy and theory of art. Many of the dreams of Nazi artists, many of Hitler's own fantasies, like the plan for a cultural and ideological memorial in Linz (much of which, like the plan for the reconstruction of Berlin, remained on paper or in plaster-cast in the office of Albert Speer) – much of this was in fact realized in the plan for the reconstruction of Moscow, in the grandeur of the new metro, in the architectural-ideological complexes of the restored cities, in the canvas, stone, marble and bronze of the masters of Stalinist Socialist Realism. After defeating the enemy, it was not only technology and armaments that the victors bore away from Germany. Just as in 1814 the Russian army had carried back from Paris the ideals of the French Revolution, so now the ideals of Nazism were transferred from Berlin to Moscow.

Unlike the red, white and black flag of Nazism designed by Hitler, the banner of the Russian Revolution, first raised in 1917, was uniformly red. Proletarian internationalism and racist nationalism had appeared to be the most consistent components of the two ideologies and allowed people to look on them as two warring opposites. This changed, however, with the defeat of Hitler.

On 24 May 1945, at the Kremlin celebration of victory, Stalin proposed his famous toast "to the great Russian people", emphasizing its capacity for "endurance" and its leading role among the peoples of the Soviet Union. The words of this toast were lauded in verse and prose, printed on M. Khmelko's vast canvas "To the Great Russian People" and interpreted as a guide for action.

The new wave of cultural pogroms that arose in 1946 swept away not only any remaining formalists, but also the new enemies – the "homeless cosmopolitans" who bowed down to the West, distorted the great Russian language and denigrated the significance of the national cultural heritage. The Central Committee decrees "On the journals *Zvezda* and *Leningrad*" (14 August 1946), "On the repertoire of dramatic theatres" (26 August 1946), and "On the film *The Great Life*" (4 September 1946) were a powerful stimulus to the development of this process; the decree "On the opera *Great Friendship* by Vano Muradeli" (10 February 1948) marked its culmination. The text of the latter accused Sergei Prokofiev and Dmitrii Shostakovich of distorting the language of the musical classics and also stated that Muradeli's opera gives "the false impression that ... Georgians and Ossetians were ... hostile to the Russian people, which is historically false, since during that period it was the Ingush and Chechens who were a hindrance to the establishment of the friendship of peoples in the Northern Caucasus".[3] By 1948 the Ingush and Chechens had been exiled from their homeland in Georgia to distant regions on account of their supposed collaboration with the Germans during the war; now they were also being held to blame for inciting hostility against the Russians at the time of the Revolution.

Two closely interlinked factors can be considered decisive in the process of the final establishment of the structure and style of totalitarian art in the Soviet Union: firstly, the general abrupt turn towards nationalism; secondly, the creation of the USSR Academy of Arts, the apex of the complex apparatus for the control of art. The first factor introduced a missing element into the general ideology of Soviet totalitarianism and evoked a second wave of cultural terror, the second marked the final completion of the cultural megamachine.

As in 1934, the mouthpiece for the new cultural policy was Andrei Zhdanov. During a speech at the February 1948 Central Committee conference with Soviet composers and musicians, Zhdanov put forward a general validation for the sharp turn from proletarian internationalism to undisguised Russian national-ism: 'Internationalism is engendered where national art flourishes. To forget this truth means to lose the guideline, to lose one's face, to become a rootless cosmopolitan."[4] This Party directive entailed firstly a radical reconsideration of the role of the national heritage, and secondly the use of the harshest measures against those "homeless cosmopolitans" who "consciously" attempted to belittle the role of Russian art in the development of world culture. All this required a still greater degree of centralization in the organizational apparatus.

A summer 1919 decree of the Soviet of People's Commissars, signed by Lenin, Lunacharskii, Stalin and Chicherin, abolished the Russian Imperial Academy of Arts on the grounds that it did not "justify itself historically"; a declaration by Narkompros noted that with this decree "free creativity defeated the empty formula of the academic canon".[5] In 1947 the Academy was re-established and once again granted the status it had enjoyed under Catherine the Great: that of

"the highest organ controlling all areas of the country's artistic education and artistic culture". As was stated in its regulations, the role of the Academy of Arts was "to further the creative development of the principles of Socialist Realism in the practice and theory of Soviet multinational artistic culture". The most worthy Stalin laureates were "elected" as members, and Aleksandr Gerasimov, the chairman of the Union of Soviet Artists, was appointed its first president. The enormous Institute of the History and Theory of Art was set up under its auspices to establish a theoretical foundation for the new ideology, and the journal *Iskusstvo*, now to all intents and purposes the organ of the Academy, introduced this ideology into the practice of Soviet artistic life. The struggle against cosmopolitanism and the assertion of the superiority and the popular spirit of Russian art, not only during the Soviet period but in all stages of its development, became the most important of the Academy's tasks.

The Zhdanov–Stalin campaign against rootless cosmopolitans, like similar German policies during the thirties, was directed primarily against cultural historians, critics and art critics who, by noting the achievements of the West, supposedly belittled the role of the national heritage. The main task on the new agenda was to establish Russian superiority in all areas of culture, art, science and technology. Russian art, which had learned from the West since the time of Ivan the Terrible, was now credited with an originality that guaranteed its superiority over all foreign models. That the walls and cathedrals of the Moscow Kremlin were built by Italian architects, that the plan of St Petersburg was elaborated by the Frenchman Leblon and its general appearance was the result of work by Trezzini and Rastrelli, that the author of the "Bronze Horseman" praised by Pushkin was Falconet – all this became insignificant and was mentioned only with considerable provisos. "The little-known Frenchman Mogne and the lively Englishman Dow – these are the main names of the foreign artists; all the rest are so insignificant as not to deserve mention. They did not exert the least influence on Russian artists, enjoying neither authority nor love,"[6] wrote the academician Mashkovtsev. It turned out that eighteenth-century Russian sculptors such as "M. I. Kozlovskii, F. S. Shchedrin and I. P. Martos must be given first place in the European art of the time, as must F. I. Shubin, who worked outside classicism"; that in comparison with Fedotov (1818–52) "how verbosely superficial appears Hogarth, coming from petty humour, leading one to a savouring of details and never attaining romantic heights"; and that "Surikov is the greatest not only of Russian, but of world historical painters".[7]

In the works of Stalinist theoreticians and historians this superiority of Russian art began to be linked less to the social conditions of its development than to its reflection of the Russian national character; and this national character was contrasted with the Western "egotistic personality of the private individual, the newly engendered bourgeois, aware of his right not only to freedom but also to domination – a personality doomed finally to the deepest isolation".[8] According

to Marx and Engels, bourgeois society left no link between people except naked self-interest and heartless money; in Russia, on the other hand, where serfdom continued until 1861 – wrote the "Marxists" of Stalin's time – it was the very backwardness of the country that went to form the national character, tied as it was through close bonds to the whole of society. "The deep link of the human personality with society remained unbroken in Russia throughout the entire eighteenth century. It did not disappear even in the middle of the century, the epoch when rococo reigned in the West with its famous slogan: 'Après nous, le déluge'."[9] This link endowed the Russian national character with a particular "humanity" and "spiritual warmth" which became the ideal and the unique quality of Russian art, guaranteeing it first place among the arts of all peoples: "Not one of them [Western artists] had such spontaneity, straightforwardness and genuine warmth as Levitskii ... Chastity and heartfelt warmth became distinguishing characteristics of Russian art."[10]

Patriotism, love of the fatherland and devotion to the State were now held up as the special worth of the Russian character and Russian art. The twilight of museum stores yielded up forgotten masterpieces, such as the sculpture "The Russian Stsevola", by Demut-Malinovskii (1779–1846) which illustrated these qualities. In order to prove the "epochalness" of this work Mashkovtsev cited a legend: "In the army of Napoleon they branded everyone who entered the service. Following this custom they branded the hand of a Russian peasant who had been captured by the French. As soon as he learnt what this meant, he seized an axe and chopped off his branded hand." The verisimilitude of the legend is rivalled only by the indisputability of the hero's moral achievement, but the Marxist academician is quite unembarrassed by the fact that the Russian peasant was a serf, that the banners of Napoleon's army proclaimed the slogans of the French Revolution, and that Napoleon was thinking of abolishing serfdom in Russia. Internationalist ideals of equality, freedom and revolution pale before the sense of tribal community which prefers the familiar whip of the master to a foreign brand. And so: "Demut-Malinovskii created a truly popular work which contains elevated perceptions about the simple Russian man and the patriotic beauty of his achievement."[11]

In texts of this kind we can easily recognize the familiar imprint of totalitarian ideology. Countless analogies could be found in the cultural and racial theorizing of Alfred Rosenberg and Richard Darre, which ascribes to the German people the same "special place" among other nations, the same link with the soil, society and the State, the same patriotism, humanity and heartfelt warmth. Whether such theorists quote Marx or Gobineau, the *Communist Manifesto* or the *Protocols of the Elders of Zion*, they conclude by emphasizing one and the same thing: the exceptional quality of the culture and people to which they belong.

The nearer we draw to our own age, the more strongly totalitarianism

affirms the cultural superiority of its own nation. Soviet appraisals of nineteenth-century art were as alike as two peas to Hitler's dinner-table discourses about how "during the nineteenth century the greatest masterpieces in each area were the works of our Germans". In the Soviet Union all this was elevated to the level of high theory. "What other country's nineteenth-century art can be compared with the art of the Russian artists Repin, Surikov and the Peredvizhniki as a whole? ... Courbet? ... In the ideological depth of his works, in his grasp of the social life of contemporary France, he cannot enter into any comparison with Repin."[12] French painting of the time as a whole? But "what a storm in a teacup this epoch will appear in the history of world art as soon as we compare the ideals, slogans, tasks and achievements of the French and Russian artists".[13]

Hitler dated the degeneracy of contemporary art to the beginning of our century, when he himself came up against the dominance of modernism in his two unsuccessful attempts to gain entry to the Viennese Academy. Although he had little respect for Impressionism and included it in his speech at the opening of the House of German Art in the list of "isms" which were "not of the least value to the German people", nevertheless the lists of works of degenerate art removed from German museums did not include paintings by Monet, Renoir or Pissarro. Soviet art criticism assigned the same decline to an earlier period – the eighties of the last century. Impressionism was declared the bearer of an anti-human and almost "Fascist" ideology. "Manet said: 'The main actor in the painting is light'. 'And not man, not rich and many-sided reality', we add,"[14] wrote Sysoev, Secretary of the USSR Academy of Arts. He concluded: "Impressionism as a method is deeply alien and hostile to Socialist Realist art."[15] As for the Impressionist discovery of plein-air painting, according to Sysoev: "In actual fact Russian artists were the first discoverers of outdoor painting in Europe. The priority of Russian art in this area is obvious to any honest researcher of art history ... Long before the appearance of Impressionism in France, almost at the beginning of the last century, Shchedrin was painting his landscapes in the fresh air, from nature."[16] The same opinion was held by Boris Ioganson, the second president of the USSR Academy of Art: "Many art historians falsely assign the discovery of plein-air to the French. It is quite astonishing how these historians can fail to notice the realist artist, the world genius of painting – the Russian artist A. Ivanov. He first led man out into nature, preserving in full measure his inner world and classic form."[17]

All this may seem now like some black parody, but by the fifties only the oldest generation of the intelligentsia could still remember that there had been such artists in nineteenth-century Europe as Turner, Constable, Goya. The country had cut itself off from the whole of world culture. During twenty-five years there was hardly a single exhibition of foreign art, contemporary or other-wise – with the exception of a very few "revolutionary" and "progressive" artists. In 1947 the Moscow State Museum of Modern Western Art – the only place in

the USSR where one could see European painting from Manet to Cubism – was closed down. The building was taken over by the newly established USSR Academy of Arts, as though to emphasize thrugh this symbolic gesture the final triumph of Socialist Realism over modernism. Displays of Russian art in the Tretiakov Gallery in Moscow and the Russian Museum in Leningrad came to an end in the eighties of the last century; during the last years of the Stalin regime even such realists as Isaak Levitan and Valentin Serov evoked suspicion on account of their slight leanings towards Impressionism.* Finally, in 1949, the Pushkin Museum of Fine Arts – the only collection in Moscow of classical Western art – was closed down. The building was then used for a permanent exhibition of gifts presented to comrade Stalin.† In this situation, with Kramskoi being praised in the pages of journals and scholarly works at the expense of Velasquez, it is hardly suprising that there was a sharp decline in the country's general artistic standards.

On the occasion of the establishment of the Academy of Arts, *Pravda* wrote: "It is absolutely inadmissible that alongside Socialist Realist art there should exist movements, represented by admirers of the bourgeois decadent West, which consider their spiritual teachers to be the French formalists Picasso and Matisse, the Cubists and the artists of the Formalist group 'The Knave of Diamonds'."[18] It goes without saying that by 1947 it was impossible even under the microscope to detect any influence of Cubism, Matisse or Picasso in Soviet art; by then any deviations whatsoever from the principles of Socialist Realism were seen as a departure from Russian tradition, as a sign of admiration of the West and "rootless cosmopolitanism". The fervour of Soviet exposures of the degeneracy of contemporary art was at the very least no less intense than that of Hitler in the thirties. As in Nazi Germany, regardless of an artist's political convictions or subjective intentions, the very form of his work was seen as a sign of the correctness or otherwise of his *Weltanschauung*. Soviet aesthetics and criticism was now attacking the heart of twentieth-century art: its main enemies were such artists as Cézanne, Rouault, Matisse, Picasso and Henry Moore ... "The images of 'Guernica' are as monstrous and pathological as in Picasso's other paintings. No, the aim of Picasso's morbid, repulsive works is not to criticize the contradictions of reality, but to make an aesthetic apology for capitalism."[19] That "after the geniuses of the Renaissance ... the daubs of some Rouault should be worth their weight in gold!"[20] "The painting of G. Wood is close to that of the German school 'Die Neue Sachlichkeit', which in its time, as is well known,

*I can remember how in 1949 we students of the art history department of Moscow University, then doing practical work in Leningrad, were taken into the closed stores of the State Russian Museum. There for the first time we saw portraits by Serov and works by Vrubel, Roerich, Kustodiev and Nesterov from the 1910s. Even we were not allowed to see works later than this.

†The museum was only reopened two years after the death of Stalin, in 1955.

encouraged German Fascism."[21] "... 'Family Group' by the English sculptor Henry Moore, 'Shivering Man' by Matta, 'Lovers' and 'Sitting Woman' by Picasso – all these works are an example of the logical culmination of the disintegration and ruin of bourgeois art. It is hard to imagine a more terrible decay and mockery of the image of man."[22] Such appraisals became an essential feature of every issue of any periodical or of any scholarly work relating to the field of art.

The white of nationalism had begun to filter into the Soviet ideological palette from the beginning of the thirties. From 1948, as the anti-Semitic campaign against "rootless cosmopolitanism" gathered momentum, the colour black appeared too. These two colours of Hitler's Nazi emblem now showed through the original red of the Soviet flag.

The very term "rootless cosmopolitanism" was borrowed from Nazi publications, and the so-called "ideology of cosmopolitanism" was a copy of Hitler's version. On the one hand, it was rooted in some international Jewish conspiracy; on the other hand it was the ideology of "war-mongers and above all of the American cosmopolitans of Wall Street".[23] The face of international imperialism, as in Germany before, increasingly took on obviously Semitic features. Art criticism did not, admittedly, speak directly of the Jewish sources of formalism and modernism. Nevertheless, the general openly anti-Semitic atmosphere occasioned by the exposure of countless Jewish conspiracies – "the murderer-doctors in white gowns", "the Weissman-Morganists" in biology, the supporters of Einstein in physics, etc. – enveloped the entire cultural sphere as well. Few issues of the journal *Art* after 1947 appeared without denunciations of "Cosmopolitan-critics": "A. Efros, N. Punin, I. Matsa and O. Beskin have still not been fully exposed ...";[24] "with all decisiveness we must refute every statement of Efros and Beskin about the internationalism (and internationalism alone) of painting ... With these views they are sliding into rootless cosmopolitanism";[25] "Efros and Punin, the most dyed in the wool and reactionary apologists of rotten, decadent bourgeois culture, were not alone in their talentless exercises. Over a number of years, for example, the journal *Iskusstvo* (editor O. Beskin) has periodically published articles by various authors in praise of major representatives of Western formalist art – Cézanne, Matisse and Picasso."[26] In 1950 the theoretical anthology of the Academy of Arts eloquently summarized the result of this campaign: "It is the crushing defeat of the anti-patriotic group of cosmopolitan critics which has cleared the way for a true Bolshevik struggle in the name of higher artistry and the advancement of craftsmanship."[27]

Of those mentioned above only Matsa continued to work. Punin, a theoretician of Futurism at the beginning of the Revolution and later an extremely important art historian, was arrested and died in one of the camps. Abram Efros, the brilliant art critic and essayist, was almost certainly arrested, though sources conflict. Osip Beskin, the main editor of *Iskusstvo* from its first establishment and

throughout the thirties, spent some years in the camps. It was he who had led the struggle against formalism, had defended the value of tradition and had put into practice the slogans of Soviet artistic ideology. Now these very slogans, though textually unchanged, had been filled with a different content.

Until the forties, Soviet theory had followed the Stalinist definition of Socialist Realism as art that was "national in form and socialist in content". The concept of "socialist content" included the whole gamut of ideological clichés: Party spirit, progressiveness, popular spirit, etc.; "national in form" was understood as implying the diversity of national traditions of the art of the peoples of the USSR. For example, the heightened colours of the great Armenian artist, Martiros Sarian, or a certain stylization of form in the work of artists from the other republics had been ascribed to their national traditions and put forward as an indication of the stylistic diversity of Soviet art within the single method of Socialist Realism. Now, however, such liberties were seen as the result of the influence of Matisse and Picasso and as a departure from the national tradition:

> The experience of Armenia demonstrates that M. Sarian's one-sided passion for the pictorial-decorative aspect of creativity has impoverished the creative potential of many young and talented artists of Armenia and has prevented them to this day from creating realistic paintings of true value. On the other hand, the experience of such Armenian artists as Nalbandian and Zardarian demonstrates that the correct utilization of the tradition of the *Russian* realistic school allows them to manage work in such extremely difficult genres as the composition portrait and the theme painting.[28]

In passages like this the Stalinist formula attains its final simplicity: national means Russian. What occupies the foreground now is questions of national sources, of the Russian artistic tradition; all other questions have faded into the background.

The new upsurge of Soviet art proclaimed in the forties was linked primarily to this ideological about-turn. It is as though the Soviet megamachine needed precisely this ideological component in order to operate at full throttle.

"The charm of history and its enigmatic lesson lie in the way nothing changes from century to century and yet at the same time everything looks quite different,"[29] wrote Aldous Huxley with regard to other times and other places. This formula may not be universal, but it certainly bears on this epoch. Nobody in Soviet Russia had withdrawn the slogan of proletarian internationalism, Soviet propaganda still proclaimed the friendship of the peoples of the world, the same red flag of revolution still fluttered over the Country of Triumphant Socialism, but, as Huxley might have said, everything looked quite different.

(ii) From the future to the past

The present and the future unexpectedly appear in a new
light, and as a result a new mission for the future lies
before us. An epoch is beginning today when the whole
of world history must be rewritten from the beginning.

Rosenberg

It is essential for us to know what happened in the past,
not, however, as it has already been told, but as it is
illuminated by the teaching of Marx-Engels-Lenin-Stalin.

Gorky

In order to reach the highest level, one must acquire roots; and, according to Orwell, whoever controls the past also controls the future.

Totalitarian ideologues have always seen true culture as a kind of ideal fiction which was partially realized in distant epochs of the past (for Marx and his followers, as well as for Hitler, in antiquity and to some extent in the Renaissance), and which would become a reality only in the equally distant future, when victorious Communism, Fascism or National Socialism united humanity into a single exultant fellowship. In the glimmer of these far horizons the whole of contemporary culture appeared of no significance, while the past, in spite of any praise accorded it, was merely useful material with which to construct the future.

When Lunacharskii resigned at the time of the October Revolution, appalled at the bombardment of the Kremlin and the resulting destruction of ancient monuments, Lenin was genuinely surprised at the inconsistency of his future Commissar for Art. "How can you?" he said to Lunacharskii, "attach such importance to one or another old building, however fine it may be, when we are talking of opening doors to a social order which is capable of creating a beauty immeasurably superior to what in the past people could only dream of?"[30] In essence Lenin was repeating one of the ideas of the avant-garde he so disliked: "One should have more regrets over a screw with a broken thread than over the destruction of the church of Vasilii the Blessed" (Malevich).[31] In the same way Trotsky evaluated the state of Russian literature and art in 1924 as "almost a stage of approach to an approach to the art of the socialist future". He made no exception for the realists who were then emerging, referring to them condescendingly as "useful manure" for future culture.[32]

Here lies one of the paradoxes of totalitarian consciousness. For all its aspirations towards the future, it always, sooner or later, ends up gazing into the past. Lenin was prepared to sacrifice any cultural treasures in order to achieve a great goal, but it was he who, in spite of the avant-garde and long

before Hitler, insisted on the preservation of the cultural tradition. Something new cannot be constructed in an empty place, he considered, and the avant-garde's denial of the past was only a logical development of the tendency of bourgeois culture to squander its own heritage; like Hitler after him, Lenin saw this as the source of all the non-realist tendencies in twentieth-century art. With the appearance in the historical arena of a new progressive class, with the victory of the proletarian revolution, the proletariat and the proletariat alone had become the legitimate heir of all human culture; it alone was capable of correctly evaluating and making an appropriate use of the highest achievements of the past. Hitler was merely modifying these well-known statements of Marxist-Leninist theory when he declared, for example, that "the gigantic works of the Third Reich ... shall one day belong to the inalienable cultural heritage of the Western world, just as the great cultural achievements of this world in the past belong to us today".[33] In the rivalry over this cultural heritage each totalitarian regime put forward its own claimant. For Communism the claimant was the Class, for National Socialism it was the Race. According to Lenin, "art belongs to the people", understood as the working masses; according to Hitler, "art belongs to the whole complex of racial values and abilities of the people", understood as a certain ethnic formation, bound together by a community of blood and soul. In each case there appears on the historical arena in the person of the people a supreme judge, endowed – either by the objective laws of history or by the right of primogeniture – with the authority to deliver judgments on the past against which there can be no appeal. For the concrete manifestations of the past are not of equal worth; the past was formed as a result of a permanent struggle of classes or races, of progressive and reactionary forces, of good and evil, and its culture is a reflection of this struggle.

The theoretical foundation for this conception lay in the so-called Leninist teaching of the two cultures, i.e. of the presence in the culture of each epoch of warring democratic and anti-democratic elements. In order to construct the culture of the future the former must be utilized and the latter discarded: "From *each* national culture we take *only* its democratic and its socialist elements, we take them *only* and *absolutely* as a counterweight to the bourgeois culture, the bourgeois nationalism of *each* nation."[34] Hitler's conception was similar: "There is only one eternal art – the Greek-Nordic art, and all such terms as 'Dutch Art', 'Italian Art', 'German Art' are merely misleading and just as foolish as it is to treat Gothic as an individual form of art – all that is simply Nordic-Greek art and anything which deserves the name of art can always only be Nordic-Greek."[35] In both Marxist and Nazi versions a sharp demarcation divides the whole history of culture into two unequal parts. On the one hand, healthy democratic or Aryan elements have existed since the very beginning; on the other hand they have always been opposed by movements that are socially or racially alien. During the development of Soviet aesthetic thought Lenin's

"democratic elements" became identified with forms of realistic portrayal of reality; in the works of Nazi theoreticians, above all those of Schultze-Naumburg and Rosenberg, the Greco-Nordic elements took on the appearance of the Aryan ideal of beauty and in the process became strangely similar to the Soviet "realistic forms". Everything that did not fit into these rigid categories was accompanied by the prefix "anti", emphasizing the hostility of the most diverse unhealthy phenomena to the progressive forces of history. "For this reason," concluded Nedoshivin, one of the leading Stalinist theorists of art, "the whole history of world art can be seen and must be understood as the history ... of the appearance, formation and development of objectively correct, or realist, art and its struggle against various anti-realist tendencies."[36] This struggle had already begun in prehistoric art, where Nedoshvin saw the "antirealist tendencies of the neolithic" beginning to crowd out the "vivid realistic representations of the palaeolithic epoch".[37] Rosenberg for his part devoted many pages of *The Myth of the Twentieth Century* to a search for the Aryan ideal in the art of antiquity, the Renaissance and the Baroque, and its struggle against other, racially inadequate, artistic forms.

According to this way of thinking, the history of culture, like that of humanity of a whole, had always included tendencies which, developing over the ages, had finally been fully realized in the art of totalitarian countries. The whole cultural evolution of humanity was merely prehistory, and only by considering the past in the light of the present could one detect its objective laws of development. Soviet methodology claimed that "any consideration of the history of art will be correct only in so far as we study phenomena in the perspective of the development which led finally to the formation of the method of Socialist Realism".[38] A similar re-orientation of the past on the Nazi present was demanded by Rosenberg when he talked of the necessity of rewriting world history.[39] To put it another way, totalitarian ideologies projected their own ambitions onto the past and recreated it according to their own image and likeness. The Nazi and Soviet variants of the history of world art then turned out to be remarkably similar.

As they traced world culture back to its sources, both ideologies found their ideal in classical antiquity. Soviet theory was following Marx's view that the era of Greek classicism was the healthy childhood of humanity and that its art was an unattainable norm. Hitler spoke in similar vein at the opening of the First Great Exhibition of German Art in Munich: "Look at the Miron and you will understand how splendid man once was in his physical beauty, and it will only be possible to talk of progress in art when we not only achieve such beauty ourselves but as far as possible surpass it."[40] What Nazi aesthetics saw in classical images was, of course, the ideal Greco-Nordic or Aryan racial type, but Hitler went on to state that the proportions of classical sculpture embodied the objective norms of human anatomy, which "later, through so-called precise scientific

researches, were accepted as correct, that is to say real". "Two millenniums and a half before us," said Hitler in 1937, "this stonecutter [saw] the human body in such a way that today, according to all discoveries of our anatomic research, it must be declared natural in the highest sense."[41] Deviations from these norms were interpreted not only as a leaning towards another, lower, racial type. As in Soviet aesthetics, they were seen as a "distortion of objective reality – an accusation levelled not only against contemporary modernists and formalists, but also against such artists as El Greco and Matthias Grünewald.

Similar elements of both style and content caused both ideologies to be drawn towards classical antiquity and repelled by the Middle Ages. Hitler loved to philosophize about different cultural epochs in the language of Spengler. In one of his diary entries Goebbels summarized the content of these conversations:

> The Führer is a man totally attuned to antiquity. He hates Christianity, because it has crippled all that is noble in humanity. According to Schopenhauer, Christianity and syphilis have made humanity unhappy and unfree. What a difference between the benevolent, smiling Zeus and the pain-wracked, crucified Christ. The ancient peoples' view of God was also much nobler and more humane than the Christians'. What a difference between a gloomy cathedral and a light, airy ancient temple. He [Hitler] describes life in ancient Rome: clarity, greatness, monumentality. The most wonderful republic in history ... The Führer cannot relate to the Gothic mind. He hates gloomy and brooding mysticism. He wants clarity, light, beauty. And these are the ideals of life in our time. In this respect, the Führer is a totally modern man.[42]

It hardly needs to be added that from a Marxist point of view the materialist bent of antiquity was infinitely preferable to the spiritual aspirations of the Middle Ages, and that Soviet aesthetics always contrasted the clarity, monumentality and grandeur of the art of ancient Greece and Rome with the gloomy and oppressive mysticism of the Middle Ages: "Renaissance, and especially Gothic, tombstones are a terrifying sight, a true *memento mori*. Their purpose is through a constant reminder of death – portrayed as a skeleton – to hold in chains of fear a humanity that is sunk in sin." The gloomy spirit of the Middle Ages is then compared with the clarity and deep humanity of the tombstones of the classical Russian masters, where "there is nothing frightening or repulsive".[43] Such appraisals are equally typical of both Soviet and Nazi versions of the history of art.

If great works of art were created in the Middle Ages, then this was achieved not thanks to Christianity but in spite of it. According to Nedoshivin, "everything living and true in mediaeval art is fed by the people's poetic attitude to the world with its firm realistic foundation";[44] according to Rosenberg, "the significant feature of Gothic cathedrals is not that they were built by Catholics, but that they were built by Germans".[45] To the Nazis, Greek sculpture, European Gothic, the Italian Renaissance and Baroque were all (in Rosenberg's words) "an ema-

nation of one and the same Aryan-Nordic genius"; to the Soviets they were all manifestations of the people's healthy view of the world and its struggle for liberation from the power of the exploiting classes. The concept of the spirit of the people, packaged in either a social or racial fashion, lit up the past with a light that picked separate fragments out of the darkness and built them into a general picture of history.

Both Soviet and German periodicals devoted considerable space to matters relating to the artistic heritage. In one issue after another of *Iskusstvo* and *Art of the Third Reich* we find articles about the same great artists of the past: about Raphael's and Leonardo's wonder at the beauty of the human body, about the deep psychological understanding of Rembrandt's images of the people, about Rubens's praise of the richness and many-sidedness of the material world ... In the work of all of these painters – in the words of Hanns Johst – the heroic world of antiquity has overcome the weariness of life that appeared with Christianity. Their life-affirming, realistic art was contrasted with the reactionary, decadent tendencies that had always existed in parallel, manifesting themselves in the morbid phantasmagorias of Hieronymus Bosch, the "hysteria" of Matthias Grünewald's Isenheim altar, the gloomy mysticism of El Greco, and (in the Soviet version) the formalist idiosyncrasies of Turner – "the sworn enemy of Constable". The general picture of the history of art was coloured in harsh chiaroscuro, any important phenomenon always finding an antithesis which it overcame through fierce struggle. It is impossible not to see in this dichotomy a typical feature of all totalitarian thinking: as Albert Speer remarked in his prison diaries, for Hitler "a distinction conferred on someone was frequently a method for rebuking someone else".[46] It would be hard to find a more appropriate definition of the approach of Soviet and Nazi art historians to cultural matters.

The history of world culture, its undeviating march along the path of progress, led to an unparalleled flowering of art in the nineteenth century. In Speer's account, as in that of many others who knew Hitler well, "For all departments of art Hitler regarded the late nineteenth century as one of the greatest cultural epochs in human history."[47] In the Soviet Union the work of the Russian artists of the second half of the nineteenth century, above all that of the Peredvizhniki, was declared "the highest example in the painting of pre-socialist society, raised to an unprecedented height that art had not attained, either before or at this time, in any other country of the world".[48] "I have seen many European museums," wrote the once-powerful Aleksandr Gerasimov in his autobiography, "and in honesty, without any jingoism, I can say that there are no such artists there as Repin and Surikov and barely anywhere can one find anything comparable with 'Easter Procession in the Province of Kursk' or 'Boiarina Morozova'."[49] We have no reason to doubt the sincerity of these words, any more than that of Hitler's devotion to the nineteenth century. Gerasimov published his autobiography a year before his death, when, dismissed

Repin: Easter Procession in the Province of Kursk (1880–83)

Surikov: Boiarina Morozova (1884–87)

from all his duties and made the scapegoat for all the sins of Stalinist cultural policy, he no longer had any reason to dissemble. (The notice of his death in 1964, signed by only two names – Nalbandian and Laktenov – was printed in small type on the back page of one of the central papers.) As for Hitler, he spent huge sums of personal money on buying works by Grutzner, Spitzweg, Defregger and other German realists he loved, considering them undervalued and intending to allocate them a central place in the collection of German art he planned in Linz. It would be wrong, however, to think that it was the dictators' personal tastes which placed the nineteenth century in the centre of the national cultural heritage; on the contrary, it was the mechanisms of development of totalitarian culture which raised people with such tastes to the heights of power.

The reasons for this lie in the history of the preceding century. In the first place, for many European countries and especially for Russia and Germany, this century marked the rise of national schools in the visual arts. It is true that, unlike in Russia – where there is a long gap between the flowering of icon painting and the rise of the academic school – the artistic tradition in Germany runs unbroken from the Middle Ages to the twentieth century. During the period of "the battle for art", such representatives of the "left wing" of the Nazi elite as Goebbels and von Schirach, the leader of the Hitler youth, did indeed have every justification for their attempts to represent German Expressionism as a part of this tradition and to propagate it as such – but they met defeat at the hands of Rosenberg and Hitler, for both of whom "the Gothic and the Renaissance were too Christianised".[50] In any case Gothic cathedrals were built not only by Germans, but also by Frenchmen, Italians and Englishmen, and it was as difficult to detect characteristics of the Aryan-Nordic genius in this essentially international style as it was to detect democratic elements or attributes of the Russian national character in Rublev's icon "The Trinity". In the eyes of the totalitarian ideologues the nineteenth century finally liberated painting, sculpture and drawing from everything supernatural. It spoke in a generally comprehensible and realistic language about comprehensible and real things, in the language of life about life itself. It did not matter that this language was also an international one, that both the European academies and the various factions opposed to them reflected themes from mythological or social reality in the forms of this reality. What mattered was that this reality appeared in the guise of national characters, landscapes and history, that democratic elements or qualities of the genius of the people were directly described.

In the second place, the nineteenth century placed this process on a firm theoretical and ideological footing. The philosophy and aesthetics, together with the scientific, political and economic theories of the time, engendered universal concepts of development, shaped by objective laws of nature or history. At the centre stood the ideas of struggle and progress according to which the

revolutionary and reactionary forces of history opposed one another and together directed the development of humanity along a predetermined path. The nineteenth century saw itself in many respects as the highest stage of this development and as a trampoline from which to rise to a still higher level. The avowed aim of totalitarianism was to establish, once and for all, the culmination of one or another of these universal schemes.

(iii) From the past to the present

> It does not become us to be Germans, since we have our
> own national life – one that is deep, powerful and original.
>
> Belinskii

> If Belinskii had lived to our time, he would probably have
> been a member of the Politburo.
>
> Trotsky

History, it is said, is a sack of facts from which each person takes what he wants. In studying the cultural inheritance of various national forms of totalitarianism it is important not to attempt to arrange these facts in a logical order, but to base one's thinking on those facts which totalitarianism itself selected. Totalitarianism itself carried out the historian's task of sifting through sources, using the scalpel of the concept of two cultures, of the struggle between racial and class elements, in order to split apart the living body of national tradition. It is not only the most important phenomena that are divided into two warring opposites; the demarcation line also divides the work of particular major artists. Lev Tolstoy, the opponent of all violence, is thus transformed (in Lenin's words) into "the mirror of the Russian Revolution", Winckelmann's theories about the classical ideal of human beauty become the foundation for racist experiments in the scientific measurement of the skull, the Nietzsche who hated German national- ism is made into a prophet of anti-Semitism, and the ocean of Pushkin's poetry is limited to the narrow confines of the revolutionary or democratic movement. Racial mongrels and social reactionaries like Heine, Dostoyevsky and the Gogol of *Selected Passages of Correspondence with Friends* are thrown out onto the rubbish dump of history, and the remaining parts, the statements of "forerunners" torn out of context, are used to construct the prefabricated building of totalitarian aesthetics and to erect a genealogical tree leading to totalitarianism itself. The latter's aim in all this is to prove the legitimacy of its origin and to establish the time-honoured nature of the qualities it attributes to its own art – true popular spirit, mass appeal, progressiveness, etc. Such manipulation of the past is a characteristic of any totalitarianism. Whether the artistic ideologies of Com-

munism and National Socialism really had a foundation in their national past is another question.

For those who have a strong sense of their belonging to German or Russian culture the question of the national sources of totalitarianism is a painful one. Thomas Mann turned his mind to it; it has tormented Russian émigrés from Nikolai Berdiaev to Aleksandr Solzhenitsyn; and it is still a question of burning importance for members of the Soviet intelligentsia. "Are the art policies of first the Nazi government and then of the Soviet dominated rulers of Eastern Germany due primarily to national characteristics or are they an integral part of totalitarian society everywhere?" asks Hellmut Lehmann-Haupt.[51] This question has been answered and evidently always will be answered in many ways.

Lehmann-Haupt himself considered that social realism is no more a typically Russian phenomenon than Nazi art is a German one,[52] just as Gerhardt Ritter considers the general ideology which led to Nazism not to be specifically German since "its features can also be found in other countries".[53] George Mosse, on the other hand, derives the *Weltanschauung* of the Third Reich from a deep-rooted German cultural tradition which manifested itself especially clearly in the nineteenth century.[54] The great Russian philosopher Nikolai Berdiaev derives Soviet Bolshevism in similar manner from Russian traditions. One's answer to the question is determined primarily by the breadth of the historical context in which one considers it. Taken in isolation, one or another form of totalitarian ideology, culture or consciousness inevitably betrays its national sources; if, however, one considers totalitarianism as a general phenomenon of our age, then one can find its roots in the soil of the most diverse national cultures.

In any case, the rational, scientific and ideological foundations of Communism, National Socialism and Fascism are not linked with any particular national culture, still less with a particular racial consciousness. The founder of Communist ideology was Marx, and the *Brief Course in the History of the All-Union Communist Party (Bolshevik)* – the gospel* of the entire Stalinist epoch – names its Old Testament prophets, stating that the "three sources and three constituent parts of Marxism" were the major representatives of English political economy, German classical philosophy and the French Enlightenment. The founders of the racial theory on which Nazism based itself were Count Josef Arthur Gobineau, the French diplomat and orientalist, and Houston Stuart Chamberlain, the son of an English admiral who took up German citizenship. Paradoxically, the term "anti-Semitism" was first coined in 1879 by Wilhelm Marr, the founder of the "League of anti-Semitism" and himself of Jewish origin. The doctrines of Italian Fascism drew considerably on Saint-Simon's theory of the State and on the works of Georges Sorel, the French engineer and follower of Marx. Among the common sources of all three ideologies were Jean-Jacques Rousseau's concept

*To a much greater degree than *Das Kapital*, or *Mein Kampf* or *The Myth of the Twentieth Century* in Germany.

of the collective will, many aspects of Hegel, Darwinism transplanted into the social field and various theories of historical progress.[55] With the injection of class or racial components all this constituted an explosive mixture.

This picture loses much of its international quality if, in search of the roots of totalitarianism, one turns to such hard-to-rationalize categories as the history of a particular people, its culture or its consciousness. In *The Russian Idea* and *The National Roots of Russian Bolshevism*, written after he had emigrated, Nikolai Berdiaev develops the idea that "totalitarianness" had always been an extremely important component of Russian consciousness as a whole. By this he means the striving to construct some "whole vision of the world" in which truth as truth will be united with truth as justice, the striving "towards the fusion of philosophy with life, of theory with practice".[56] Berdiaev saw manifestations of this consciousness in the "totalitarian" manner in which Vissarion Belinskii understood Hegel, in the twin origin of all Russian philosophy – "religion and faith from the Slavophiles, revolution and socialism from the Westernizers" – and in the universality of the spiritual concepts of Tolstoy and Dostoyevsky. This "holism" distinguished Russian consciousness from the more differentiated consciousness of the West, and it is this disparity that gave rise to such typically Russian traits as mistrust of the West and the accompanying aspiration to find roots in the people, the soil and the national character, together with Messianism, the search for a special path in history, the sense of the Russian nation as something exceptional and, above all, the affirmation of every routine idea as an ultimate truth, based on incontrovertible laws of nature, history or the divine will. It was from such elements that Russian Bolshevism constructed its ideological system, and Berdiaev proceeded to the logical conclusion: "In accord with the nature of the Russian mind, the revolution could only be totalitarian. All Russian ideologies have always been totalitarian, whether theocratic or socialist."[57]

This "Russian idea", however, is by no means exclusively Russian. In their analysis of the cultural and ideological sources of National Socialism, German historians – even those like Mosse who do not like to resort to the term "totalitarianism" – use essentially the same stereotypes in order to describe the central line of development of German culture. "What differentiated the Germany of this period [the nineteenth century] was a profound mood, a peculiar view of man and society which seems alien and even demonic to the Western intellect."[58] What Mosse has in mind most of all is the populist or *Völkisch* ideology. This fruit of European romanticism had coloured German thought from the time of Fichte's famous address to the German nation (1807–8). Diverse resolutions to questions of the special place of the Germans among the other peoples of Europe, their historical path and mission, their cultural or racial superiority, engendered countless philosophical and political societies, organizations and Bunds throughout the nineteenth century and led finally to calls for practical action. The

intellectual climate of nineteenth-century Russia was similarly coloured by burning discussions between Westernizers and Slavophiles. During the second half of the century the ideas of the Slavophiles found a practical outlet in revolutionary populism and at the same time infiltrated governmental spheres in the guise of the Pan-Slav ideology which "is similar in its fusion of Romanticism and Nationalism with German Pan-Germanism".[59] If, according to Berdiaev, the sources of the Bolshevik coup lie in Russian consciousness, then, according to many German historians, the legitimate heir of Pan-Germanism was Hitler. Patriotic ideas of national self-consciousness were, of course, widespread in Europe after the French Revolution and the Napoleonic wars; but, writes Mosse, "this impetus never penetrated as deeply as in Germany, nor did it lead to the same end".[60] Nowhere, one could add, citing Berdiaev, except in Russia.

The ideology that sprang up on this soil drew the two countries together. Herzen called the Russian love of Hegel an epoch of intellectual awakening in Russia, and Schiller's career in Russia was even more spectacular than in his own country. The ideas of German Romanticism, its search for higher human and national values in the traditions of the peasantry, met with a deep resonance in the Russian soul. The humanity, warmth and openness to collective needs and interests of the Russian soul were contrasted with the cold rationalism, egotistic individualism and lack of soul of Western man. From the mid-nineteenth century a negative attitude to the West was a constant feature of both German and Russian cultural consciousness. The applicability of the Western model of development to Russia was denied by the Slavophiles and – in different ways – by Tolstoy and Dostoyevsky; even the Westernizer Herzen became deeply disillusioned with it, while the revolutionary Belinskii agreed on this matter with the reactionary Leontiev. "Are the Russian and the German attitudes towards Europe, Western civilization, and politics not closely akin? Haven't we Germans also our Slavophiles and Westernizers?" wrote Thomas Mann in 1917.[61] He had no doubts then that the German and Russian peoples were closer one to another than Russia and France, and incomparably closer than Germany and the Latin world. The enormous and unrealized potentials of a still young nation were seen in each country as a stimulus to the development of a culture which was destined in the near future, following its own "third" path, to surpass that of any other European country.

It is not by chance that it was German aesthetics which introduced the "cult of life" concept of the superiority of life over art. This introduced a strong note of realism into the development of German Romanticism. "This strange combination of Realism and Romanticism resulted in the typically Germanic concept of *Weltanschauung*, a concept which implies the acquisition of an exact perception of the world through knowledge derived from pleasant and unpleasant practical experiences rather than from academic channels of

learning."[62] In Germany the idea of the "cult of life" was formulated at the beginning of the nineteenth century in the works of the brothers Schlegel. In Russia the theoretical foundations for a similar cult were laid by Nikolai Chernyshevskii in his definition of the beautiful: "This is the true definition of the beautiful: 'the beautiful is life, that being is beautiful in whom man sees life as he understands it; a beautiful object is that object which reminds him of life'."[63] Chernyshevskii's master's dissertation, *The Aesthetic Relationship of Art to Reality*, was published in 1855 and played an enormous role in the development of the theory and practice of Russian art; written in a clumsy language, with Russian philosophical terms explained by their German equivalents, it set out to establish the truth of this single thought. Art in all of its manifestations – painting, sculpture, architecture, music and poetry – was declared in every respect to be immeasurably beneath life, since by nature it was unable to reproduce it. In spite of the poverty of this philosophy – or rather on account of it – Soviet artistic ideology elevated Chernyshevskii to the position of its chief predecessor and an unquestionable authority on aesthetic matters.*

Chernyshevskii's aesthetics had no populist overtones. The idea of the uniqueness and superiority of Russian culture appeared for the first time in Russia not in philosophy but in literary criticism. In the middle of the century Belinskii claimed that every artist and writer "expresses the consciousness of the people, which stems from the *Weltanschauung* of the people", and that literature and art as a whole form "the consciousness of the people"[64] (in this he was almost repeating the Schlegels' axiom: "History is the self-consciousness of the nation"). For Soviet historians of culture, however, such distinctions had no meaning: all progressive figures of the past – Chernyshevskii, Belinskii, Dobroliubov, Pisarev, Stasov, etc. – were obliged, first and foremost, to be patriots, and so they all "struggled against movements whose members gazed with bated breath at everything engendered by the West and, in ecstasy that amounted to self-oblivion, praised its culture and denied their own. 'The furious Vissarion' (Belinskii) referred to such people as 'passportless wanderers among humanity'."[65]

The general growth of national self-consciousness during the nineteenth century led to the rise of national schools of realistic art in many countries of Europe and America, but had an especial significance for Russia and Germany, not so much with regard to the artistic achievement of these schools (Courbet's understanding of realism bore infinitely richer fruit in France than, for example, Knaus's in Germany) as with regard to the feeling of national self-worth in these countries. The principal realistic schools in Germany were the Biedermayer (Ludwig Richter, Carl Spitzweg, Karl Blechen), the Düsseldorf school (sen-

*The Schlegels' "cult of life" is, not surprisingly, listed in L. Redel's *The Roots of Totalitarianism* among the ideas which led to National Socialism.

timental genre-painters like Ludwig Knaus and Benjamin Vautier), Munich painters of everyday life like Eduard Grutzner – much loved by Hitler – and the social realists Karl Hübner and Karl Lessing – who were highly valued by Marx. In Russia there arose the powerful movement of the Peredvizhniki. The stylistic norms and artistic vision developed by these schools served as a foundation on which both varieties of totalitarianism were able to base their aesthetics. In the forties and early fifties more than half of the books published on art in the Soviet Union were about the Peredvizhniki, while Vasilii Stasov, their ideologue, became as indisputable an authority in the field of art criticism as Chernyshevskii in philosophy and Belinskii in literature.[66] This movement, therefore, deserves to be examined in a little more detail.

In 1863 fourteen final-year students of the Petersburg Academy of Arts, headed by Ivan Kramskoi, refused to paint their graduation piece on a prescribed theme ("Feast in Valhalla"), left the Academy and organized an artists' cooperative with the aim of arranging for the exhibition and sale of their own paintings. Towards the end of the sixties the cooperative began to fall apart, but in 1871 the Brotherhood of Travelling (*Peredvizhniki*) Exhibitions arose in its place. Its founder members were Ivan Kramskoi, Vasilii Perov, Nikolai Ge, Ivan Shishkin and others; they were soon joined by such major painters as Ilia Repin

Shishkin: Morning in the Pine Woods (1889)

and Vasilii Surikov. The work of the Peredvizhniki and their sympathizers was central to the development of Russian art up to the nineties.

The ideology of the Peredvizhniki was most clearly expressed, and in many respects established, by Vasilii Stasov, the most important figure in Russian art criticism during the second half of the nineteenth century. All art, according to Stasov, was inseparable from the consciousness and life of the people. "Nationality and Realism," wrote Stasov, "these are the two main elements of any Russian art: nationality and realism – this is our supreme law in art."[67] He explained that art "not derived from the roots of the life of the people is firstly useless and secondly insignificant and always aimless".[68] This supreme law was instilled by Stasov into the consciousness of his wards, and any deviations from it were mercilessly chastised in print.

Unlike most Russian artists of earlier generations, the Peredvizhniki came with few exceptions from the lower social classes – the peasantry, the petty bourgeoisie and the lower grades of the civil service. They knew Russian life well, agonized over its "painful questions", and were little interested in anything else. Whereas earlier graduates of the Academy aspired to travel abroad and many major painters (Ivanov, Shchedrin, Briullov) of the first half of the century spent much of their lives there (especially in Italy), this new generation was tied to Russia both by its cultural interests and by the burden of social origin. Perov, for example, won an Academy grant to travel to France, but then sent a request from Paris to curtail his stay, since he found it far less useful than the study of the "immeasurably rich subjects from urban and rural life in our fatherland".[69] V. Perov became the acknowledged master of these themes and helped to establish in Russia the genre of scenes from everyday life. Sympathy for the oppressed and a lyrical compassion for individuals were combined with a sarcasm that was expressed through social contrasts; his paintings could well have served as illustrations to Dostoyevsky's "The Humiliated and the Insulted" or to Nekrasov's "citizen" poems. Ilia Repin (1844–1930) endowed scenes of popular life with a truly epic quality in such paintings as "Barge Haulers on the Volga" (1870–3) and "Easter Procession in the Province of Kursk" (1880–3). Interest in Russian life at this time stimulated the flowering of landscape painting, whose founding father was Ivan Shishkin (1832–98). It was in his works that the style and aesthetic views of the Peredvizhniki, founded on the ideas of Chernyshevskii, acquired their final form: "A man with an uncorrupted aesthetic sense enjoys nature completely, finding nothing inadequate in its beauty"; it does not enter his head "to change something or other in this wood, to add something for the fullness of his aesthetic pleasure".[70] Shishkin therefore portrayed fields and woods with the accuracy of a botanist, "changing nothing and adding nothing".

The revolt of the Peredvizhniki against the Academy began during the most liberal period of Russian history, two years after the freeing of the serfs; the movement reached its peak during the period of "dark reaction" when, as a

result of the Russo-Turkish war (1877–9), patriotic feelings from Pan-Slavism to Greater-Russian chauvinism were at their most intense. The chief patron of the Peredvizhniki was Aleksandr III, the most nationalist of the last Russian Tsars. In 1886, after visiting their fourteenth exhibition on Kramskoi's invitation, he reserved first option on works from subsequent exhibitions for the museum of Russian art that he planned; he also made his Academy review its attitude towards the movement. During the nineties Repin, Shishkin and other important Peredvizhniki became full members of the Imperial Academy of Arts. The original revolutionary-democratic impulse had now disappeared: Kramskoi painted Aleksandr III speaking before a group of peasant elders; Surikov sang the praises of Russian armed might ("Yermak. The subjugation of Siberia", "Suvorov crossing the Alps", etc.); and Repin painted a vast canvas entitled "A Solemn Meeting of the State Council".

Having become official artists, the Peredvizhniki took upon themselves the function of custodianship which had previously been fulfilled by the Imperial Academy. The first Russian experiments in *plein air* painting, influenced by French Impressionism, came up against their stubborn resistance; the works of Mikhail Vrubel, the "solitary genius" and direct predecessor of Russian symbolism, were blocked by their juries and never included in Academy exhibitions; and the "World of Art" movement, founded at the end of the nineties by Alexandre Benois, Sergei Diaghilev and Konstantin Somov with the aim of building bridges between Russia and Europe, became their *bête noire*. By limiting Russian art to purely national problems, the Peredvizhniki became an obstacle to its further development.

Stasov's ideology, with its emphasis on nationality and realism, is very similar to that of the *Völkisch* German thinkers proclaimed by National Socialism as its cultural forerunners – for example, Paul de Lagarde (1827–91), Julius Langbehn (1851–1907) and Möller van den Bruck. None of these, for all the claims of the Nazis, can be considered a racist. To Lagarde "Germanism lies not within the blood but in the character", and van den Bruck considered the impulse which united people into a nation to be "intellectual and cultural affinities", rather than biological kinship.[71] Nevertheless, when they proposed the nation as the main formative element of culture and history, it was their own people that they had in mind, and they endowed it with special traits, a special mission and qualities superior to those of other European nations. The assertion of national originality and cultural superiority was in fact the common ground of these thinkers. Belinskii saw in the past of Russia potentials so rich that "they would have been enough for several Shakespeares and Walter Scotts", and Stasov even ascribed to it the merit of having saved Greek art for humanity through being the heir of Byzantine culture.* As for the present, in the nineties –

* This idea became fundamental to Soviet art criticism in its approach to the problems of Old Russian icon-painting.

while Impressionism was flowering in France and while Cézanne, Van Gogh and Gauguin were fighting for recognition – Stasov continued to claim (still thinking of the Peredvizhniki) that "artistic Russia is a whole thirty years ahead of the other countries of Europe".[72] What mattered most of all was to protect art from foreign influences, since "Nothing destroys art so much ... as another hand thrust into the soul and feelings of the artist ... When this happens – goodbye to originality, goodbye to independence, goodbye to power and vital feeling, the artist has already lost for ever what is most precious in him: his *own* soul and thinking, his *own* expression of them."[73] What Stasov meant, of course, was a *foreign* hand reaching into the *national* soul; and any German *Völkisch* ideologue would gladly have put his name to this and other similar statements.

This kind of ideology was the fruit of general theories of culture according to which the economic backwardness of Germany and Russia had preserved the patriarchal ways of life of the people with more stability than in furiously developing Europe; this had created special conditions for the formation of the human personality and the national culture. If in other countries industrialization had transformed man into a philistine and a bourgeois, if it had torn culture away from its national foundation and sacrificed it to cosmopolitanism, in Russia and Germany man still remained firmly linked to the soil, the people, society and the State. In this lay the pledge of development. The new German art must base itself on the peasantry, "the best and simplest expression of the *Volksthum*",[74] stated Langbehn. And the peasantry as the embodiment of the people was the main theme and source of inspiration of the Peredvizhniki. For these reasons it was not only Marxism that had the prerogative to criticize capitalism for destroying the foundations of the people. Möller van den Bruck's *The Third Reich*, which was published in 1923 and provided the name of Hitler's State, was originally entitled 'The Third Path': neither the capitalist exploitation of man by man, nor liberal parliamentary democracy, but the State of the People, held together by the will of the Leader.

In Russia and Germany at the turn of the century, these ideas led to a firm conviction of the decadence and decline of Western culture. The godfather of these ideas was Max Nordau, who in 1893 published a book entitled *Degeneration* (*Entertung*). Oswald Spengler provided the movement with a firm philosophical basis in his *Decline of the West*. This was greeted with equal enthusiasm by both German and Russian avant-gardes (it was translated into Russian in 1917): direct and indirect citations can be found from it in many texts by the Russian Futurists, Constructivists and Production artists, and George Grosz writes in his autobiography: "Spengler exerted quite an influence upon me and made me aware of the fact that instead of being in a temple of art, I was in at the clearance sale of a huge warehouse".[75] The "leaden determinism" (in Thomas Mann's phrase) of *The Decline of the West* attributed a direction to the historical and cultural process which allowed the avant-garde to look on themselves as the

vanguard of humanity in its escape from a cultural dead end. Hitler too saw himself as a part of the world cultural avant-garde; on his assumption of power he offered Spengler a position of considerable prestige – which the philosopher refused to accept.

While for Spengler the decline of European culture was linked to the deepest spiritual processes of her history, the populist ideologues from whom totalitarianism borrowed its ideas saw things more simply. For Adolf Bartels the degeneration of art resulted from the fact that capitalism leads to the pursuit of pleasures ... the contemporary epoch was "characterized by vulgar materialism and brought low by social democracy": hence its main characteristic – "unhealthy pessimism and immorality".[76] These thinkers saw Impressionism with its interest in technical problems as a catastrophic break with a sound popular base and so with the ideological seriousness of a creative approach to life. Contemplating this monster from different corners of Europe, Langbehn and Stasov reached the same conclusion: its cosmopolitan concept of "art for art's sake" was a terrible threat to the nationalist principle "art for the people". The portrait of Impressionism drawn in the articles of Dietrich Eckhart, Hitler's ideological tutor, corresponds exactly with that drawn fifteen years earlier by Stasov: the French were "superficial", their subjects were "absinthe drinkers, blowsy nudes, dull-witted peasants, grotesque clowns, hypocritical patriots, distorted landscapes".[77] The penetration of Western influences destroyed the healthy body of the national cultures and was the work of alien elements – "cosmopolitans" according to Stasov and "Jews" according to Langbehn, Eckhart – and many others. These thinkers saw the new movements in art as the apocalypse of their own comfortable little world where they were the bearers of supreme and immutable spiritual truths.

Of all these revilers of the new it was Stasov who was the most dogmatic and aggressive. Stasov branded the modernists, both at home and abroad, as "the poor in spirit" and "a hostel of lepers".[78] Of a painting by Vrubel he wrote: "however much you look at it, from in front, from the side, from above and below, even from behind, it still remains rubbish, rubbish and rubbish – ugliness, ugliness and ugliness". Of the "World of Art" movement he wrote that we do not need these "worms of art";[79] that "art which is unripe and overripe, rotten, sick, pock-marked and riddled with worms is not necessary and must be destroyed as something harmful and vain".[80] It would be no exaggeration to say that Stalinist Socialist Realism inherited from Stasov not only a complex of ideas, but also its vitriolic terminology. Stasov was probably the first Russian critic to use the term "cosmopolitan", an epithet with which he rewarded anyone he considered to be an admirer of Western culture.

Stasov was no philosopher, and many of his statements were polemical thrusts against forgotten opponents. The real context of his ideas does not concern us at present; what is more important is the image of him created by

Stalinist theoreticians: that of a dyed-in-the-wool Russian nationalist, a bearer of a uniquely true artistic vision, and a believer in the use of harsh measures in order to realize this vision. The dictatorial narrowness of his thinking was presented as a concern with principle, and the following statement of his was endlessly repeated: "There [in the West] they suppose that this direction and that direction are both just, both legitimate from their own point of view ... We do not yet have this noble apathy and limp tolerance, we consider that in art, as in life, there can only be one truth."[81]

There is one other fundamental dogma of totalitarian aesthetics whose origin lies in the nineteenth century – the assertion of the special role of art and its creator. No longer, as in the Middle Ages, a part of one integral whole, emancipated from the service of enlightened monarchs, art began to seek justification for its existence in new conceptions of its role, place and function. This process, common to all European countries, led to similar results in both Germany and Russia. While in England the Pre-Raphaelites and members of the Arts and Crafts movement saw their ideal in the work of the artist-craftsman who fashions man's material surroundings, in Russia and Germany the dominant concept was that of the artist-creator, the teacher and prophet who reveals the ultimate truth to humanity. In Russia the profound metaphysics of Pushkin's poem "The Prophet" was translated by Chernyshevskii, Belinskii and Stasov into the limited concept of the artist as "the unmasker of society", "the conscience of the epoch", "the teacher of life". This concept first appeared in literary criticism and then found fertile soil in the strictly hierarchical structure of Russian society, every sphere and every level of which had its mentors and teachers. Not only the revolutionary democrats, but also the various governors of the country – from Nicholas I to Lenin and beyond – had a deep faith in the transformative and educative function of art, whether as a way of asserting the power of the State or as a way of bringing down its foundations: a direct line can be traced from the exile of Pushkin, through Dostoyevsky's penal servitude and the anathema pronounced against Tolstoy, to the cultural pogroms instigated by Zhdanov. And during the period of liberal reforms, when serfdom – until then the foundation of the Russian Empire – was abolished, whole strata of Russian society gladly accepted such artist-teachers as their spiritual guides. It is not chance that the portrait was one of the main genres in the work of the Peredvizhniki, nor was it chance that the models of their best paintings were members of the Russian intelligentsia, supposed teachers of life: "Herzen" by Ge, "Dostoyevsky" by Perov, "Stasov" and "Tolstoy" by Repin, and Kramskoi's portrait of Nekrasov, the poet whose creative credo had met with such resonance in the epoch: "You do not have to be a poet but you are obliged to be a citizen". It is probable that there was nowhere in Europe where this genre was valued so highly during the second half of the century and where it attracted such social attention. Many generations of the Russian intelligentsia looked on these portraits almost as cult objects.

In Germany the concept of the artist as teacher and prophet had deep roots in the Romantic tradition. In his controversial book *Rembrandt as Teacher* (1891) Langbehn took the work of the great Dutchman as his image of the artist as spiritual teacher and leader of the nation. The great German poet Stefan George was obsessed with the supposed prophetic gift of the poet – a subject examined more critically by Thomas Mann in *Doctor Faustus*. Dietrich Eckhart (Germans joked, while this was still possible, that Hitler had borrowed from him not only his ideas but also his moustache) attributed to the artist the function of high priest as well as that of prophet. Whether the artist-prophet preaches the metaphysics of race or the dialectics of popular consciousness, whether he proclaims social justice or the spiritual renaissance of the nation, is of secondary importance. What matters is that in both versions the mission of art is to influence the consciousness of the masses; it is this concept which was inherited by totalitarian politicians and which constituted the nucleus of their artistic ideology. In the statutes of the Union of Soviet Artists it was formulated as the "ideological refashioning and education of the workers"; in the statutes of the Chamber of Visual Arts as "to assist the development of German culture in the spirit of responsibility towards the people and the State".

The mission of the politician, more dangerously still, was similar to that of the artist. Hitler saw himself as the architect of the Third Reich, who "creates according to the laws of beauty", and Goebbels had Hitler in mind and was paraphrasing him only slightly when he said: "The true politician stands in the same relationship to his nation as does the sculptor to marble."[82] Walter Benjamin referred to this synthesis as Hitler's aestheticizing of politics.

Rooted in a very different cultural tradition, Churchill, himself an artist and one who had little time for modernism, also wrote a treatise on art. Its title, *Art as a pleasant pastime*, speaks for itself. And in his political entourage we find no architects, artists and writers like Rosenberg, Speer, Goebbels and von Schirach – the leader of the Hitler youth and self-styled oustanding lyrical poet of National Socialism.

It would, of course, be difficult to define these nineteenth-century concepts as totalitarian in themselves. Any ideas – those of Hegel, Nietzsche, Nordau, Spengler, Chernyshevskii, Stasov or any other philosopher, critic or writer – can be seen in the context of their culture to have been warring against other ideas, correcting them and being corrected by them, forming together with them the living fabric of historical thought. They become totalitarian only when they are torn out of this context, when they are translated into the language of politics and levelled against concrete forms of life. Stasov and the Peredvizhniki were canonized under Stalin, and Aleksandr Gerasimov warned in 1952: "any idle talk about the low level of artistic culture of the Peredvizhniki is an insolent lie and slander".[83] Under Hitler Langbehn's *Rembrandt as teacher* was declared a classic, Bartels was awarded the rank of honorary member of the National

Perov: Dostoyevsky (1872)

Repin: Vladimir Vasilievich Stasov (1883)

Ge: Portrait of Herzen (1867)

Socialist Party, and Stefan George was offered the presidency of the National Academy of Poets. Although George, appalled by Nazism, refused the offer and died in exile in Switzerland, the Stefan George prize continued to be awarded to the best works of National Socialist literature. In the Soviet Union prizes, city streets and warships continued in similar fashion to be named after Ilia Repin – another émigré. Their ideas were seen as absolute truths, and anyone disagreeing with them was looked on as a political enemy.

In an historical perspective, however, it is impossible not to see the continuity of these ideas, the process of their gradual transformation into a weapon of totalitarian ideology. In Russia this process began as a series of academic arguments between Westernizers and Slavophils; in Germany it begins with "a necessary and universal rebellion against the tyranny of French conventions and classical forms; and in the end, in the recent past, there was the exhibition of 'degenerate art' in Hitler's Munich".[84]

CHAPTER FIVE

Function and Language

Art is a function of the life of the people, to which meaning
is given by the divinely inspired artist.

Goebbels

Whatever sources one turns to in studying totalitarian culture – the speeches of leaders, the texts of Party documents, or the statutes of artists' unions – one always finds precise formulations stating that art is not simply an autonomous sphere of activity of the human spirit, but an object that is created according to predetermined (not necessarily benevolent) aims. The concept of pure art, of art for art's sake, of laws of artistic development independent of the human will is alien to totalitarian consciousness. In Hitler's words – "There is no more danger-ous idea than the slogan of French liberalism, 'art for art's sake'".[1] In Soviet texts this phrase is always framed by ironical inverted commas on the grounds that any apparent lack of ideological content is merely a ruse or camouflage. Imprisoned by their own ideology, totalitarian thinkers sincerely believed, for example, that all non-realist movements in twentieth-century art were con-trolled by someone outside, with the aim either of poisoning the people's con-sciousness or of distracting it from the urgent tasks of the class struggle. They also believed that all they need do was formulate a task on the basis of the one true *Weltanschauung* and take administrative measures to direct art towards its execution. Art would then not only fulfil the necessary social functions, but stand on the threshold of a new Renaissance.

(1) Propaganda, mass appeal and *Volk* spirit

Our propaganda is the spiritual revolution of our people.

Hitler

Objectivity has nothing in common with propaganda, and propaganda has nothing in common with the truth.

Goebbels

We not only "removed heads" ... we also enlightened them. Lenin

The propaganda function is only too obvious. The totalitarian ideologies themselves talk of it openly, and it is the usual focus of any study of totalitarian culture. It was allotted as important a role in the art "of a new type" as it had played in the appearance and development of the regimes themselves.

The very organization of artistic life was such that art was always under the jurisdiction of propaganda. In Germany the Reich Chamber of Culture was set up as a part of Goebbels's Ministry of Popular Enlightenment and Propaganda. Hitler attached increasing importance to this ministry over the years and allocated more funds to it than, for example, to the entire Ministry of Foreign Affairs (55.3 and 49.4 million marks in the year 1937).[2] In October 1940 Goebbels combined the artistic and political sections of his ministry, subordinating art to the tasks of political propaganda still more completely.[3] In the USSR all the existing elements of the cultural megamachine were subordinated as early as the twenties to Agitprop (the Party Central Committee's "Section for Agitation and Propaganda") which, under different names, has remained the highest organ for the control of culture throughout the history of the Soviet State.

The extraordinary significance attached to art by totalitarian societies can most easily be explained by its supposed effect as propaganda. In December 1941, when Guderian's tanks had exhausted their supplies of fuel and come to a stop on the outskirts of Moscow, when tens of thousands of hungry and poorly clothed German soldiers were dying in the frosts, a German train arrived at a local station. Instead of fuel, winter clothing or provisions for the dying army, it was loaded with slabs of red marble with which to construct a monument to Hitler in Moscow. And in 1943 mosaic ceilings for the third, most splendid, line of the Moscow metro were assembled in blockaded Leningrad; these joyful images of Soviet people striding towards the sun and happiness, under the guidance of their great Leader, were then transported by special planes to the capital.[4]

Soviet art can be said to have begun with Lenin's plan for monumental propaganda,* and National Socialist art with a similar massive programme. The first monuments, reliefs and stone slabs inscribed with revolutionary slogans appeared in public squares and on the walls of buildings in Moscow and St Petersburg in 1918, while the first German monuments appeared in the autumn of 1933. Still earlier, however, the spirit of the totalitarian revolutions found expression in the art of the poster.

As has already been shown, the art of the political poster reached its peak in Russia during the first years after the Revolution, when the avant-garde set about the production of mass "agitprop" art. Nowhere before had so many of the

* Soviet historians still see this plan as the turning point in the development of Soviet art: "This was the starting point for the planning and realization of a conscious state art policy. Lenin's draft became the model for the entire Soviet art policy during the revolutionary era." (A. A. Strigalev, "Kunst der Revolutionszeit 1910–1932" in *Kunst und Revolution Russische und Sowjetische Kunst 1910–1932*, Vienna, 1988, p. 31.)

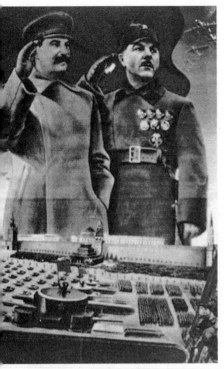

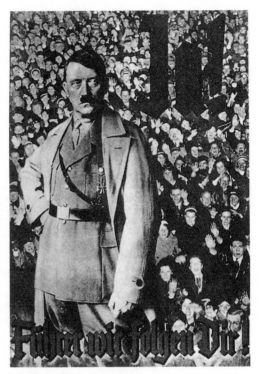

Russian poster: Stalin and
Voroshilov

German poster: Ja! Führer We are
Following You (1933)

most important artists of the time (Rodchenko, Maiakovskii, Klutsis, Malevich,
Lissitzky, Altman and others) devoted themselves to this formerly humble genre.
The designs they created were transferred from paper to the walls of agit-trains
and agit-ships, to the cloth of banners, and to the ceramic dishes, cups and
teapots being turned out by the restored Tsarist china factories outside Petrograd.
Alongside the plan for monumental propaganda this was the most important
artistic development under Lenin. But as the avant-garde faded away, so agitprop
art lost its revolutionary charge and the political poster gradually returned to
its traditional language – that of kitsch and coloured photographs.

Nazi posters first appeared at the same time as the movement itself and
attained their widest circulation at the end of the twenties and beginning of the
thirties.* Before elections and during political campaigns they were usually
displayed in the same places as the posters of the German Communists, and it
was often only the presence of a swastika or a hammer and sickle, of the Führer's

* The largest collection – approximately 8,000 examples – of Soviet and Nazi posters is that in the archives of
the Hoover Institute in Stanford, California.

German poster: The Workers Have Awoken

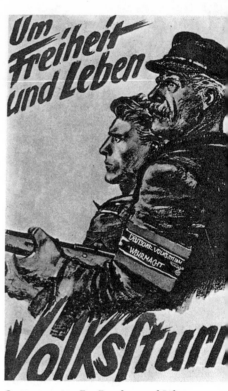

German poster: For Freedom and Life

Serov (poster): Our Cause Is Just:
Victory Will Be Ours

moustache or the Communist leader Telman's shaven skull, that allowed the observer to determine their political import. Their stylistic similarity was blindingly obvious, although this in itself is of little importance: any political poster is by definition propagandist and therefore requires similar techniques. More interesting is the similarity of their slogans and visual symbolism. The same symbolic images moved from poster to poster, bearing an identical meaning: the figure of a worker tearing off his chains, a hand blocking an enemy hand, the fist of a worker crashing down on the head of a capitalist or the table around which a parliamentary meeting is being held, a hammer, the spider of world imperialism, the cobweb of corruption ... Even this, however, is hardly surprising: both German Communists and Nazis were following the same model, that of Soviet Russia.

In *Mein Kampf* Hitler wrote: "Since I began seriously to study political events, I have been interested in the highest degree by propagandist activity. I saw that the organizations of Socialist-Marxists constructed this instrument and exploited it with remarkable craft. I soon understood that the correct use of propaganda is true art – something that to all intents and purposes remains a secret to the bourgeois parties."[5] For the National Socialist Party it was Goebbels who elevated propaganda to the level of high art, and he has been called, not without reason, "the man who created Hitler".[6] Like Hitler, Goebbels painstakingly studied the methods of the enemy and made use of them for his own ends. In an election campaign at the end of the twenties, for example, he used the Marxist slogan "The worker has no property ... he has nothing to lose but his chains",[7] and his newspaper *Der Angriff* appeared under the motto "On behalf of the oppressed – against the oppressors". Both sides addressed their propaganda to the same social groups, the same masses, the same class; this obliged them to make use of an appropriate language.

The theory of such a language had also been elaborated in detail in *Mein Kampf*: "The capacity of the masses for perception is extremely limited and weak. Bearing this in mind, any effective propaganda must be reduced to the minimum of essential concepts, which themselves must be expressed through a few stereotyped formulae ... Only constant repetition can finally bring success in the matter of instilling ideas into the memory of the crowd ... The most important thing ... is to paint your contrasts in black and white."[8] These principles were applied by Hitler not only to the written and spoken word, but also to any form of mass communication, whether in stone, paint or pencil, and after his assumption of power he adhered to them strictly. In a speech at the 1935 Party Congress in Nuremberg he asked: "Can we allow ourselves to make sacrifices for art when on every hand we are faced with so much poverty and misery? Is not art in the last resort a luxury for the few?"[9] He then answered these rhetorical questions in the negative: art was not the property of the privileged classes; it belonged to the people, was created for the people and must therefore speak in

a language they could understand: "The objection that only a small part of a people can understand and take its share in artistic experience and thus be interested in art is false."[10] And during his speech at the opening of the Exhibition of Degenerate Art Hitler gave a summary of Nazi cultural policy: "So-called works of art which cannot be understood directly . . . will from now on no longer find a path to the German people."[11] Hitler did not merely make promises; on the contrary, he forced his subordinates to put these principles into practice, often against their will. Goebbels, in particular, was no enthusiast for the idea of "art for the people". In his artistic tastes he was probably closer to Lunacharskii than to Hitler or Rosenberg. Nevertheless, obedient to the demands of propaganda, he required German artists to create works "which would be comprehensible to the most uneducated storm-trooper". In this he appears to have been guided not only by Hitler, but also by Lenin.

The well-known transcripts of Klara Tsetkin's conversations with Lenin, whose ideas Goebbels had greatly respected in his youth, were published first in German and then in Russian. In one conversation from the year 1920 Lenin expressed an idea that was to become a cornerstone of totalitarian aesthetics:

> What matters is not what art gives to several hundred or even several thousand members of a population of millions. Art belongs to the people. It must penetrate with its deepest roots into the very heart of the broad working masses. It must be understandable to these masses and loved by them. It must unite the feeling, thoughts and will of these masses, it must elevate them.[12]

Just as it is impossible to detect in a seed the outlines of the future plant, so it is difficult at first to make out the sinister import of this passage. What Lenin had in mind was propaganda, the propaganda to whose tasks he had already subordinated his cultural policy. A few sentences further on, discussing the function of art in the society he was constructing, he said: "We not only 'removed heads' . . ., we also enlightened them".[13]

Lenin, however, could not help but understand the danger of reducing all art to the level of mass tastes; even he did not pronounce these sentences quite as they were later to be engraved in the consciousness of Soviet citizens. In Klara Tsetkin's German text his central thought was expressed somewhat differently: "art must be *understood* by these masses" (*Sie muss von diesen verstanden*)[14] rather than ". . . be understandable" to them.

In the first Russian translations this phrase appeared in both variants and gave rise to stormy arguments. "Understood" allowed a more liberal interpretation, that the masses could be educated to understand art; "understandable" allowed a more hard-line interpretation. Even the members of the AKhRR, the most consistent and aggressive proponents of the idea of mass appeal, could not bring themselves – given the accessibility of the German original – to interpret

Lenin's words unambiguously; instead the words "understood" and "understandable" were used interchangeably and so began to lose their contrasting meaning.[15] At the first AKhRR Congress in 1928, Emelian Iaroslavskii, their main patron on the Central Committee, tried to bring these discussions to a conclusion. "Many people here are arguing over whether to be understandable or to be understood," he said. "If you wish your art to be understandable, then of course it will be understood."[16]

In the increasingly charged atmosphere of the twenties the directive that art should be comprehensible to the masses, supported by the authority of the leader, became a central argument in the struggle for realism. At the beginning of the thirties Lenin's quotation was finally canonized in the later version, and in all subsequent publications of AKhRR documents the words "understood by the masses" were carefully altered to "understandable to the masses".[17]*

The directive that art should be comprehensible to the masses (or the people) was given different ideological packaging in Russia and Germany. In Germany, the racist aesthetic naturally put most emphasis on "popular spirit", considering the source of the new art to lie in the collective soul of the German people, in its *Weltanschauung*. This was how the League of Struggle for German Culture began its campaign, and one of Rosenberg's early works was entitled *The Aesthetics of the People*. In Soviet Russia the class theory of arts proclaimed the labouring masses with their healthy "class vision of the world" to be the true creator of all artistic values. In 1923, however, the revolutionary Futurists, sensing the new currents of Soviet cultural policy, used the pages of *LEF* to present their opponents with an entirely legitimate question: "How long is it since you replaced the revolutionary word 'the class' by the bourgeois word 'the people'?"[18] The concept of mass art, which was widely current during the first years after the Revolution and engendered agitprop, was gradually replaced by the concept of popular spirit; this latter, alongside progressiveness and Party spirit, became one of the three pillars on which the edifice of Socialist Realism was supported. In reality, however, Socialist Realism had no more of a popular foundation than National Socialist art.

Goebbels himself, guided by the demands of total propaganda, not only went against his own artistic tastes, but also clashed with such ideologues of racist (*Völkisch*) aesthetics as Himmler and Rosenberg. The latter held firmly to their belief in popular and national art. Himmler's province included archaeology, and the SS special institute, the Ahnenerbe Foundation, carried out research on

* The affair of the quotation has a sequel at the beginning of the sixties, during Khrushchev's "thaw". A Soviet scholar read the German original and published Lenin's actual words in the press, together with his commentary. The whole edifice of Soviet aesthetics threatened to collapse. The Institute of Marxism-Leninism apparently held a special meeting to discuss the matter, and its elders came to a Solomon-like judgment: since Clara Zetkin's translation appeared during Lenin's lifetime and he did not correct it, then the orthodox variant should be considered correct. In retrospect Lenin would probably have agreed with this decision: the whole spirit of his pronouncements on art, the whole of his cultural policy is closer to the Soviet fraud than to his original words.

the distant past of the national sources of German culture. The institute's archaeological publications bore a quotation from Himmler as an epigraph: "A people lives happily in its present and future so long as it is conscious of its past and the greatness of its ancestors."[19] Rosenberg saw art as the embodiment of the soul of the people and he considered this "a matter of conviction and not a subject for tactics or politics"[20] – although he can hardly be said to have acted on these beliefs in his role as editor of *Art of the Third Reich*. Hitler himself spoke of the eternal values and popular sources of true art in almost every speech. In all areas of culture the racist ideologues rooted out alien influences and implanted national forms. Even the Latin script was temporarily abolished, all official publications being printed in Gothic letters. In early 1941, however, Hitler's Chancellory issued instructions, sighed by Martin Bormann, banning the Gothic script: it had apparently been infiltrated by the forms of letters of the Jewish alphabet. The true reason was more simple: the archaic writing was incomprehensible to the masses and made the task of propaganda more difficult. Over this question Hitler the ideologue of racism was on the side of Goebbels the propagandist. He left Old German runes and the pantheon of pre-Christian mythology to the care of Himmler's institutes, *Art of the Third Reich* remained under the editorship of Rosenberg, but the practice of National Socialist art was geared to the demands of the Ministry of Propaganda.

In no country, at no time, had true popular art ever been realistic. Its language had tended always to fantasy, to the grotesque, to stylization, to expression, to the "primitive". This is why many artists turned to it at the dawn of modernism, drawing their inspiration from icon-painting, popular prints, stained glass, and the wood and stone carving of the unnamed artists of Gothic cathedrals and Russian medieval churches; and this is why any true popular art was deeply alien to the spirit of totalitarianism.

In 1935 Hitler himself made it very clear what one should think of such work. "When destroyers of art of this type," he declared to the Party Congress at Nuremberg, "presume to desire to give expression to 'the Primitive' in the consciousness of a people they should remind themselves that our people at least, some thousands of years ago, had already long grown out of such 'Primitivism'."[21] All this meant that potentially the people had already reached the level of being able to understand what totalitarianism presented as high art. It was necessary only to educate them a little – and the priceless riches of culture, both past and present, would lie open before them. A general campaign was instigated to introduce the working masses to the sphere of culture, a campaign which, according to the claims of totalitarian propaganda, met with unparalleled success. The Nazi Workers' Front organization "Strength through Joy", responsible for the organization of the workers' leisure, Mussolini's similar organization "Dopo Lavoro", and the various "Commissions for the Creativity of the People" set up by the Union of Soviet Artists – all these arranged countless evening

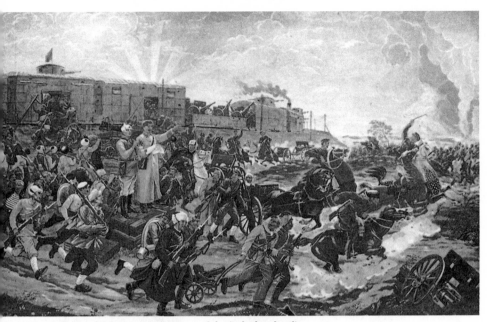

nov: The Defence of Tsaritsyn (miniature of the Palech school)

Stalin Plate (1951)

schools, courses and amateur circles for beginning artists. Under professional guidance workers learned to mould portraits of the Leaders and to paint revolutionary scenes in accord with the principles of the Führer or of Socialist Realism. The same professionals were sent with the same directives to the remaining centres for traditional crafts. Under their ideological guidance the Palekh miniaturists, who had once produced the decorated style of Russian icon, now embellished lacquered boxes with scenes of revolutionary struggle, most often copied from paintings by Stalin laureates; the carpet-makers of Bukhara and the lace-makers of Kalyazin framed portraits of Stalin with traditional ornamentation; the Ural metal-smiths made cast-iron busts of Party and State leaders; and Bavarian wood-carvers adorned tables and armchairs with Nazi emblems for the local Gauleiters. All this passed for true popular art, and in this there was a certain logic: the difference between professional and amateur work, between applied art and the traditional crafts, lay only in the degree of technical accomplishment; with regard to style and theme it had been entirely erased. "The particular development which popular creativity has undergone in our country," wrote Nedoshivin, "is a magnificent example of the destruction of the abyss between art that is popular in the narrow sense of the word and what we conventionally call 'high art'."[22] Any difference of principle between them has been erased. The appeal made by totalitarian art to the people – to the *Herrenvolk* or the ruling class, to the *Weltanschauung* or the world view of the class – was in fact an appeal to the crowd; mass art, disguised as popular art, had lost all popular traits.

"Mass appeal" and "popular spirit" in totalitarian art are two sides of one coin. "Mass appeal" was a concern of the propaganda department, "popular spirit" belonged to the sphere of aesthetics and philosophy. The Soviet term *agitprop*, used both as the name of the section of the Central Committee responsible for culture and also to designate the art engendered by the Revolution, presupposed two ways of influencing the consciousness of the masses: directly, through agitation – through slogans and their visual equivalent – and indirectly, more subtly, through propaganda. The former was addressed to the masses, the latter to the more complex and differentiated class or ethnic community known as "the people". "The finest kind of propaganda," said Goebbels, "does not reveal itself; the best propaganda is that which works invisibly, penetrating into every cell of life in such a way that the public has no idea of the aims of the propagandists."[23]

Not only did the public often have no idea of the aims of the propagandists, but by no means every artist was aware that he was executing a task that had been set in front of him. They created "high art", but every artistic genre, depending on its place in the hierarchy, was visibly or invisibly included in the common task of instilling into the consciousness of the people the ideology necessary to the Party and State: portrait painting reproduced the image of the

great leader and the New Man, historical painting praised the heroism of revolutionary struggle, landscapes revealed the grandeur of Mother Russia or of socialist transformations, etc. In order to bring these ideas to masses "whose capacity for perception is limited and weak", it was essential to embody them in a precise and finished image, removing anything diffuse, indefinite or ambiguous.

There are two words in the vocabulary of totalitarian aesthetics which were used to express the strongest possible criticism of a work of art: "unfinished" and "daub". "I will not tolerate unfinished paintings!" Hitler shouted as he selected paintings for the 1937 exhibition. Afterwards, round the dinner table, he explained to his entourage: "When I visit an exhibition, I never fail to have all the daubs pitilessly withdrawn from it. It will be admitted that whoever visits the House of German Art to-day will not find any work there that isn't worthy of its place."[24] The Soviet *Art* wrote in similar vein: "Even today some artists send in raw material to exhibitions, half-finished work, studies and sketches instead of completed paintings ... Such liberalism on the part of the jury corrupts artists."[25] In both countries the main criterion for judging a work was the finish of its technique and the painter's professional competence in imitating real objects. "The highest praise comrade Stalin would give a painting," reminisced the eminent Socialist Realist artist Isaak Brodskii, "was contained in these two words: 'living people'. In this he saw the greatest merit of a painting. 'A painting must be living and comprehensible' – I have remembered these words of comrade Stalin for ever."[26] And in 1948, as he unleashed a new wave of cultural terror, Zhdanov declared: "Not everything accessible is of genius, but everything of true genius is accessible; and the more accessible it is to the broad masses of the people, the more truly it is a work of genius ... Music that is incomprehensible to the people is not needed by the people."[27]

The totalitarian ideal was the language of the propagandist poster, tending towards colour photography. It is symbolic that Hitler appointed Heinrich Hoffmann, his court photographer, as the man responsible for choosing works for the main German exhibitions. "From Futurism to Photorism" is how wits defined the progress of German art from the avant-garde to the Principles of the Führer, and the House of German Art was ironically nicknamed the "Palazzo Kitzchi". It is no less symbolic that Isaak Brodskii, a former pupil of Repin and one of the founders of Socialist Realism, was the first artist to make use of photographs on a large scale. His vast canvases of Party congresses and speeches given by leaders depicted dozens, even hundreds, of individual figures with the detail of portraits. At the end of the twenties the term "Brodskii-ism" was coined as a synonym for "photographism".

To limit the language of totalitarian art to impartial photorealism would, however, be as great a simplification as to limit its variety of functions to that of propaganda. The objective depiction of reality was condemned by totalitarian aesthetics as crude naturalism, since it was not reality, not the concrete forms

Hilz: A Peasant Venus (1944)

Brodskii: Lenin at Smolnyi (1930)

Katsman: Kaliazin
Lacemakers (1928)

Wendel:
The Art Magazine

of life that were the object of propaganda, but a myth – the image of which art was called upon to create. It is this that was its second, more differentiated and complex, function.

(ii) Myth and life, art and reality

> Myth is invention. To invent means to extract from the sum of the given its fundamental meaning and then embody this in an image – this gives us realism.
>
> Gorky

The language of photorealism would have been entirely adequate to carry out the function of depicting reality. It could not, however, be used to embody the joy of a utopian dream that had finally been realized. "Paint truthfully," Stalin encouraged Soviet painters; "Depict life as the normal human eye sees it," was the burden of Hitler's numerous speeches. But what does "truthfully" mean, and what is "normal vision"? Initially, in both Germany and Russia, these questions generated fierce discussion at all levels. To the left stood the terrible Scylla of modernism, threatening either to dissolve the world into an abstract and formless mirage or else to shatter it into thousands of Cubist fragments and Expressionist distortions; to the right lay the no less terrible Charybdis of naturalism, its indiscriminating surface reflecting all aspects of life, however unworthy. The goal, however, was clear: to portray the joyful world of an achieved Utopia.

According to Nazi theoreticians a truly Germanic art cannot be naturalist, since naturalism is "the literary manifestation of the positivistic, rationalistic age and therefore especially susceptible to Jewish intellectualism".[28] The Soviet view was that coarse, soulless naturalism was a characteristic of imperialist culture and especially of Fascism; whenever the Soviet press listed the most dangerous enemies of socialist culture the term "formalism" was followed by its mirror image – "naturalism". Both terms were used to designate an infringement of the sacred principle of truthfulness to life. In search of this truth both cultures followed the same path and came to the same conclusions.

While a definition was being found for the methods of the art "of a new type", the terms "romanticism" and even "ideal realism" achieved considerable currency. "Myth," wrote Gorky, "is invention. To invent means to extract from the sum of the given its fundamental meaning and then embody this in an image – this gives us realism. But if to the meaning of what has been extracted from the given we add ... what we desire, this gives us the romanticism which lies at the foundation of myth and is extremely useful in that it encourages the awakening of a revolutionary attitude towards reality, the attitude which, in

practice, changes the world."[29] In these words of Gorky – who had an unerring ability to express the most secret yearnings of socialist culture – "invention" and "reality" lose their traditional opposition and are united in a dialectical synthesis; myth grows out of reality and its features are already contained in it. Myth and invention are what constitute the "fundamental meaning of reality". To express myth in a realistic image means to reflect in art the genuine "truth of life" which was the main principle of socialist realism. At the First Congress of Soviet Writers and all subsequent cultural congresses much was said of the need "to add to the powerful current of realism a certain stream of revolutionary romanticism"[30] since "realism, not warmed by the blood of romantic excitement, is only an external likeness of life".[31] This corresponded to the spirit of the epoch, which referred to itself as "the youth of humanity" and demanded to be reflected in its "heroic thrust", in its "revolutionary development" towards the bright future, during the course of which it had to overcome a multitude of difficulties and deprivations. "We are born in order for fairy tale to become reality" – the words from the "Aviation March", together with the chorus "Still higher, higher and higher", resounded during the thirties throughout the territory of the Soviet Union; almost the same words were sung, to the same tune, by the youth of the Third Reich. It was not only in the visual arts that one culture borrowed ideological clichés from the other.[32]

Goebbels put forward a similar concept when he opened the Reich Chamber of Writers on 15 November 1933:

> Their attention [i.e. that of writers and artists] is drawn ... to an ideal realism, to that heroic life-concept, which today re-echoes through the marching steps of the brown columns, which accompanies the peasant as he pulls his ploughshare through the soil in his fields, which has given the worker a sense of a higher goal in his struggle for existence, which stops the workless from despairing, and which fills the work of reconstructing Germany with an almost soldierly rhythm. It is a kind of steely Romanticism which has made German life worthwhile again, a Romanticism which does not hide from the hardness of life or strive to escape from it into blue beyonds, a Romanticism which has the courage to face problems and to look them straight in the pitiless eye, firmly and without wavering.[33]

Mature totalitarianism inherited this concept from the earlier stage of its development, but was by no means satisfied with it. The language of romanticism demanded fantasy, brilliance, exaggeration, lofty aspirations and dynamic forms; now that the future had moved so close to the present, had in fact become its tomorrow, all this came to be seen as a distortion of living truth and even as a dangerous flight from reality occasioned by dissatisfaction with life itself. When Hitler saw the catalogue of the exhibition "Young Art", staged in Vienna by von Schirach, the chief "romantic" of Nazi youth, he shouted out angrily: "The title alone is all wrong. 'Young art'! Why, these are all old men, idiots from the

day before yesterday who are still painting this way. The Reich youth leader ...
[should] not make propaganda against us!"[34] Only the fact that von Schirach
was married to the daughter of Heinrich Hoffmann saved him from disgrace.
The regimes had matured and grown older; they could not allow the existence
of other, newer, ideals.

It was for this reason that Goebbels's "steely romanticism" so irritated
Rosenberg – who allowed no liberties with living truth on the pages of *Art of
the Third Reich*. That such liberties could not be allowed at major German
exhibitions was made equally clear by both Heinrich Hoffmann and the Führer
himself. Romanticism survived only in the background to portraits of Hitler, and
in the emotional tone of landscapes.

In his own speeches Hitler never used the term "romanticism" and made no
appeals to myth (he readily admitted that he had not found the time to read
Rosenberg's *The Myth of the Twentieth Century*). With the triumph of Stalinist
Socialist Realism these terms vanished from Soviet vocabulary as well. Steely or
revolutionary romanticism was replaced by the art of living truth.

In his 11 September speech on art at the Party Congress in Nuremberg,
Hitler formulated this principle as precisely as Zhdanov had done at the First
Congress of Soviet Writers. "I am on the contrary convinced that art, since it
forms the most uncorrupted, the most immediate reflection of the life of the
people's soul, exercises unconsciously by far the greatest direct influence upon
the masses of the peoples, but always subject to one condition: that it draws a
true picture of that life and of the inborn capacities of a people and does not
distort them."[35] The conception of art as the faithful depiction of reality was
not, however, an invention of either Zhdanov or Hitler, but something inherited
from the nineteenth century, although the new epoch did indeed introduce
certain innovations in its view of the relation between art and life.

Soviet theory and criticism elaborated this dialectic with great thoroughness.
Party documents, annual sessions of the Academy of Arts, theoretical antholo-
gies on aesthetics and almost every editorial of the journal *Art* insistently
reiterated the idea of Socialist Realism as the highest form of faithful reflection
of reality:

> Socialist Realism is not a simple continuation of the old realism, even of its
> highest manifestations. It is an art that is imbued with a deeply Bolshevik spirit
> of tendentiousness ... Socialist Realism is a new factor in the development of
> world artistic culture, the hope and banner of the art of all advanced and
> progressive humanity. Socialist Realist art is the highest form of artistic know-
> ledge of reality.[36]

The reason for Socialist Realism being "the highest form of knowledge of reality"
and "the banner and hope of humanity" lay in the different character of the
new reality to be depicted. "The progressive Russian art of the past did not have
enough that was beautiful in the reality that surrounded it, and there was more

than enough that was base and ugly ... The life of the Soviet people is exactly the 'poetic reality' which, according to Belinskii, 'makes art poetic and endows it with an inner force of development' ... It is for this reason that Soviet painting portrays principally the positive sides of life, developing the affirmative genre."[37] In all this Soviet criticism was simply inculcating the concept which constitutes the very kernel and foundation of all totalitarian aesthetics: the principle of the identity of the artistic ideal in art and in life.

This was the logical conclusion of the so-called "Leninist theory of reflection". In Russia attempts to clothe it in the dress of Marxist philosophy and to give it the form of a completed "academic" theory met with success only at the very end of the Stalin period, in the late forties and early fifties, when it was elaborated in the utmost detail in the aesthetic treatises of individual theorists and the collective anthologies of entire special research institutes. In Germany such theories never attained such elegance of form, remaining at the stage of slogans, invective and Party prescriptions. Another cause of this lack of development was Goebbels's ban on art criticism in 1936.

The concept of the identity of art and reality was probably most fully elaborated in *Towards a Theory of Art* by G. Nedoshivin, one of the most important official aesthetic theorists:*

> The contradiction between poetry and truth cannot be resolved within the confines of bourgeois society – or indeed of any society that is divided into antagonistic classes. It can be resolved only when the invincible contradiction between the condition of society and the ideals of its progressive members is no longer present in the social order itself, when there arises a definite harmony of social and personal interests, when the struggle of antagonistic classes is abolished and there arises a moral and political unity of the people. Then the basis in reality of this contradiction between poetry and truth is itself destroyed, then the truth of the social order itself appears deeply poetic and true poetry becomes possible only on the paths of truth. In other words, this is realised in socialist society.[38]

The same idea was repeated by other critics to a wider audience: "As the severance between dream and ideal is destroyed in social life on the one hand, and in actual reality on the other hand, so this severance is destroyed in the socialist art which reflects the life of socialist society."[39]

Soviet Socialism had overcome the antagonism of the classes only by battling firstly against the nobility and bourgeoisie of old Russia and then against its own peasantry and intelligentsia; Hitler's National Socialism, on the other hand, had been free of class antagonism from the beginning. The German people had shown its "moral-political unity" in the 1933 elections and Hitler intended to

* As happened more than once in the history of Soviet aesthetic thought, this book was published only after the culmination of the epoch for which it was intended, and so did not play the role that could have been expected. It can, however, be seen as the most fully argued justification of the fundamental concepts of all totalitarian aesthetics.

establish the Third Reich for a millennium, if not for eternity: "The Revolution has brought us in all areas without exception everything that we expected from it ... There will not be another revolution in Germany during the next thousand years."[40] For him, as for the Bolsheviks, the revolution was the "final and decisive battle" after which "the human race would arise", admittedly with the exception of members of the wrong race or class; and like Stalin he mercilessly suppressed any revolutionary possibilities in both politics and culture. The meaning of the "eternal values" in art which Hitler never tired of proclaiming and which he contrasted with the decadent fashion of constantly changing "isms", lay for him in the fact that they reflected the ideals of the people, embodied in the reality of a Reich that had been established for centuries to come. In 1939, at the opening of the Third Great Exhibition of German Art in Munich, Hitler said: "For however numerous in their thousandfold variety may be the historical vision or the other impressions which life may make upon the artist and which enrich him for his creative work, which arise before his mind and awake his enthusiasm, yet over and above them all stands the present day splendour of his own time, which need not fear comparison with the very grandest epochs in our German history."[41] "And since we believe in the eternity of this Reich," he said in another speech, "... these works of ours shall also be eternal".[42] Behind these "eternal values" one can make out the same concept of the identity of the ideal in life and art.

Totalitarianism does not produce new ideas. It claims to be unique only in so far as it is the realization of man's age-old dream of earthly paradise. The Schlegel brothers' romantic "cult of life" and Chernyshevskii's theory of the superiority of life over art provided the foundation for totalitarian aesthetics, and the theory of the identity of social and artistic ideals became the main component of the ideological fuel that fed the cultural megamachine. There was nothing this megamachine could then produce other than the myth of the happy life of a people achieving great aims under the guidance of great leaders. The embodiment of this myth can be seen as a second function of totalitarian art, more complex and differentiated than its primary function of propaganda.

Totalitarian art contributed to the mythologizing of reality at all levels of its thematic structure. "The day will come," wrote the sculptor Sergei Merkurov, "when there will appear in sculpture not only Vladimir Ilich as his contemporaries knew him – Vladimir Ilich Lenin, but the symbol, the reflection of his epoch, the image of the leader of the greatest revolution, the leader of his people and the world proletariat, Lenin as the people imagine him and as he was in reality."[43] These words of the artist who, together with Nikolai Tomskii and Evgenii Vuchetich, did most to embody the myth of the Leader, words spoken a quarter of a century after the death of Lenin, express the fundamental idea of this myth more completely than many volumes of discussions by theorists: the real leader was not the man known by his contemporaries, his Party

comrades – who themselves left descriptions of him – but the man "as the people imagine him". The people, of course, could imagine him only as he was presented by art, and this was not how he had been seen by his contemporaries. It is enough to compare the first classic embodiment of the "Lenin theme" – Aleksandr Gerasimov's "Lenin on the Tribune" (1930) – which, according to the critics, completed the transition from documentary record to image,[44] with the photograph it was painted from. "The metamorphosis of the man into a symbol was carried out extremely effectively. At times the popular imagination transformed the swarthy, dark-haired Hitler into the ideal racial type, and we find an astonishing number of assertions that the Führer was a blond with blue eyes."[45] Soviet citizens, for their part, would certainly have been surprised to learn that in real life Stalin was short, pock-marked, bandy-legged and had one arm thinner than the other – his portrayals contained not a hint of such physical inadequacies. see p. 317
see p. 316
(below)

It was not only the image of the leaders that underwent transformation, but also their role in historical events. In many pictures from the first exhibitions of the AKhRR, for example, Trotsky was depicted as the founder of the Red Army (it is unlikely that these works have been preserved even in the most closed of Soviet special stores); from the mid-twenties this role was transferred to Lenin, and from the thirties to the mid-fifties it was shared between him and Stalin. They were portrayed, both together and individually, in all the main episodes of the Civil War: in army headquarters by the telephone line (Igor Grabar's painting of this title), in the trenches of the front line (Robert Frents's "Stalin at the Petrograd Front in summer 1919"), taking important decisions over maps of military operations, etc.

During the whole of the Second World War, Stalin, according to Khrushchev, did not once visit one section of the front or one liberated city, with the exception of a single short drive along the Mozhaisk road after the front line had been strongly fortified.[46] Nevertheless there were dozens of portrayals of him with generals in defensive positions ("Stalin, Voroshilov and Rokossovskii at the defensive lines near Moscow" by Konstantin Finogenov, "Stalin at the Front near Moscow" by Pavel Sokolov-Skalia), in the trenches with the soldiers ("Stalin in a Trench" and other drawings by Finogenov), and on ships (Viktor Puzykov, "Stalin on the cruiser *Molotov*"). On 22 October 1922, during the "March on Rome", Mussolini arrived in the capital by car, but Conti's painting "La Prima Andata", shown at the 1930 Biennale, portrayed the Duce on a white horse at the head of armed detachments. Hitler was afraid of horses, but Lanzinger's popular painting led the German people to imagine him as a horseman. Works of art were also created on such purely mythological themes as the young Stalin helping a wounded comrade who had been shot during a demonstration, or Hitler accomplishing some equally courageous feat during the Munich *putsch*. see p. 188

Two other main themes of Soviet historical painting can also be seen as

Finogenov: Stalin at the Front Lanzinger: Hitler, the Standard-bearer

largely mythological – "The Storming of the Winter Palace" and "The Salvo see p.
from the *Aurora*". On the night of 24/25 October 1917 the Winter Palace in
Petrograd, the location of the Provisional Government, was guarded only by a
women's regiment and a handful of poorly armed students; in countless Soviet
paintings, however, we see a revolutionary crowd, many thousands strong,
storming an impregnable fortress. The reality of the salvo, supposedly fired at
the Winter Palace that night by the cruiser *Aurora*, is still more doubtful. Did it
really take place? And if it did, did it have any effect? It is as impossible for
someone brought up on the iconography of Soviet art to ask such questions as
for a medieval monk to doubt the Immaculate Conception. With the heavy
emphasis placed by totalitarian art on the reflection of "living truth", all such
representations automatically took on the character of historical facts and
entered the history books as documentary records.

The reality of historical events is quickly erased from the memory of gen-
erations, and the life of political leaders runs its course in spheres inaccessible
to ordinary people. Their own everyday life, however, their own work and
leisure, was no secret to them – and it had little in common with the fairy tale

depicted in art. Such a division could well lead to a pathological split in the consciousness of someone who is shown an image that contradicts all his experience and is made to believe that this is his own life. With regard to this problem one could say that ideology played the role of a social psychiatrist.

At the Nineteenth Party Congress in 1952, G. M. Malenkov, the chief ideologue after the death of Zhdanov, proposed a new understanding of "the typical" in Soviet art. In itself this concept was nothing new in Soviet aesthetic thought. It had gained currency long before Socialist Realism and was based on Engels's well-known definition of realism as "truthfulness of reproduction of typical characters in typical circumstances". In the early stages of Soviet art this meant that, even though what was typical of the new reality was always good, nevertheless this good was already sufficiently widespread to be fully recognizable in its everyday image. The predecessors and first representatives of Socialist Realism did indeed depict their heroes as recognizable and not entirely perfect figures, carefully showing the shoots of the new life bursting through the unattractive features of the old. After four decades of the Soviet regime, however, such an interpretation of the typical was considered dangerous. The typical, according to Malenkov, was not the "statistical average", "not what there is more or less of in life, but what corresponds to the essence of the given social force, regardless of its arithmetical frequency".[47] It was not what could be seen in everyday life by the naked eye and was in fact more noumenon than phenomenon, more easily grasped by the reason of a philosopher than by the vision of an artist. "This is why a grasp of Marxist-Leninist theory is essential to the artist as a reliable precondition for a deep penetration into reality, without which it is impossible to create truthful and typical images. This means that in Socialist Realist art progressive Communist ideology is indissolubly linked with truth of representation; it is impossible to separate them one from another, let alone to contrast them."[48]

All this was far from new, both in its theoretical essence and in its practical implications. Malenkov's definition of the typical in fact differed little from Gorky's thoughts on myth and invention. For totalitarian culture, however, these words of the ideological leader, pronounced from the rostrum of the Party Congress, meant a new stage, a turning point, in history.* What had previously

* In his autobiography the literary critic Andrei Siniavskii describes the sudden change imposed on Soviet culture by these "new ideas": "Academic and research programmes, aesthetics, philosophy and philology were all hurriedly revised. New chairs were established, new textbooks and dissertations completed. As a matter of emergency institutes and collectives brought out works on the typical as the exceptional in Marxism. Science galloped forward. And no one, absolutely no one in the world except a few renegades like me, knew that Malenkov's entire theoretical contribution had been taken word for word from an old, forgotten Literary Encyclopedia. And taken not just from anyone, but from the former White émigré Sviatopolk-Mirsky, who had foolishly returned to Russia and, according to rumours, had already died of hunger in a camp as an enemy of the people. Meticulous historians can easily check me by taking down Malenkov's speech at the Party Congress and comparing it with a volume of a forgotten encyclopaedia under 'R' for 'Realism ...' (A. Terts. *Spokoinoii nochi* (Good Night), Syntax Editions, Paris, 1984, pp. 328–9.)

been veiled by such vague and romantic terms as "myth", "invention" and "revolutionary development" appeared now in the guise of the concrete law of the one true theory; as a result it became an injunction. "This was why the question of the typical takes on a political character";[49] this was why any departure from the typical, "any artistic 'botch' [was] so unacceptable", why it was seen as something that could "harm the souls of millions of people".[50]

With the help of such theories everything fell into place. The typical was not what was most widespread but what was most exceptional. It was no invention, it already existed in the present, somewhere nearby, it had already acquired visible features in the magnificence of the stations of the Moscow metro, in the happy holidays of the children in the model pioneer camp "Artek" (the only such camp in the entire Soviet Union), in the exploits of heroes of labour and war. And the sole task of totalitarian art was to reflect such typical features of the new life.

Nazi aesthetics never attained such clarity – partly because Hitler preferred the spoken word to the written, and practical action to philosophizing. Even so, criticism in the Third Reich intuitively grasped the expectations of the epoch and demanded the same deep penetration into the essence of the new reality, the same progressiveness and Party spirit in its perception of it: "Now as always the main aim of genre painting is to aid our understanding of the everyday ... one of its most important tasks is the construction of images that transform individual Germans into typical representatives of their race and profession."[51] Noting the movement of art towards the reflection of the typical, Nazi observers concluded with satisfaction: "They [German artists] are no longer painting absinthe drinkers and roulette players ... They are no longer interested in the grim uniformity of slums, urban desolation ... They don't even claim the right to depict scenes of hopeless misery with undertones of sharp criticism, implied accusation, or heart-felt compassion in an attempt to rouse the social conscience of the observer. They want to be spokesmen for the positive side of life."[52] Soviet criticism of the same years is full of indignation against "certain" or "a few" artists who still paint "old bridges, still lifes, little old churches, a poetically dilapidated fence, old huts leaning to one side ... etc." "This 'poetic' rot," wrote Sysoev, the Academic Secretary of the USSR Academy of Arts, "all this old junk makes it impossible to breathe. Such – if I may use the word – art demeans Soviet man, draws him away from our reality, makes art pointless and harmful ... From such sympathy with the old it is not far to indifference towards the new. What does such art have in common with the most progressive art of the world, the great, revolutionary art of Socialist Realism? Absolutely nothing."[53]

Totalitarian art did indeed have nothing in common with the "gloomy relics of the past" that made up the lives of ordinary people in their difficult present. Difficulties and inadequacies were seen as temporary, the result of a conspiracy by enemies of socialism who would be destroyed through merciless struggle.

"The philosophy of 'world-sorrow' is not our philosophy. Let those who are departing grieve, and those who have had their day," repeated Stalin, quoting from the journal *Art*. He went on to say that "the art of socialist realism is unconditionally and consciously optimistic, the art of the new world, gazing boldly into the future".[54] Social optimism was indeed the principal component of the content and language of totalitarian art throughout its development. Slight liberties were taken from time to time over matters of form, but not in one Soviet or Nazi exhibition would one have seen a sad face – except, of course, in portrayals of the appalling life of people in hostile countries. Even in battle scenes during the war "the characteristic trait was optimism and faith in the victory of life over death". *see p. 344–45*

It is here that we find the main reason for the antagonism of Nazism towards Ernst Barlach – "the most German of German artists" and realistic enough in many of his works even from the point of view of official ideology. Letters have been preserved, sent to Barlach by a certain *Obersturmbahnführer* for art, in which the latter enthuses over the work of the great sculptor and finds only one inadequacy: Barlach's peasants were "too sad and tired".

Barlach's sculptures were taken down and partially destroyed in the mid-thirties. At the same time a very popular monument to Gogol by Nikolai Andreev disappeared from Gogolevskii Boulevard in Moscow, since, according to *Pravda* of 14 May 1936, the sculptor had distorted the image of the great writer, "treating him as a pessimist and a moaner". Andreev was an important Soviet sculptor who had modelled Lenin from life and was officially recognized as the founder of the iconography of the Leader, but even this was not enough to save him from humiliation: his Gogol was replaced by Tomskii's more optimistic version.

Rather than being derived from the present, this optimism was injected into totalitarian art from the mythical future. As the present day grew more terrible, as the struggle grew harsher and victory drew nearer, as hunger and terror put an end to more and more millions of lives, so the imaginary heaps of food on kolkhoz tables grew vaster and the smiles on the faces of workers more radiant. It is to the mid-thirties, immediately after collectivization and the subsequent terrible famines in the Ukraine and Central Russia, that we owe the most famous and optimistic portrayals of kolkhoz abundance. And it was in 1937, at the height of the Stalinist terror, that Mukhina's "Worker and Collective Farm Woman" was sculpted – that bright image of the Soviet people striding into a joyful future.

This optimistic myth embraced even the aspects of life which totalitarian propaganda was most reluctant to exhibit. In 1935, for example, a theme exhibition in the Karelian town of Povents was devoted to the White Sea Canal – which was constructed almost entirely by forced labour. The forced labour of inmates of Nazi camps was portrayed in such well-known paintings as "Granite Quarry in Mauthausen" by Wilhelm Dachauer and "Marble for the Reich

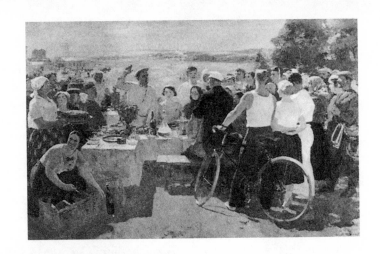

Sergei Gerasimov: A Collective
Farm Festival (1936–37)

Mercker: Marble for the
Reich Chancellery

Gaponenko: To Dine with
the Mothers (1935)

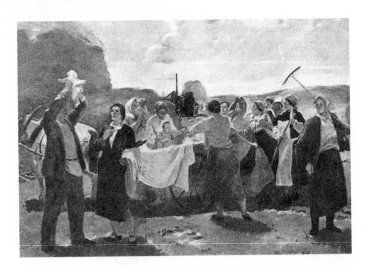

Chancellory" by Erich Mercker. The task of "warning and deterrence"[55] does not appear to have entered into the intentions of either the artists or the commissioners of the paintings. On the contrary, the people portrayed carry out their work with the usual joyful enthusiasm; slogans like "Work makes free" or "Work is a matter of honour, valour and heroism" embellished the gates not only of Auschwitz but also of a number of Soviet labour camps. Taras Gaponenko's once famous "To Dine with the Mothers" (1935) depicted the thrilling joy of a meeting, in the fields of a collective farm, between a group of mothers and the babies who had been brought out during the lunch break to be fed. According to one art historian, the viewer of this painting was intended to "remember how difficult the lot of a peasant mother had been, how she had been torn between home and field in the conditions of the old village with its heavy labour and its need"; he was supposed to see in this painting the "harmony of the social and the personal in the Soviet village".[56] No one commented on the portrayal of breast-feeding mothers as having to perform heavy physical work; this was something so widespread as to be taken for granted. What this painting was intended to reflect was the "typical" or exceptional characteristics of the new life: i.e. the Party's concern for the labourers, which transformed inordinately heavy labour into a joyful festival. All this bore as much relation to reality as Lautréamont's "thrilling meeting on an operating table between an umbrella and a sewing machine". Nevertheless, in the Soviet Union, it was given the name not of sur-realism but of sots- (i.e. socialist) realism.

In Germany the term "realism" was not applied to National Socialist art. This was chiefly because during the twenties it had gained wide currency in the pages of the German Communist press and so had become associated with the philosophy of materialism that Nazism supposedly repudiated. Von Schirach, Rosenberg and Hitler often used the word "idealism" and called for the construction of a purely spiritual and ideal art that had been purged of both Jewish pragmatism and Marxist materialism. However, Hitler, Stalin, Zhdanov, etc. all appeared in more than one role; and if as political ideologues they gave their words a different political colouring, if as theoreticians they used different terminologies, as critics they imposed identical tasks on art and demanded the use of identical artistic techniques for their execution.

In its cultural policies, totalitarianism initially made use of material handed down to it from the past, selecting whatever was most suitable. As a result of this orientation towards the past the artists it attracted were primarily traditionalists. There was a difference, however, between the German traditionalists and the Russians.

In February 1933 the Nazis began to purge the German Academies of modernists, intending to restore to these traditional institutes their former status as guardians of the principles of a strict academic realism. At this time the main administrator of German artistic life was the academician Adolf Ziegler, to whom

rumour ascribed the rediscovery of the techniques of the Old Masters.

Since the rebellion of the Peredvizhniki, however, the Russian Imperial Academy had been seen as a major obstacle to free creativity and a bulwark of reaction; it is for this reason that it was abolished in 1918. And from 1922 Lunacharskii and the Party leadership decided to back the Peredvizhniki in the person of the AKhRR. For two decades the chief administrator of Soviet artistic life was Aleksandr Gerasimov, a fervent adept of this movement.

In their attempt to bring art closer to life the Peredvizhniki had gradually moved away from the lacquered surfaces of academic compositions, developing their realistic style through studies from life. Their most important representatives, above all Repin and Surikov, assimilated various techniques of the modern movements, often using thick strokes and even some of the coloristic elements of plein-air. It was this stylistic hybrid that provided the foundation for the earliest stage of Socialist Realism. The thick strokes used by Repin successfully conveyed the romantic excitement of revolutionary scenes, while plein-air patches of sunlight evoked the fervently joyful atmosphere of kolkhoz holidays, sporting contests and meetings of the leaders with their people.

The two totalitarian cultures thus began from different starting points and Soviet criticism of the thirties had some justification for the contrast it drew between its own realism and the academic pseudo-classicism of the Nazis, accusing the latter of pomposity and brutality. But the nearer Stalinist socialism drew to final victory, the less adequate grew the language of revolutionary romanticism to express the solemn and confident rhythms of its progress; in the same way the descriptive realism of the Peredvizhniki became less able to reflect the "typical" quality of Soviet reality. The new order was being constructed not by a revolutionary surge of the masses, not even by their daily work, but by the iron will and wisdom of the leaders. Mussolini, who usually went to bed at ten in the evening, never turned off the light in his office, and the myth of the never-extinguished light of Stalin's pipe and table-lamp left its mark on painting, poetry and song. Mature totalitarianism demanded sobriety of language, static forms and monumentality. From the democratic qualities of the Peredvizhniki it had regressed to the imperial spirit of Russian classicism.

With the establishment in 1947 of the USSR Academy of Arts academic classicism became the official language of Socialist Realism. Not only was the great Russian academician, Karl Briullov (1799–1852), who had been seen by progressives from Stasov to the first Socialist realists as the chief enemy of democratic culture, now elevated to the same heights as the "great predecessors" Repin and Surikov; even such representatives of late "bourgeois-salon" academicism as Heinrich Semiradskii and Konstantin Flavitskii were held up to Soviet artists as models of consummate technical perfection. Among the paintings shown at All-Union exhibitions during the late forties and early fifties there are few portrayals of Stalin on the rostrum, Stalin meeting representatives of

the people or Stalin talking intimately with writers. Instead he is shown as detached from his surroundings – which in turn become merely a background to his symbolic figure. His greatness cannot be measured by any human scale; a fitting setting can be provided only by the towers of the Kremlin (as in a portrait by Aleksandr Gerasimov), the wise silence of his own office (as in portraits by Dmitrii Nalbandian and Fedor Reschetnikov), or the epic breadth of

see p. 315 (above), see p. 314

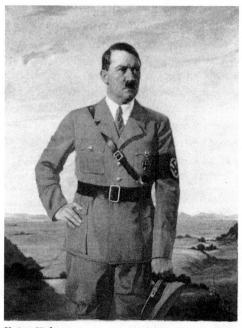

Knirr: Hitler

the Russian landscape (as in one of his last portrayals, Fedor Shurpin's "Morning of our Fatherland"). The wise harmony of his thinking, his god-like solitude, could be better conveyed through Poussin's classicism than through the language of Repin's genre painting. In these late ceremonial portraits the iconography of the Leader is identical to that of the Führer. It was not a matter of direct borrowings or influence; the language of totalitarianism, like that of any other culture, was evidently subject to certain laws.

see p. 316 (above)

see p. 313 and p. 315 (below)

"Every remarkable phenomenon of the present bears on it the stamp of Stalin's genius", wrote the Soviet press. But not only the present. Past and present alike, with all their upsurges, conflicts and achievements, were now transformed. History had gone full circle; under the shadow of the Leader's gigantic figure it had acquired a final, harmonious outline.

The last All-Union exhibition of the Stalin epoch can be seen as the apotheosis

of this style and spirit. Historical figures now thought and acted like ordinary Soviet citizens or their leaders; all that was left of history was a cultural or ethnographic background. Just as Anatolii Iar-Kravchenko portrayed Stalin, Voroshilov and Molotov listening in Gorky's flat to a speech by the great proletarian writer, so Viktor Artamonov portrayed Pushkin and Zhukovskii, the leaders of Russian literature, listening in Glinka's flat to the playing of the great composer. The main hero of the first days of the October Revolution turned out to be the poster hoarding on Senate Square in Petrograd displaying the decree instigating Soviet power ("The First Word of Soviet Power"); the most important event in the life of a Soviet factory was a new issue of the factory newspaper (the painting under this title by Anatolii Levitin and Iurii Tulin); and one might well think that in Boris Shcherbakov's painting on a revolutionary theme ("Your Time is Over!") the same workers, now clad in soldiers' greatcoats and leather jackets, are handing a notice of dismissal to a negligent director who has been criticized in such a newspaper – rather than a copy of a nationalization decree to the factory's former owner. Tragic conflicts, no longer typical of life, disappeared also from art; if they remained, it was only at the level of the sufferings of a bureaucrat on reading just criticisms in *Pravda* under the disapproving gaze of his family ("Slated" by Ivan Griniuk), or of the reaction of the family circle to their youngest member being given a low mark at school (Fedor Reschetnikov "Two again!"). It was as though the myth of the happy life had been so deeply instilled into people's consciousness as no longer to need direct, epic expression. In late Stalinist art the heroism of labour and struggle was replaced by the depiction of the tender gratitude of people living in a utopian realm. The central events of family life were such episodes as trying on a new officer's uniform (Nikolai Ponomariev, "The New Uniform") or the ecstasy of being granted a new flat (Aleksandr Laktenov, "The New Flat"). All this resembled not so much see p. the work of the Peredvizhniki, with its epic embrace of popular life, as the entertainments permitted by the Petersburg Academy as a "low genre" and considered suitable for less able students; it was also remarkably similar to the didactically sentimental scenes of the Munich painters so admired by Hitler.

In canvases of all sizes and on all themes details executed with photographic accuracy went to form symmetrically balanced compositions, contrasts of colour were toned down by a general blandness, and any roughness of texture disappeared beneath a sleekly varnished surface. Even such leading lights of Socialist Realism as Arkadii Plastov, Iurii Pimenov and Sergei Gerasimov were now accused of impressionism and lack of finish,[57] and their place was taken by the new academicians – Laktenov, Nalbandian, Reshetnikov and others. Heroes of war and labour, famous people, milkmaids and steel founders were immortalized in static forms of noble white marble. The now fashionable elegant nudes of the academician Matvei Manizer were almost indistinguishable from the work of Fritz Klimsch, one of the twelve "immortal" masters of the Third Reich. The

Ponomariev: The New Uniform (1952)

beautiful life and developing tastes of the people demanded forms that were elegant as well as comprehensible, as Zhdanov pointed out in 1948. As a result totalitarian sculpture took on more and more the stylistic features of a kind of "cemetery classicism". It is characteristic that during his visit to Moscow in 1939 Heinrich Hoffmann paid especial attention to only one work of Socialist Realism – the monument in the Novodeviche cemetery to Stalin's wife Allilueva. In his own words, this was "one of the most beautiful I have ever seen".[58] Late National Socialist art, however, judging by the catalogues of German exhibitions and press reports, was developing in the opposite direction, drawing nearer to life, gradually diluting its pseudo-classicism with elements of genre painting and realistic narration.

Writers on the art of the Third Reich deny its realism on the ground that its aesthetic theory was based on the purest demagogy: "every positive tie to reality was destroyed".[59] But the links of Soviet art with life were no less, if no more, illusory, and its demagogy was infinitely more elaborate. Nevertheless, the term "realism", qualified by the epithet "socialist", has become so firmly attached to Soviet art that it is hardly worth trying to replace it. In any case it was a kind of realism – if realism is understood as the formal principle "of the reflection in art of life in the forms of life itself".

Imprisoned by its own ideology and propaganda, totalitarian consciousness

not only believed fervently in the applicability of this principle to its own art, but also tended to look on it as universal. On 26 December 1939 Goebbels noted in his diary: "Got to know the inner rottenness of English society by reading Maugham. This society will collapse if it is pushed hard enough."[60] The Soviet cultural figures who met at the first congress of writers found evidence of the decay of bourgeois society in *Journey to the End of the Night* by Louis-Ferdinand Céline.[61] The irony of Maugham and the phantasmagorical quality of Céline appeared, according to their own theories, to be merely a literary device, a way of emphasizing the typical in the reflection of living truth. Such hermetic self-centredness of thought led the totalitarian leaders, on more than one occasion in history, to fatal errors in their appraisals of real situations and people.

Totalitarian art can be seen as realism "of a special type", different from all other European realisms. "In the forms of life itself" it reflected not reality, but ideology and myth in the guise of reality. And it reflected this ideology only too faithfully. From a method of perceiving the world – like nineteenth-century realism – it had been transformed into a method of instilling into the world a particular kind of perception, and as such it was endowed with a dynamic charge. Its principles were both obligatory for its own age and of universal application to all other ages; if it needs an epithet to distinguish it from other realisms, the most appropriate designation is probably "total realism".

The functions of the art "of a new type" included the construction of a universal myth, the propagandizing of this myth and the influencing of the consciousness of the masses with its help. Behind all these lay yet another function, half esoteric, not always directly acknowledged, but perhaps the most important of all: the creation of a New Man.

(iii) The semantic revolution and the new man

This is the task of our time: from a new myth about life to construct a new man.

A. Rosenberg

In the Soviet Union a new man is being born ... The new man, the citizen of the Soviet Union, demands a new aesthetics. Our developing art also demands a new aesthetics.

N. Altman

The myth of the new reality was constructed outside the sphere of the visual arts. Its general outlines were first sketched in Party directives; the social sciences then endowed it with the appearance of a uniquely true theory; and finally official literature, theatre and cinema retold it, transforming dry lists of figures and prescriptions into relationships between "real" people. Painting, drawing

and sculpture were allocated the role of finding an embodiment for this myth, their final products evaluated as "artistic images", that is, as revelations through the individual of the typical. Whether we take the human figure (the Leader, an artist or a steel founder, furnished with real names, patronymics and surnames), or a scene from everyday life or history, the individual is portrayed only as an embodiment of something more general. It is as though such portrayals are enveloped by an invisible web of verbal definitions, literary associations and ideological clichés, and it is this that gives rise, in a prepared consciousness, to the "artistic image". Contrary to the claims of totalitarian aesthetics, it was not form that revealed content; content was in fact brought into form from outside, making a work of art into a kind of screen on which to project the myth of the new reality. Before being embodied in plastic form, however, this myth had to be realized in language.

Researchers, beginning with Hannah Arendt, have noted that the alteration of consciousness through the alteration of language is probably the most sinister feature of totalitarianism. As Buchheim puts it: "concepts, words, and values are robbed of their traditional meanings ... Totalitarian rule attempts to encompass the whole person, the substance and spontaneity of his existence, including his conscience ... the regime wishes to create – in accord with its own ideological scheme and with social engineering techniques – a wholly new society, a 'new type of man', as Lenin put it – even a new world."[62]

The idea of the construction of the New Man* is included in any utopian programme and constitutes the aim and kernel of all totalitarian ideology. Karl Marx himself wrote about the man of the future who would overturn fixed ideas and destroy the sacred things "of the old people". Inherited by Italian Futurism from Marx's student Georges Sorel, this concept became a part of Fascist doctrine. The entire art of the post-revolutionary Soviet avant-garde developed under this banner. The coming birth of the New Man was prophesied in a play by the young Goebbels. In 1915–17 a still younger Mao Tse-tung began his political education in a Marxist student circle called "The society for the study of the New Man". As for Hitler, he appears to have orientated his whole ideology towards the task of constructing this new man: "Those who see in National Socialism nothing more than a political movement know scarcely anything of it ... It is more even than a religion: it is the will to create mankind anew."[63] It was a general hatred of the "old man", of bourgeois consumer psychology, that drew many artists to the revolutionary movements: from the Futurist Maiakovskii to the realist Gorky, from the militant racist H. Brute to the refined intellectual and modernist Gottfried Benn. At the time of the birth of Socialist Realism this idea was repeated again and again at congresses and meetings of

*More precisely, the "new human being". In Russian "New Man" (*Novii chelovieck*) means both man and woman. The Nazi and Fascist ideologies were, first and foremost, concerned with maleness.

Soviet writers, artists and architects. Finally, in our own time, Soviet propaganda has stated more than once that the Soviet Union has engendered a new, supreme type of rational man. In 1976, for example, Brezhnev reported to the Twenty-fifth Party Congress that "Soviet man was the most important product of the last six decades".[64]

The figures who look down on us from the canvases of the official totalitarian artists are, nevertheless, anatomically normal and are portrayed in familiar human situations. Only their optimistic smiles, or perhaps thoughtful severity, distinguish them from anyone else. If the avant-garde images of man as a machine or robot, as the giant of a future world, are set aside – as they were by totalitarianism itself – then it might seem that the concept of the new man was never embodied. It is only when seen as images or allegories, within the context of their social mythology, that these figures reveal inner links that do indeed make them into representatives of a new human species. They can then be seen to speak in a language in which ordinary words and forms have been filled with an entirely different content.

In 1950, at the height of the struggle against cosmopolitanism, Stalin's new teaching on language suddenly dropped, like a bolt from the blue, on the heads of Soviet scholars. The Great Helmsman had gained yet another title – that of the great linguist, who had discovered the incontrovertible laws of linguistic thinking. In *Marxism and Questions of Linguistics*, published first in *Pravda* (20 June 1950) and then as a separate brochure, Stalin asserted, contrary to traditional Marxism, that language stood above class. Language, according to Stalin, like the means of production, served not individual classes but the people as a whole, and as a result was something more stable than social structures.

> Over a hundred years have passed since the death of Pushkin. During that time the feudal order and the capitalist order have been abolished in Russia, and a third, socialist order has arisen ... But if, for example, one takes the Russian language, then during that large interval of time, it has not undergone any fracture, and the contemporary Russian language differs little in its structure from that of Pushkin.[65]

There was no need for Stalin to interpret his statements: the well-practised cultural apparatus drew the necessary conclusions in each area. Since the literary and conversational language had not changed since the days of Pushkin, then the language of painting could not have changed since the days of his contemporary, Karl Briullov. All deviations from the common language of the people, all experiments or revolutions, all "isms", were socially alien, ephemeral slang and jargon, a tribute to commercial fashion inspired by the enemies of a truly national culture. Soviet criticism endlessly repeated such statements as this: "The process of constant 'revolutions' in art was made into an object of a

particular kind of speculation by the rich patrons and art dealers who supported, through their own contributions, the most aggressive and sensational schools. ... In Germany 'left art' was supported by S. Fischer and Kassirer ..."[66] (Fischer and Kassirer were, incidentally, also chosen by Nazism – because of their artistic tastes, because they were capitalists and because they were Jews – as scapegoats for the corruption of the German people.)

What made Stalin turn away from world problems and devote his attention to the apparently specialized field of linguistics? To explain this as a matter of personal vanity is inadequate. The heir of Lenin, the builder of the most powerful of all totalitarian States, Stalin understood that language is a powerful instrument for levelling the consciousness of the masses. To the Führer's well-known "One State, One People, One Führer" he added a fourth element – "One Language".

The concept of "the common language of the people" also provided the basis for "the Principles of the Führer". Hitler did not, admittedly, venture into the area of linguistics and spoke exclusively of art; from *Mein Kampf* onwards, however, he constantly emphasized the idea of its eternal values and unchanging language. "There is only one art – Greek-Nordic," said Hitler in 1930; "true art is and remains eternal, it does not follow the law of the season's fashions,"[67] he declared at the opening of the first Great Exhibition of German Art in 1937. A year later, at the opening of the second exhibition, he developed this further:

> Art cannot be constantly changing with changing fashions. We speak of an "eternal art", and that eternity is conditioned by the unchanging character of the people which creates or sustains that art. The creator of the art alters its character only imperceptibly through the centuries and thus true art ... is only subject to slight changes. To produce these changes is the privilege of those God-endowed artists to whom it is granted to draw their inspiration from a people's innermost heart ...[68]

Hitler and Stalin, however, like totalitarian culture as a whole, expressed themselves in a language that was very definitely not that of Goethe and Pushkin. "We speak not in order to say something, but in order to obtain a definite effect," said Goebbels, defining the nature of this language; he added that this effect had nothing in common with truth.[69] Matters of linguistics interested the totalitarian leaders least of all; their aim was to obtain a definite effect. "Why is it necessary," asked Stalin, "that after each revolution the existing structure of language, its grammatical order and basic vocabulary, should be destroyed and replaced by new ones? ... To whom is it necessary that 'water', 'earth', 'mountain', 'forest', 'fish', 'man', 'walk', 'make', 'produce', 'trade', etc. should be called not water, earth, mountain, etc. but something different? ... What use to the revolution is such upheaval in language?"[70] It was necessary, of course, to these artists and scholars against whom Stalin's sarcasm was directed, who had tried in their time to find names for the new social and psychological phenomena engendered

by revolutionary change, who had tried to make these new words into "a file of language" (Maiakovskii's expression) in order to "work over people's block heads". It soon emerged that it was not necessary to invent new words in order to work over people's heads; it was enough to fill the old words with a new content. "It is the mark of the really gifted artist," said Hitler, "that he can express new thoughts with words that have already been coined."[71]

It may be that "water" or "hill" preserved their previous meaning, but such words as "trade", "produce", "morality", "freedom", "honour", "conscience", "democracy", "humanism" and even "man" acquired a different, and often opposite, meaning. This process began with the first appearance of societies "of a new type" and led to the formation of an entirely new linguistic phenomenon, the German variant of which the philologist Victor Klemperer named "Lingua Tertii Imperii" and which Orwell so penetratingly described in his analysis of "newspeak". Stalin's *Marxism and Questions of Linguistics* established this phenomenon apparently for eternity. He asserted that semantics and vocabulary had changed by not more than one per cent since the time of Pushkin and warned linguists against "overvaluing and abusing semantics in their analysis of the changes of linguistic forms".[72] Totalitarian semantics was thus not a matter of the invention of new concepts, but of restoring their "true meaning" to words that had been distorted for centuries by bourgeois and capitalist societies and by foreign races. In affirming the constancy of its language and thinking, totalitarianism was turning to the past in order to legitimize itself, to establish its own existence, for both present and future, as the culmination of the history of humanity.

The chief mechanism for instilling this language into people's consciousness was the education system. On 15 March 1933, in a speech to the officials of the newly established Ministry of Popular Enlightenment and Propaganda, Goebbels defined his aims: "The people must learn to think as one whole, to act as such, and to offer themselves to the disposal of the government with an open heart."[73] The ideal was to subject the individual to a process of continuous ideological processing, to impress the sacred principles of the new morality once and for all on the blank pages of his consciousness. With the help of crèches, kindergartens, schools, institutes and political youth organizations,* a mythological picture of the world was instilled into the individual's consciousness; in this picture the new Soviet or German man was both the centre and the supreme product of evolution. Anything contradicting this picture was firmly repudiated. Bottai, the Italian Minister of Education, demanded "a Fascist school, a Fascist pedagogy – Fascist teaching to create the Fascist man, by the thousands upon thousands".[74]

According to Nazi pedagogy, "The teacher is not just an instructor and a

* The Octobrist, Pioneer and Komsomol organizations in the USSR, the Nazi Hitler youth which kept to the same age divisions, the Young Pioneers and Red Guards in Maoist China, and Mussolini's Babilla, were very similar in their aims and structure and embraced virtually the entire youth of their countries.

transmitter of knowledge. He is more than that. He is a soldier, serving on the cultural-political front of National Socialism ... The task of the German educator is to form human souls."[75] In the Soviet law on schools teachers were referred to as "the sculptors of the spiritual world of the young personality";[76] together with writers and artists they too were awarded the title of "fighters on the ideological front".

The visual arts performed an auxiliary role in the process of constructing the new man, translating verbal definitions into the language of visual forms. In themselves, these forms differed little from the language of nineteenth-century art, just as the words of the literary language still preserved almost the same calligraphy and phonetics. The attempts to pour new wine into old bottles did, however, in both countries, achieve the hoped-for result.

In one of the most highly regarded works of Socialist Realism, "Lenin's Speech at the Third Congress of the Komsomol" by Boris Ioganson (the second president of the USSR Academy of Arts) we see Lenin making an explanatory gesture as he addresses the komsomols of the first post-revolutionary intake

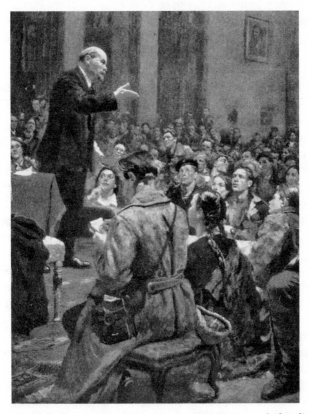

Ioganson: Lenin's Speech at the Third Congress of the Komsomol (detail) (1950)

from the platform of the Palace Hall. What is Lenin speaking of with such thoughtful conviction? What are the komsomols listening to with such reverence? The Third Congress of the Komsomol holds a special place in the history of Soviet social thought: it was then that Lenin formulated the principle of a new – Communist – morality. "At the basis of Communist morality," he stated, "lies the struggle for the consolidation and completion of Communism. This is the foundation of Communist upbringing, education and teaching. This is the answer to the question: how should one study Communism?"[77] These somewhat vague words were imprinted on the consciousness of the youngsters – chosen exclusively from the ranks of the proletariat – in the same way as Goering's words to a different audience: "How often I have been asked, 'Well, what actually is your programme?' I have been able to point full of pride to our simple and good SA men and say, 'There stand the bearers of our programme; they bear it upon their clear, free brows, and the programme is called: Germany! All the principles that can serve the rise and preservation of Germany are acknowledged as the only points in our programme. All others, which may damage the Fatherland, are rejected and are to be destroyed.' "[78] Hans Frank, Hitler's Minister of Justice and the President of the German Academy of Law, said more concisely: "What is right is what serves the people; what is wrong is what could harm it."[79] Ioganson's painting is thus not merely a depiction of an episode from the life of the Leader; what it captures is the birth of totalitarian morality. In Lenin's time the word "morality" was considered bourgeois; in Stalin's time it came back into currency, but only accompanied by the epithets: "new", "Communist", or "Soviet". Without these epithets it implied something hypocritical and sanctimonious, something relating to the old days. With them it acquired a new meaning: there is no universal morality, the only morality is that of the class, and whatever is useful to the Party and State is moral. In this lies the very essence of the linguistic revolution effected by totalitarianism.

Strictly speaking, the totalitarian regimes did not establish any fully elaborated concept of the new man; this was impossible for them, since their true aims not only contradicted the basis of the doctrines they professed, but were too esoteric even to be formulated in ordinary terms. The idea of the construction of a new type of people with a special morality and psychology was the most esoteric of all these aims. It is not by chance that the term "new man", so popular during the revolutionary upheavals themselves, was soon replaced by the more inoffensive terms "Soviet man" or "German man". In creating the image of the "new" ("Soviet" or "German") man, totalitarianism proceeded not from a theoretical conception, but from practical experience, selecting the most "typical" examples from life and then elaborating them.

In art the illusory existence of the new man can be traced at three different levels. At the top of the hierarchy stood the image of the leader, the embodiment of the finest qualities of the new man. Articles on the theme "The image of

Vuchetich: Monument to Dzerzhinskii, Moscow

Soviet man in art" – and there were many such articles – always began with a description of the countless canvases and monuments portraying Lenin and Stalin. Genre painting endowed them with every positive characteristic to be found in ordinary people; the monumental genre endowed them with super-human valour and elevated them to the status of an unattainable ideal. Transformed into pure allegories, they served not as examples to be imitated but as objects of worship – as, of course, did portraits of Hitler.

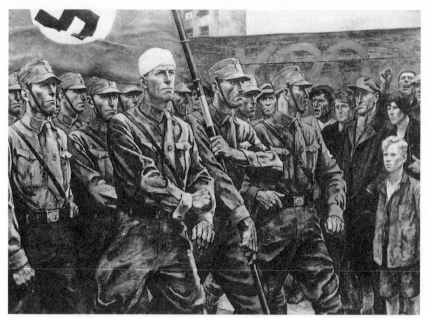

Eber: That Was the SA

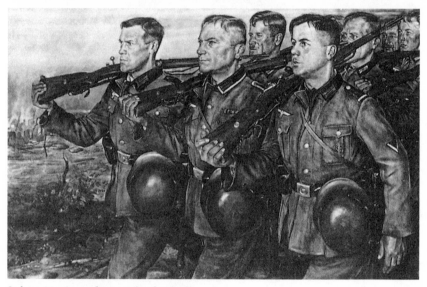

Siebert: My Comrades in Poland (1940)

At the next level came their Party comrades, together with leaders of the Cheka and SS. Such paintings as "Interrogation of Communists" by Boris Ioganson, "Left March" by Aleksandr Deineka, "That was the SA" by Elk Eber, "The Political Front" by Ferdinand Staeger, "My Comrades in Poland" by Georg Siebert were among the most popular and officially acclaimed. Monuments to Feliks Dzerzhinskii – a man whose tender love of children led him to dream of see

see

206

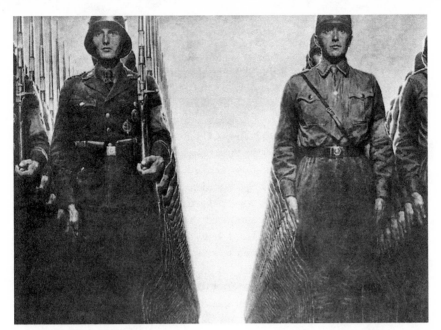

Staeger: The Political Front

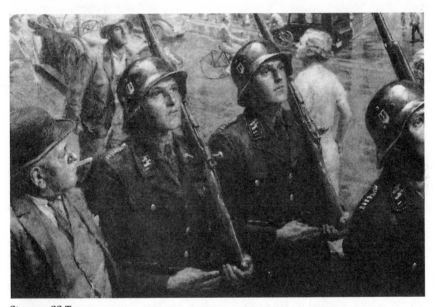

Staeger: SS Troops

the modest post of commissar for education but who instead created the Cheka and the first Soviet concentration camps – still adorn Dzerzhinskii Squares in Moscow and other cities. Busts and portraits of Himmler, Heydrich and Müller were given places of honour at the Great Exhibitions of German Art. These men were glorified by the two regimes not on account of the torrents of blood they

see pp. 233, 327

had shed, but as apostles of the new morality and of the new humanism that was its highest manifestation.

"Humanity [is] a word that one often does not dare to use, as though it has become a foreign word,"[80] wrote Wilhelm Frank, the Nazi Minister of Internal Affairs, in his diary in July 1942. In the USSR this word underwent ingenious metamorphoses. In a speech at the First Congress of Writers in 1934, the poet Surkov remarked: "At our congress a word has been granted full rights of citizenship which, until recently, we looked on with mistrust and even hostility. This word is humanism ... We were obliged, and had the historical right, to despise and hate people who pronounced this word. But now we accept this word into our currency."[81] This word, however, returned into Soviet currency with a different meaning, contained in its qualifying epithet of "new". At the same congress Gorky explained that "to be a humanist means not only to love one's people, the Party, the State and Stalin; it also means to hate their enemies". Surkov, developing the ideas of this speech, accused certain Soviet poets of a lack of awareness of the most important feature of humanism "expressed in the stern and splendid concept of *hatred*"; as an example of the humanism of the new man he mentioned a district Cheka head, who, in thirteen years, had sentenced hundreds of people to be shot.[82]

In Germany it was the role of the SS to cultivate a new breed of people with a similar morality; SS officers were supposed to be the elite of this breed. It was, in fact, probably only in the SS that the construction of the new man was carried out consciously and systematically on the basis of a fully worked out "scientific" theory. To join the SS, one had to prove the purity of one's Aryan ancestry as far back as 1750, and Himmler himself studied photographs to check whether or not the appearance of candidates conformed to racial standards. Himmler, like the head of the Cheka, demanded the very highest morality from officers who carried out the bloodiest of work. "We must be honest, decent, loyal and comradely to members of our own blood, but to nobody else. What happens to a Russian or to a Czech does not interest me in the slightest," said Himmler in 1943 to workers in concentration camps. He continued: "Most of *you* must know what it means when a hundred corpses are lying side by side, or five hundred or a thousand. To have stuck it out and at the same time ... to have remained decent fellows, that is what has made us so hard. This is a page of glory in our history which has never been written and will never be written."[83] The SS motto, devised by Himmler himself, read: "My honour is my devotion". A similar slogan was repeated by the NKVD head, Yezhov, at the height of Stalin's purges: "For us in the NKVD our work is its own reward".[84] These selfless knights of honour acted in the name of history and on the orders of history – the highest judge whose laws had been revealed to them and which justified everything.

> You look round – and see enemies:
> You hold out your hand – but there are no friends:
> But if he says: "Lie!" – you lie.
> But if he says: "Kill!" – you kill.

These lines of the poet Bagritskii were often quoted as the formula of the new humanism. "He" in this context refers to the century, to the age, to history itself. Reinhard Heydrich, the chief organizer of the system of death camps which provided the "final solution" to the Jewish question, remarked in similar vein: "To preserve our people, we must be hard on our opponents, even if we run the danger of perchance harming an individual opponent and of possibly being decried as unrestrained ruffians by a few no doubt well-meaning persons. For if, as National Socialists, we do *not* fulfill our historic task because we are too objective and humane, we will nevertheless not be credited with mitigating circumstances. It will simply be said: In the judgment of history, they did not fulfill their task."[85]

The unwritten "pages of history" mentioned by Himmler did not often find direct reflection in the art of total realism. Its canvases and monuments show us strong-willed, stern, ascetic faces of people marching in step, looking the enemy fearlessly in the face during battle or interrogation, accepting death with heroism but seldom inflicting it. The activities of these new people, their morality and motivation, were usually left to the imagination, but anyone in the least ideologically educated could easily decipher these allegories. These were the bearers of "the culture of mankind" who in the coming decades, according to Himmler, would exterminate the "subhuman" opponents of Germany, "the basic people of the Northern race";[86] they were the people who have come to "a great and final reckoning with five sixths of the world", who "answer today for the future of the world"; they were "the heirs of humanity", "the only true humanists of the world, proletarian humanists . . ."[87]

At these two levels the new man was displayed in his ideal essence, as a supreme example that not everyone could follow. The mass preparation of images of the new – Soviet, German, Italian or Chinese – man took place at the third, lowest level of the hierarchic structure of genres.

Mussolini, the most direct and least consistent of the totalitarian dictators, saw Fascism as "a laboratory from which a new culture, a new way of thinking and a new kind of person would emerge".[88] Just as the typical "Italian of the Renaissance" had existed four centuries earlier, so – in his view – must the typical "Italian of Fascism" be created now. A prize was even established for a work of art describing the typical features of this "Italian of Mussolini". In his countless speeches the Duce listed some of the virtues of this new breed. They "must learn to hate more and rejoice in being hated";[89] they must be less individualistic than their predecessors, less talkative, less critically minded, more serious, organized and hard-working; they must have less love of comfort and

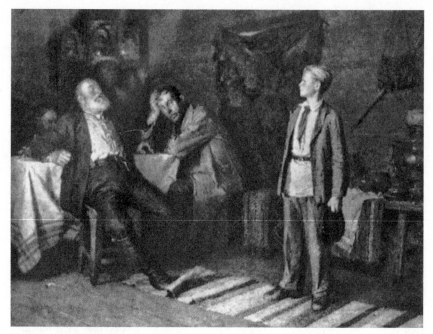

Chebakov: Pavlik Morosov

they must sleep less (in the entire body of totalitarian art it is barely possible to find one portrayal of anyone sleeping); they must "repudiate altruism" (i.e. in accordance with the principles of the new humanism they must place devotion towards the State higher than love of their neighbour); finally – most important of all – they must be warriors, "always ready to sacrifice their lives" in order to pave the way for their country's "imperial destiny".[90] Ideologues from any other totalitarian country would have agreed with this.

The totalitarian press emphasized the crucial importance of reflecting these characteristics of the new man in art, using the terminology appropriate to the colour of its ideology: "In so far as every national rebirth is in its essence the problem of man, then it is natural in the choice of themes that the German man should be placed at the centre of our art of today. Guided by a correct instinct, artists look for their models first of all in comrades from the people who are healthy by nature";[91] "The history of Soviet genre painting is the development of the theme of the birth of the new, Soviet man, of the appearance of new forms of social behaviour."[92] These new forms of behaviour endowed people with a new morality and new concepts of humanism, became an important theme of totalitarian art.

In Chebakov's painting "Pavlik Morozov" – as in many other paintings on this popular subject – the new man in the person of a young Pioneer casts a

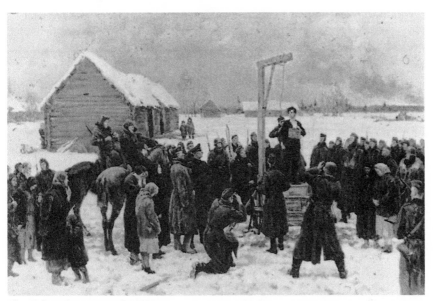

The Kukryniksy: Tania (1942–47)

smouldering look at some old people contorted (with fear? in anger? in amaze-
ment?) beneath the icons in a dark corner of a hut. His inspired pose and the
proud carriage of his head are reminiscent of portrayals of the young Lenin.
What is happening in this painting? Anyone not initiated in the legend would
find it hard to say. But in Soviet Russia everyone knew the myth of Pavlik
Morozov – the most widespread and sinister of all the myths engendered by
totalitarianism. A young boy supposedly denounced his father, an anti-Soviet-
minded peasant, at the time of collectivization; the father was shot and the boy
brutally killed by an avenger. Through literature, poetry, painting and cinema
the image of the martyred informer and patricide was instilled as the supreme
example of the new morality and the new forms of behaviour. The Octobrist
organization for eight to eleven year olds, many million strong, bore his name;
monuments to him were erected on playgrounds; Sergei Eisenstein began an
unfinished film on this subject, "Bezhin Lug". Pavlik Morozov occupied one of
the most honoured positions among Soviet martyrs and in the gallery of images
created by Soviet art. Later, during the War, his image was joined by that
of Zoia Kosmodemianskaia, the young partisan girl. In the painting by the
Kukryniksy,* "Tania" (Tania was Zoia's partisan name), the most famous on
this theme, the girl stands on the gallows, a noose round her neck and looks
proudly round at the crowd of executioners. The Germans hanged many Russian

* The collective pseudonym of three painters who worked together – Mikhail Kupriianov, Porfiri Krylov and
Nikolai Sokolov.

partisans, but it was Zoia Kosmodemianskaia who became the embodiment of the people's struggle against the occupiers – not because her partisan activities inflicted the greatest damage on them, but, according to legend, because she died with the name of Stalin on her lips.

It is hard to say whether the image of Pavlik Morozov was the direct model for the young man called Quex created by Nazi propaganda. In any case the myth is similar: a Communist father, and a son who supports the Nazis and is brutally killed by enemies. Everything corresponds except that the son does not inform: unlike the ideology of class, the ideology of race did not consider it a special virtue that children should denounce their parents. Quex is an invented martyr, the hero of one of the most popular Nazi films. Horst Vessel was a real-life Nazi hero. In reality he was killed by the lover – who happened to be a Communist – of his prostitute mistress; in myth he became the ideal example of the new man. Goebbels modelled his image on the Michael of his early novel: a worker, soldier, thinker and poet, selflessly devoted to an idea and perishing in

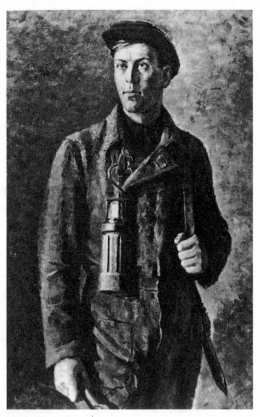

Riazhskii: Stakhanov

the struggle for a bright future. Set to music, one of his poems became the storm-troopers' anthem.

The images of heroes and martyrs – and there were more than enough of these in official exhibitions – served as examples of supreme self-sacrifice, of selfless devotion to the people, to the State, to the Party and above all to the Leader. Another, no less important, quality of the new man was his ability, in Mussolini's words, to "work more and sleep less". As early as *Michael* Goebbels had prophesied: "The new German man will be born in the workshops, not in books".[93] And in the Soviet Union the birth of the new man was announced on 31 August 1935: during the preceding night the young miner Aleksei Stakhanov had apparently cut 102 tons of coal, overfulfilling the plan by 1,400 per cent. It was considered that only the five-year plans, based on the one true ideology, could endow Soviet man with the strength for such achievements. Goering's four-year plans, however, also demanded fulfilment and overfulfilment of targets; they too advanced heroes in each area of the economy. Famous miners, steel workers, foresters, corn-producers, tractor-drivers, milkmaids and hero-mothers (bearing children was put on the same level as physical labour) became a source of inspiration for many of the best-known artists in both countries. Not only countless theme exhibitions devoted to labour, but also special alleys and galleries of portraits of "heroes of labour" became places of pilgrimage – usually compulsory – for the working masses and youth as a whole; they themselves were called upon to equal the achievements of the figures portrayed.

The vast scale of the efforts made by totalitarianism to construct the new man is indisputable. The whole system of education and propaganda was subordinated to this aim. "First the new man, then the new state",[94] proclaimed von Schirach. But was this new man really created – in art and/or in reality – or were all such claims mere rhetoric? An affirmative answer usually evokes only a sceptical smile, and art itself appears to provide an important argument against such an answer: it is often said that the figures portrayed in totalitarian art differ little from the creations of bourgeois realism.

The former Futurist Gino Severini wrote in the forties: "... in the unfree conditions in which Russian art existed, the 'new man', necessarily expressed by 'new means', not only did not have the requisite climate for birth, but even if he had been born, he would not have been recognized, and even if recognized by a few, he would not have been tolerated."[95] All this is only partially true. The new man of totalitarianism is an esoteric being; his real existence is portrayed in the "pages of glory" which were never written, or, if partially written, were intended only for initiates. If such a man with such a new morality had revealed his inner essence in a realistic image, he would have evoked nothing but horror and revulsion. As the totalitarian regimes matured, conversations about the new man grew more hushed. What had been open became secret. In the early thirties excursions were still arranged to German concentration camps and

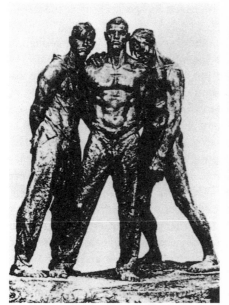

Fieveiskii: Stronger than Death Oesten: Work Comrades

Soviet artists still created heroic images of the builders of the White Sea Canal;
as the scale of the terror grew ever vaster, so the very existence of the camps
became enveloped by an ever more impenetrable blanket of silence. In the realm
of art images of revolutionary sailors, idealistic SS officers, heroic commissars
and rock-like Bolsheviks faded away into history, frozen monuments of bronze
and marble. The image of the new man appeared now in the more recognizable
and accessible image of "our lad", "the straightforward fellow", the man of the
crowd. The iron-willed sailor Zhelezniak, who had arrested the Provisional
Government, was replaced by Vasilii Terkin,* a jack-of-all-trades and a jester, see p.
(above
with an answer for every occasion; stern delegates and charwomen were
replaced by self-satisfied *Hausfraus* contemplating the walls of their new flats
and emanating a grateful devotion to the Leader. Art endowed them with such
virtues as industriousness, devotion, optimism, capacity for self-sacrifice, good
looks, etc. All these were traditional values of the past; this led Mosse to state:
"The new German man was the ideal bourgeois".[96] This would indeed have
been so but for the fact that under totalitarianism these universal values had
acquired a new meaning: devotion meant blind faith in the Führer, optimism
meant a thoughtless, uncritical attitude to the present, a readiness to make

* Zhelezniak – "zhelezo" is the Russian word for iron. Terkin – "tertii" means "grated"; someone can be referred
to as "tertii" if he is quick-witted, a survivor, someone who can go through anything and land on his feet. Vasilii
Terkin was the hero of two popular works: a narrative poem by Aleksandr Tvardovskii and a painting, "Rest after
Battle", by Iurii Neprintsev.

sacrifices meant murder or betrayal, love meant hatred, honour meant informing. The exceptional was put forward as the normal and typical. The "new man" thus had many faces and was omnipresent. In different situations he took on different appearances which, one overlaying another, both revealed and hid his secret essence; if one is to say that he was the "ideal bourgeois", then one must add "of the new type".

From the point of view of totalitarian aesthetics art not only passively reflected life, but was also a powerful tool for influencing consciousness and forming the new man. With this aim in view, vast human and material resources were expended in all the totalitarian countries; they could not but bear fruit, though this fruit did not always correspond with the slogans inscribed on the banners.

Propaganda claimed, and art demonstrated through images, that the new man with his exceptional qualities had already been born. In the subjects of paintings and sculptures people recognized their own features, and this filled them with a legitimate pride in the face of other nations. Few people, however, could identify with the principles of morality and behaviour implicit in the artistic image of the new man. Few people were able, in the name of bright ideals, to denounce their parents, to herd people into gas ovens, to overfulfil plans by 1,000 per cent, or to accept a martyr's death with the name of Hitler or Stalin on their lips; few Germans felt that their lives conformed with the Führer's ideal to be as tough as a thong, as swift as a hound and as hard as Krupp steel. Everyone to a greater or lesser degree felt that his faith was not strong enough, his work not productive enough, that his consciousness was not yet free from the birth marks of the accursed past and that he could not see reality in the same way as his heroes from literature and art. Totalitarian man was proud of his country's power and his leaders' wisdom; at the same time he felt defenceless in the face of this power that might, at any moment, be turned against him. During the day he fulfilled production plans and strode boldly towards the sun; at night he all too often trembled in fear of arrest. On a chronically empty stomach he contemplated mountains of pictured abundance; he was obliged to cultivate the new man in himself, but inevitably felt that this new man was someone else. "The ideal subject of totalitarian rule is not the convinced Nazi or the convinced Communist, but people for whom the distinction between fact and fiction ... and the distinction between true and false ... no longer exist,"[97] wrote Hannah Arendt. In his consciousness delusions of grandeur in the face of other nations were strangely combined with an inferiority complex in the face of his own country – and this is perhaps one of his most important defining characteristics. It was with such pliant material that totalitarianism (how consciously?) constructed its new man. The role allotted the visual arts in this process was not unimportant. To carry out this role they did not need to invent new means of expression; within the semantic context of the "newspeak" developed by totalitarianism the old means were more than adequate.

Structure

(i) Theme art

At the beginning of the 1980s, one English observer, who had recently been introduced in Moscow to certain elements of the megamachine of totalitarian culture, came to the conclusion that "the Soviet system may have made a monster – but it is a monster that works with frightening efficiency".[1] This monster functions according to laws unknown in democratic societies, where artistic styles usually emerge spontaneously and only then engender new structures and new forms of organization of artistic life. Totalitarian culture develops otherwise: organization precedes structure, and structure is only gradually fleshed out with a new style. Rather than being painted on canvas, the history of art is planned on paper.

In totalitarian countries the past and present are made up of what is fixed in official publications, what reaches the mass audience at official exhibitions, what receives approval at the highest levels of the ideological apparatus, what is sifted through a complex system of encouragement, rewards, prizes and titles into a hierarchical order. Everything else is either destroyed – during periods of *Sturm und Drang* – or is silently passed over as though it had never existed – during periods of stability. The hierarchy of values is developed systematically and is promulgated from above to impose a new and rigid structure on the country's artistic life.

In order to understand the nature of this structure, it is enough to look through the contents, or even just glance through the chapter headings, of any work published in the Soviet Union after the twenties on the history of Soviet art. Only in brief introductions does one find any mention of the various artistic ideas, movements and groupings that once existed in the country – and even then only within the context of the struggle against them and final victory of the one true artistic method; everything else is simply a monotonous list of the achievements of this method, arranged under such headings as "the Soviet historical painting", "the Soviet portrait", "genre painting", "landscapes", "theatrical decoration", etc. B. Hinz, the author of *Art in the Third Reich*, describes the art of National Socialism as exactly such a structure. The main German exhibitions were arranged strictly according to theme: portraits, landscapes, still lifes, etc.

> This method of grouping pictures according to content and not, as is customary in the twentieth century, according to schools, stylistic affinities, artists' collectives, and other such categories, is indeed reminiscent of a weekly outdoor market where fish, flowers, meat, pottery, and other items are offered for sale at different stands ... Potential buyers do not go into the gallery looking for "a Picasso," "a Kandinskii," or "an Expressionist," but for a picture of a landscape, a cow, a bouquet of flowers...[2]

If one looks through the catalogues of the main Soviet exhibitions from the mid-thirties to the end of the fifties, even just at the illustrations, one will be struck by the same kind of arrangement.

In the short Foreword to the English edition of this book, Hinz finds it necessary to dissociate himself from any parallels that appear to emerge between National Socialist and Socialist Realist art:

> The occasional similarities that do exist occur in the manner of presentation, in the marked focus on objects, but this is hardly sufficient evidence for assuming that these two styles are identical. Not only are the dominant modes of art in these two political systems different in origin, a key factor in distinguishing between them is their divergent attitudes toward reality. Two major themes of Soviet art, the truck driver and the female tractor driver, do not occur at all in the art of the Third Reich. In contrast, men appear almost exclusively in the role of the ploughing, sowing, or resting farmer, and there are innumerable paintings of women as nudes ... and as mothers.[3]

Apart from the lorry and tractor drivers, who certainly do not constitute a main theme of Soviet art, there is a bewildering discrepancy between Hinz's position here and the material contained in his book: the official documents, organizational principles and criteria of aesthetic evaluation are nearly all equally typical of Socialist Realist art – and the author's conclusions are equally applicable to it. The same could be said of nearly all books on the culture of the Third Reich. All this – even without Hinz's rich illustrative material – adds up to considerably more than "chance similarities".

Such conclusions as Hinz's are possible only if one looks on the art of a particular country simply as a collection of artifacts of equal importance, forgetting their social function and the place each of them occupied in the artistic life of the time. Stylistically and thematically, the art produced under totalitarian regimes is not all of the same nature. Adolf Ziegler's nudes were popular in Germany, as were Petr Konchalovskii's splendid lilacs; from time to time even Aleksandr Gerasimov tore himself away from engraving images of the leaders and painted damp terraces or the juicy surface of fruits refracted in the facets of crystal vases. Even during the blackest years of both Nazism and Stalinism there were still working artists who did not accept the official ideological or aesthetic dogmas: Barlach, Kollwitz, Dix, Hofer and Nolde in Germany; Filonov, Tatlin, Rodchenko, Petrov-Vodkin, Tyshler and Sarian in Russia. If all the works of art produced under totalitarianism were thrown into a heap, then one could prove

anything whatever through a careful selection of items.* What matters is that totalitarianism did itself evaluate these artifacts and that it did allocate each of them a particular place in the structures it created.

With the defeat of "formalism" in the USSR and "modernism" in Germany, criticism, politics and aesthetics shifted their attention from the question of artistic language (how to paint, or rather how not to paint) to the question of theme (what to paint). While Hitler's early speeches consist largely of invective against Jewish influences and "Kulturbolschewismus", his speech at the First Great Exhibition of German Art includes direct indications as to what National-Socialist art should portray. Primarily he required it to reflect the formative powers of the new life and of history, to praise those who "form the people and lead them behind them", those who "create history".[4]

In Soviet art the struggle for theme began with the foundation of the AKhRR and grew increasingly bitter after the establishment of Socialist Realism. The Soviet press, above all the journal *Iskusstvo*, thundered against artists and critics who did not understand the importance of choice of theme for the correct reflection of the new Stalinist reality. "The choice of theme is one of the first steps in the formulation of one's ideas. Between the themes of the Red Army, Magnitostroy and the still life lies a distance of a vast scale ... It is incorrect to grant equal rights to all themes."[5] Four years later, in 1938, *Iskusstvo* adopted a more threatening tone: "Some aestheticians suppose that the theme of a painting is something external to art ... This is a deeply mistaken and harmful point of view."[6] Only in bourgeois countries could art fearlessly capture whatever lay in the artist's field of vision; Soviet artists, "while selecting figures and objects to be introduced into a painting, must be clearly aware of their role in the general system of the visual image and must compel them not merely to display themselves to the viewer but to say something to him".[7] These ideas were very soon put into practice.

During the thirties the Union of Soviet Artists, the Reich Chamber of Art and the Fascist Syndicate received their instructions from the Party and State and transmitted them to their members; the latter then executed their commissions on the allotted themes. So-called "theme exhibitions" became the main way in which the totalitarian regimes brought their art to the masses.

From 1936 to 1939 the attention of the Soviet ideological organs and artists' unions was focused on the organization of at least five vast theme exhibitions:

* The well-known Soviet philosopher Mikhail Lifshits, for example, used this method in order to prove "brilliantly" the existence of direct links between modernism and the art of Fascism and National Socialism. The illustrations to the chapter "The art of Fascism in Germany" in his book *Art and the Contemporary World* include works by Kanold, Hunter and Doll, accompanied by comments like "an imitation of Cézanne", "an imitation of Van Gogh", "an imitation of Die Neue Sachlichkeit", etc. He included a painting by Franz Marc, who died in 1916, but not one work by the official favourites. (M. Lifshits, *Art and the Contemporary World*, Moscow, 1978, pp. 307–18.) Given the complete lack of information in the Soviet Union about the work of Nazi Germany, this argument appeared only too convincing.

"The Centenary of the Birth of Pushkin",* Twenty Years of the Workers and Peasants' Red Army" (1937), "Twenty Years of the All-Union Leninist Komsomol", "The Industry of Socialism" (both in 1938) and "Comrade Stalin and the People of the Country of the Soviets in Visual Art" (1939–40). The last of these can be seen as the consummation of the cult of Stalin – a cult which the visual arts had played an important role in establishing. These All-Union exhibitions were opened in the capital and then toured other cities; at the same time each province celebrated its own anniversaries on a more local scale: "Mordovia Past and Present" (Saransk, 1935), "The Fourteenth Anniversary of Soviet Armenia" (Erevan, 1935), "In Memory of S. Kirov" (Leningrad, 1936) "Shota Rustaveli and his Epoch" (Tbilisi, 1937), "The History of Bolshevik Organizations in the Transcaucasus" (Tbilisi, 1937), "The Twentieth Anniversary of the Liberation of Belorussia" (Minsk, 1938), "The Twentieth Anniversary of the Liberation from Kolchak's Rabble" (Omsk, 1939), "The 125th Anniversary of Taras Shevchenko" (Kiev, 1939) ... The Moscow exhibition halls also housed exhibitions displaying the achievements of various areas of the economy: "Railway Transport" (1935), "Socialist Agriculture" (1936), "The Food Industry" (1939), "The Mountain Regions of the USSR" (1936), etc.[8] The scale of all this activity grew so vast that eventually the only museum of Western art in the capital had to be requisitioned too; such exhibitions as "Lenin in Engraving", "Stalin in Works of Graphic Art" and "The Storming of Perekop" were held every year in the rooms of the State Museum of Visual Art. Even before this, however, the museum could only exhibit copies of Greek classical art and works by Old Masters from the Renaissance to the nineteenth century: but for a few, purely propagandist, exceptions, exhibitions of foreign art came to an end in the mid-twenties.

In Germany major theme exhibitions began to be held in 1935. In 1936 two such exhibitions were held in Berlin alone: "The Autobahns of Adolf Hitler through the Eyes of Art" and "To the Glory of Labour". These were followed in other cities by: "German Farmer – German Land" and "Paintings of the Motherland" (both in 1938), "Art and Seafaring", "The Polish Campaign in Paintings", "Blood and Soil", "Race and Nation", "Nation of Workers", and so on. "A survey of how the Reich came into being"[9] – Goebbels's comment on the 1940 exhibition "The Greatness of Germany" – encapsulates the aim of most of the theme exhibitions held both in Germany and in the USSR.

*Its opening on 16 February 1937 coincided with the beginning of the political show trial of Piatakov, Radek and others. It was evidently in order to balance the political terror that the anniversary of the poet was celebrated on such a grand scale. As well as the main exhibition in the Moscow Historical Museum, a smaller exhibition was held in the main halls of the Tretiakov Gallery. The art press, however, did not review the exhibition. In its fourth issue for 1937 the journal *Art* stated in a special insertion that the second and third issues "are being delayed for technical reasons". It is not hard to guess the nature of these reasons: the two issues obviously contained too many illustrations, writings and other mentions of those who had been declared "enemies of the people" or were suspected of sympathy with them. The second issue (March–April) evidently did not appear, at any rate it cannot be found in major libraries outside the USSR.

It is interesting to note the lack of one-man exhibitions by living painters. In Russia such exhibitions were not held until the end of the Second World War; in Germany the only such exhibition was Arno Breker's in 1940. There appear to have been three main reasons for this: firstly, no artist could yet claim to have truly embodied the principles of the Führer or of Socialist Realism (they acquired plastic form only gradually, and stylistic interpretations of them changed from year to year); secondly, no hierarchy had yet been established according to which a particular artist could have laid claim to a supreme degree of official recognition; thirdly, the individual was supposed to be yielding to the collective.

In Italy personal exhibitions continued to be held throughout the Mussolini regime but were not a determining factor in the country's artistic life. As early as 1932 the exhibition "Art of the Fascist Revolution" was accompanied by a large-scale propaganda campaign and became the forum for the proclamation of new cultural policies; from 1937 Mussolini himself chose both the themes and titles of the main exhibitions: "The Fascist Youth of Italy", "They Listen to the Duce's Speech on the Radio", "The Battle for Grain", "The Consciousness Formed by Fascism", "The New Europe Rising up from the Bloody Slaughter-House", etc.

As we have already seen, the Cremona Prize in Italy and the State Prize in Germany were established in 1937; the inauguration of the Stalin Prize was announced on 21 December 1939 – Stalin's sixtieth birthday. These prizes were not only a reward, not only a caress from the Party, but also, as is shown by the following passage, an indication of new goals: "In the allocation of the Stalin prizes one must see not only a recognition of the merits and successes of individual artists, but also directions as to which types and genres of art are of most interest today, which artistic techniques and methods best meet today's needs."[10] Awarded every year, they were the central pillar of an artistic structure in which individual themes or subjects, combined into genres and embodied in different kinds of art, constituted a number of different levels of a rigid hierarchy. The questions – What was this structure? What stood at the centre and what lay on the periphery? – can best be answered by studying the list of Stalin prizes.

The first prizes were awarded in early 1941 for works dating from 1934 (the official beginning of Socialist Realism) to 1940:

> A. Gerasimov. "Stalin and Voroshilov in the Kremlin" (originally entitled "Guarding the Peace"), 1938.
> B. Efanov. "An Unforgettable Meeting" (a meeting between Stalin and other members of government and the wives of heavy industry workers), 1938.
> B. Ioganson, "In an old Factory in the Urals" (difficult working conditions in Tsarist Russia and the awakening of class consciousness), 1937.
> N. Samokish. "Fording the Sivash" (the Civil War), 1935.
> M. Manizer. Monument to Lenin in Ulianovski, 1940.

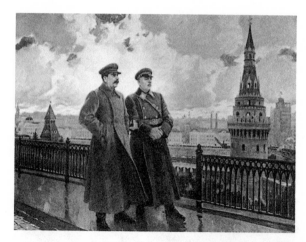

Gerasimov: Stalin and
Voroshilov in the Kremlin

Efanov: Unforgettable
Meeting (1937)

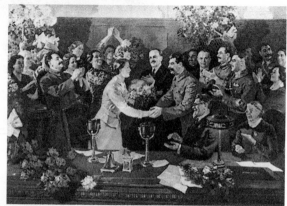

Ioganson: In an Old Factory
in the Urals (1937)

Manizer: Monument to
Lenin, Ulianovsk (1940)

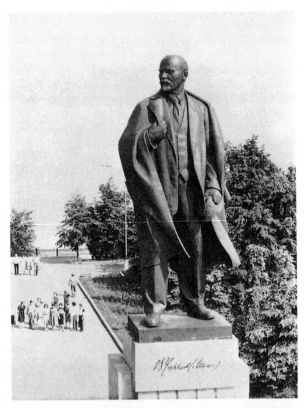

Merkurov: Statue of
Stalin, Great
Soviet Exhibition

S. Merkurov. Monument to Stalin at the All-Union Agricultural Exhibition, 1939.

S. Kakabadze. Monument to Stalin in Tbilisi.

V. Ingal and V. Bogoliubov. Monument to Ordzhonikidze.

N. Tomskii. Monument to Kirov, 1935.

V. Mukhina. "Worker and Collective Farm Woman", 1937. see p. 366

F. Fedorovskii. Theatrical decor for *Prince Igor*, 1934.

M. Sarian. Theatrical decor.

I. Toidze. Illustrations to *Shota Rustaveli*.

The first Stalin prizes were thus allocated as follows: (a) according to theme: images of Stalin – 4 works; images of Lenin – 1; images of comrades of the leaders – 2 (also portrayals of Voroshilov, Kaganovich, Molotov, Khrushchev, Ordzhonikidze and others in the works by Gerasimov and Efanov); images of workers – 1; historical themes – 2; (b) according to genre: theme paintings – 4; monumental sculptures – 6; others (illustrations and theatrical decor) – 3.

The prize was not awarded during the war and was only reinstated in 1946; from then it was awarded annually. In the first year, prizes were awarded separately to works produced during 1943–4 and 1945. Out of 13 prizes, only 2 went to depictions of Stalin (paintings by Efanov and Nalbandian), 4 went to paintings of the war, 4 to paintings of generals and cultural figures, 2 to landscapes and 1 to a historical painting. Only 7 prizes were awarded in 1946, but in 1947 10 were awarded to depictions of Lenin and Stalin alone, 4 to the former and 6 to the latter.

The All-Union exhibition of 1947 coincided with the thirtieth anniversary of the October Revolution. A special conference of the USSR Academy of Arts, the first since its foundation, was held to discuss this exhibition, and the results of its labours were published as a weighty volume entitled *Thirty Years of Soviet Representational Art*. Both the conference and the book began with a lecture, "The Image of the Positive Hero" by Aleksandr Zamoshkin (then the director of the State Tretiakov Gallery) which includes the passage: "The heroic image of Soviet man is the main theme. Around it is concentrated all the multiplicity of living phenomena, scenes, types and characters that visual art must reflect." This is followed by a list, many pages long, of reproductions of the images of the leaders, and then by descriptions of the heroic images of the military, of artists, of collective farm workers, etc.[11] The logical implication of all this is that Stalin and Lenin were the personifications of everything best in the "positive" and "heroic" image of Soviet man, and that it was around this theme that "all the multiplicity of living phenomena" was gathered.* In 1949 no less than thirteen images of the great teacher and leader were awarded Stalin prizes.

The Stalin prizes constitute the very heart of official Soviet culture – music,

*Zamoshkin's lecture is only an example. A similar logic imbues all contemporary works, lectures, articles and speeches on the Soviet visual arts.

architecture and literature as well as the visual arts. The prize-winners were the artists whose entire work was focused on the themes and genres most important to Soviet ideology – above all, the "theme painting" and the monumental sculpture. The leading artists during the forties were: Efanov, who received four Stalin prizes, for "Unforgettable Meeting" (1941), "Stalin beside the Bed of the Sick Gorky" (1946), "Portrait of Molotov" (1947) and "Leading People of Moscow in the Kremlin" (1949); Tomskii, who received three prizes, for monuments to Kirov (1941) and General Cherniakhovskii (1947) and the bas-relief "Lenin and Stalin – the Leaders of the Soviet State" (1949); Vuchetich, who received three prizes, for his monuments to General Cherniakhovskii (1945) and General Efremov (1946) and for the bas-relief "Stalin's Oath beside the Tomb of Lenin" (1949); and Khmelko, who produced exceptionally pompous compositions including the figure of Stalin, e.g. "The Triumph of Our Fatherland" see p. and "To the Great Russian People" – and who disappeared from view at the end of the Stalin epoch.

Prize-winning works were automatically included in the "golden collection" of Soviet art. They opened the major exhibitions, were included in school textbooks in the guise of historical documents, served as illustrations to scientific works and circulated throughout the country in thousands of copies and millions of reproductions. The anthology *Thirty Years of Soviet Representational Art* stated that Mikhail Avilov's "Comrade Stalin's Arrival at the First Cavalry Army" had see p. become "the most popular Soviet painting, sharing this honour on the basis of the enormous demand for reproductions, copies and author's repeats only with Aleksandr Gerasimov's painting 'Stalin and Voroshilov in the Kremlin'."[12] There were indeed few military institutions of the time where one would not have found reproductions of Avilov's painting, few civilian institutions without a copy of Gerasimov's.

In Germany, as well as prizes, titles and rewards, one other way was found of establishing an artistic elite. In 1944, on the eve of military catastrophe, Goebbels compiled a list of twelve outstanding cultural figures who were to be exempted from military service and work in the armaments industry. Known as "List A" or "The List of the Immortals", this included: Arno Breker, Josef Thorak see p. and Fritz Klimsch, who all produced vast Nazi monuments and portraits of (above 312, Hitler; Herman Gradl, Artur Kampf and Leonard Gall, the painters of the best- (botto 367, known theme paintings; Professor Wilhelm Kreis, the director of Hitler's "plan (above see p. for monumental propaganda"; and Paul Schultze-Naumburg. Of earlier well-known figures only Georg Kolbe was awarded the title of "immortal": after undergoing several years of persecution he had restored his reputation with portraits of the Fascist leaders, most notably of General Franco. There was also a larger "List B" – "Divine Talents" – which included several hundred names of Nazi writers, artists, musicians, actors, singers and dancers, etc. Naturally these "immortals" and "divine talents" were granted other privileges in addition to that of exemption from military service.[13]

In order to understand the nature of totalitarian culture it is essential to look on what it created through its own eyes. It is important to realize that the reality of Hitler or Stalin was never considered to be uniformly splendid. It was formed by the wise and unbending will of the leaders – and this was what was most important. It was born during the heroic battles of the revolutionary struggle of the entire people against the enemies of progress and humanity – after the cult of the leaders there was nothing more sacred than the memory of the history of the revolution. It then reproduced itself and grew stronger thanks to the selfless labour of the masses – the corpus of totalitarian saints included not only the leaders, not only the heroes and martyrs of the revolution, but also the unnamed workers in the persons of "the steel-worker", "the miner", "the soldier", etc. Finally, everyday life itself, illuminated by the light of revolutionary trans-formations, took on new tones: daily life, nature and even traditional still lifes took on a new and deeper meaning in so far as they reflected characteristics of the new reality. Seen in this way, totalitarian reality will no longer appear as a dynamic empire changing its outlines from day to day, but as a well-ordered system of values tending to crystallize for ever into a hierarchical pyramid.

In one chapter of his book Hinz convincingly demonstrates that the Third Reich brought back the classification of art according to genre that was so characteristic of the nineteenth century. Totalitarian art not only restored nineteenth-century genres, but arranged them according to a rigidly hierarchic system; all this can be seen even more clearly in the Soviet variant than in that of the Nazis.

(ii) The hierarchy of genres – the centre

(a) The official portrait (iconography of the leaders)

It would be extremely desirable that people standing at the head of the movement's party should, finally, be depicted with the stern colours of Rembrandt in all their living clarity.

Karl Marx

"Does Big Brother exist?"
"Of course he exists. The party exists. Big Brother is the embodiment of the Party."
"Does he exist in the same way as I exist?"
"You do not exist," said O'Brien.

George Orwell, 1984

"The cult of the personality of Stalin" which Khrushchev attacked in his secret speech at the Twentieth Congress of the Communist Party of the Soviet Union, and to which he attempted to ascribe all the failures and crimes of the preceding regime, was in actual fact a defining characteristic of all variants of totali-

tarianism: the impersonal, faceless cult of the Leader. In societies "of a new type" the leader is "the simple consequence of this type of organization, he is not needed as a person, and as such he is indispensable to the movement".[14]

The concept of the decisive role of the individual personality in history was an organic part of the ideological doctrine of both Fascism and National Socialism. It would seem, however, to contradict the very essence of Marxism, according to which history is created by the people as a whole, divided into classes. In Russia the orthodox Marxist historical school of Pokrovskii, until its suppression at the beginning of the thirties, taught Russian and world history almost without mention of the names of tsars and generals; some Soviet literary critics of the twenties believed that the entire work of Pushkin was merely an emanation of Russian society and that if the poet had not been born his main works would have been composed by someone else; and El Lissitzky, on behalf of the Soviet artistic avant-garde, said of the past: "Our grandmothers believed that ... man is the measure of all things".[15] According to one ideology Rousseau's "collective will" and Hegel's absolute spirit were embodied in the personalities of Frederick the Second, Bismarck, Napoleon, Garibaldi, Mussolini and Hitler; according to the other ideology they took the form of the objective and impersonal laws of historical materialism. Nevertheless, although they began from opposite premises, all totalitarian ideologies finally converged on the same point: the cult of the Leader, Führer, Duce or Chairman as the measure of all spiritual values. "What values can we throw on the scales of history? The value of our own people ... A second and I would dare to say still greater value is the unique personality of our Führer Adolf Hitler,"[16] declared Heinrich Himmler, his words backed by the might of the Gestapo.

Similar ideas became the small change of art criticism and were provided with an extremely detailed substantiation by aesthetic theory: "Among all the riches of all the material of life the first place is occupied by the images of our leaders Lenin and Stalin."[17] From the mid-thirties Soviet journals demanded in one issue after another that artists should "mould, sculpt and imprint on monumental canvases the gigantic figure of the leader", and that they should "preserve it for future generations".[18] Aleksandr Gerasimov said to the artists under his care: "The task of the construction of images of Lenin and Stalin, the geniuses who created Socialism, and of their closest comrades, is one of the most responsible creative and ideological tasks that art has ever faced."[19] By meeting these demands, totalitarian art was transformed into one of the regime's most important tools for establishing the cult of the leader.

The history of totalitarian culture provides a partial answer to the common question as to whether this cult is created by the leader himself or by the system to which he belongs. If we compare the personality of one or another totalitarian dictator with his canonic image in art, then we will find that this image does not always correspond to his actual tastes, self-image or ambitions.

For the 1938 Great Exhibition Hitler chose only one portrait of himself: on horseback in knightly armour (this painting by Lanzinger later hung over the see p. 188 (right) table in Albert Speer's office, and copies or reproductions could be found in offices throughout the Reich). But the reception hall of Hitler's private Munich residence, the "House of the Führer", was adorned by Ziegler's triptych "The Four Elements", a depiction of four female nudes; and Hitler's favourite artists were Eduard Grutzner, Defregger and other nineteenth-century German sentimental realists. Similar scenes by the Russian Peredvizhniki – reproductions from the journal *Ogonek* – adorned the bedroom of Stalin's secret dacha outside Moscow (according to his daughter Svetlana Allilueva). Stalin, however, evidently enjoyed the god-like quality of his own image in sculpture. And Mussolini, who in his youth had paid tribute to the Futurists, was only too glad to take up heroic poses for sculptors.

Mao Tse-tung, on the other hand, a peasant's son from a distant province, could never have seen monuments to the cult of any personality other than the Buddha – with whose grandeur he was not, at least initially,* in the least disposed to identify himself. As for Lenin – educated in the Russian democratic tradition – it is unlikely that he would have found aesthetic pleasure in contemplating either his mummy in the Mausoleum or the sculpted image, lost in the clouds, that was to crown the tower of the planned Palace of Soviets. Yet it was Lenin himself who with his decree "On the erection of monuments to great figures of social and revolutionary activity" created the preconditions for this transformation of art into the instrument of his own cult. So, one comes to the conclusion that the structure of art in totalitarian countries, with its emphasis on the cult of the leader, was not the creation of the demonic will of the leaders themselves but the result of certain general laws of development of totalitarian societies: Stalin's "Byzantineness", rooted in the Russian Imperial tradition, Hitler's obsession with art, the psychopathic traits present in both of them, Mussolini's delusions of grandeur – all these played their role, but not one of the first importance.

Lenin, whose plan for monumental propaganda was central to his cultural policy, clearly did not aspire to exploit it for self-aggrandizement. The list of figures to whom monuments were to be erected contained only the names of past heroes and martyrs of the Revolution; living leaders could expect to be granted this honour only after they had completed their earthly tasks. Lenin's plan may have been the beginning of the totalitarian cult, but only of its first stage – the cult of the dead.

The history of National Socialist art began with the same cult: the new regime's first construction, solemnly unveiled on 9 November 1933, was a monument to the fallen of the Nazi movement. This was followed by a flood of

*In 1945 he was proclaimed at a Party Congress to be "not only the greatest revolutionary and State figure in the history of China, but also the greatest theoretician and scholar".

monuments, memorials, monumental cemeteries and even special "castles of
the dead" intended to evoke a sense of reverence in the face of the grandeur of
the Third Reich's history. "Berlin should be full of such military monuments;
that's part of its character,"[20] said Hitler to Professor Wilhelm Kreis, who
planned also to "dot the map of Europe from east to west, north to south, with
monuments celebrating German sacrifice and victory".[21]

In 1933, when Lunacharskii said that it was time to "summon up a second,
more solid, more mature wave of monumental propaganda",[22] he was talking
not of past revolutionary figures but of living people. And yet, while in normal
society the private lives of dictators, tsars and presidents are to some extent open
to the public, while they exist in the consciousness of the public as real people,
the personality of the totalitarian leader is shrouded by an impenetrable cloak
of mythology; this has been noted by both George Orwell and Hannah Arendt.
Big Brother is present everywhere, but no one sees him; every possible virtue
and achievement is ascribed to him, but no one can distinguish reality from
legend; his face looks down from every wall and newspaper, but no one knows
what he really looks like: his portrayals have remained unchanged for ten or
twenty years and it is impossible even to be sure that the beloved leader is still
alive (Stalin, for example, remained officially alive for three days after his physical
death). The life of the leaders runs its course in another dimension, where the
words "living" and "dead" have another meaning.

Until the end of the twenties it was Mussolini who went furthest in this
respect: as early as 1924 Venice Biennales began with sculptures or paintings
of the Duce. In early Soviet art hardly anyone, other than members of the
AKhRR, devoted an appropriate degree of attention to this theme; and images
of Hitler and his comrades first appeared only after the Nazi assumption of
power. The cult of the leader was established simultaneously in both cultural
and public life; political trends were immediately embodied visually. In the Soviet
Union this cult was first established during the years 1929–30, the years of
Stalin's rise to absolute power; the soil, however, had already been prepared by
Lenin and his "cult of the dead".

In 1924, immediately after the death of Lenin, his body was transferred to
a temporary wooden mausoleum; this, according to the official decree, was in
order "to offer anyone so wishing, who had been unable to come to Moscow for
the day of the funeral, the possibility of saying goodbye to the beloved leader".[23]
It was then transferred to another mausoleum, more solid but still wooden, until
in 1930 a marble mausoleum was built in Red Square to the design of the
architect Aleksei Shchusev; intended to last for ever, this became the sacred
centre of the Soviet political liturgy. A year later the decision was taken to build
the Palace of Soviets, intended to be the highest building in the world. It was to
be crowned by a hundred-metre statue of Lenin and was to serve as a memorial
to him both in itself and through the paintings and sculptures it housed. During

see p
(belc

the course of work on the project the themes of these paintings and sculptures were repeatedly changed and by 1938 the journal *Iskusstvo* was able to write: "Plastic compositions and paintings must show Lenin and Stalin leading the peoples of the Union towards freedom and happiness";[24] the cult of the living was already encroaching upon the cult of the dead. It is symbolic that the Palace of Soviets was in fact never built (the swimming pool "Moscow" was built in its place), even though countless monuments were erected to Stalin, including a sculpture on the Volga–Don canal which was only marginally smaller than the *see p. 312* planned figure of Lenin.

The construction of such monuments required time. In the USSR they began to appear on a large scale only from the mid-thirties; in Germany the projects were never realized. Paintings and graphic art began to seem a more appropriate vehicle for the cult of the leader.

There are many thousand surviving portraits of Lenin and Stalin, but not

:urov: Statue of Stalin (1940s) Breker: Hitler (detail) (1938)

more than twenty or thirty accessible portraits of Hitler – a tiny fraction of the number produced. Heinrich Hoffmann witnesses that every year the jury had to go through up to 150 portraits of Hitler, mostly executed from photographs.[25] Most of them were destroyed after the war, but in any case, until 1939, Hitler himself sifted through them; obsessed with the idea of "high art", he was extremely dissatisfied with the quality of the portraits and gave instructions that not more than one portrait of him should be shown at each Great Exhibition. Even judging by those that were chosen, the general level was extremely low, even lower than that of the work of Soviet artists, who had after all had fifteen years of practice at the somewhat obsolete genre of the "official portrait".

A strict canon held sway in this genre, but there were several different images of the leader, each demanding its own compositional scheme and emotional interpretation:

Firstly, "Lenin/Stalin/Hitler/Mao as the Führer or Leader". Here the his- see pp. 313, 222 a 195 torical figure appeared only in its most abstract and symbolic essence. A general monumentality and majesty revealed the impersonal and superhuman nature of the leader. The classical embodiment of this image is in paintings of Hitler and in the countless monuments to Stalin – from Merkurov's monument-museum in Yerevan, a museum contained within a monument, to the already mentioned vast sculptures on the Volga–Don canal.

Secondly, "The Leader as the Inspirer and Organizer of Victories". This demanded elements of expression, a language of gesture, excitement and contrast to convey the energy of will emanating from the leader, an energy intended to infect and win over the viewer. In the Soviet Union these qualities were ascribed more often to Lenin than to Stalin. In sculpture, the first important monument to Lenin, by Vladimir Shchuko and Sergei Evseev, erected in 1926 outside the see p. Finland station in Leningrad, established a compositional scheme which became almost canonical. Since then Lenin has been portrayed gazing ahead, his right see p. hand either stretched out in a didactic gesture or else lying on the lapel of his jacket (if the latter, then the strength of his will was emphasized by the carriage of the head) and his left hand holding a cap.* In painting this composition was canonized by Aleksandr Gerasimov's painting "Lenin on the Tribune" (1930); its general features are repeated to this day.

Thirdly, "The leader as the Wise Teacher". Here there is an additional see pp. 180 (? and 1? psychological element, an emphasis on the leader's intelligence, piercing under-standing, modesty, straightforwardness, humanity, etc. This category includes

*The strictness of this canon is illustrated by a – possibly apocryphal – story once widely told in Moscow. A monument to Lenin was to be unveiled in a provincial town, and the plaster statue was brought from the capital in a carefully packed box. This box was damaged *en route*. Since there was very little time, a local sculptor was summoned during the night; without fully opening the box he quickly restored the head. After the speeches the ribbon was cut and the coverings removed to reveal Lenin on a pedestal with an outstretched hand; he had a cap on his head and a second cap in his left hand. Merely to imagine such a blasphemous infringement of the established canon was to experience an emotional shock.

countless portrayals of Lenin and Stalin at work in their studies, speaking at congresses, etc., and also much of the iconography of Mao Tse-tung.

Lastly, "The Leader as a Man" or "The Friend of Children, Sportsmen, Collective Farm Workers, Scholars, etc".* This category required realistic detail, see p. 322 and ecstatic awe gave way to glowing tenderness. This category, however, verges on that of the historical painting, discussed in the next section.

The image of Stalin was depicted in all these ways and was embodied in every type of art from vast monuments to genre painting. The iconography of Hitler, however, was limited to the first category with a few elements of the second. He was portrayed full-face, his organizing will being emphasized by his general expression, his purposeful gaze, and various external features: a military or Party uniform (in all portraits), a romantically stormy landscape as background (in portraits by Knirr and Hommel), symbolic sculpture (Erler), buildings see pp. 195, 315 (below) and 313 in the process of construction, a map thrown on the floor, etc. "He stands like a statue, grown beyond the measure of earthly man"[26] – this description from the *Völkischer Beobachter* is applicable to all paintings and drawings of the Führer. Unlike Stalin, Hitler never appeared in the guise of the straightforward fellow – going for a walk, having a chat, caressing a child – except in photographs. Even then he preferred to take up more hieratic poses.

Hitler came to power legitimately, winning a majority in the 1933 elections. He believed that at a fateful hour Providence had chosen him – a simple boy from Linz – in order to lead the German people. He saw himself as the voice of the people, the embodiment of the nation's will, an emanation of its soul – it was on this self-image that his public image was founded. It was forbidden, for example, to print photographs of him in Bavarian shorts, wearing glasses or with a small dog, since this might detract from the majesty of the leader of the German people.

During the brief period of the Soviet-German pact Hitler tended to ascribe similar qualities to the personality of Stalin. In 1939 he included Heinrich Hoffmann, the court photographer he referred to as "my eye", in the German delegation to Moscow. Hoffmann's mission was to capture the image of Hitler's powerful neighbour.† Together with very pleasant impressions of Stalin's sincerity and good will, Hoffmann brought back a large sheaf of photographs. But there was not one which Hitler considered suitable for publication – they all showed Stalin holding a cigarette. The problem was finally solved by retouching the photographs.[27]

What Stalin really thought of himself will never be known. He rose up from

*Cf. the titles of many well-known Soviet paintings and sculptures: "Lenin – the Leader", "Stalin – the Inspirer of Victories", etc.

†In their time Van Eyck and Rubens had been entrusted with similar missions – in Van Eyck's case, to capture the image of the powerful neighbour's daughter.

the depths of the Party apparatus, supplanting and destroying far more popular figures. Until the mid-twenties his popular image as a revolutionary leader, as a founder of the Army or State, or simply as a man, was infinitely less clearly defined than, for example, that of Trotsky, Bukharin or Zinoviev. It was precisely these gaps in his political existence that Soviet art was required to fill in. This is the reason for the vast number of genre paintings of Stalin, intended to "document" episodes of his public life – including some which never occurred – and traits of his personality – including some which were extremely uncharacteristic. This is the reason for the countless canvases portraying him at almost every key battle of the Civil War. This is why the image of Lenin as the inspirer see pp of the Revolution was always, whatever the situation, accompanied by that of 332((and 2. Stalin, its practical organizer.

"The leadership of the German people has changed," said Hitler at the 1938 Nuremberg Party Congress. "It has been created by National Socialism through a merciless process of selection. But, in so far as this selection relates to the years of our struggle, it represents a supreme value that cannot be replaced by anything else."[28] Thus, confusing the struggle for power, the establishment of power and the people who became its embodiment, Hitler proclaimed them all to be a supreme value of National Socialism. It is not surprising, therefore, that in the main Nazi exhibitions, in illustrated albums and in books on art, the official portrait of the Führer was followed by portrayals of his comrades.

The Great Exhibitions of German Art included a considerable number of portraits of Hitler's ministers, Reichsmarschalls and generals. These were usually busts, in accord with the realistic tradition of the nineteenth-century burgher portrait; sometimes the figures were portrayed in their working environment, e.g. the portrait of Reinhard Heydrich by Josef Vietze; sometimes they were see p. portrayed three-quarter length, e.g. Hitler's Party deputy, Rudolf Hess, by Walter see p. Einbeck. All of them, unlike portraits of Hitler himself, had something of the quality of genre painting, and there were certainly no full-length portraits against the background of symbolic dawns or building sites. It was evidently only Hitler who had the right to a pure, monumental portrait.

If one leafs through catalogues of the main Soviet exhibitions of the forties, one sees that the images of Lenin and Stalin are also always followed by portraits of their comrades. Depictions of the latter are either modelled on portraits of Stalin ("Molotov on the Tribune" by Aleksandr Gerasimov, "L. Beria in his office" by Iraklii Toidze, etc.) or else show them in scenes from everyday life, either with Stalin or on their own: "Gorky reading from his own work to Stalin", "Molotov and Voroshilov" (a painting by Iar-Kravchenko), "Molotov and Stalin Walking in a Glade in the Forest with Children" (Efanov), "Voroshilov Skiing" (Brodskii), etc.

Both Soviet and German sculptors produced an abundance of plaster and bronze busts of Party and State leaders – which usually ended up in the offices

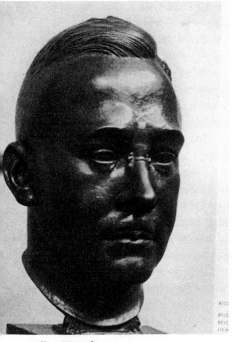

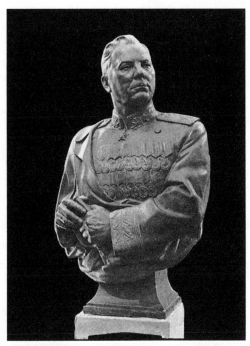

Miller: Himmler Vuchetich: Bust of Voroshilov

the institutions they directed – but never portrayed them full-length. Numerous monuments were erected to dead comrades of Stalin, including people like Kirov and Frunze whom he himself had had assassinated. Stalin and Hitler were the only living figures who had the right to be immortalized in full-length monumental sculptures and paintings.

Ceremonial portraits of the leaders and monuments to them constitute the centre of the structure of totalitarian art. Any change of leaders therefore creates a vacuum which threatens to destroy the whole structure unless it is immediately filled. In the history of Soviet art we can see how from the mid-thirties the image of Lenin was supplanted by the more monumental image of Stalin: in 1939, for example, a painting by Konstantin Iuon was given the title "Comrade Stalin during a Speech by Lenin at Smolnyi" – even Lenin himself now retained significance only in so far as he was listened to by Stalin. And in Evgenii Kibrik's large 1947 drawing with the portentous title "On 24 October Lenin Arrived *see p. 332* at Smolnyi during the Night" we see Lenin on the palace staircase signalling to *(below, left)* Stalin with a wave of the hand to go first, symbolically showing him the way towards the bright future. After Stalin's death and Khrushchev's secret speech, monuments to Stalin were blown up and portraits transferred to special stores; his figure was even removed from several of the most popular group compositions

and replaced by someone else. In "Lenin Proclaiming Soviet Power", for example, painted in 1947 by Vladimir Serov (the third President of the USSR Academy of Arts), the figure of Stalin stood in its expected place beside that of Lenin; now, however, this famous masterpiece of Socialist Realism shows us some unidentified figure in Stalin's place. The same fate, of course, befell portrayals of many of Stalin's comrades during his own life. During the thirties, at the height of the terror, Stalin laureates were obliged to scrape off their canvases the images of Tukhachevskii, Iakir, Bukharin and Ezhov; in this they were, incidentally, continuing the revolutionary tradition of Jacques Louis David, who, one after the other, as they were guillotined, had removed members of the Convention from his painting "The Tennis Court Oath". The same artists – Nalbandian, Efanov, Tomskii and Vuchetich – went on to paint and sculpt first Khrushchev and then Brezhnev, keeping to the same traditional iconography ("Brezhnev on the Tribune" by Nalbandian, "Khrushchev in the Trenches" by Khmelko, etc.). The culmination of all this was perhaps Nalbandian's painting "Novorossisk. Malaia Zemlia" – the name of a position on the Front where a *see p. (below)* Colonel Brezhnev once served and which came to be thought of as a key battle-ground, of all but decisive importance to the outcome of the Second World War. Soviet history did not have time to create images of Andropov and

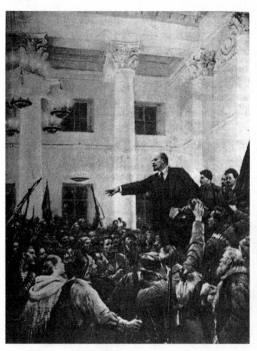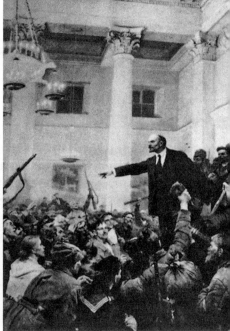

Serov: Lenin Proclaiming Power (with Stalin) Serov: Lenin Proclaiming Power (without Stalin)

Chernenko but unless *perestroika* is successful, we may yet see images of Gorbachev speaking from tribunes, at congresses, among the workers and – who knows? – perhaps even on the front line during the Great Patriotic War.

It is difficult to draw a clear dividing line between the "official portrait" and the genres that belong to the next levels of the artistic hierarchy. In any case, Soviet ideology, translated into the language of art criticism and theory, affirmed that the image of the leader is not limited by the features of his human personality, that it "is revealed in historical reality, in the multiplicity of situations of the revolutionary past and present, in communion with people, with the masses".[29] In practice this meant that the depiction of any historical event or real situation should be like an individual flourish in a splendid frame surrounding the portrait of the leader. The rest of totalitarian art thus began to take on the role of a pedestal for his monumental figure.

(b) Historical painting

> The more precisely we know and observe the laws of nature and life ... the more we follow the will of Providence. The more we comprehend the will of Providence, the greater our successes will be.
>
> Martin Bormann

> The more precisely we know and observe the laws of history and the class struggle, the more we follow dialectical materialism. The more we comprehend dialectical materialism, the greater our successes will be.
>
> Josef Stalin

The contradiction between the objective laws of dialectical materialism or the will of Providence and the historical role ascribed by totalitarianism to the Leader was resolved by both ideologies in their understanding of history: history itself, strictly speaking, began on 25 October 1917 or 30 January 1933, while all humanity's past was merely an approach to these dates, merely the prehistory of Communism or National Socialism. Nazi ideology in the person of Rosenberg pronounced that "today world history must be written anew", and the historian Walter Frank said that "all German history ... must be seen only as the prehistory of National-Socialism".[30] "I have understood," said Bruno-Iasenskii to the First Congress of Soviet Writers, "that in this country, where the entire history of humanity is being constructed anew, where the very greatest of

revolutions has revalued all values, facts and circumstances acquire an entirely different quality."[31]

The understanding of history had already acquired an "entirely different quality" in the theories of the Soviet avant-garde, above all in their idea of constructing through art a new reality, a new society, in which there would be no place for any relics of the past. "The new chronology begins from October 25 1917" – this formula of the Constructivist Aleksei Gan would have been acceptable to most members of the avant-garde. It was clear even then that the laws of dialectical materialism determined the development of humanity only during its prehistory and that, according to Marx himself, the task of refashioning the world now belonged to philosophy, science and art. These ideas played the role of midwife at the birth of Socialist Realism – at the First Congress of Soviet Writers. Gorky explained that "it is essential for us to know what happened in the past – not, however, as it has already been told, but as it is illuminated by the teaching of Marx-Engels-Lenin-Stalin", and the ideologue Kirpotin formulated the totalitarian approach to the history of culture: "World art to this day has been the art of the prehistory of humanity, when man was subordinate to elementally formed social laws that were independent of him."[32]

In 1937, at the opening of the First Great Exhibition of German Art, Hitler spoke in a similar fashion of the qualitatively new character of National Socialist art. According to Berthold Hinz, "This turn toward a 'new and genuine German art' ... called for a rewriting of history; and the entire National-Socialist ideology did in fact ... revolve around anchoring the present in the past".[33] The once elemental laws of history and nature, understood in theory and reduced by Marxism-Leninism to a code of absolute truths, ceased for the first time to be unpredictable and began instead to serve as a scientific instrument for directing the course of history into the only correct channel.

Soviet Historical Painting,[34] a book published in 1970 by Viacheslav Zimenko, the chief editor of *Iskusstvo* in the fifties after Stalin's death, contains 64 reproductions of historical works by Soviet artists; 55 of these portray events since 1917 or immediately preceding the Revolution, and 9 cover the other thousand years of Russian history. For all the obsession of National Socialism and Italian Fascism with the grandeur of their own past, paintings on historical themes – in the usual sense of these words – account for only a minute proportion of the work produced in the Third Reich and Mussolini's Italy. History appeared mainly as the history of the struggle for the new order; the past existed only in so far as it related to this struggle, and the bright future already existed as the revolutionary potential of the present. The present day looked on itself as history, and this is what endowed it with such grandeur. Zimenko's book included Ivanov's "Family. The Year 1945", painted 1960–4; this portrayed nothing more than a meal in a village hut, but even so everyday an episode from the year of victory over Germany had already acquired a noble patina of history.

"Every word of mine is historical!"[35] Hitler shouted to Otto Strasser; as for Stalin – his life was "saturated with such rich content, so splendid, so inseparably linked to the struggle of the Bolshevik Party, to the victories of the Great October Socialist Revolution, to the construction of socialism in the USSR, to all the outstanding events of the new epoch, that every remarkable phenomenon of the time bore on it the imprint of Stalin's genius".[36]

With the exception of the official portrait and monument, most depictions of the leaders can be seen as part of the genre of historical painting. In one short article on Soviet historical painting, written in 1947,[37] fourteen out of forty paintings mentioned include the names of Lenin and Stalin in their titles; a large number of the remainder depict them taking part in such events as "The Fifth Congress of the Russian Social Democratic Party" (Serebrianii), "The Second Congress of the Comintern" (I. Brodskii), etc. And, as we have seen, the lion's share of the Stalin prizes from 1934 to 1953 was awarded to representations of the leaders.

In the degree of its elaboration the iconography of Lenin and Stalin in Soviet art is second only to that of Christ and the most important Christian saints; it did in fact follow a similar pattern. Portrayals of Lenin and Stalin began with childhood and ended with life beyond the grave.

In 1939, while the Tretiakov Gallery staged the exhibition "Stalin and the Soviet People", the State publishing house "Art" produced an album of reproductions of the paintings exhibited, intended for display in workers' clubs, collective farms, factories, etc. Each of the several dozen reproductions depicted a different period of the Leader's life. The exhibition and the album both began with Grzelishvili's "Comrade Stalin in his Early Years", portraying him, book in hand, among a group of boys of the same age. To people who had not yet forgotten the images of the church such a painting could easily have seemed reminiscent of portrayals of the young Christ expounding Holy Writ to an admiring crowd. The subject of Korotkov's "Stalin – the Organizer and Leader of Social-Democratic Circles in Tbilisi in 1898" is described by its title, as are many works on similar themes ("A Political Demonstration by the Workers of Batum under the Leadership of Comrade Stalin in 1902" by A. Kutateladze, "Comrade Stalin at a Meeting of Baku Oil-Workers" by V. Sidamon-Eristavi, etc.). The relation of these subjects to the traditional iconography of Christ's ministry is obvious. Two years before, the *pièce de resistance* of the First Great Exhibition of German Art was a portrayal by Otto Hoyer of the young Hitler speaking at one of the first meetings of the National Socialist Workers' Party of Germany. The biblical associations of its title, "In the Beginning was the Word", also convey the esoteric, inner meaning of many similar works. A considerable number of portrayals of the leaders correspond to paintings of "Christ's Appearance to the People". The September 1941 issue of *Kunst dem Volk*, a Nazi journal published in Vienna, began with a colour reproduction of "Portrait of the Führer

see p. 319
(above)

see p. 323
(above)

in the Frankfurt Physicians Corporation", a painting by Georg Poppe, depicting Hitler visiting a military hospital, which had been the centrepiece of the year's Munich exhibition. A list of "appearances" of Lenin and Stalin in Soviet art to soldiers, workers, sailors, collective farm workers, children, wives, generals and writers could easily fill dozens of pages. Especially widespread in the Soviet Union *see p* were compositions on the theme "Christ in the Wilderness" or the Leader in *and 3* Exile ("Lenin in Shushenskoye" by Basov, "Lenin in Razliv" by Rylov, the Kukryniksy and others, "Stalin in Turukhansk" by Sokolov-Skalia, etc.). Less *see p.* canonical themes include the leaders going for walks, with children, at home,

Not only the leaders themselves but also all events linked to their names were canonized. Totalitarian chronology was based on the heroic battles and victories of revolutionary history. National festivals were celebrated on 25 October (7 November new style) 1917, 24 October 1922 (the beginning of the Fascist regime), 30 January 1933 (the beginning of the Nazi regime), the birthdays of Lenin, Stalin, Mussolini and Hitler, May Day and Labour Day. Mussolini, admittedly, did move this last holiday to 21 April, explaining that the previous date was "of foreign origin and had been imposed by the Socialist International",[38] but its meaning remained the same. All these events and dates became common subjects of what, at least in Soviet art, was referred to as "historical painting".

The history of the Nazi movement was somewhat lacking in heroic events. With the exception of the failed Munich *putsch* in 1923, National Socialism's path to power was marked only by political brawls in beer cellars and street fights

Hoyer: Wounded SA Man

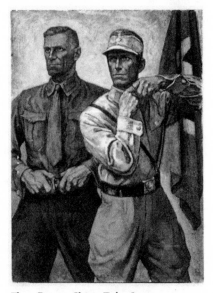

Eber: Brown Shirts Take Over

between storm-troopers and Communists. This was hardly adequate material for the creation in art of the solemn image of the Nazi Revolution spoken of by Hitler. It was evidently for this reason that "historical painting" consisted mainly of depictions of festival processions, parades, and Party meetings or public gatherings on the anniversaries of victories and in memory of the fallen. A forest of arms flung up in the Nazi salute, the rhythmic tread of ranks of storm-troopers or workers, columns marching through the night, bearing banners and standards and framed by the shafts and pillars cast by countless searchlights – all this reflected the theatrical rhetoric with which Albert Speer endowed such scenes in real life. It was the best-known artists of the Third Reich who were the masters of this genre and it was such paintings as "30 January 1933" by see pp. 330 Artur Kampf, "The Celebration of 8 of November" (the anniversary of the Munich *putsch*) by Paul Herrmann, "This is Your Victory" (the laying down of see p. 338 wreaths on the graves of the victims of this *putsch*) also by Paul Herrmann, "Ceremonial Evening Meeting of Nazis in the Konigplatz in Munich" by Fritz Gärtner and "That was the SA" by Elk Eber which, together with portraits of see p. 206 (above) the Führer, opened the main German exhibitions.

Soviet art naturally had its fair share of similar paintings. The epic portrayal of the war with Germany begins with Iuon's "The Parade in Red Square in Moscow on 7 November 1941" and ends with the equally well-known "Triumph see pp. 338–39 of Our Fatherland" by Mikhail Khmelko, a depiction of the victors laying the banners of the defeated Germans at the foot of the mausoleum. In both Russia and Germany, meetings and high-level conferences taking place in the present

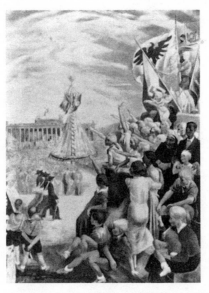

Hangenstenberg: May Day Celebration 1937

Herrmann: November Celebration at the Hall of Generals (1940)

Gaertner: Nazi Evening Ceremony in the Königplatz in Munich

were seen as a part of history and depicted with equal pomposity: if the German uniforms in Conrad Hommel's "Reichsmarschall Goering at Luftwaffe Head-*see p. 325* quarters" were replaced by Soviet Uniforms, no one would notice anything wrong. A similar substitution could be performed, in reverse, on Boris Shcher-bakov's "Group Portrait of the Heroes of the Soviet Union from the Military Engineers" and on countless similar works by A. Gerasimov, Efanov, Laktenov,*see p. 324* Katsman and many others. It would be wrong, however, to suggest that there is always an exact correspondence either of theme or of emotional interpretation.

Behind the Bolsheviks in their struggle to power lay an armed uprising in Petrograd, almost three years of civil war, a bloody struggle against their own peasantry, and the radical measures taken during industrialization. The main subjects of "historical painting" were therefore not celebrations of historical events, but the events themselves – or at least fictitious versions of them: "The Salvo from the *Aurora*", "The Storming of the Winter Palace" and "The Storming of Perekop" were among the canonized subjects of Soviet historical painting during the thirties and forties and remain so to this day. Soviet theory required from these paintings "firstly, a heroic treatment of the theme, secondly a 'mass' scene, a composition with many figures, richness of subject and narration, psychological and dramatic unity of impulse, a general monumentality and magnificence".[39] Most of these demands were met by the supposed masterpieces of both Socialist Realist and National Socialist art; richness of narration and psychological interest, however, were to be found more in Soviet work. An enormous number of paintings depicted the underground struggle of Bolsheviks under Tsarism, the first days after the Bolshevik coup, episodes from the con-struction of socialism in town and country, etc. The positive image of Soviet man was displayed in the martyrdom of Pavlik Morozov and the heroic resistance*see p. 210* of a Bolshevik against class enemies ("Interrogation of Communists" by B.*see p. 333* Ioganson) or of a Komsomol girl against her Fascist executioners ("Tania" by*see p. 211* the Kukryniksy); it was also displayed in scenes of enthusiasm on vast building sites and in the universal rejoicing of festival processions, meetings and dem-onstrations. Even the latter, however, lack the relentless rhythmical organization which lends a sense of monumentality and magnificence to most Nazi works on these themes. The main emphasis in the Soviet paintings is on the excitement and rejoicing of the crowd, on faces wreathed in smiles among patches of sunlight, flowers and red banners. This divergence in treatment can be explained in two ways. Firstly, as a result of different artistic traditions: the earthy genre painting of the Peredvizhniki on the one hand, and the exalted romanticism of German art on the other. Secondly, a considerable role was played by the clichés of political propaganda with which each ideology created an image of its opponent. Soviet ideology saw Fascism as a "philosophy of the fist". a cult of aggression and of the superman which found its artistic expression in pseudo-classicism and coarse naturalism. Racial theory looked on the Soviet people as

a disorganized mass, lacking in self-discipline and the intuitive sense of beauty which alone can create eternal forms in art. Each ideology set itself up in opposition to the other.

Even these stylistic differences, however, lessened with time. During the forties the Great German Exhibitions included a number of genre paintings

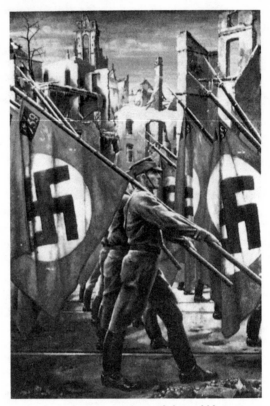

Tschech: High Nazi Morale amid the Rubble

relating to the history of the Nazi movement. Adolf Reich's "From the History of the Underground Struggle in Austria" showed police searching a Nazi activist's flat during the struggle for the unification of Austria and Germany; Jacob Mann's "The Fatherland Calls" showed a Nazi agitator calling upon people to join the Nazi Party or perhaps vote for Hitler . . . And during the first years after the War such Soviet paintings as Khmelko's "The Triumph of Our Fatherland" began a series of vast canvases in which the victorious State took on a truly imperial grandeur, while in the paintings and murals of Pavel Korin the images of its see p leaders, soldiers and generals froze into the hierarchic immobility of figures in icon painting.

Reich: Wool Collection

Mann: The Fatherland Calls

Truly historical painting only won the right to a place in Soviet art relatively late, after Stalin, in the face of the catastrophe of the first months of the war, had appealed to Russian patriotism in a speech which in many respects determined the whole of subsequent Soviet ideology: "May you be inspired in this war by the indomitable image of our great ancestors Aleksandr Nevskii, Dmitrii Donskoi, Kuzma Minin, Dmitrii Pozharskii, Aleksandr Suvorov, Mikhail Kutuzov!" This speech rehabilitated history and had "enormous significance in the choice of themes and subjects in historical paintings of this period".[40] It was at this time that the "Internationale" was replaced by a new State anthem which asserted that: "An indissoluble union of free republics has been cemented for ever by Great Russia".

"Aleksandr Nevskii" by Korin, "The Duel between Peresvet and Chelubei" by Avilov and "Ivan the Terrible in Lithuania" by Sokolov-Skalia were the first examples of this new genre, which blossomed fully only after the war. The images of Russian tsars and generals now stood beside those of revolutionary leaders, and battles for the establishment of the Russian Empire were now as important as battles for the construction of the Proletarian State.

Battle-pieces, of course, belong to the genre of historical painting. In view, however, of their special importance in the general structure of totalitarian art, they deserve special consideration.

(c) Battle-pieces

Wars are divided into just – popular and liberating – and unjust – imperialist and aggressive.

Lenin

Violence in certain circumstances has a deep moral meaning.

Mussolini

Humanity has become what it is thanks to struggle ... A peace that lasts more than twenty-five years inflicts great damage on the nation.

Hitler

In the spring of 1941 Hitler ordered the High Command to set up an organization of war artists. The artists followed the army, attached to different units, and documented the war in the air, on the sea and on land. There was nothing unusual about any of this; similar groups of artists were attached to the British and American armies. The task of documentation was inevitably interwoven with that of propaganda, and the war art of all these countries met both these

requirements; it consisted mainly of realistic sketches of battles, troop movements and army life, and portraits of soldiers and officers which later, in the artists' studios, were transformed into genre paintings and battle-pieces. All this naturally led to a stylistic similarity between the works of war artists of different countries, a similarity which allowed the two American authors of a book on German war art to insist that there was no difference between them: according to them, the book's title *German War Art* could perfectly well be changed to 'American War Art'.[41] This is an obvious exaggeration. It is not simply that American artists were much freer in their choice of style and manner of execution, or that the English organization of war artists included such artists as Henry Moore, Graham Sutherland and John Piper, who used the material of the war to create tragic masterpieces; the main difference between the war art of the totalitarian and democratic countries is one of function.

War always and everywhere creates the preconditions of the "totalitarian situation". It sanctions the supremacy of the common over the personal, excites the people's love of their fatherland and of those who govern their fate, engenders heroism at the front and zealous industry in the rear; it reinforces the role of the State as the collective defender of the common interests of the nation and justifies such consequences of this as censorship, centralization, and an ideological pressure on certain areas of art. But these features, which in democratic countries are engendered by a critical situation and disappear together with this situation, constitute the very core and aim of totalitarian ideologies; totalitarian regimes exploit all means, including art, in order to keep the people in the conditions of such critical situations: they either wage war, celebrate victory, or make ready for a new war.

Mussolini took from Futurism the idea of war as "the hygiene of the world" and remained true to it until his inglorious end. All Hitler's speeches, writings and conversations at table are imbued with the idea of struggle as the motive force of history. "The idea of struggle is as old as the world," he wrote in *Mein Kampf*. "In struggle the strong is the victor and the weak perishes. Struggle is the father of all things."[42] For all the popular conception of Hitler as a mystic, someone who turned for the resolution of important questions to astrologers and occult teachers from the East, the works of serious researchers show him to have been a strict rationalist who thought in the categories of the materialist philosophy and science of the nineteenth century. Alan Bullock writes in his fundamental Hitler biography that his political opinions were founded on hidebound Darwinism.[43] "The idea of struggle ... so deeply marked the content and tone of the book [*Mein Kampf*] that at times even the idea of race, the other cornerstone of National Socialist ideology, had to take second place."[44] It is hardly necessary to prove that this formula, like Darwin's theory of the survival of the fittest, is of sacred importance to the Soviet understanding of society and history.

War art in the democratic countries was engendered by an extraordinary situation; with the resolution of this situation it receded immediately to the periphery of artistic life. Its style was essentially different to that of the dominant artistic movements of the time (most of them non-figurative) and it lasted only for the duration of the war. In the art of the totalitarian countries, however, the theme of war occupied a central place, together with the official portrait and the historical painting, throughout its entire development: the Grekov studio of war artists was established in the Soviet Union in 1934 – thirteen years after the end of the Civil War and seven years before the beginning of the next war.[*]

"Except in struggle, there is no more beauty"[45] – this slogan was shared by Italian Futurism and the Soviet avant-garde. In the early, prewar works of Boccioni, Carrà, Malevich and Tatlin the abstract idea of struggle was embodied in contrasts of colour and the collisions of plastic masses or "lines of force". With the appearance of the AKhRR this theme was embodied more concretely. Their first, July 1922, exhibition was dedicated to the life of the Red Army and included 184 exhibits; "in the Fifth Anniversary of the Red Army exhibition there were 245, in the outstanding, 'landmark', Tenth Anniversary exhibition there were 288, in the Fifteenth Anniversary exhibition there were 674, in the Twentieth Anniversary exhibition (1938) there were about 1000".[46] In terms of number of exhibits there is no theme in Soviet art which can rival that of war: army jubilees were celebrated by vast exhibitions every five years, and the battle-piece, of little importance in Europe since the invention of photography, was once again of central importance. Socialist Realism and the Grekov military studio were born in the same year and under the same star. Victory over Hitler elevated this genre to new heights.

During the development of the battle-piece over the centuries – from Leonardo to Vereshchagin – the emphasis in the emotional image gradually shifted: from the heroism of combat and victory to the tragedy of loss and destruction. It is this tragedy that we see in George Grosz's and Otto Dix's depictions of the First World War and in Henry Moore's and Graham Sutherland's depictions of the Second. Totalitarianism has a different point of view: "The characteristic feature of the Soviet battle-piece, including drawings from the Front during the Great Patriotic War, is optimism and humanism, faith in the victory of life over death, of good over evil."[47] Nazi humanists, for their part, saw the work of Grosz and Dix – to whom the War was a triumph of evil over good – as a mockery of the Germany army: it was under this caption that their paintings were displayed during the exhibition of "Degenerate Art".

There is a vast distance between the direct portrayal of war by artists at the front and the totalitarian concept of military art. The text of a recent book on the Soviet battle-piece consists mainly of a discussion of the activity of war artists

[*] The Soviet Union entered the Second World War (referred to as the Great Patriotic War in the USSR) in 1941.

on the various fronts, while the sixty-two colour reproductions do not include a single painting produced between 1941 and 1945. (E. Vostokov, *Greckovtzy*, Moscow, 1983). This calls for explanation.

During the war itself artists from the Grekov studio, like their counterparts from the German "Staff of Military Artists", were attached for various lengths of time to active units. They made sketches from life during their spell at the front and then, on returning to their studios, produced epic paintings based on this material. There are an enormous number of these drawings and paintings.* The reality before both Soviet and German artists was essentially the same, and their works are similar in subject and style, direct impressions of the reality of the war. Works like these accounted for most of the exhibits at the first Soviet exhibitions after the war – but the critics unanimously declared that they reflected the war falsely and inadequately. It was during the war that Aleksandr Deineka, one of the most talented Soviet painters, produced his finest realistic work. The figure of an airman with an unopened parachute hurtling down onto some upturned rails; sinister-looking stakes, blocking the way to German tanks on the outskirts of a deserted Moscow; the heroic and tragic spirit of his "Defence of Sebastopol": all these were extremely popular during the war years *see p. 342 (below)* themselves, before the intoxication of victory. Deineka had moved a long way from the lapidary quality of his famous "Defence of Petrograd", seen by Soviet critics as a classic example of a formalist approach to a heroic theme; nevertheless, these realistic works too were subjected at the end of the forties to sharp criticism for their "poster-like images", lack of psychology, foreign influences and formalism.[48] The drama of defence was replaced in Soviet art by the exultation of liberation; Pavel Sokolov-Skalia "Liberation of Sebastopol" and "Liberation of Kaluga", Petr Krivonogov's "Victory over Berlin" and Mikhail *see p. 339* Khmelko's "Triumph of Our Fatherland" became the exemplary battle-paintings. The "heroic annals" of the Great Patriotic War were thus compiled post factum, after the final victory, and the image they convey is very different from that captured by military artists at the front. *see p. 343 (above)*

Scenes of actual fighting occupy a relatively modest place in Soviet military art. As in historical painting as a whole, the first place goes to images of the leaders as organizers and inspirers of the key victories. These were the works which were awarded Stalin prizes first class and which were included in the "golden collection".

The second place goes to battle scenes, ranging from epic canvases to pure genre painting. The demands of optimism and humanism did not encourage a faithful depiction of the front, and this function was partially assumed by the newly emerging genre of the panorama, as embodied in the vast "Stalingrad

* The Washington "Military Collection", to which the works of the German war artists were transferred in 1947, includes over 9,000 photographs of these works (the originals were recently sent back to West Germany); the Soviet war artists produced at least the same quantity of work.

Krivonogov: Victory over Berlin

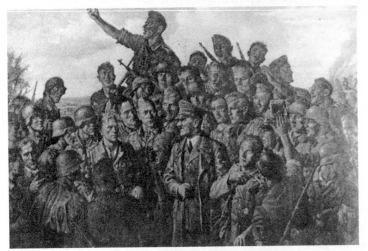

Schiebe: Hitler at the Front

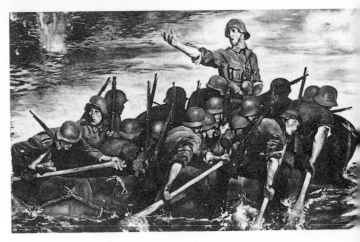

Padua: 10 May 1940

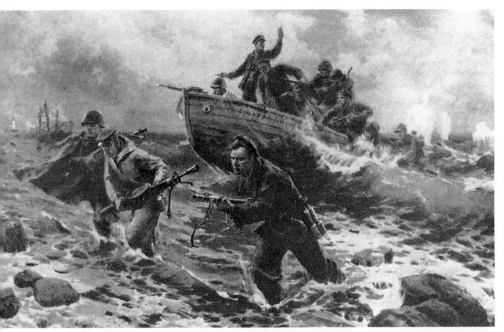

zykov: Sailors from the Black Sea

er: The Battle for Warsaw (1940)

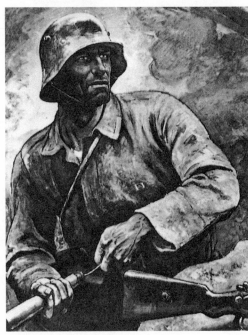

Eber: The Last Handgrenade (1940)

Battles" or "Defence of Sebastopol" created by large collectives from the Grekov studio. Through a combination of plaster-casts and perspective painting these works evoked an illusion of authenticity, and for this reason, after many years with military units and travelling exhibitions, they usually ended up in the various war museums. Although an enormous number of battle scenes were produced, the highest rewards and honours were bestowed on artists for depictions of parades and victories and for memorials to the war in both sculpture and painting. One of the most famous of these was Krivonogov's "On the Kursk arc", a depiction of a heap of twisted machinery against the background of a crimson dawn, in which the real events of the war are enveloped by a lyrical haze of reminiscence. The most popular military genre painting was Iurii Neprintsev's joyful and optimistic "Rest After Battle" (1951), which, in its variety of psychological characterization, can be seen as a paean to the good nature, mother-wit and humanism of the straightforward Russian soldier. see p. (abo

German exhibitions of the war years were also opened by canvases such as "Hitler on the Battle-Field" or Conrad Hommel's "Reichsmarschall Goering at *Luftwaffe* Headquarters", but comparatively few works of this kind were in fact produced. Nazi military art never matured to victories and parades, being interrupted at the stage of sketches from the front and the premature battle- s ee p

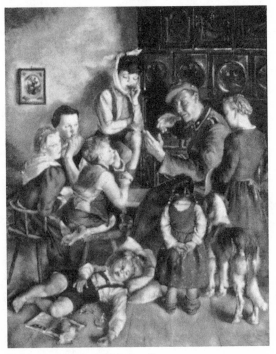

Padua: A Soldier and his Family

pieces produced from them by Padua, Eichhorst, Siebert and other war artists. These are stylistically more rigorous and have more of a documentary quality – partially a matter of German tradition, but more importantly a result of the outcome of the war: if Hitler had been the victor, it is unlikely that its reflection in Nazi art would have differed materially from its actual reflection in Soviet art.

The official portrait, the historical painting and the battle-piece constituted the core of the official art of Hitler's Germany and Stalin's Russia. A considerable number of similar works were produced in Fascist Italy. The cult of the Duce was celebrated with no less splendour than those of the Führer and the Leader, and Mussolini himself evidently had doubts as to its sincerity. In his auto-biography he ingenuously describes how the murdered Count Foscari, on the verge of death, "wanted to have always near him my photograph. He declared himself glad and proud to die and that from me he knew how to die".[49]

In spite of this testimony, however, it would be stretching a point to say that portraits of Mussolini constituted the centre of Fascist art.

His picture – often in one of his Napoleonic poses – was already displayed on all public buildings and could sometimes be carried in procession through the streets like the image of a patron saint. Devout fascists might have his photograph printed at the head of their writing-paper, together with one of his short apodictic pronouncements. He was compared to Aristotle, Kant and Aquinas: he was the greatest genius in Italian history, greater than Dante or Michelangelo, greater than Washington, Lincoln or Napoleon; he was, in fact, a god.[50]

Firstly, no iconographic or stylistic canon was ever established. One moment Mussolini was portrayed riding into Rome on a white horse against a background of banners and armed units, another moment his powerful naked torso fused with figures of reapers in the universal enthusiasm of "The Battle for Corn"; one moment he appeared in the guise of a Roman deity or a Renaissance bust à la Donatello, another moment a brutal profile was constructed from Futurist spirals and dynamic lines. Secondly, none of the Italian artists most acclaimed at the time – neither de Chirico, Carrà, Severini, Funi nor Sironi – ever painted such works. They were produced mainly by members of the Fascist Syndicate of Arts whose names disappeared into Lethe with the collapse of the regime. They should be seen more as agitprop art on behalf of the regime than – as in Germany and the USSR – as its highest artistic achievements. Italian exhibitions were devoted mainly to the themes of labour, everyday life, sport and youth; and it was to theme paintings of this nature that the majority of the Cremona prizes were awarded. The image of the Duce, visible or invisible, did indeed always accompany Italians in both their work and leisure; according to the general totalitarian hierarchy of genres, however, the theme constituted not the centre of official art but its varied periphery.

Italian poster: Mussolini

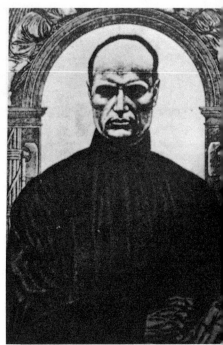

Italian poster: Mussolini

Bust of Mussolini

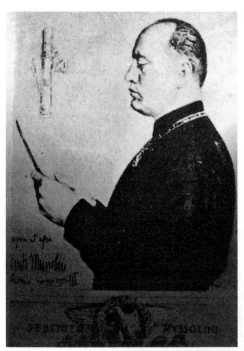

Italian poster: Mussolini

Italian poster: Mussolini

(iii) The hierarchy of genres – the periphery

(d) Genre painting

Life has become better, life has become gayer.

Stalin, 1937

The German people live better in the present day than
five years before, and a great deal better than in the days
of the shameful democratic system.

Goering, 1938

Both Socialist Realist and National Socialist art were based on an important national tradition of genre painting which blossomed above all in the second half of the nineteenth century. Both cultures saw this as the most important value in their artistic heritage and believed that they themselves were developing it to a new and higher level. In both countries, however, the themes of the new genre painting considerably outgrew their traditional framework.

> Pictures of marching columns and youth groups, battles in the World War, reapers in the field ... heroic works at the glowing forge, and formations of ships putting out to sea ... Our readiness to affirm the world of today and our renewed penchant for enterprises of great magnitude have given rise to something truly new in the field of our genre painting, namely, the heroic landscape of *engineering activity* in a revitalized Germany. The scenes we encounter here show work on our new highways, on dams, on the huge factory complexes that will bring about our economic liberation.[51]

Soviet critics wrote of a similar variety of themes:

> The most varied sides of the life of the people, its diverse activities and everyday life find their reflection in Soviet genre painting. Such major socio-political themes as labour, the struggle of nations for peace, the Soviet family and school, Soviet friendship and love, and many others, closely interlinked by the progressive ideas of the struggle for Communist society, constitute the themes of Soviet genre painting.[52]

The "marching columns" of parades, demonstrations and youth detachments, the depictions of battles and of zealous labour on building sites, factories and the fields of collective farms are thus also included as a part of "genre painting". If one is to judge by the size of the theme exhibitions, the number of prizes and rewards and the dimensions of canvases and monuments, then the first place among the different themes must go to that of labour. This was also the central theme of what Italian Fascism attempted to make into its official art.

The importance of this theme in the Soviet Union is hardly surprising. Since the first days of the Revolution it had been of central importance to both the

Futurists and the Proletkults, who in fact saw their own work as being no more valuable than any other form of production. Throughout all the subsequent changes in cultural policy the theme of physical labour remained a symbol of a class world-view and of Marxist ideology. In the history of Soviet art the 1939 exhibition "The Industry of Socialism" was considered "a turning point" and "a landmark".

Mussolini's corporatist State and Hitler's racialist State attributed no less significance to this theme. "A citizen of the State is evaluated according to the product he produces, his work, his ideas,"[53] pronounced the Duce. The walls of public buildings in Italy were accordingly covered with monumental frescoes glorifying labour. "Germany has now become the country of labour," announced Goering in a report to the 1938 Party Congress in Nuremberg about the progress of his four-year plan for the development of the economy. He did also state that "it is now necessary for workers to work ten hours a day and more",[54] but it was considered that enthusiasm alone would lead the workers to do their utmost since labour, freed from capitalist exploitation, had now become "a matter of honour" (Stalin broadened this to "a matter of honour, valour and heroism"). Germany, like the USSR, was swept by a wave of exhibitions devoted to labour: "To the Glory of Labour", "The German Peasant – the German Land", "A Nation of Workers", "Art and Technology", etc.

It is often said that the main theme of Nazi art was the everyday life of the peasants, linked as this was to the ideologically fundamental concepts of land and race. With regard to the initial stages of Nazi art this is certainly true: 40 per cent of the exhibits at the first Great Exhibition of 1937 were depictions of nature and agricultural life.[55] But the task of creating a war potential in industry necessitated a change in emphasis, and village idylls were soon replaced by depictions of zealous factory workers. In 1943, one of the reviews in *Art of the Third Reich* stated:

> Until this day, the figure of the worker, who only recently, with the beginning of the industrial epoch, appeared in our cultural history, has not been granted a sociological substantiation. The worker, degraded by Marxism to the level of a homeless proletarian, has in the social context of our people become the soldier of technology, forging weapons for the fighter on the Front. In him, as in the peasant and the soldier, are embodied the finest qualities of our race.[56]

The Soviet theme painting evolved in the opposite direction. As the centre of Soviet ideology shifted – from class-orientated proletarian internationalism towards Russian national patriotism – primary importance was accorded to the concepts of the Motherland (the new rules of Russian grammar accorded this word a capital letter), the fatherland (with an optional capital F) and the nation. The image of the "straightforward Soviet fellow" was linked now to that of the Russian peasant, the "muzhik", whose work and everyday reality were rooted in timeless layers of the people's life and whose image had preserved its eth-

Motovilov: The Stonebreaker Koelle: The Stonebreaker

nographic characteristics over the centuries. "This thick-set warrior-muzhik [it is the paintings of Arkadii Plastov which are under discussion] and his fair-haired children and grandchildren seem to embody the powerful forces of the people's black earth, forces that nourish life ... The life and labour of the village, the living types of Russian peasants, captured in all their everyday surroundings, with a crust of bread, a pitcher of milk or of sour kvas, form a picture which embodies whole strata of popular or national life."[57] Concepts of the national, of the indigenous, became the most important criteria of evaluation, and in postwar Soviet genre painting such works as Plastov's "The Tractor-Driver's Break" (1949) and Tatiana Iablonskaia's "Bread" (1951) were, if not more numerous, at the very least accorded more importance than works on industrial themes. In all this totalitarian art was not merely following an abstract dogma of class or race, but fulfilling the concrete demands of the social system: Hitler's definition that "art is a continuation of politics by other means" is applicable not only to National Socialism. *see p.* *(below*

"The triad of worker, farmer and soldier as equals in social production is a frequent theme and could almost be called a *topos* of National Socialist ideology,"[58] remarks B. Hinz. One of the most frequently reproduced works in

the Third Reich was indeed Schmitz-Wiedenbrück's "Workers, Peasants and *see p. 344 (above)* Soldiers" (1941), while in the Soviet Union this triad was frequently embodied in decorative murals and panels: in the pavilions of the All-Union Exhibition of Economic Achievements, the postwar stations of the Moscow metro, etc. The themes of labour and war reflected a single impulse behind these regimes that was simultaneously constructive and destructive; it was the Nazis' chief architect who organized their machinery of destruction (Albert Speer, Minister of Armaments) and the Soviet Minister of War who acted as chief patron of the fine arts (Voroshilov, cultural curator for the Central Committee). "In smelting furnaces belching out flame, in smoking factory chimneys, in the rumble of shipyards, our artists see the same national will to life which, in other circumstances, inspires the soldier on the battle-field and the peasant behind the plough",[59] wrote *Art of the Third Reich*, summing up the exhibition "Art and Technology".

Labour and struggle often fused into a single emotional image. The most famous works on the theme of labour (Dormidontov's "Ship-building Factory" or Artur Kampf's "Rolling Mill") give the impression of a desperate battle against an invisible enemy; Ivan Shadr's reliefs in Moscow, Artur Hoffmann's reliefs *see p. 346 (above)* in Germany almost twenty years later and Torakh's projects for autobahn monuments all resembled not so much scenes of peaceful labour as the battles

Plastov: Harvest Time (1945)

Thorak: Monument to the Labour Movement (maquette)

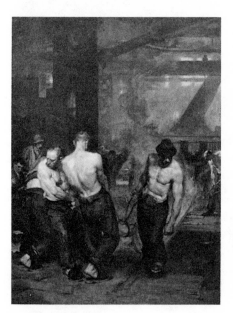

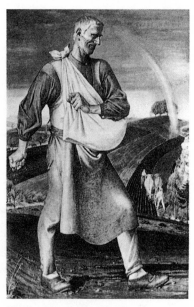

Kampf: Rolling Mill Martin-Amorbach: The Sower

of ancient gods and heroes. In other paintings the blue skies of tall building sites blossom with the fireworks of electric welding, while cheerful youths and girls in overalls lay down, row upon row, the bricks of a new and happy life. According see p. 347 to Soviet (and not only Soviet) aesthetics, this was the first time that "labour, i.e. the most human of all the activities of man, was being glorified and its poetic, splendid content being revealed".[60] In Stalin's Russia, as in Hitler's Germany, work was a compulsory duty; in art, however, it appeared in the guise of the supreme citizenly virtue. Man no longer simply worked – he struggled for the plan, for victory, for his own liberation.

The faceless technology and the uniform zeal of the workers bestow a striking similarity upon portrayals of industrial scenes in Nazi and Soviet art. Each regime, however, brought its own contribution to the portrayal of agricultural labour. In Nazi art the peasant was usually portrayed against an idyllic background of the timeless life of the people. In spite of the extremely high level of agricultural technology in Germany, the German peasant was portrayed either striding behind a primitive plough, broadcasting seed into the bosom of Mother Earth, or gathering in the harvest with pitchfork and scythe. This was how village life had been portrayed in Soviet art of the twenties; one might well think that the image of the sower in Oscar Martin-Amorbach's painting had been borrowed from Ivan Shadr's sculpture of the same title or even from the design on one of the first Soviet bank-notes. From the beginning of the thirties, however, Soviet paintings had swarmed with tractors, threshing-machines and combine harvesters.

A sociological approach sees this change as an indication not only of the non-realistic character of the art of the Third Reich, but also of an important divergence between the arts of the two countries. It would be wrong, however, to imagine that this reflects a difference of either ideology or agricultural organization. Art in totalitarian countries fulfils the function of "masking the social deficit"; what it highlights is what is lacking at that moment in the social system.

In the ruined Soviet villages of the early thirties a tractor was as great a wonder as a piece of beefsteak on a peasant's table. Germany, on the other hand, had no need to advertise its high level of agricultural technology; on the contrary, mechanization was erasing the very way of life, the very ethnic features which Nazism saw as most timelessly German. This is why the art of the Third Reich is so full of portrayals of labourers surrounded by the trappings of traditional peasant life; this is why there are so many interior scenes of simple peasant families listening together to the radio, reading newspapers or even looking at see p. 349 and p. 181 (below) the reproductions of Nazi art distributed by "Strength through Joy"; this is why the theme of motherhood was so widespread.

Nazism championed the family as a cell of the social organism. Revolutionary Marxism initially considered it a bourgeois institution doomed to extinction in the conditions of socialist society. The whole previous system of human relations

was to be destroyed in the name of a new collective way of life; and it was to *see pp and 3*
the construction of this way of life – every aspect of it from new types of dwellings
to clothes and crockery – that the energies of the post-revolutionary Soviet
avant-garde were directed. By the thirties, however, all this had changed. Laws
intended to reinforce the family were as strict in Stalin's Russia as in Hitler's
Germany. Divorce was made difficult, abortion forbidden and child-bearing
encouraged; in both countries an institution of "heroine-mothers" was estab-
lished, dispensing special medals and financial rewards to mothers of many
children. In spite of all this, in Soviet genre painting of the thirties and forties
we find almost no depictions of interior family scenes. If one were to judge by
art alone, one might well come to the conclusion that Soviet man never lived
at home or spent time with his family, but instead passed his entire existence in
factories, on the fields of collective farms, at Party meetings and demonstrations,
or surrounded by the marble of the Moscow metro.

The explanation for this lies in the reality of Soviet life. The old way of life *see pp and 3*
had been destroyed, and the new way had become a nightmarish existence in
crowded communal flats or tumbledown village huts left over from Tsarist days.
It was impossible, for all the flexibility of the concept of "faithfulness in the
reflection of reality", to include any of this in the joyful picture of the new life
being propagated by Socialist Realism. It was only at the very end of the
Stalin period that genre paintings like Laktenov's "The New Flat" appeared; *see p.*
the gulf between the image and the reality, however, was so vast that even
Soviet criticism coined the phrase "the lacquering of reality". (It is possible,
though, that the critical attacks on Laktenov's painting were occasioned not so
much by the implausibility of the scene as by its hidden elements of truth: the
expressions of blissful ecstasy on the faces of the figures betray just how
extraordinary it was for an ordinary Soviet family to obtain a flat to themselves.)
The new way of life, hailed by propaganda as one of the main achievements of
the Stalin regime, was in fact the most severe "social deficit" in the country; in
Soviet art, however, this was masked, by the creation of an illusion of joyful
collective existence. According to a Soviet author: "Soviet genre painting more
and more often began to take on a solemnly monumental character, becoming
a poem in colour to the free constructive labour of Soviet people and their happy,
prosperous life."[61]

The thematic structure of totalitarian art developed only gradually, and the
importance of particular genres and themes changed from one period to another.
In the early stages of Soviet, Italian and German art a considerable role was
played by the interrelated themes of youth and sport. In early Nazi posters and
in works by Deineka, Funi and Sironi, air, water and sun, the dynamics of speed
and the health of young bodies fused together into a symbol of a joyful dawn or
spring. At the time this theme embodied the youth of the regimes, their future
and their hopes, and it required a simplified treatment of monumental or dynamic

forms. But Hitler was fifty by the beginning of the War, and Stalin was seventy by the end of it. Totalitarian culture appears to have sensed the awkwardness of lauding qualities that its Leaders no longer possessed. Youth became a fact of social life rather than a part of the natural cycle, and the healthy nakedness of young bodies was clothed in the uniforms of political youth organizations. The theme of youth lost its romantic halo; from being a social allegory, it became a subject for genre painting.

see pp. 354 and 355

The main exhibitions of the Third Reich did, however, include large numbers of depictions of boys and girls from the Hitler Youth, marching beneath swastikas or giving Nazi salutes. As well as similar images of Komsomol boys and girls, Soviet art included countless genre paintings of children joining the pioneers, of group hikes and Komsomol meetings and oaths. Pioneer schools and palaces were adorned with the slogan: "Thank you, Comrade Stalin, for our Happy Childhood". Stepan Dudnik's painting of this title (the best known of the subgenre) depicted a happy crowd of pioneers offering flowers to Stalin; other variants were simply joyful little pictures of childhood. For all this, the themes of youth and sport continued to become increasingly peripheral. In Germany and the USSR they became subjects for sculpture and decorative murals rather than for painting itself. The romanticism and dynamism of the two themes evidently contradicted not only the frozen official style but also the inertia that was so characteristic of the mature totalitarian systems. The regimes grew older together with their leaders; it is symbolic that in 1946 the Stalin prize first class was awarded to Aleksandr Gerasimov for his "Portrait of the Four Oldest Artists". Only in Italy did this theme remain important. The 1940 theme exhibition "Fascist Youth" was one of the most important of all, and the Cremona prize first class was awarded to Cesare Maggi, one of the exhibitors, whose style still retained elements of the romantic symbolism of the twenties.

(e) Landscapes, still lifes and nudes

> Instead of the willows where Savrasov's "Rooks" arrived every year to build their nests, there were smoking factory chimneys ..., the quiet forest paths of V. Baksheev and the bright dawns of V. Belianitskii-Birulia resounded with impassioned Komsomol songs and round-dances, while pioneer bonfires crackled.
>
> *Thirty Years of Soviet Representational Art*

The place of landscape painting in the hierarchy of genres of totalitarian art depended on the ideological significance attributed to depictions of nature at the various stages of its development. "Sometimes in landscape painting we see the specific features of a given landscape, sometimes a segment of the broad whole of our society ... Sometimes it is a fragment of the Reich that evokes in us a

sense of devotion, sometimes it is a fragment of the Mother Earth who makes everything for us, relying on our immortal alliance."[62] This passage from a Nazi history of art reveals the classification of landscape painting which was held, implicitly or explicitly, by all totalitarian aesthetic thought. Landscapes were divided into three types: pure landscape – as understood by most nineteenth-century artists – landscape as a symbol of the Motherland, and landscape as a symbol of the New State.

Pure landscape was repudiated by totalitarianism as the fruit of aestheticism and unthinking observation. "The *plein-air* civilization of modern painting which began with French Impressionism does not belong either to the soul or to the language of the soul: it does not contemplate, but looks."[63] Following the same logic, Soviet criticism of the forties and fifties attacked major artists for "ideological indeterminacy", "a departure from the fundamental theme", and other mortal sins, asserting that "all this began with Impressionism".[64] "The liberated man," it was said, "has ceased to be the ecstatic, but often silent and inactive, observer of conditions of nature that are filled with poetic lyricism; he has become nature's tireless reconstructor and transformer."[65]

The two latter types, essentially a part of "theme painting" as a whole, were what totalitarian aesthetics understood by landscape painting. The evolution of this genre was determined by the varying ideological needs of different periods. In the first Munich exhibitions – as we have seen – 40 per cent of the exhibits were paintings of the motherland, and the people was seen as bound to the soil by the blood ties of biological and agricultural cycles. In Soviet exhibitions of the twenties and thirties there were very few such paintings. The acclaimed examples of the realistic landscape were Boris Iakovlev's "Transport Returns to Normal" (1923), Petr Kotov's "Furnace No. 1" (1934) and other similar *see p* works whose titles speak for themselves. After the War, however, a Stalin prize – admittedly, only second class – was awarded to Nikolai Romadin's series of landscapes "Volga – Russian River". Soviet criticism now required of artists the production of "good landscapes, which reveal the poetic riches of our nature", since "a contemplative landscape, a landscape-picture, educates our people, heightens its sense of cheer and joy and reinforces its love for the Motherland"; the image of Russia itself began to rival that of its transformation through socialist labour. In Nazi art, on the other hand, the industrial landscape grew more important after the beginning of the war. Judging by the reviews in *Art of the German Reich* of such theme exhibitions as "Art and Technology" (1942), they consisted almost entirely of depictions of blast-furnaces, smoking factory *see* chimneys, stone quarries and hurtling trains; and the works of the most important German practitioners of this genre – Franz Gerwin, Leonard Sandrock, Erich Mercker – were indistinguishable in style or iconography from the landscapes of Iakovlev and Kotov. In short, the evolution of the landscape obeyed the same laws and followed the same course as that of theme painting and genre painting.

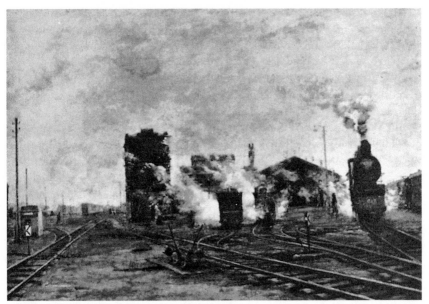

Iakovlev: Transport Returns to Normal (1923)

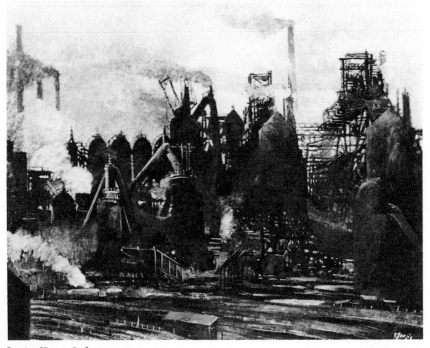

Jorzig: Heavy Industry

Nevertheless, until the end of the Stalin period, Socialist Realist ideology looked with a certain suspicion upon the growing importance of landscape painting. In 1952 the all-powerful Aleksandr Gerasimov warned: "There are some artists who are moving away from topical themes to landscapes or still lifes. I do not, of course, mean by this that we do not need still lifes at all, but in no circumstances should still lifes ... become a means of moving away from important themes of central importance to the present day."[66]

In European painting the still life since Cézanne had become a laboratory for the analysis of the inner essence of things; in Cubism and Futurism it had become almost the most important genre. Partly for this reason totalitarian aesthetics looked on it especially askance. Thus, in a review of the 1934 Venice Biennale, one Fascist critic noted with approval: "In the entire Russian pavilion I noticed only two still lifes – Soviet artists do not have the time to occupy themselves with such exercises."[67] This constitutes about 2 per cent of the exhibits. The number of still lifes at subsequent exhibitions, both German and Soviet, did not increase; if anything, it fell. And in the late forties there were an increasing see p number of attacks in the Soviet press on practitioners of this genre – Konchalovskii, for example, who painted apples and lilac that no one needed, diverting the consciousness of the masses from the urgent problems of the construction of socialist society. In the totalitarian hierarchy of genres it was the still life and the pure landscape – as opposed to its more ideological varieties – that occupied the lowest place.

There is one other theme whose position in the hierarchy of genres is different in the arts of the two countries. When Albert Speer arrived in 1942 in occupied Kiev, he was surprised by the sculptures of sportsmen in the city stadium, executed in the familiar realistic manner. It was not the similarity with Nazi work that surprised him, but the difference: the bodies of the Soviet athletes were modestly clad in bathing suits.[68]

There are very few representations of the naked body in the art of Stalinist Socialist Realism; in National Socialist art, on the other hand, it had a very esteemed role – in allegories and mythological compositions as well as straightforward studies of nudes. If one associates this genre with the traditional salon, set aside for the entertainment of hot-blooded Gauleiters from the Nazi elite, then one must conclude that ideology was less central to Nazi art than might otherwise appear. To those who deny the phenomenon of totalitarian culture, this difference is another argument for seeing Nazi and Soviet ideological systems as opposites.[69] The naked body, however, was in fact of no less importance to Nazi ideology than electric welders and female tractor drivers to that of Socialist Realism.

Hitler in his personal life was no lover of pornography, but one of the artists he valued most highly was a painter of nudes, Adolf Ziegler; and when the jury see p of one of the Munich exhibitions voted against P. M. Padua's erotic "Leda",

Hitler countermanded their decision. In this he appears to have been guided by *see p. 180*
(above)
ideological principles rather than personal tastes.

Racial ideology drew its arguments not only from anthropology and eth-
nography, but also from aesthetics; in particular, it derived the Nordic racial
type and the Aryan ideal of beauty from Winckelmann's theories of classical
harmony. The naked body in Nazi art bore the mark of this ideology, and among
countless Ledas, Danaes, Elements and Judgments of Paris we find a number of
paintings with such titles as "Peasant Venus" (Sepp Hilz), "A Peasant Grace"
(Oscar Martin-Amorbach), "Youth" (Wilhelm Hempfing), "Time of Maturity"
and "Rest while Gathering in the Harvest" (Johannes Beutner), etc. From the
point of view of Nazi aesthetics the naked body revealed someone's racial type;
from the point of view of Soviet aesthetics it hid his social essence. The two
ideologies were no less ideologies for being of different hues.

Nazi and Soviet theoreticians of art devoted much effort to establishing that
their aesthetic ideals were independent of all previous aesthetic categories. They
asserted, for example, that "all the abstractly-formalist norms that lay at the
basis of the classical ideals of the past are alien" (to the aesthetic ideal of Soviet
art).

> The ideal of Socialist Realism lies not in any artistic norm, but in the real,
> practical reconstruction of life ... Soviet art has no aims other than the aims
> of the people, no ideals other than those of the Bolshevik Party. This is why
> what appears most beautiful is the work which most fully expresses the struggle
> of peoples under the leadership of the Communist Party for the ideals of
> Communism, the work which is imbued with the spirit of Bolshevism and calls
> people to heroic achievements on behalf of their socialist Motherland.[70]

Robert Boettcher, the head of art education in Nazi Germany, asserted in similar
fashion that "art must not primarily be concerned with artistic form; formal
features cannot be the main factor in its development", and that it demands the
"deepest thought content" and that its function is to be a social cement.[71]

CHAPTER SEVEN

Architecture and Style

(i) Ideology in stone

We will erect the sanctuaries and symbols of a new and noble culture.

Adolf Hitler

Our task is the struggle to embody in the language of architecture the great slogans of our epoch.

From the conclusions of the All-Union Creative Conference of Architects, 1934.

When Hitler was once asked why he had not become an architect, he replied: "Because I decided instead to become the Architect of the Third Reich!"[1] In November 1934 – immediately after the establishment of the principles of Socialist Realism – the All-Union Congress of Soviet Architects greeted comrade Stalin as "the first architect and builder of our Socialist Motherland".[2] Neither Hitler's answer nor the architects' greeting were given thoughtlessly. In totalitarian thinking the task of scientifically constructing an advanced society and a new man was strongly associated with more ordinary processes of construction. "Never and nowhere has the word 'to build', expressing one of the fundamental needs of society, taken on such a deep and all-embracing meaning as in our country."[3] The ideal image of the future State was that of a splendid architectural construction that would endure for centuries. It may be for this reason that enormous attention was devoted in all the totalitarian countries to the development of architecture; a special role and function in the creation of the State were ascribed to it, and it was controlled in at least as centralized a manner as all other spheres of creativity.

Quite a lot is known about Hitler's direct intervention in architectural matters.[4] Not one important architectural project escaped the pencilled criticisms of this failed architect. He personally laid the foundation-stones of important buildings, and in speeches on the occasion of their opening he never missed a chance to develop his ideas about the enormous role of architecture in the spiritual life of the people.

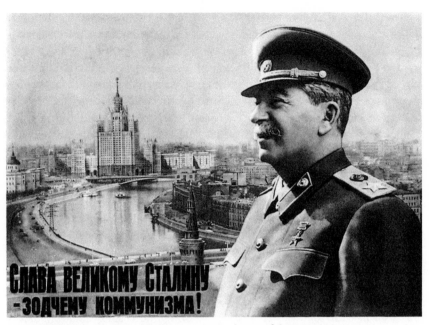

Russian poster: Long Live Great Stalin – the Architect of Communism

Stalin, on the other hand, preferred to remain in the background; the ideas behind all the more grandiose architectural projects were, nevertheless, attributed to him. "Stalin also attentively follows the course of development of Soviet architecture. As the initiator of such undertakings as the reconstruction of Moscow, the construction of the Moscow–Volga canal, the metro and the Palace of Soviets, he takes an exceptional interest in their architectural and artistic appearance. The general idea on which the replanning of Moscow is based belongs to Stalin."[5] It is hard to say how much he really was involved: contemporary sources obviously exaggerate, while later sources say nothing at all. All that can be said with certainty is that it was impossible for the construction of any important building or architectural project, at least within the bounds of Moscow, to begin without his signature on the design.*

* The incontrovertible authority of his signature is imprinted, is particular, on the exterior of the Hotel "Moscow", designed by Aleksei Shchusev and built in the years 1935–8: the left and right wing of one façade are very different, which, considering the predilection of totalitarian architecture for strict symmetry, looks somewhat strange. At one time a story went round Moscow to explain this. "Of this legend one could say that if it didn't exist, it would be necessary to invent it. The legend says that when Shchusev ... made the elevation for the façade, he divided it in half with a thin line, drawing one variant to the right and another to the left. According to one version Shchusev was never admitted to Stalin's office and was unable to explain about the two variants, Stalin then signed the design unthinkingly and it was impossible to deviate from what he had authorized. According to another version, Stalin understood abut the two variants and intentionally placed his signature exactly in the middle. One way or another, the hotel façade still surprises anyone who takes it into his head to compare the left and right halves, but the building is so vast against the scale of Moscow, that people who do not know the legend usually do not notice anything." (V. Papernii, *Culture "Two"*, Ardis, Ann Arbor, 1985, pp. III, 307.

The history of architecture in the totalitarian countries follows the same stages of development as any other sphere of art. The battle for the ideology of "popular" architecture began long before the establishment of Socialist Realism and the Principles of the Führer. In Germany the vanguard in this struggle was formed by the members of the Kampfbund Deutscher Architekter und Ingenieure, an offshoot of Rosenberg's League of Struggle for German Culture. In order to recover its former greatness – in their view – architecture should turn to the national heritage, place itself at the service of the people and State, and embody their ideals. Works of art and architecture "have a political-biological significance ..., which unfortunately is not recognized by anybody but the bolshevists",[6] wrote Schultze-Naumburg, an important figure in the Kampfbund, in 1930, at a time when the general outlines of Soviet cultural policy had ceased to be a mystery to the outside world. In Russia similar ideas were put forward from the end of the twenties by the right wing (Karo Alabian, Arkadii Mordvinov, Leonid Poliakov and others) of VOPRA, the All-Russian Organization of Proletarian Architects whose ideology was similar to that of the AKhRR. The main thrust of their campaigns was directed against modernist architecture, which was declared alien to the instinct of the race or the world-view of the class and was seen in both countries as a soul-destroying and cosmopolitan product of capitalist standardization. Attacks on cubes and flat roofs ("the children of an alien blood and other horizons"), and on "box architecture" (the attempts of capitalism to herd the proletariat into slums) appeared with equal frequency in both the Nazi and the Soviet press.

The battle for architecture, like the battle for art as a whole, came to a

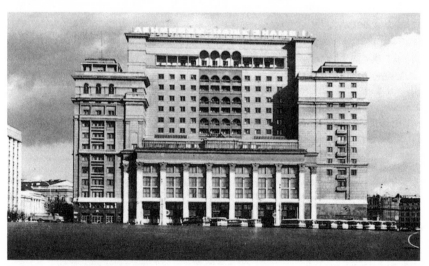

Hotel Moskva, Moscow (1935)

conclusion at almost the same time in both Russia and Germany. The 1932 Central Committee decree abolished all architectural organizations and groupings which had existed in the country during the twenties; and Nazis did the same on coming to power in 1933. Not long before this – and again almost simultaneously – the two main centres of contemporary architectural thought were abolished: VKhUTEIN (the former VKhUTEMAS) in the USSR and the Bauhaus in Germany. They were replaced by professional unions. In Germany all practising architects and builders were included in one of the chambers of Goebbels's Chamber of Culture; in the USSR they formed the Union of Soviet Architects, established in 1934. The Union's main organ, *Architecture of the USSR*, became the only periodical in the field. Meanwhile, architects who did not accept the "Principles of the Führer" began to emigrate from the Third Reich. Karl Mey, Walter Gropius, Erich Mendelsohn, Ludwig Mies van der Rohe and Otto Wagner all ended up abroad; Bruno Taut left for the Soviet Union in 1933, saw the reality of socialist architecture and asked to return; denied entry by the Nazis, he died on his way to Japan. The Soviet Union no longer allowed emigration, and the most important remaining representatives of the architectural avant-garde – Konstantin Melnikov, Ivan Leonidov, El Lissitzky, Vladimir Tatlin and others – took a vow of eternal silence. Like the other arts, architecture in both countries was subject to the principles of the Führer and of Socialist Realism, and its development was conditioned by the same factors: ideology, organization and terror.

"Every great period in history finds its final reflection in the value of its constructions,"[7] said Hitler, who, like the other totalitarian dictators, never for a moment doubted the greatness of his epoch. For this reason totalitarian architecture was required to be radically different from the architecture before it, engendered as it had been by a time of decline and decadence which "owe their origin and maintenance in a lesser or greater degree to the capitalistic interests of individuals" (Hitler).[8] The determining factor of the new architecture was to be its racial or popular character. "For the first time the people has become the only commissioner of [Soviet] architecture, its supreme judge";[9] for the same reason, according to Hitler, "the building created by the people as a whole must worthily represent those who commissioned it – the whole people".[10] What this commissioner and supreme judge required from architecture was not material conveniences and bourgeois comfort, but the glorification of the present epoch. Critics, theoreticians and ideologues held forth in the name of the people about the new architecture as "ideology in stone", "an embodiment of the most progressive world-view", "a stone chronicle of victories and achievements", "a political confession", etc. In a speech to the 1935 Party Congress in Nuremberg, Hitler formulated this principle with his usual rhetoric: "Yes, and even if the last living witnesses of such an unfortunate people have closed their mouths in death, then the stones will begin to speak."[11]

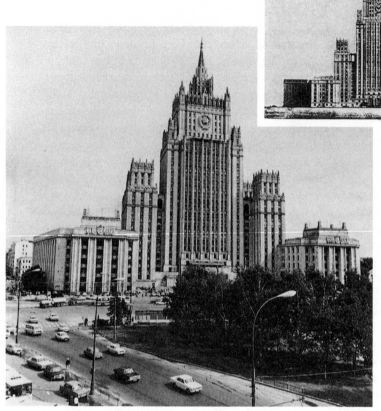

View of Smolenskaia Square and the building of the USSR Ministry of Foreign Affairs and the USSR Ministry of Foreign Trade and (above) the same building project, without the spire

In the Soviet Union the concept of "speaking architecture" came to be understood almost literally after the regulations of the Union of Soviet Architects had decreed that Socialist Realism, with its emphasis on "the reflection of reality in its revolutionary development", was the fundamental method of Soviet architecture as well. "Guided by the great ideas of Lenin-Stalin, architecture is called upon to reflect in its works the greatness of the epoch of the construction of Communism"[12] – this was the general directive followed by theory, criticism and practice alike. Thus, during the construction of the first skyscraper in Moscow – the Ministry of Foreign Affairs on Smolenskaia Square (1948–52) – the architects, Vladimir Gelfreikh and Mikhail Minkus, "held before them the task of reflecting in an artistic image the sense of pride of the Soviet people in their Socialist State which had crushed Fascism in battle and become still stronger and more powerful, their sense of pride in their socialist Motherland as the invincible stronghold of all progressive and freedom-loving humanity".[13] The Komsomolskaia-koltsevaia Moscow metro station received the highest praise and awards because the architect, Shchusev, had conceived the whole station, interior and exterior alike, with all its murals and ornamentation, as an illus-

Izmailovksaia Station,
Moscow Underground

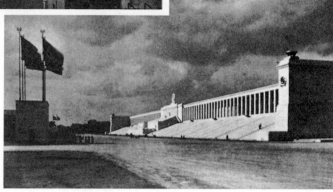

Speer: Reich Stadium,
Nüremberg

tration to Stalin's wartime speech about the great warriors of the Russian past. Serpukhovskaia metro station, on the other hand, built at the same time, was harshly criticized in the press on the grounds that "it did not tell of even one heroic event in the history of our people, did not immortalize it; it did not glorify either the beauty of the present day of the Soviet people or the greatness of its aspirations towards the Communist tomorrow".[14] Werner Rittich, an important Nazi ideologue of architecture, referred to Paul Troost's complex of Party buildings on the Munich Königplatz as "a symbol in stone of the philosophy of National Socialism, its greatness, its struggle for power and its final victory"; he also saw Speer's pavilion at the 1937 Paris exhibition as a "symbol of pride, strength and self-assurance" and his stadium in Nuremberg as a "symbol of greatness, strength and the significance of the Party principles".[15]

Stones spoke of the same thing, but in different ways. Firstly, while architecture in Italy, Germany and the USSR alike was orientated on national traditions, these traditions were not all of the same nature. Architecture arose within a historical complex and often – though not always – had to reckon with this. Secondly, each of the three countries wanted its image of the epoch's

271

grandeur to be unique. Hitler, for example, kept a jealous eye on the achieve-
ments of Stalinist architecture. According to Speer, "After the war with the
Soviet Union had begun, I now and then saw evidence that the idea of Moscow's
rival building had preyed on his mind more than he had been willing to admit.
'Now,' he once said, 'this will be the end of their building for good and all.'"[16]
The Führer was very worried when he learned that the Palace of Soviets was
to be higher than the building he was planning himself. "In the end he calmed
himself down with the thought that his building would still be unique: 'What
does one skyscraper more or less amount to, a little higher or a little lower? The
great thing about our building will be the dome!'"[17] The result of this adjustment
was Speer's plan for the Great Hall in the centre of the new Berlin, with the see p.
biggest dome in the world; its diameter was to be seven times greater than that
of Michelangelo's dome in Saint Peter's. When plans for the reconstruction of
Rome became known at the beginning of the thirties, the same spirit of rivalry
led to protests from among the Fascist elite against these "Germanic in spirit
architectural constructions"; people even said, "we do not want Bolshevik
architecture".[18]

Hitler, Mussolini, and Soviet theorists speaking in the name of Stalin all
proclaimed the principle of popular or mass architecture. With regard to ideology
this led in each country to one and the same conclusion: in the dark capitalist
past there had existed an unbridgeable divide between the unique dwellings of
the dominant classes and those of the ordinary people; now this division was to
be overcome. "First of all, in an increasing measure, there must be a rise in the
standard of architecture, a rise determined by mass construction: an increasing
significance is being attached to the countless objects [i.e. buildings] whose
construction formerly lay outside the bounds of architecture as an art." It was
considered that the dwellings constructed by capitalism "have for a long time
had nothing in common with architecture".[19] And Hitler for his part was
implying something similar when he said that "every building, large or small,
must now be considered first of all not as a part of our German riches, but as a
part of our German culture."[20]

Like that of many other words, the meaning of the word "*massovost*"* as
applied to architecture can only be understood within the context of totalitarian
language as a whole. It definitely did not mean the construction on a grand
scale of buildings that satisfied the needs of the masses. Hitler said more than
once that the characteristic features of the architecture of the past most worthy
of admiration were "not the grandeur of the houses of private citizens, but the
testimonies of social life which tower high above them". In 1935 he assigned a
concrete task to the architects of the Third Reich: "Unfortunately in bourgeois
ages the architectural development in public life was sacrificed to objects serving

*This has been translated hitherto as "mass" or "mass appeal". [*Translator's note*]

private capitalistic enterprise. The great task in the history of culture which lies before National Socialism consists above all in abandoning this tendency."[21] This capitalist tendency was combated still more determinedly by Stalinist architecture. "Mass" architecture was seen as a part of public architecture, serving society as a whole and expressing the high ideals of the collective. For this reason any construction, regardless of its practical purpose, began to be seen primarily as an aesthetic object: "Architecture is not simply a matter of putting up buildings in such a way as to make them solid; it belongs to the realm of the fine arts."[22] The entire sphere of totalitarian architecture became a part of high art and was therefore subject to artistic ideology. It was automatically included in the general system of values, and developed the same hierarchy and structure as any other realm of art.

As the multiplicity of phenomena were arranged according to a strict hierarchy of genres in representational art, so space was structured in a similarly hierarchic manner by architecture. A centre was chosen and all the remaining points, of varying social significance, were arranged round it. This at least is how town-planning was understood. "The leadership of a real national community must possess its leading local centre which is raised above all rival cities."[23] Hitler was thinking, of course, of Berlin – and as the capital not only of the Third Reich but of the new order in Europe. In June 1936 he showed Speer his plans for the reconstruction of Berlin and soon afterwards appointed him as chief architect for the project – supposedly to be completed in 1950. Hitler did not protest when Speer wrote three X's on the project instead of his own name: everyone would know who was the "anonymous" author.[24]

The architectural ambitions of the other totalitarian dictators were similar. Stalin called Moscow "a model for all the capitals of the world",[25] for the whole of progressive humanity. The general – or "Stalin" – plan for the reconstruction of Moscow was finally ratified, after many years of discussion, by a special decree of the Party Central Committee and the Soviet of People's Commissars in July 1935. And on 22 October 1934 Mussolini spoke in Rome before a large crowd to initiate the clearing of the old quarters where the new Fascist centre was to be erected.

The main city needed a centre, and this centre needed a main building, one which would provide a focus for the whole country and even – in the not distant future – for the entire world. This main building was therefore required in one way or another to surpass everything that had been built previously. In Moscow the Palace of Soviets, the highest building in the entire world, was to fulfil this role; in Berlin, the House of the People, with the biggest dome in the world. All other buildings were planned with reference to these ideological centres.

In 1939 work began on clearing the quarters of Berlin round the old Reichstag. The new Berlin was to be situated on either side of the boulevard see p. 369 running north from the Southern Station, itself intended to be larger than Grand

Central Station in New York. The vast station square – over a kilometre long and three hundred metres wide – was intended, according to Speer, to "stupefy travellers with the power of the Reich", and was to be crowned by a triumphal arch 110 metres high, the biggest in the world. On its surface Hitler intended to engrave the names of the 1.8 million who fell during the First World War. The boulevard was to be flanked by administrative and memorial buildings whose grandeur was to increase as one drew nearer to Adolf Hitler Square and its House of the People; more than 22 million cubic metres in volume, the latter could have contained several Washington Capitols. Its circular hall beneath the 300-metre dome was intended for gatherings of 150–800,000 people and was to be the centre for the celebration of the Nazi political liturgy. The original plan was that the building should be crowned by an eagle with a swastika in its claws, like the Nazi pavilion at the 1937 Paris exhibition, but Hitler introduced an ideological correction: "To crown this greatest building in the world the eagle must stand above the globe."[26] On bad days this eagle, gripping the world in its claws, would have been hidden behind the clouds. The annual First of May demonstrations, previously held in Tempelhof fields, were to pass before the House of the People, and by 1939 the Ministry of Propaganda had worked out a detailed scenario for them – "from the gathering of schoolchildren to cheer a foreign guest all the way to the mobilizing of millions of workers to express the will of the people".[27] According to Speer, the whole complex "expressed in the forms of architecture the political, military and economic might of Germany. At its centre was the absolute ruler of the Reich, and in close proximity to him, as the highest expression of his power, stood the vast building with the dome that was to be the dominant in the structure of the future Berlin. This plan was an expression of Hitler's saying: 'Berlin must change its face in order to adapt to its great new mission'."[28]

A similar mission was allotted to Moscow, and it too was required to change its face accordingly. The dominant in the structure of the future Moscow was to be the Palace of Soviets and a decree authorizing its construction was issued in February 1932. The largest church in Moscow – the Church of Christ the Saviour near the Kremlin – had been pulled down shortly before, and it was on this site that the stepped tower, 415 metres high and crowned by a 100-metre statue of Lenin, was to be erected. Taller than the recently constructed Empire State Building, it was to house the supreme organs of Soviet power and the apartments of the Leader. The main conference hall was, admittedly, smaller than Hitler's House of the People and had room for only 21,000 people; on the other hand, as many as 50 of the 6,000 halls and rooms were intended for ceremonial occasions. The main architect was Boris Iofan, later to be Speer's rival at the 1937 exhibition in Paris, but the general idea behind the Palace was ascribed to Stalin. Sceptics pointed out that in bad weather Lenin's head and outstretched hand would be hidden behind the clouds, but this failed to diminish

see p
(belc

the general enthusiasm. An entire large institute worked on the project for many years, until the beginning of the fifties. A vast foundation pit was dug on the site of the church, and the press never tired of describing the future grandeur of a construction which was to contain 17,500 square metres of oil painting, 12,000 of frescoes, 4,000 of mosaics, 20,000 of bas-reliefs, 12 group sculptures up to 12 metres high, 170 sculptures up to 6 metres high, and so on. Both the architecture as a whole and the symbolism of the decor were intended to express the power of the Country of Victorious Socialism.

Nothing of either the Palace of Soviets or the House of the People was ever constructed. Nevertheless, much of what remained on Nazi drawing-boards was realized in the post-war architecture of Stalinism.

According to official Soviet data, 1,700 cities and towns and over 70,000 villages in the territory of the Soviet Union were destroyed during the war. Moscow itself suffered considerably less than most cities; nevertheless, it was the "Stalin" plan for the reconstruction of Moscow that absorbed most of the country's creative energies and resources. The intoxication of victory led to plans that were still more grandiose, also ascribed to Stalin. Eight high-rise buildings were planned – and seven built – on the intersections of the main radial routes with the Sadovoe Koltso ring road and the Moscow river. Each exemplified the new type of Stalinist architecture, and as a whole they constituted a single spatial structure focused on the capital's ideological centres – the silhouettes of the Kremlin and of the future Palace of Soviets.

The Ministry of Foreign Affairs, the first of these buildings to be completed, *see p. 270* was required, as we have seen, to reflect the "sense of pride of the Soviet people in their Socialist State". This idea was embodied in an imposing series of blocks of increasing size: four six-floor blocks, followed by four fifteen-floor towers, followed by a central twenty-seven-floor tower crowned by an octagonal turret which was in turn crowned by a huge spire. A similar pattern was followed in the construction of the other high-rise buildings: the vast Moscow University complex on the Lenin hills, the Leningradskaia and Ukraina hotels, the blocks of flats on Kotelnicheskaia quay and others. Their spires framed those of the Kremlin, considerably exceeding them in height, and the most important building, crowned by the cyclopean figure of Lenin, was to stand at the centre.

Not only the capital but also every other city had its clearly defined position in the totalitarian hierarchy of space. The second city in Germany was Munich, "the capital of the Nazi movement" and the centre of German culture; then came Nuremberg, "the city of Party Congresses"; then Graz, "the city of the People's Revolution", and Hamburg, "the city of foreign trade". In the USSR Moscow was followed by Leningrad, "the cradle of the Revolution", and then by the capitals of the various republics in order of importance – Kiev, Minsk, Tbilisi, Yerevan, etc. Certain quite remote towns acquired a special importance thanks to their position in the social hierarchy of space: Linz, which was linked

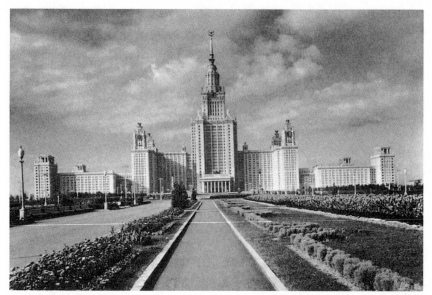

Moscow State University

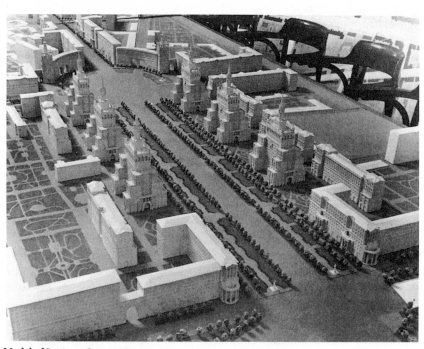

Model of Lusinov Street, Moscow

to the name of Hitler; Ulianovsk (formerly Simbirsk), the birthplace of Lenin; Stalingrad, the "hero-city", and so on. The significance of each city was to be revealed by its architecture.

Governmental decrees issued during the war on the reconstruction of ruined cities emphasized the "necessity of their being replanned"; this, to all intents and purposes, meant the construction on their sites of something entirely new, "socialist in content and national in form".* The ideal was a system of broad boulevards, framed by imposing architecture and leading from a ring of symmetrical high-rise buildings towards a central, government or Party, high-rise building with a spire; modelled on high-rise buildings in Moscow, this central building was always the highest in the city. The height of the buildings and the richness of their finish depended on the significance of the particular town or city; they did, however, always echo the towers of the Kremlin, thousands of kilometres distant though these often were. The central tower with its figure of the Leader was a prerogative of Moscow.

Goebbels, after talking in July 1941 to some German soldiers who had been in Russia, noted in his diary that their confidence in victory over Bolshevism went together with admiration of the power of its ideological architecture: "they are astonished at the big Party buildings that the Soviets have built even in the villages. Ley, so they say, ought to do the same here some time. Well, that time will come!"[29] For the Third Reich the time never came; its ruined cities were restored under a different kind of regime, in West, if not in East, Germany. But there is evidence in plenty that similar town-planning schemes passed through Hitler's head. Before the War, during a visit to Augsburg, the Führer once outlined his ideas on architecture to Speer over coffee and strudels in a café.

> "I have been looking at the map of the city," he began. "If we tear down the tumble-down houses in the Old Town, we will have room enough for a grand boulevard. Fifty meters wide and more than a kilometer long. Then we will also have a connection with the railroad station and relieve the traffic on medieval Maximilianstrasse. And at the end there'll be a new Party Headquarters. That will then form the core of the new Augsburg forum. There'll have to be a tower also, to crown the whole. How high is the tallest tower in Augsburg, now, Wahl?" The Gauleiter threw a look of embarrassment at the mayor, who turned for help to the city architect, who finally, after some cogitation, gave a figure. Hitler added twenty meters, saying that in any case the new tower must be higher than the tallest church steeple in the city ... Just as, in the Middle Ages, the cathedrals had towered over the homes and warehouses of the burghers, so the Party buildings must surpass modern office buildings.[30]

The spirit of a legend recounted by V. Papernii is very similar:

> It is known that many of the initial designs of the skyscrapers were without

*Thus, the basis of the general plan for the reconstruction and development of old Minsk was the radial- and ring-road plan, quite uncharacteristic of this city, that was adopted for Moscow. A similar fate befell Stalingrad (the former Tsaritsin and present-day Volgograd), Kalinin (the former Tver), Rostov-on-Don, and other cities.

spires. There is a widely current oral myth that Stalin went to look at the
completed skyscraper on Smolenskaia Square designed by Gelfreikh and Minkus.
"Where's the spire?" asked Stalin. A spire was designed and prepared – in the
course of a day according to one version, in the course of a week according to
another, in the course of a month according to a third. If this is true, it means
that the man who stood on the highest rung in the hierarchy of culture
turned out to be more sensitive to the spatial expression of this structure than
professional architects.[31]

This last point is very true: Stalin and Hitler did not simply express their
personal tastes; what spoke through their lips was the soul of totalitarian culture.

The high-rise buildings of the late Stalinist period appear at first sight to be
very different from the neo-classical buildings constructed in both Germany and
Russia before the war. This difference is symptomatic of a change in Soviet
cultural policy as a whole.

The art and architecture of Socialist Realism proclaimed itself from the very
beginning to be the legitimate heir of the universal cultural tradition, and in
particular of classical antiquity. Lunacharskii, for example, advised the designers
of the Palace of Soviets "to base themselves to a much greater degree on
classical architecture than on bourgeois architecture – or more precisely, on the
achievements of Greek architecture".[32] From the human harmony of scale of
the Greek temples it was a natural progression to the more soldierly triumphal
arches of ancient Rome, and at the First Congress of Architects in 1934 Shchusev
stated: "The public and utilitarian buildings of ancient Rome are in their scale
and artistic quality a unique phenomenon in the whole of world architecture.
In this area *we alone are the direct heirs of Rome*, only in socialist society and with
the help of socialist technology is construction possible on a still greater scale
and of still greater artistic perfection."[33] Shchusev was evidently unaware that
he was repeating, almost word for word, ideas about Rome put forward many
times by Hitler – "... clarity, greatness, monumentality. The most wonderful
republic in history ..."[34] – and that the architecture of the Third Reich had
already laid claim to the position of heir to ancient Rome. In any case a system
of orders, porticoes and pediments, temple friezes, sarcophagus bas-reliefs, and
Renaissance caissons was an essential element of architectural finish; in both
countries endless colonnades adorned the façades of the main buildings – from
Speer's Nuremberg stadium to the Lenin Library in Moscow, from the plans for
the House of the Soldier in Berlin to the State theatres in Novosibirsk, Minsk,
Sochi, Alma-Ata and many other cities. In Germany the main proponent of the
neo-classical style, before Speer, was Paul Troost, who designed the House of
German Art in Munich and is considered to have exerted a powerful influence
on Hitler's own architectural tastes; in Russia these ideas were championed by
Ivan Zholtovskii, the architect of the first neo-classical building in Moscow
(1934) and supposedly a personal adviser to Stalin on architectural matters.

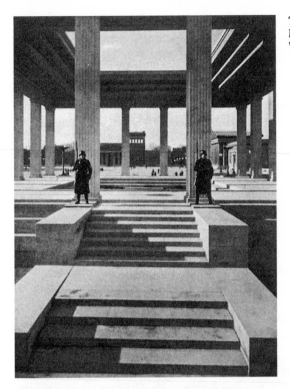

Troost: Hitler *Putsch* Memorial, "Eternal Watch", Munich

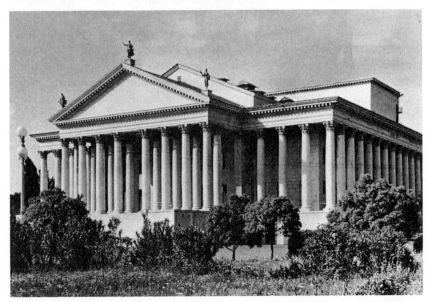

The Theatre in Sochi (1938)

The construction of high-rise buildings, however, began during the patriotic fervour of the struggle against cosmopolitanism, a time when the obligatory source of inspiration for artists and architects lay in national tradition. Soviet architectural theory now saw high-rise buildings as a continuation and development of the central tradition of Old-Russian architecture; the spires were more or less exact copies of the tops of the Kremlin towers and seventeenth-century Moscow tent churches. Classical and Renaissance façades were replaced by cartouches, coats of arms, turrets, Kremlin merlons and palisades of spires. In its search for the grandiose, totalitarian architecture borrowed from the most varied periods and cultures, drawing inspiration from the monumentality of the Egyptian pyramids, the capriciousness of Babylonian ziggurats, the splendour of European baroque and the eclectic synthesis of all these elements in the architecture of the nineteenth century. Consciously or otherwise, it followed both Hitler's advice that it was "better to imitate something good, than to produce something new but bad"[35] and the principle adhered to by Speer in his own work: "An indisputably original style can arise out of the combination of various historical elements."[36] The centre of stylistic gravity of Soviet architecture "shifted first from Greece to Rome, remained for some time in Rome ... and then, moving first to the East, began to draw nearer and nearer to Moscow. The path to the culmination of history now appeared to lie through the past of Russia."[37] The spirit of totalitarianism, while consciously striving towards the strict forms of classical architecture, was somehow fated to be dissipated into a showy and eclectic "baroque". Its main buildings thus became strange hybrids of the architecture of palace, church and fortress.

For all the talk about the unsurpassed value of their national monuments, the totalitarian regimes were in practice only too ready to destroy them. Hitler justified the destruction of old Berlin on the grounds that "its monuments had not the same significance and beauty of form as those of other cities of the Reich",[38] and in 1941 he said it would be no great loss if English bombs destroyed the German capital.[39] Mussolini's Via dell'Imperio and other boulevards ripped through the old centre of the capital in order to create a new "monumental centre, truly worthy of the greatest artistic traditions of ancient Rome and its imperial future". It was built on the site of hundreds of demolished buildings, including unique Renaissance and Baroque monuments which Mussolini dismissed en bloc as "picturesque local colouring".[40] As for the Soviet capital, Loveiko, then its chief architect, noted with satisfaction in 1957 that "today one can bring back to mind the image of old Moscow only through old photographs and archive material".[41] The national past was always readily sacrificed to the grandeur of a present that was to endure for ever. As Hitler said:

> The small needs of daily life, they have changed through the millennia and they will continue to change eternally. But the great evidences of human civilization in granite and marble they stand through the millennia, and they

alone are a truly stable pole in the flux of all other phenomena ... Therefore these buildings of ours should not be conceived for the year 1940, no, not for the year 2000, but like the cathedrals of our past they shall stretch into the millennia of the future.[42]

"I am building for eternity,"[43] he repeated as he laid the foundations of the House of German Art – and this ambition can be considered typical of totalitarian architecture as a whole. In a speech at the First Congress of Architects, for example, G. Krasin, the deputy head of work on the Palace of Soviets, proposed the same task: "This edifice must not only be built to last for a determined period, it must be long-lived for ever, just like the long-lasting idea of constructing our whole society for ever".[44] Speer developed this cult of eternity in his theory of the "value of ruins", which he applied in his own work. "By using special materials and by applying certain principles of statics," he wrote, "we should be able to build structures which even in a state of decay, after hundreds or (such were our reckonings) thousands of years would more or less resemble Roman models."[45]

If Speer's projects had been executed, they would have been "the most grandiose state structures since the time of the Pyramids".[46] To this one must add: if the projects of Iofan, Gelfreikh and other Stalinist architects had not been realized. The cults of eternity and of vastness went together. The dimensions of this kind of architecture, rather than being based on the individual, were calculated from some super-personal point of view. It would have been impossible, for example, for anyone standing on earth to grasp the harmony of the symmetrical silhouettes, kilometres apart, in the new centres of Berlin and Moscow, just as it was impossible to understand the spatial symbolism behind the construction of certain individual buildings.* The increase in scale from year to year was rivalled by the ever-growing splendour of the decor, and in 1938 the journal *Architecture of the USSR* noted with pride that, while the average station on the first line of the Moscow metro had required 1,700 cubic metres of marble, the average station on the second line had used as much as 2,500 cubic metres.[47] In the last metro stations of the Stalin period, the ground-level booking halls, intended only for passengers to pay their five kopeks and walk to the escalator, were twelve to fourteen metres high and eight to ten times greater in volume than in the first stations.

It was on the construction of these "palaces for the people", these "places of national glory" and "symbols and sanctuaries of the new culture", that resources were expended, and it was their architects – Troost, Speer and Gleyzer in Germany, Iofan, Shchusev, Gelfreikh and Zholtovskii in the USSR – who were the most important figures in the cultural establishments of these regimes. The

* A classic example of this "invisible" architecture is the Red Army Theatre in Moscow, built in 1940 in the shape of a five-pointed star. It was said that when the architects came to Kaganovich for advice, he simply placed his inkpot on the drawing paper, draw a pencil line round it and said: "Build it like this."

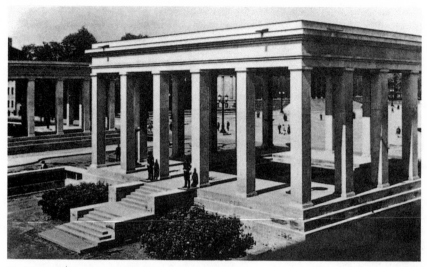

Troost: Hitler *Putsch* Memorial, "Eternal Watch", Munich

supreme achievements were considered to be such monuments of ideological architecture as the Lenin Mausoleum in Red Square and "The Eternal Watch" (the Memorial to the Fallen in Hitler's 1923 *putsch*) on Königplatz in Munich, the Ministry of Foreign Affairs in Moscow and Goering's Ministry of Aviation in Berlin, the Moscow metro and the House of German Art, Hitler's Reich Chancellory and the House of the Soviet of Ministers of the USSR, together with countless other gathering-places, stadiums, monuments and memorials – not to mention the projected Palace of Soviets and House of the People.[48] Considerable attention was also devoted in both countries to the construction of theatres; these combined the function of "guardians of the eternal tradition" with (at least initially) that of a site where the main political events and anniversaries could be celebrated. It was in such eternal and monumental forms that the spirit of totalitarian culture soared highest and breathed most freely; other realms of architecture, such as blocks of flats or industrial buildings, were considered increasingly peripheral in proportion to their lack of ideological function. Even this realm, however, had its centre and its periphery, its representative and its utilitarian architecture.

Goering's private residence was built by Speer in the form of the Pitti Palace in Florence and with baroque interiors. Other Party bosses built their dwellings in a similarly pretentious style. As early as the thirties new main roads in Moscow had been lined by splendid and showily decorated façades. By the end of the forties the cost of the external finish of such buildings was as much as 30 per cent of the overall figure, and the countless turrets, spires, arches, sculptures and entrance halls reduced to a minimum the proportion of useful space and

made some of the rooms far from practical for everyday living – even though they were inhabited by people considerably more eminent than the members of the working class who were supposedly the true masters of these "palaces of the people". The standard of construction was so low that immediately after their completion metal gratings had to be installed on the façades at the level of the first floor, in order to protect passers-by from falling ceramic tiles and other pieces of decoration. If Hitler had managed to realize his plans for the reconstruction of Berlin, one can assume that its main roads would have been adorned by similar façades.

All these developments took place in the USSR in spite of a housing crisis of colossal dimensions. The general plans for the reconstruction of Moscow, the first of which was ratified in 1922, as well as those for other cities, called for the demolition of an enormous number of houses; at the same time resources for restoration, major repairs and improvements were held back for decades. The official norm was four square metres of living space per head, but very few people enjoyed even this. Most of the town population lived in communal flats with three to five people in one small room, and five to ten rooms for each kitchen and washroom. The need of ordinary people for elementary comforts was considered by totalitarianism to be one of "the small changing needs of everyday life" that were so insignificant before the face of eternity.

The difference between ideological and utilitarian architecture was drawn very clearly. Once, as they looked at the 300-metre-long reinforced-concrete façade of the Krupp factory in Essen, Hitler said to Speer: "What you have here are different requirements from those governing a Party forum. There our Doric style is the expression of the New Order; here, the technical solution is the appropriate thing."[49] And Rittich said in similar fashion: "For such buildings the only condition is the provision of maximum productive efficiency."[50] For all its frenzied campaign against flat roofs and reinforced-concrete boxes, totalitarianism quietly accepted the use of these "bourgeois" forms for housing and industrial buildings. Such glass and steel industrial buildings as those of the AEG (the All-German Electrical Company), designed by the modernist Peter Behrens,* or the aviation research centre designed by Brenner and Deichman, were little different from the much-abused products of the Bauhaus. And in 1933 the "Bureau for the Beauty of Labour" was set up under the auspices of "Strength through Joy"; its slogan was "The Everyday Life of Germany must become Beautiful!" and its role was to re-equip old factories according to modern principles of simplicity and rationality and to organize the leisure of the workers. Speer, appointed head of the Bureau, made an agreement with the Imperial Chamber of Culture about the secondment of artists, architects and designers to re-plan shop floors in a contemporary manner and to organize workers' clubs,

* It is worthy of note that Behrens remained head of the department of architecture of the Prussian Academy throughout the Nazi regime.

stadiums, small parks, etc. – so that labour, which had previously been reduced to a "joyless compulsion", would take on "a new spirit".[51] The Bureau inspected over 67,000 factories and many of its plans were realized. Hitler, who had said that "in the future there will be only one more nobility – the nobility of labour", saw the work of the Bureau as showing the "palpability of the socialist idea".[52] In 1939, however, the activities of the Bureau were severely curtailed, and soon afterwards it was closed down.

In the USSR industrial and administrative buildings were still being constructed in the contemporary style throughout the thirties; the model Stalin Factory Palace of Culture (1932–7) by the Vesnin brothers and the industrial complex of the newspaper *Pravda* by Golosov are two examples. In 1936 it was still possible for Le Corbusier to win a competition and design the Ministry of Light Industry on one of the main streets in Moscow. The age, however, dictated its laws even more implacably than in Germany; ideology steadily infringed even on this, peripheral, area of architecture.

In the thirties such purely functional constructions as the Drieper Hydroelectric Station were still hailed as models of Soviet architecture; in the postwar period, however, this role was allotted to the Volga–Don canal complex, opened see p in June 1952. Constructed in record time, at huge expense, and with the help of a vast amount of forced labour, this complex was intended as an "architectural monument to the socialist epoch and its architect – I. V. Stalin". Each of the thirteen sluices was constructed in the shape of a triumphal gate or arch, richly adorned with reliefs and crowned by large sculptural compositions; the engineering buildings imitated the palace architecture of the Empire; and the approach to the complex was dominated by cyclopean sculptures of Stalin ... As for more practical concerns such as housing, the position became so grave that a criticism of Stalinist architecture appeared in the very first issue of *Architecture of the USSR* after Stalin's death (March 1953); under Khrushchev this criticism was to develop into the important "campaign of struggle against architectural excesses". It is to the facts which percolated into the Soviet press from 1953 to 1956 during this campaign that we owe most of our understanding about the reality of Stalinist building. In 1955, for example, *Architecture of the USSR* revealed that "in Stalino and Makeevka [the most important Soviet coalmining centres] only the central regions have been provided with sewers, while the majority of the mining settlements with houses of two or three storeys have no sewers at all".[53] The realms of architectural and industrial design, like those of genetics, cybernetics and relativity theory, were declared under Stalin to be "bourgeois pseudo-sciences" and were rehabilitated only at the beginning of the sixties.

Throughout the territory of the totalitarian States and for the duration of the regimes many diverse kinds of building were built. Successful Nazis were able to have houses built for themselves in the Old-German spirit or in the style

of the latest innovations of the avant-garde; forgotten by everyone, Konstantin Melnikov realized his avant-garde dreams in the design of his own round house in Moscow; Mussolini took into account the lessons of functionalism when he planned new Fascist cities; everywhere workers' barracks and concrete factory blocks were constructed in which one could, if one wished, see a continuation of the tradition of modernist architecture. All this could have been built anywhere. Totalitarian architecture, however, is represented not by any of this, but by what the regimes themselves saw as the most complete expression of their ideology, power and expansionism and so considered to be their greatest achievements. Architecture of this kind was not and could not have been built anywhere else in the twentieth century.

Its grandeur was not the result of the creativity of individual geniuses, but the product of a machine fuelled by ideological slogans. Albert Speer, sentenced at Nuremberg for his use of forced labour on building sites and factories, devoted a lot of thought during his twenty years in Spandau to the value of what he had built. He compared his own projects and constructions with the Moscow University complex and the reconstruction work then being undertaken in East Berlin and was unable to come to any conclusion. But when, after his release, he saw his own drawings, models and photographs, he realized how incomplete his grandiose projects had been, how pedantic, timid and dry his drawing of details. "During my imprisonment, this design ... had assumed in my memory a bright, almost pleasant character. But when I once again saw the colour photographs of the model after a lapse of more than twenty-one years, I ... became aware of the cruel element in this architecture. It had been the very expression of a tyranny."[54] If Iofan had been in Speer's place, he might very well have come to a similar conclusion.

If representational art reflected the visible features of the bright future in images, architecture showed us this future become reality. Thus, when he began a vast programme of house-building after Stalin's death, Khrushchev announced to the world that "it is in these houses now being built that the people of the Communist future will live".[55] Under all totalitarian regimes architecture was seen as a synthesis, uniting all branches of art and intended to determine the style even of the art of the distant future. As in the "epoch of the pyramids", it embodied ideology in a form intended to endure for centuries. Nevertheless its stylistic eclecticism is obvious, as is the fact that it was orientated on the past more than the future; equally obvious is the difference between the national traditions drawn on by each totalitarian culture. All this must make one question once again whether it is possible to speak of totalitarian art as a phenomenon of the culture of our time. Can the art of the various totalitarian regimes truly be seen as a whole, as a single phenomenon with a common ideology, structure

and style, or did each regime create its own distinct variant? And if one can see totalitarian art as a single entity, then is it the fruit of revolution or of restoration, that is, was it constructed according to some new model, or was it a reiteration of what had gone before?

(ii) Restoration or revolution?

> In a certain sense National Socialism did produce its own art, but a close examination of it will reveal nothing except a repetition of the principles of the nineteenth century, a sterotyped imitation of external nature mingled with declamatory pathos. It is strange how similar National Socialism and Bolshevism are in this respect, for all their mutual hatred.
>
> Franz Roh

Totalitarian culture had resurrected the division of art into various genres, but it sensed the inadequacy of a visual image divided into different thematic units. For this reason the place of honour in totalitarian aesthetics, at least in its Soviet variant, was allotted to the more general concept of the "theme painting", which, according to official historians, "strives to affirm a new content in life" which "the old art had not known".[56] This concept embraced all genres, even the landscape and the still life, provided they were endowed with ideological content. National Socialist art did not itself use this term, but there is no doubt that it placed an equal emphasis on ideological content and drew the same contrast between ideological art and "pure art" or "art for art's sake".

Anything depicted in accord with these requirements became a part of the whole and acquired meaning and beauty in so far as it partook of the exalted values of the political doctrine. A portrayal of a working family listening to the wireless became the highly ideological theme-painting "The Führer Speaks", see and the gay animation of a gang of small boys on the street was explained by the title "They Saw Stalin" (Dmitrii Mochalskii). A simple landscape became "German Earth" (Werner Peiner), "Liberated Earth" (F. Kauselbach), "Fertile Earth" (G. Vastaieev, "Kolkhoz Earth" or "The Spaces of Our Fatherland" (Nikolai Romadin), a place where "Transport Returns to Normal" (Boris Iakovlev), a source of "Marble for the Reich Chancellory" (Erich Mercker) or of stone see p for "Stalin's Building Sites", or a site for "The Highroads of the Führer" (Karl (mi Theodor Protzen).

Genre paintings of scenes of labour or leisure acquired an allegorical meaning through such titles as "Blood and Soil" (Erich Erler), "Bread" (Tatiana Iablon- see p skaia), "Kolkhoz Harvest" (Sergei Gerasimov) and "Bastions of Our Time" (R. (bel Gessner). Portraits of actual people were transformed into generalized images of "The Woman Delegate" or "The Chairwoman" (Georgii Riazhskii), "Boy from see p the Hitler Youth" (Emil Dielmann), "Girl from the Hitler Youth" (E. Schmitt), 358 355

see p

"German Peasant" (G. Tabert), "Komsomol Girl", "Steel-Worker", "Soldier", etc. Even a mere still life could become a quotation from Stalin's speech about the joys of kolkhoz life ("The Fruits of Kolkhoz Abundance" by Iakovlev) or serve as an illustration to Hitler's remark that the Germans were a "nation of soldiers and artists" (Hugo Zimmermann's "Leisure" where a violin and a helmet *see p. 362* side by side on a table symbolize the spiritual kinship of poetry and war). At the same time, paintings with apparently neutral titles and subject-matter were stamped with ideological signs: a banner with a swastika fluttered over Eduard Handel-Mazzetti's "Mountain Landscape", a scene of peaceful peasant labour was depicted with a damaged French tank in the background (Eduard Thöny), while the everyday life of Soviet soldiers was given the poetic title "The Larks are Singing" (P. Zhigimont). In theme paintings of this kind the text, i.e. the subject depicted, was deeply immersed in the ideological sub-text; the latter was the true content of the text, subsuming it within a generally joyful and heroic picture of life. As the German historian Richard Grunberger remarked of one of the Munich exhibitions: "Every single painting on display projected either soulful elevation or challenging heroism ... All the work exhibited transmitted the impression of an intact life from which the stresses and problems of modern existence were entirely absent."[57]

It is difficult, and perhaps impossible, to estimate the exact quantity of what in the USSR was called "theme art". The 1952 All-Union touring exhibition,[58] the last under the Stalin regime, consisted of 160 paintings and sculptures. If one adds together the paintings on revolutionary and historical themes, the portraits of the Leaders and other important figures (laureates, peoples' artists, heroes of labour, etc.), and the ideological genre paintings and landscapes, then the total comes to 123, more than three-quarters of the exhibits. This figure probably under-represents the actual importance of theme art: the "ideologically neutral" section of this exhibition consisted of small china statues, minor sculptures and decorative figures of animals; the paintings consisted mainly of landscapes by artists from the various national republics. These were of little importance beside the vast canvases and sculptures that made up the rest of the exhibition.

In his book *Art under a Dictatorship* H. Lehmann-Haupt arrives at similar figures for Nazi Germany. According to his data the degree of "corruption", i.e. of subordination to ideology, in National Socialist art can be seen in approximate percentages: 80–90 per cent with regard to painting, 70–80 per cent with regard to sculpture, 40–60 per cent with regard to architecture and 20–30 per cent with regard to the applied arts.[59] It must be borne in mind, however, that the German exhibitions included a large number of traditional landscapes in the style of the preceding century, peasant scenes that did not always include sunshine and smiles, and family scenes indoors that did not always take place beneath a portrait of the Führer.

"The eternal values", "the natural laws", and "the timeless order of things", seen by Nazism as the basis of the life of the people, included human existence in the natural, biological cycle. The sower, the peasant behind the plough, the family eating a traditional meal, the nude – all these themes were quite acceptable and in fact constituted the periphery of official art. This periphery did, however, grow narrower with time, and in 1942 Rittich noted with satisfaction the increasing role at the Munich exhibitions played by works with a broad social content and which had been executed in accord with State commissions; he explained this by the "social reorganization in our time of artistic life".[60] In Germany, as in the USSR, the centre was encroaching on the periphery and it may well be that all art, without exception, was eventually imbued with ideology.

In this light the restoration in totalitarian art of the style of the preceding century seems revolutionary enough. Totalitarian art may indeed have resurrected a hierarchy of genres fixed by the European academies at the dawn of their existence – with representative architecture, monumental sculpture, the official portrait and the historical composition at the centre and genre painting, utilitarian building, the landscape and the still life on the periphery. Nevertheless, for all the apparent similarity between total realism and its historical prototype, the inner structure of the former reflected very different social and ideological realities.

In the first place, by the mid-nineteenth century the strict academic hierarchy of genres had already begun to fall apart. The landscape painter Caspar David Friedrich, for example, is far more important in German painting than any of the historical painters of his time, and Repin is certainly not remembered in Russian art for his portraits of the Tsar's family. In totalitarian art, on the other hand, the importance of the artist was always defined by the importance of the genres in which he worked.

In the second place, while restoring the structure of genres, totalitarian art tended to erase the boundaries between them. As we have seen, the ceremonial portrait became a cult object, subjects from contemporary life suddenly turned into historical compositions, still lifes turned into political allegories, and so on. This monolithic quality, this ideological integration, this fusion of aesthetics and politics, was equally unknown to the nineteenth century, with its eclecticism and its exaggerated emphasis on creative individuality, and to the licentious and sceptical eighteenth century. It was, however, known to more distant centuries.

Every revolutionary movement, in both politics and culture, however fiercely it repudiates the preceding era, must have some kind of historical example before its eyes. An absolute denial of the past is possible only during the early stages of revolutionary movements, only in the name of an unrealizable utopia: Kazimir Malevich and Antonio Sant'Elia certainly did not see their projects for flying cities as capable of immediate realization. As soon as a utopia begins to seem in

any way practicable, its apostles look back, searching in the past for a confirmation of the grandeur of what is to come. This is what happened with Italian Futurism and – somewhat differently – with the Russian avant-garde. And in Germany after November 1918 the most revolutionary artists and architects demanded a united effort to construct a just social order, a "new community" and even a "new totalism" (Gropius's phrase); to achieve all this it was considered necessary to build a bridge to "the golden age of cathedrals".[61] "A completed building is the final aim of all the plastic arts", stated the first Bauhaus manifesto. "Let us create a new guild of craft without the class differences which erect a barrier of arrogance between the craftsman and the artist. Let us plan together a new building of the future, which will unite architecture, sculpture and painting into one whole and which one day will rise towards the heavens from the hands of millions of workers, like a crystal symbol of a new destiny."[62] The architect himself, according to Bruno Taut, was to be a "social priest"; immersing himself in the "collective soul of the people", he was to learn of its spiritual needs before it knew them itself.[63] The emblem of the Bauhaus – Feininger's Expressionist drawing of a cathedral rising towards the stars – embodied these upward aspirations of the German avant-garde.

It was this longing for an integral view of the world, for collectivism, for the establishment of a single style in culture and life, that totalitarianism found most valuable in the heritage of the revolutionary movements. The sources of totalitarian culture lie equally in the "revolutionary" ideas of the nineteenth century, for which it professed such admiration, and in the "retrospective" aspects of the contemporary avant-garde, which it crushed so harshly.

(iii) "To the golden age of the cathedrals"

One's political position is not one position among many
others. It must form the basis for one's attitude towards
life as a whole.

<div align="right">Hitler</div>

Only by evaluating all the phenomena of life and all its
events in the light of the tasks and aims of Communism,
in the light of the struggle of the Soviet people to construct
a Communist society, can the artist ideologically justify
his high calling as an artist of a socialist society, an artist
of a new type, a standard-bearer of the Soviet people.

<div align="right">*Iskusstvo*, 1949</div>

It might seem absurd to speak of the style of a culture which itself professed eclecticism and constructed its monolith from fragments of the past. Innovation and originality, however, are far from being the most important feature of a

major style. In both ideology and culture old bricks have often turned out to be more solid and reliable than new.

From the point of view of the totalitarian ideologies it was Western culture, divided into countless "isms", in thrall to ephemeral fashion, contemptuous of "eternal values", which had condemned itself to a stupefying lack of style. "Democracy," said Mussolini, "deprives the life of the people of its 'style': of a definite line of conduct, of brilliance, strength, and picturesqueness, of elements of the unforeseen and miraculous, in short of everything that relates to the soul of the people."[64] Hitler himself avoided the word "style" and sometimes even denied the necessity for it in National Socialist art; he understood style, of course, very superficially – as an aggregate of ready-made formal devices. The aesthetics of the Third Reich echoed these views: "For us there does not exist a question of contemporary style; the only thing which has significance is the inner position of the architect and the character of his works ... All genuine works of German architecture ... embody the deep spiritual values of the contemporary political and social doctrine and philosophy of life."[65] The concept of style was equally secondary in Soviet aesthetics – Socialist Realism was officially designated not a style, but a creative method – and the same integral view of the world was required: "To us it is now absolutely obvious that what is meant when we talk of the progressive and popular spirit of our art is not only a matter of particular themes. ...; what we have in mind is the purposefulness of creativity as a whole, the attitude of the artist to the reality that surrounds him."[66] To someone familiar with the esoteric language of ideological texts, this means that whatever an artist depicts, whether the Leader or a cucumber, whatever an architect builds, a palace for the Party or a public toilet, he must be guided by his *Weltanschauung* and remain aware of the role of what he depicts in the general ideological context. As though not trusting the word "style", the totalitarian ideologies all demanded from art an integral view of the world, embracing all realms of life, such as had been the foundation for all major styles in the past, above all those established by the great religions. "The political *Weltanschauung* of Fascism and National Socialism," wrote Mosse, "cannot be evaluated in the terms of traditional political theory ... To all intents and purposes it was a theology which provided the framework for a national cult. Its rituals and liturgies were a central and integral part of a political theory which was not based on the weight of the printed word."[67]

Faith and atheism, materialism and idealism, reason and instinct are the fundamental philosophical categories used by "left-wing" and "right-wing" totalitarian ideologies alike in order to contrast themselves and their opponents. Soviet propaganda portrayed National Socialist ideology as a form of religion which returned humanity to the darkest aspects of the Middle Ages; Hitler himself was seen as a mystic who turned to astrologers, palmists and occult

Eastern teachings for the resolution of important questions.* The Nazis, for their part, portrayed Communism as a crassly materialistic doctrine propagated mainly by Jews. All this obscured the similarity of the two ideologies, preventing outside observers from penetrating to their core. Those on the inside, however, were more perceptive; Berdiaev, for example, at the dawn of the new era, referred to Bolshevism as a "distorted, inside-out, realization of the Russian idea",[68] and called the Bolsheviks themselves "a religious atheistic sect which has seized power in its hands".[69]

The hatred of the Nazi ideologues for religion as a whole and Christianity in particular was no less fierce than that of the Communists. In *The Myth of the Twentieth Century* Rosenberg attacked the Christian Church as savagely as he attacked the Jews[70] – as did his ideological rival Goebbels in his private diaries. Martin Bormann, Hitler's number two during the final period of the Third Reich, declared that "The Nationalist Socialist and Christian conceptions are incompatible". He explained this as follows:

> The Christian churches are based on human ignorance and attempt to keep a vast part of humanity in ignorance, since this is the only way for the Christian churches to retain their power. National Socialism, on the other hand, is based on a scientific foundation. The unshakeable principles of Christianity, by which it has been guided for almost two thousand years, have congealed more and more into dogmas that are cut off from life. National Socialism, in contrast, if it wishes to achieve its aim, must always be guided by the most recent data of scientific researches.[71]

These ideas of Bormann, like many other ideas of his, corresponded so closely to the Soviet viewpoint that several members of Hitler's entourage, people who knew him well, expressed genuine suspicions that he might be a Stalinist agent.[72] It is clear, however, that Bormann's ideas were derived not from Soviet anti-religious propaganda, but from Hitler himself: "in Hitler's eyes Christianity was a religion fit only for slaves; its ethics he detested, and he mocked all talk of a life after death. Death was the end: such immortality as man could achieve was in the race and history ... Once the war was over, he promised himself, he would root out and destroy the influence of the Christian churches in Germany, but until then he was a good deal more cautious than some of his followers, like Rosenberg and Bormann, in attacking the Church publicly."[73] In rooting out traditional religion, however, totalitarianism always strove to establish another religion – in its place and in its image.

"I am a religious man, although not in the usual sense of this word,"[74] said Hitler of himself; and those who knew him (Hoffmann, Speer, Goebbels) affirmed that the Providence he repeatedly invoked was by no means an empty word to

*This is how he is seen in Lion Feuchtwanger's novel *The Brothers Lautenzak* – which has been translated into Russian and published in the USSR – and how he is still portrayed in Soviet historical works.

him. Bormann was only translating Hitler's high-flown rhetoric into simple ideological formulae for the Gauleiters when he pronounced:

> When we National Socialists speak of a belief in God, by God we do not understand, as do naive Christians and their clerical beneficiaries, a manlike being who is sitting around in some corner of the spheres ... the force which moves all these bodies in the universe, in accordance with natural law, is what we call the Almighty or God The more thoroughly we know and attend to the laws of nature and life, the more we adhere to them, the more do we correspond to the will of the Almighty. The deeper our insight into the will of the Almighty, the greater will be our success.[74]

Mussolini himself, with characteristic directness, referred to Fascism as a "religious conception".[76] The Soviet leaders for their part avoided the use of religious terminology, but their version of Marxist teachings often took on a somewhat mystical tone: "The Party in the last analysis is always right, because the Party is the single historic instrument given to the proletariat for the solution of its fundamental problems ... for history has created no other road for the realization of what is right."[77] These words of Trotsky lie at the foundation of the cult of Stalin and of all subsequent Leaders.

For all his hatred of Christianity, Hitler more than once emphasized the need for careful study of the history of the Catholic Church, which, thanks to its brilliant organization, had retained power for two thousand years. In a speech to the Party senators he proclaimed that "the Party must construct the pyramid of its leadership in accord with the model of the Church" and that this pyramid must "rise above the tiers of the Kreisleiter and Gauleiter to the body of Senators and finally to the Leader-Pope".[78] This, of course was the model of all totalitarian organizations.

Social life as a whole continued – in spite of a few timid attempts to change the church calendar as had been done during the French Revolution – to flow along the channel of the traditional cycles, although with slight changes to the rituals and festivals. Under Stalin, for example, the church marriage rite was restored in all its details except that it took place in a Palace of Weddings rather than a church and was presided over by a representative of the Party organization rather than by a priest. Christmas was still officially celebrated in Nazi Germany, although not a word was said about Christ in the carols and the manger was shown as empty.[79] Christmas without Christ and the manger without the baby – this can be seen as the epitome of totalitarian pseudo-religion.

This view of the world was the leaven which enabled cult forms of art, with the cult of the Leader at the centre, to emerge almost spontaneously. Hitler was referred to in Germany by the same title as Christ – the Saviour. And the most frequent epithet applied to the dead Lenin was "eternally living" or even (in Maiakovskii's phrase) "more living than all the living". As for Stalin, he was

Taust: Hitler and God

looked on during the last years of his life as immortal; to speak of his approaching death and replacement was seen as evidence of conspiracy, as a provocation for which one could be arrested.

George Mosse – like many others – has referred to this kind of *Weltanschauung* as a "secular religion" and to its accompanying rituals as "the political liturgy". Totalitarian culture was not only a part of this liturgy, but in many respects the creator of it. It can be seen, in addition, as a realization of the avant-garde dream of an art that was both produced and consumed collectively.

Art "belonged to the people", but was not of course intended for individual consumption. In Germany, paintings from official exhibitions were admittedly offered for sale. The prices were not high, and the market, according to witnesses, was very lively. Nevertheless, few people other than Party bosses would have decorated their private apartments with portrayals of Hitler and his comrades or of marching storm-troopers. In the USSR not even high-placed functionaries could have entertained the idea of similar purchases. They could be contemplated only in "temples of art", as museums were called, in Palaces of Labour, Culture and the Revolution, in official institutions and public places. The figure of the Leader, whose universal essence was embodied in the official portrait and monumental sculpture, was broken down in the inferior genres into a variety of different images, each addressed to a different group of the population according to class, profession, nation or age. In playgrounds, kindergartens and pioneer camps there usually stood a plaster cast of a curly-haired boy in an old-fashioned suit, rather like a child in an old daguerreotype ("Lenin in Childhood"); in the

main halls of schools and universities hung Viktor Oreshnikov's "Lenin at the
University" or a similar work by another artist; kolkhoz clubs and village soviets
were all required to possess a work modelled on Vladimir Serov's "Bearers of a
Petition to Lenin", while workers' clubs were adorned with depictions of Lenin
or Stalin addressing the revolutionary proletariat; especially popular in Georgia
was Iraklii Toidze's "Stalin at Rioges" (a hydroelectric power station being built *see*
in Georgia). Every Soviet institution – schools, hospitals, People's Commissariats,
factories, military and scientific establishments – had its "red corner" for the
celebration of the political liturgy, and all of these contained paintings or
sculptures on the above themes – originals or reproductions according to the
importance of the institution.

Ideological education was carried out in similar fashion in the Third Reich:
"The Nazis even had altars in the factories – little rooms which they called
worship rooms which were constructed like churches except that on the altar
there were the symbols of the party."[80] Art did not only serve a cult; the works
of art themselves were transformed into cult objects, the most revered taking on
a sacred character. This is shown particularly clearly by a memorandum,
addressed to Hitler in 1936 by the Council of the German Evangelical Church,
which included the passage: "We must inform the Führer of our embarrassment

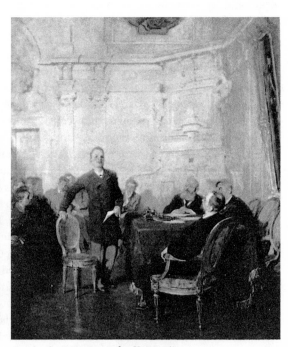

Tsigal: Lenin in Childhood Oreshnikov: Lenin at the University

Recreation Room, Braunschweig

that the forms in which he is worshipped are often identical to the forms of worship of God alone. Only a few years ago the Führer did not accept that portrayals of him should appear on church altars ... Today he is portrayed as a national high-priest and even as an intermediary between God and the people."[81] Portraits of Stalin did not appear on the altars, but one could easily end up in a camp for a lack of respect towards his holy image.*

The novel and revolutionary quality of totalitarian art – in comparison with that of the preceding centuries – lay not only in its orientation towards the collective viewer; it also embodied in a distorted form yet another of the backward-looking dreams of the avant-garde – that of collective creativity. The most obvious example of this kind of creativity in the USSR was the so-called '"brigade method": one, often not especially large, work was created by several artists

*In Vladimir Voinovich's novel *The Life and Unusual Adventures of Soldier Ivan Chomkin* (Ardis, Ann Arbor, 1975, p. 55) Party organizer Borisov, growing excited in a conversation with kolkhoz chairman Golubev, accidentally slaps the head of a plaster cast of Stalin. "His mouth immediately dried up. His jaw dropped and he gazed at Golubev, unable to take his eyes off him as though hypnotised. Golubev was scared to death himself. He wished he hadn't seen this, but he had seen it, he had! What could he do now? Pretend he hadn't noticed? But what if Borisov went off and repented? He'd worm his way out himself, while he, Golubev, would catch it for not reporting this. And if he did report him, then he'd still be imprisoned just for seeing this. They could both remember the story of the schoolboy who had fired a sling at his schoolmistress, and instead broken the glass of the portrait. If he had knocked out the schoolmistress's eye, he would probably have been pardoned for his youth, but he had hit not an eye but the portrait – and that was nothing more or less than an attempt at assassination. And where this schoolboy was now, no one knew." This episode should not be read as satirical exaggeration.

under the guidance of one master. This method was most widely used at the end of the Stalin period. The painting "Lenin's Speech at the Third Congress of the Komsomol", attributed to Ioganson, was the work of five artists, Tomskii's relief "Lenin and Stalin – the Leaders of the Soviet State" was the work of seven sculptors, and Vuchetich's high relief "We Vow to you, Comrade Lenin" was the work of three sculptors. This was how the anonymous icon-painters and the builders of the medieval cathedrals had worked; totalitarian culture, however, was far from anonymous. Needing a personification of its achievements, it put forward leaders in every realm. The name of the author was, nevertheless, a symbol of collective creativity whether he had worked alone or led a brigade; what lay behind his name, after all, was not his individual talent but the vast megamachine of culture in which his role was that of a "cogwheel and screw" (Lenin's phrase).

At the same time, totalitarian theory stubbornly emphasized the importance of the personality of the artist and of creative initiative, claiming that these guaranteed freedom of development and excluded the establishment of any rigid canon. "Not constraint by formalist canons coming from Cézanne and Picasso, but rather a multiplicity of forms, not the violence to the individual creative proclivities of the artist that is dictated by the laws of bourgeois art and the crushing terms of the markets, but rather a complete blossoming of personal creative initiative and individual style – these are the foundations of Socialist Realism, requiring the socialist conviction of the artist and the faithful realistic depiction of reality."[82] In his important article "Paths of German Cultural Policy" Rosenberg insisted in similar vein on the necessity of guaranteeing the right of German artists to creative initiative, on the grounds that "our ideal of beauty in no circumstances excludes the multiplicity of personal temperaments".[83] Nothing refutes these statements more convincingly than totalitarian art itself and its rigid canons.

In its purest embodiment – the theme painting, the official portrait and the monumental sculpture – totalitarian art ceased in any way to be realistic in the nineteenth-century sense of the word. It was no longer a psychological portrait of a concrete individual or a picture of the "morals and customs of its epoch". Still less can it be seen ás individual symbolism in the spirit of Vrubel or Franz Von Stuck – an expression of the relationship between the artist and the universe. In essence it was a rational allegory of a social myth, immersed in a mythological context. Behind what is depicted one can glimpse the features of social arche-types – the leader, the warrior, the worker, the exploiter and the exploited, good and evil themselves. In this context every traditional genre or subject acquired a particular meaning. Berthold Hinz has written of National Socialist art: "Every child and every cow ... – once they were painted – could no longer be what they were ... A nude was no longer a nude, a factory no longer a factory, a landscape no longer a landscape ... They became masks of the proclaimed

Poster: Stalin at the Helm (1933)

substance, masks that made up the face of the National-Socialist system."[84] In both Nazi and Stalinist art the subjects of paintings became not only masks, but rather symbols and allegories: just as it is impossible to determine the name of a saint depicted on a medieval icon or to understand the meaning of Dürer's allegories without a knowledge of Christian iconography or Renaissance symbolism, so it is impossible to understand the meaning of the figures depicted in totalitarian art without a knowledge of their social context. Each such work is an image in the original sense of the word: a symbol of greatness or happiness, a sacred sign, an object of worship or icon. It is these images, these symbols – architecture included – that constitute the body of work which we can call the stylistic phenomenon of totalitarian art.

Most historians, discussing the culture of one or another of the totalitarian regimes, simply deny the existence of the phenomenon of totalitarian culture, either pointing to stylistic, ideological or thematic differences in the art produced under the different totalitarian regimes, or else attempting to establish the similarity of certain elements in totalitarian culture to elements in the past or present culture of the democratic countries. Thus, after pointing out the stylistic similarity of the Soviet and Nazi pavilions at the 1937 exhibition in Paris, R. Taylor, the author of the principal study of the architecture of the Third Reich, admits that "one is tempted to say that this style is typical of totalitarian dictatorships". He immediately overcomes this temptation, however, arguing that in the thirties neo-classicism was "the official style of many countries".[85]

Features of this style can indeed be detected in the buildings of many different countries during the thirties and forties. They can be seen, for example, in the marble colonnades of the administrative centre of Washington and in the Senate

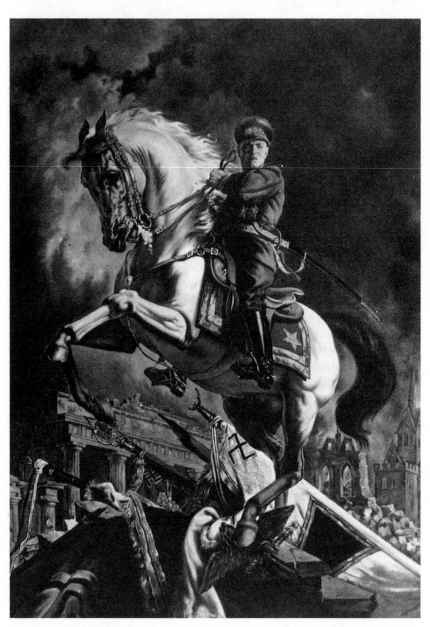

Iakovlev: Marshal Zhukov

House of London University, and it would be legitimate to draw parallels with totalitarian architecture but for the fact that these buildings represented not the epoch nor the State as a whole, but merely particular institutions. One can refer to their style as the style of official buildings, but not as "the official style". We shall find little reference to these works in general histories of twentieth-century art; the culture of the time was, and still is, represented by a very different style of painting, sculpture and architecture.

Albert Speer, the chief architect of the Third Reich, after thinking about totalitarian architecture for many years, both before and after his release from Spandau, came to the conclusion that there was no such thing as a Nazi ideology or style in architecture: "There was no 'Führer's style', for all that the party press expatiated on this subject. What was branded as the official architecture of the Reich was only the neoclassicism transmitted by Troost."[86] This statement corresponds to a now widely held view, which it may in fact have helped to establish.

Many authors, writing about the artistic style of one or another totalitarian regime – or more often about their absence of style – think only of an aggregate of formal elements typical of the period from eighteenth-century Academicism to late nineteenth-century Realism. Looking at it in this way, it is indeed difficult to make out the features of a new style, and if it were only a matter of the resurrection of old forms, then Franz Roh would be right in declaring that the art of the totalitarian regimes is not worthy of serious analysis.

Formal and stylistic features were never precisely fixed by totalitarian aesthetics. As we have seen, the artistic language changed with time, always remaining, however, within the limits of realistic portrayal. Its "realism" was not so much a stylistic factor as a sign of the artist's loyalty, a form of his participation in collective thinking. Hitler himself did not demand great ideological fervour from his court artists; many of the most important cultural figures of the Third Reich were not even members of the National Socialist Party. It was according to formal qualities that totalitarianism distinguished between friends and enemies: a non-Party realist, even an émigré, was more ideologically acceptable than such convinced Nazis or Bolsheviks as Nolde and Lissitzky. Personality does not play an important role in collective society; what matters is the product created. It was the subordination of such depersonalized products to a common goal, their orientation to one centre, that constituted the style of totalitarian art.

The project for the Palace of Soviets can be seen as an ideal model of this see p. 364 (below) style and its development: the cyclopean figure of the leader, thousands of square metres of paintings and frescoes linked with his name, dozens of vast sculptures – all of this, the work of hundreds of artists, sculptors and architects, had a defined place in an ideal structure that had been planned not by the reason of a mere individual, but by a higher will: Boris Iofan's name was only a symbol for the

creativity of thousands of anonymous masters who had embodied a divine design – attributed, as has been said, to Stalin.

Nazi aesthetics demanded a similar orientation of all its culture on an ideological centre: "Each public building must be planned in such a way that all its parts face the Führer; each architectural detail must express the kinship between the Führer and the people and must bear on it the Nazi emblem and the flag with the swastika – the symbol under which a fighting party became a national movement."[87] "Facing the Führer" does admittedly imply a somewhat different relationship to the ideological centre than the vertical aspirations of Soviet architecture. This difference can best be explained by the different character of the political liturgy in the USSR and Germany.

Hitler spoke, Stalin was silent. During the first years of the Nazi regime the Führer would appear before huge crowds in several different cities in the course of a single day. Albert Speer's social designs, composed from marching crowds and thousands of searchlights, led up to his own charismatic speeches. The striking effect of all this was noted not only by Nazi propaganda, but also by foreign diplomats. Goebbels, himself an atheist, commented: "When the Führer last addressed the people, it felt as though Germany had been transformed into one House of God ... This was religion in the deepest and most mystical sense of the word."[88] The whole of National Socialist culture can be said to have been orientated on the Führer; every official building or complex – the House of the People, the Reich Chancellery, the Nuremberg Zeppelin Fields, the Berlin stadium – faced a certain empty but sacred place where the Führer was visibly or invisibly present. Metaphorically speaking, Hitler extended over the horizontals of the space of the Reich.

Stalin's symbol, in contrast, was a vertical. The Leader dwelt behind the unapproachable walls of the Kremlin, and, according to legend, his office light shone all through the night, beside the ruby-coloured Kremlin stars. It was only two or three times a year, during important demonstrations, that the Soviet people contemplated the bust of their Leader above the parapet of the Lenin mausoleum. It was on this image, on this Leader, that Soviet culture was orientated.

Stalin – let alone Lenin – was more a symbol than a man, and the role of Soviet art was to decipher this symbol, to reveal different aspects of the existence of this superman in thousands upon thousands of genre paintings. National Socialist art was less prolix and its language tended to a more lapidary and monumental symbolism; the Führer himself provided the more everyday element.

The *language* of totalitarianism was addressed to its contemporaries; its *style* – if that is understood not as an aggregate of formal devices but as the self-expression of an epoch – was addressed to posterity, to eternity. On its periphery, totalitarian art used the language of realism to engage in propaganda, to create

popular myths and to educate the masses; at its centre, it followed a strict stylistic canon in order to establish a cult. The style of totalitarian art was derived from a structure that attempted to unite all its elements into a single magnificent temple built for all ages and all people.

In its monolithic quality, in its subordination of separate parts to a single whole, in its hierarchy of values, totalitarian art resembled not so much the art of the nineteenth century as that of more distant centuries when religious painting was central and everything else was significant only in so far as it reflected the heavenly in the terrestrial. Totalitarian art bridged the nineteenth century, with its bourgeois individualism and tolerant eclecticism, to meet "the golden age of the cathedrals" of which "pioneers of contemporary design from Morris to Gropius" had dreamed. After destroying the avant-garde, it attempted to realize its ideal of a "new community", a "new totalism", in which society would be organized on a rational basis and subordinated to strict aims. In this respect, for all its retrospective tendencies, totalitarian art is a legitimate child of our age. It is another matter that it realized the dream of the avant-garde in a distorted form and attempted to construct its monolith out of the forms and concepts of the nineteenth century rather than with contemporary materials.

The project for the Palace of Soviets was never realized; like similar projects of Hitler and Mussolini, it was unrealizable, serving chiefly to indicate an ideal model of style to which one should aspire. Faust's "Stop, moment!" was the obsessive and utopian dream of every totalitarianism. Fascist art merely aspired to this ideal, while that of Nazism drew closer; it was Stalinist Socialist Realism, however, that approached its realization most nearly.

Encounter in Berlin

During the last days of the war Soviet bombs and artillery barrages destroyed Hitler's Reich Chancellory, designed by Albert Speer and containing sculptures by Arno Breker and Josef Thorak. In a bunker not far away Hitler and Goebbels did away with themselves, What weapons failed to achieve was completed by bulldozers: like many similar "symbols of the grandeur of the Third Reich", the Reich Chancellory was soon razed to the ground. In 1946, however, its fragments were used to construct the memorial "to the soldiers of the Soviet army fallen in the battle against Nazism" or, as it was soon christened, the "Victory *see* Monument". This was unveiled in 1949 and the Germans who had survived Nazism were confronted, in the Berlin Treptow Park, with a *chef-d'oeuvre* of Stalinism that was to be a symbol of their own future culture.

This was not, of course, the first postwar encounter of the German artistic intelligentsia with Soviet aesthetic dogma. The Soviet authorities in occupied Berlin had immediately devoted considerable attention to cultural matters. Their programme for the development of art in Germany "had at first sight looked rather good, especially in comparison with the meager, or non-existent directive of the Anglo-American occupation programe".[1] Initially the Soviet "commissars for art" spoke of the freedom of creativity under true Socialism, opened exhibitions and museums of contemporary art and made friendly gestures towards modernist artists.

After a year, however, both during meetings with artists and on the pages of the Moscow-financed press, the Soviet representatives advanced ideas that were already only too familiar to the German intelligentsia: "Art must be popular and serve the people", "be closely linked with life", "reflect the achievements of socialism" and embody "eternal values". In all this it opposed the decadent art of the West, a concept which included the German artists who not long before had represented "degenerate art" at Nazi exhibitions. Among the artists attacked were Käthe Kollwitz and Ernst Barlach; as before, they were criticized for their monstrosity of form, their anti-human content and their departure from national tradition. "Exactly like the Nazis – from the ideas down to the very wording"[2] was the verdict of German artists present at one such meeting.

The Berlin memorial embodied these dogmas, and its creators, the sculptor Evgeny Vuchetich and the architect Iakov Belopolskii, were awarded the Stalin

prize first class. A traditional triumphal arch revealed the horizontals of grave-stones and marble banners laid on the ground; these in turn led to the vertical of the monument to the Soviet warrior.

> The complex and magnificent spatial symphony is crowned by a life-affirming image which overcomes sorrow for the past and instils confidence in the future. On a high pedestal, raised up on a high conical mound, stands the grandiose statue of a Soviet warrior who is trampling underfoot the fragments of a Fascist swastika. In the warrior's right hand is a lowered sword, in his left hand a trustfully clinging child ... In this outstanding work the Soviet art of Socialist Realism opposes the decadent art of the bourgeois West that is so lacking in great ideas.[3]

It is as though the material of Hitler's Reich Chancellory became the essence of

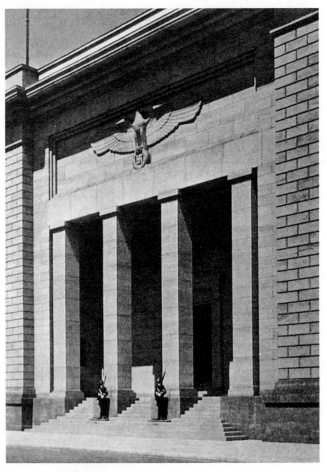

Speer: Reich Chancellery, Berlin

Breker: The Sentinel Breker: The Avenger

the Soviet monument. Familiar as they were with the language of Nazism, the Germans had no difficulty in deciphering these "great ideas".

One detail of the generally realistic figure of the Soviet warrior was unusual: instead of a sub-machinegun or hand-grenade he grasped a Teutonic sword. To Soviet viewers this evoked associations that had very little to do with military victory: for two decades a sword against a shield had been the official emblem of the security organs. German viewers would have been equally quick to interpret this detail: the Teutonic sword was an essential attribute of all the military monuments of the Third Reich. Wamper's "Genius of Victory" held one *see* up to the skies, Kolbe's and Schiebe's German warriors leaned on one, Breker's "Avenger" wielded one in combat, his soldier "Standing on Watch" was drawing one from the scabbard, and his allegorical figure "Wehrmacht" beside the entrance to the Reich Chancellory grasped one in his hand. Now, however, this sword was lowered, pointing to the Nazi emblem being trampled underfoot by the Soviet warrior. This too was a familiar detail: the foot of a worker or storm-trooper, trampling underfoot the hydra of Bolshevism or Capitalism, had been an important part of many well-known Nazi posters.

Erected at the centre of what had once been the Third Reich, the monument to the Soviet warriors became a symbol not only of victory but also of the cultural policies of the new Germany. Its realism, pomposity and cemetery optimism were put forward as a stylistic model for the German variant of Socialist

Realism. Supply engendered demand: during the following three decades there was not one country in the Soviet bloc where the ideology of totalitarian art was inculcated with such rigid consistency, where its language attained such purity of form as in the German Democratic Republic.[4] The soil, of course, had been only too well prepared.

Soon after the war an opinion poll was carried out in Germany in order to ascertain the attitude of the population to contemporary modernism. Seventy-five per cent of those questioned said they approved of it; among men aged 28 to 35, however, i.e. among those whose intellectual and aesthetic education had coincided with the years of the Nazi regime, 40 per cent disapproved of it.[5] A decade before, many of them had evidently formed part of the vast crowd that had mocked the works of "degenerate artists" displayed in the House of German Art. As the German art historian Rave has written of this exhibit:

> Droves of people came to see this exhibition day after day. There is no point in trying to tell ourselves that some few of them perhaps came to say goodbye to works of art they loved. It is clear that the propagandist purpose of dealing a death blow to genuine contemporary art had for the most part been achieved.[6]

It was, however, less a matter of propaganda than of organization. It is clear that many of the hundreds of thousands of visitors to the 1937 exhibition were visiting an art gallery for the first time. It is likely that this was organized in the same way as in the Soviet Union, where crowds of workers, peasants, soldiers, children and pensioners were ferried to exhibitions by official buses and lorries. The reaction of the German public to what they were seeing for the first time can easily be guessed. The task of education and propaganda was mainly to keep their aesthetic sensibility at the same low level. This is the reason for the wide dissemination of totalitarian culture and for its remarkable persistence; this is why the Nazi art destroyed by Soviet bombardment was so quick to rise from the ashes in its new guise of Socialist Realism.

The Stalinist model of totalitarian art survived Hitler's for a decade, penetrating deeper and deeper into the sphere of mass consciousness and spreading more and more widely through the countries under Soviet influence. After Stalin's death and Khrushchev's denunciations of him, this model began to fall apart; at the same time, the epoch that had given birth to it became shrouded by an increasingly impenetrable blanket of silence and distortion. Of all that the spirit of Stalinism had created nothing proved more fragile than its works of art. The chief monuments erected in honour of Stalin were destroyed in the second half of the fifties, and paintings depicting him and his disgraced comrades (Molotov, Beria and Kaganovich) were removed to closed stores. Now one can see only poor reproductions in the periodicals of the time – which are themselves more and more of a bibliographical rarity. Everything, therefore, that had constituted the core of classical Socialist Realism has now disappeared, leaving

yet another "memory gap" in the history of totalitarianism. The contemporary observer is left only with the empty envelope of its rhetoric.

Stalinist art was replaced by a new variant of Socialist Realism, with the same ideology (no one has yet replaced the triad of Party spirit, popular spirit and progressiveness) and the same organization (the Union of Soviet Artists, the Academy of Arts and the Ministry of Culture still form an all-embracing megamachine). In its external image, however, this post-Stalinist Socialist Realism differs from the classical model. It is those artists who at the time were most fiercely attacked who are now seen as the forerunners or even founders of Socialist Realism: Kuzma Petrov-Vodkin, Martiros Sarian, Ilia Mashkov, Petr Konchalovskii, etc. ... Thus, at the 1979 "Paris–Moscow" exhibition in the Centre Georges Pompidou the Stalinist Realism section was opened by figurative works of Malevich from the late twenties. At the vast Soviet exhibition in Düsseldorf in 1984 the art of the thirties and forties was represented mainly by Sarian, Aleksandr Tyshler, Robert Falk, and pupils of Filonov; the official art of Stalinism was remarkable only for its absence. Works peripheral to Stalinist art or else created either before the beginning of the thirties or after the middle of the fifties have been passed off as classic examples of Socialist Realism; this has often, understandably, confused contemporary Western researchers.

Strangely enough, the art of the other totalitarian regimes has, for different reasons, undergone similar metamorphoses. The vast 1982 exhibition in Milan, as we have seen, almost ignored the most important official art of Fascism; and in several exhibitions, including "Art of the Third Reich", which toured various German cities during the seventies, and "Realisms", in the Paris Centre Georges Pompidou, Nazi art was represented without portraits of the Führer or works on "historico-revolutionary" themes. Dissociated from the aesthetic structure to which they belonged and thus deprived of their true content, such incidental fragments of the totalitarian whole as were exhibited appeared similar to peripheral manifestations of modern culture as a whole.

The archaism and eclecticism of totalitarian art, its orientation towards the past, its lack of the spirit of free exploration and innovation – all these make it an "element foreign to the spirit of this [modern] culture". Nevertheless, if one considers the art of this century on a global scale, totalitarian culture begins to seem less unique. Throughout our century art "of a new type" has appeared wherever a totalitarian regime of one or another hue has subjected the realm of culture to its needs. Historical traditions have laid their imprint on each national variant, but taken as a whole the latter appear considerably more similar one to another than to what is now usually called "the spirit of twentieth century art". If we consider the scale of totalitarian art and its wide dissemination, then it does not seem over-bold to define it as a second – after modernism – international style of contemporary culture, a style which deserves both its own name and the most careful study.

Postscript on Iraq

Iraqi art from the time of Saddam Hussein provides yet another fine example of how, under a totalitarian regime, any national artistic tradition becomes transformed into an international style common to all regimes of this kind.

Islam strictly forbids representational art, and for many centuries the only forms of artistic expression in the countries of the Arab world were calligraphy and ornamentation. Only in the twentieth century did foreign artistic influences penetrate these countries. Saddam Hussein, an Orthodox Sunni who prayed five times a day, chose to ignore the ban on representational art imposed by the Koran; instead he took up the idea – an idea borrowed from other totalitarian regimes – of art as an important weapon in the struggle for power.

There is no doubt that Saddam's regime was indeed totalitarian. "The hidden influence of Stalin can be sensed in every act of Saddam," writes the Palestinian journalist Abu Said Aburish ("Stalin's Student" in *Novosti v Novosibirske*, 1 April, 2003). Saddam's admiration for Stalin dates back to his youth. He collected literature about Stalin. He was proud of the similarities between their life stories; both he and Stalin – like Hitler, Mussolini and Mao – came from a very poor background. And Saddam marked his seizure of power with a wave of vicious, Stalin-style purges both in his own Ba'ath ("Arab Socialist Renaissance") Party and in the apparatus of State. Arrests, tortures no less refined than those practiced by the KGB and the Gestapo, "voluntary" confessions and testimonies on the part of those accused of involvement in countless imaginary plots, the executions that followed these "plots" – all this constitutes an almost exact repetition of the methods used by Stalin during the 1930s. On one occasion, when questioned about torture and executions by a correspondent from *Newsweek*, Saddam responded with naïve surprise: "Of course, all these things happen. How do *you* think one should treat those who are against the regime?" (A. Sabov, "Saddam's Devil" in *Rossiiskaya gazeta*, 22 March 2003). Saddam placed art at the service of the State and made its main purpose the creation of a cult of his own self. "Pictures [of Saddam] in homes, posters in every shop, restaurant and public building, larger-than-life painted cutouts draped along avenues, streets and squares, to say nothing of the Leader's continuous presence on radio and television screens – all this became a part of everyday life in Baghdad," writes Samir al-Khalil (Samir al-Khalil, *The Monument* [Andre Deutsch, 1991], p. 41-42). Saddam Hussein's image was visibly present in every

area of the nation's life – on plywood panels along the roadside, on wristwatches, on children's toys,

Like other Arab countries, Iraq had never, in all its history, been acquainted with art of this kind. But Saddam, like Gorky and Rosenberg in their time, called for a reassessment of history itself: "the writing of history must be from our [Baath's] point of view" (ibid., p. 36). Like Chairman Mao, Saddam believed that there were two main evils in his country's past: feudalism and the influence of the West. And, like all totalitarian leaders, he wanted to create a New Man. His central project was the construction of a new – Arab – man, and the first building block in this project was the education of children: "the child in relation to his teacher is like a piece of raw of marble in the hands of a sculptor" (ibid., p. 36). Did Saddam know Goebbels' words, "Hitler relates to the nation as a sculptor relates to marble," or did he come to this idea by himself?

The clichés of totalitarian ideology defined the way Saddam managed his country's art. But is it possible to draw an exact analogy between the art engendered by his regime and the art of other totalitarian regimes? New times, new technologies, a different artistic tradition – or, in the case of representational art, the absence of such a tradition – all this left its imprint on the art of Saddam Hussein's Iraq.

In August 1989 an announcement was made in Baghdad about the unveiling of what was claimed to be the greatest monument in the world: "Under the guidance of the Leader-President, Saddam Hussein (God preserve and watch over him), and in execution of the orders of his Excellency, and on the occasion of one year passing since the great victory, the 'Victory Arch' will be opened on Tuesday Muharram 7, 1410 [Muslim calendar]" (ibid., p. 2). What was meant by "the great victory" was the end of the eight-year war with Iran, which had – in fact – ended disastrously for Iraq. The country was ruined. The economy had been destroyed and the relatively high standard of living made possible by the vast income from the sale of oil had reverted to its previous low level. Nevertheless, Saddam was willing to spend billions of dollars on the glorification of his own name. In similar fashion, Hitler had sent trainloads of marble to Russia instead of supplying the German armies freezing to death outside Moscow in late 1941, while Stalin, for his part, had ordered workers starving to death during the Blockade of Leningrad to construct mosaics that were then transported by plane to Moscow in order to decorate a new metro station.

The Victory Arch in Baghdad, which marked one end of an avenue bearing the same name, was intended to commemorate a conclusive victory over Iran; it was planned long before the end of the war. To enter the avenue one passes under an arch formed by two forearms growing out of the ground 60 meters apart from each other. Each hand holds aloft a huge sword, and the tips of the swords cross at a height of forty meters (the height of the Arc de Triomphe in Paris). The 16-meter long bronze forearms, each of them 20 tons in weight, were cast in bronze from a

moulding taken from a plaster-cast of Saddam Hussein's own forearms. The 24-ton blades of the swords were made from the melted-down guns of dead Iraqi soldiers. The cement plinths on which the forearms rest each hold 2500 helmets taken from Iranian soldiers. A bronze flagpole bearing a bronze Iraqi flag rises from the point where the two swords meet. An identical arch, several hundred meters further on, marks the other end of the avenue.

In the case of these arches, the symbolic has replaced the representational. There is no concrete image of Saddam, but the bronze forearms evoke his presence, (it was widely advertised that they were modelled on Saddam's own forearms) and the sword held by each hand is the Sword of Qādisiyyah – an allusion to the battle of al-Qādisiyyah in 636 in which Arab armies under the command of Saad defeated the Persians and thus made possible the Islamic conquest of Persia. To bring home the supposed similarity between these two wars against the Persians, one of the posters in Saddam Hussein's Baghdad bore the words "From Qādisiyyah Saad to Qādisiyyah Saddam." And the greatness of Saddam's own "victory" over Iran was, of course, evoked by the accumulation of enemy helmets and by the metal from which the two swords had been cast.

It could therefore be said that in this Victory Arch, at least, Saddam acknowledged the Islamic tradition that art should be symbolic rather than representational. The Victory Arch, however, is an exception. Other memorials erected at this time are more straightforwardly representational. The memorial complex at Basra, for example, consists of eight life-size figures all pointing with identical gestures towards Iran, the enemy responsible for their death. Samir al-Khalil has characterized the style of this monument as kitsch. This term can, in fact, be applied to *all* the art produced under Saddam: paintings, monumental sculpture, mosaics, posters, graphic work. Whatever the medium, the chief hero is always Saddam Hussein. Here he appears, sword in hand and mounted on a white horse, as the liberator of Jerusalem; here he appears, clutching a machine gun, as a fearless warrior on a contemporary battlefield; here he appears as a good and kind father, sharing a meal with his nation; here the gates of a Byzantine cathedral serve as a pedestal for a gigantic figure of Saddam that has been cut from plywood; and bronze sculptures of him tower over countless city squares.

If the art produced in Saddam Hussein's Iraq differs from the realistic art of other totalitarian regimes, this is only by virtue of its inferior quality, by virtue of its being kitsch; no artist working for the Iraqi dictator was as gifted as Arno Breker, Vera Mukhina or Alexander Gerasimov. Moreover, the times had changed and new aesthetic theories had helped to bring about the worldwide emergence of new artistic forms. Samir al-Khalil himself has described the art of Saddam Hussein's Iraq as a cross between the Nazi architecture of Nuremberg and the casinos of Las Vegas.

* * *

Both Iraq and China provide examples of the universality of the mechanisms of totalitarian culture; wherever in the world they begin to function, whatever national soil provides the raw material, whatever everyday reality they reflect in their magic mirrors, these national soils and everyday realities take on one and the same image – that of a socialist paradise where happy nations guided by wise leaders build a new life and wreak fierce vengeance on their enemies.

ALBUM OF
TOTALITARIAN ART

The album contains the most important and typical works of totalitarian art. It aims to show not only the stylistic and thematic similarity of the art of different totalitarian regimes (mainly German and Soviet), but also its overall structure; in other words the hierarchy of genres which totalitarianism itself created. This hierarchy is described mainly in Chapters 6 and 7, but I have also included within the album certain works which are discussed in other chapters. Page references for these works are given in the margin.

<div align="right">I.G.</div>

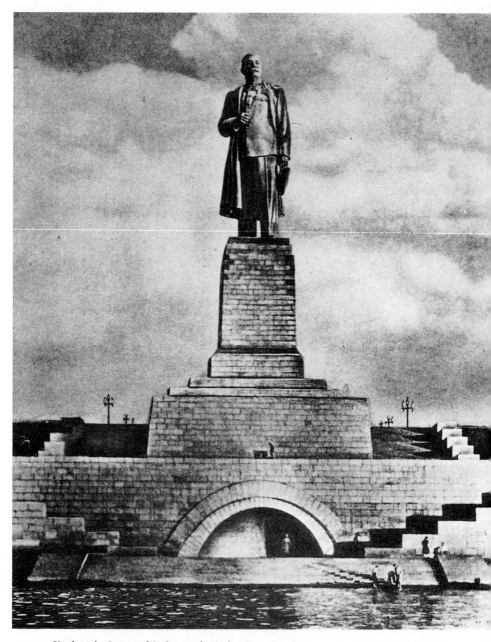

Vuchetich: Statue of Stalin on the Volga-Don Canal

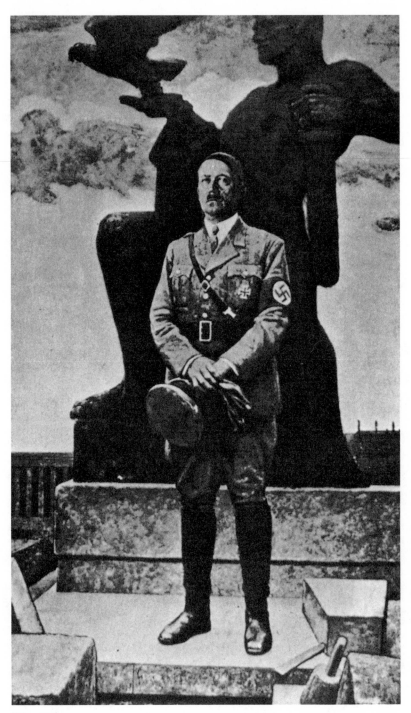

Erler: Hitler

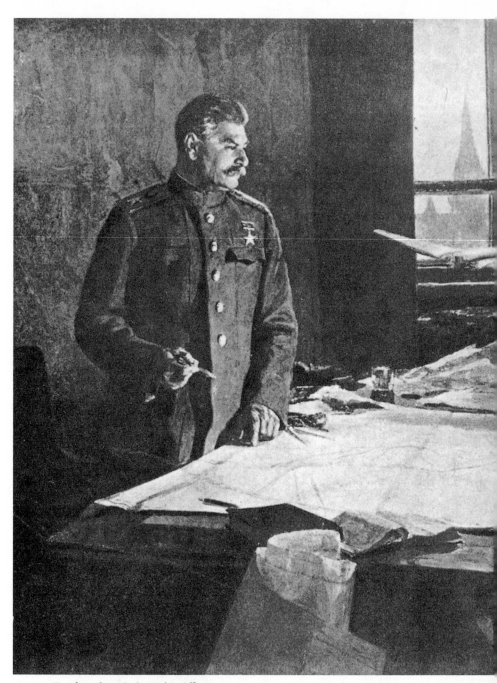

Reschetnikov: Stalin in his Office

A. Gerasimov: Generalissimo Stalin

Hommel: The Führer

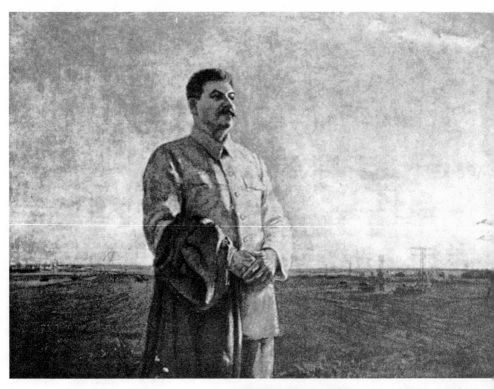

Shurpin: The Morning of
our Fatherland (1948)

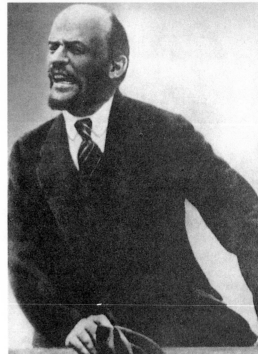

Photo: Lenin on the Tribune

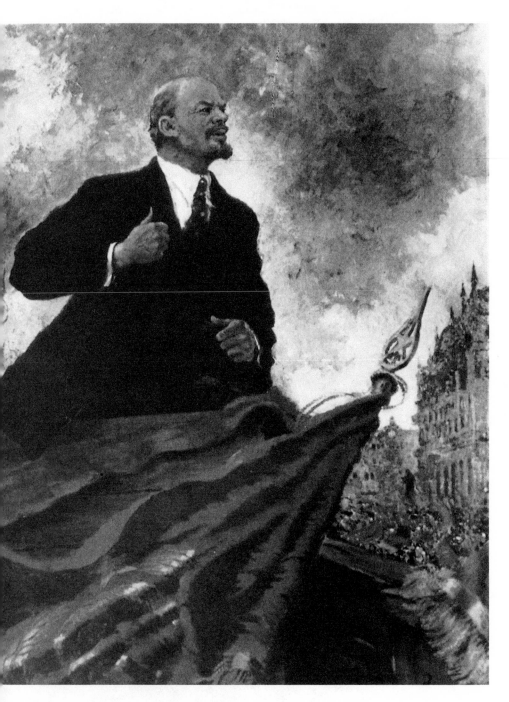

A. Gerasimov: Lenin on the Tribune (1930)

Shchuko/Evseev: Statue of Lenin at the Finland Station, Leningrad (1926)

Grzelíshvili: Comrade Stalin in his Early Years

Nadareishvili: Stalin at a Meeting in 1905

Sokolov-Skalia: Stalin in Turukhansk [in Exile]

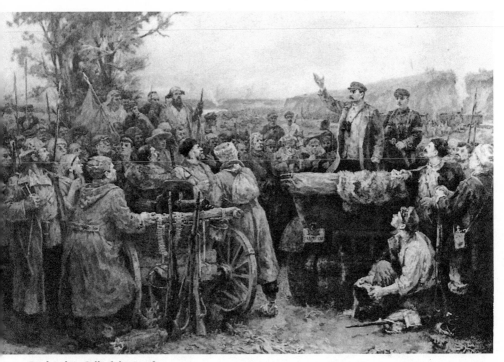

Pavlovskii: Call of the Leader

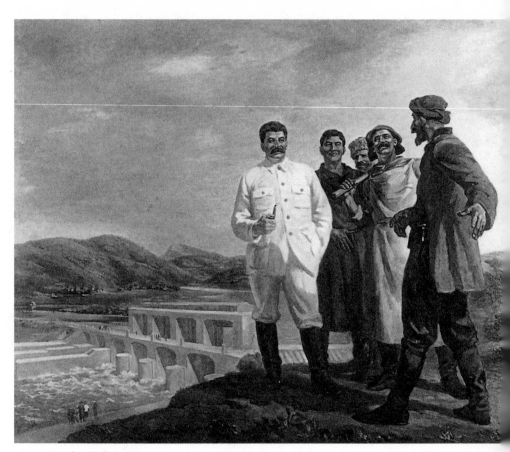

Toidze: Stalin at Rioges

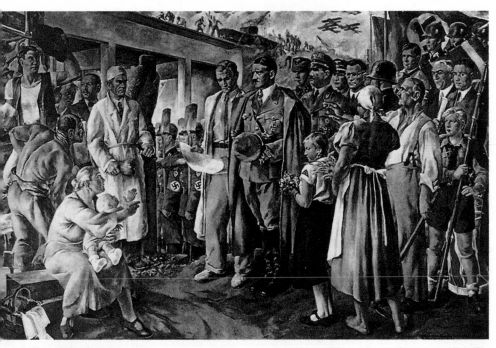

Poppe: Portrait of the Führer in the Frankfurt Physicians' Corporation

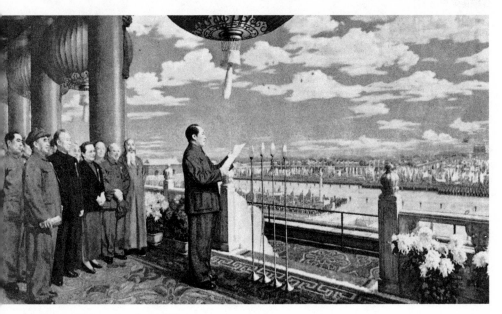

Mao's Speech on 1 October 1949

A. Gerasimov: Stalin at a Meeting with Commanders

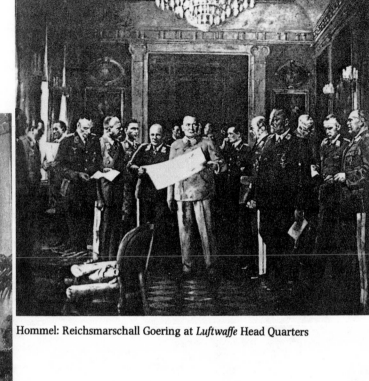

Hommel: Reichsmarschall Goering at *Luftwaffe* Head Quarters

Einbeck: Rudolf Hess

Vietze: Heydrich 1941

Samsonov: Great Leaders of the
Revolution – Dzerzhinskii

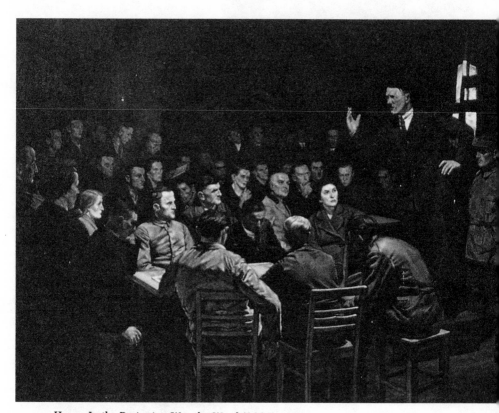

Hoyer: In the Beginning Was the Word (1937)

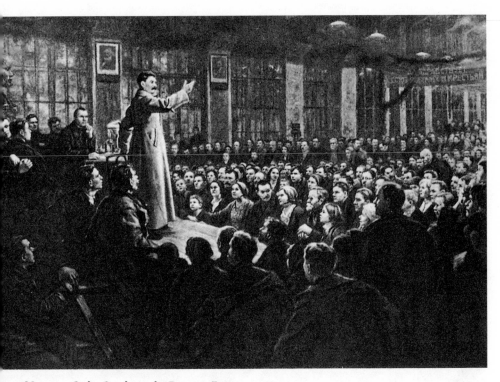

Moravov: Stalin Speaks in the Dynamo Factory

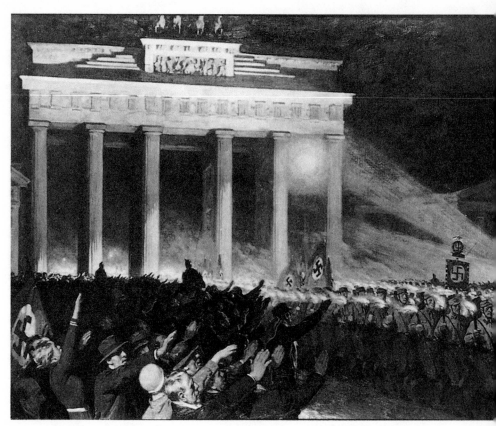

Kampf: 30 January 1933

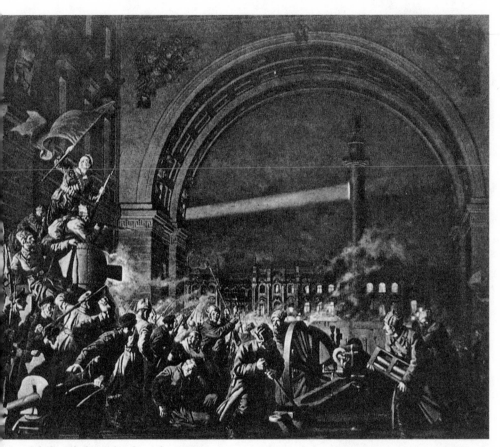

Sokolov-Skalia: Salvo from the *Aurora*

H. Schmitt:
Hitler *Putsch*

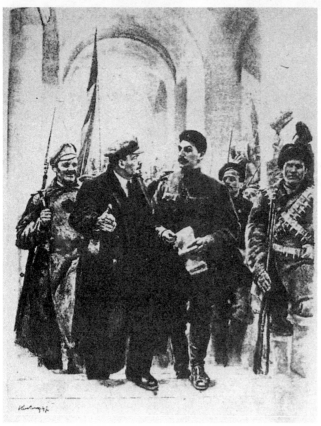

Kibrik: On 24 October Lenin Arrived at Smolnyi during the Night

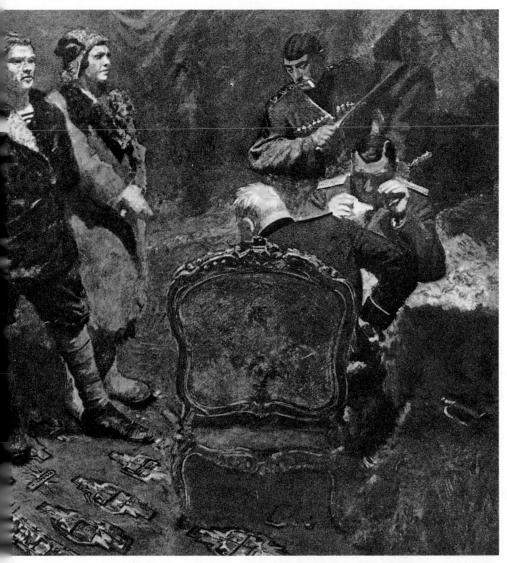

Ioganson: Interrogation of Communists (1933)

Petersen: The Horseman of Valsgarde

Korin: Aleksandr Nevskii (1942–43)

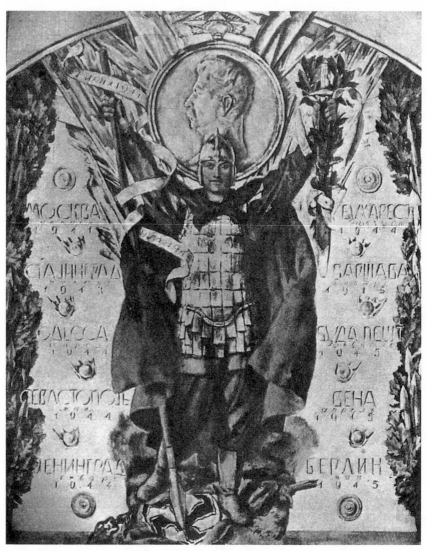

Lansere: Victory

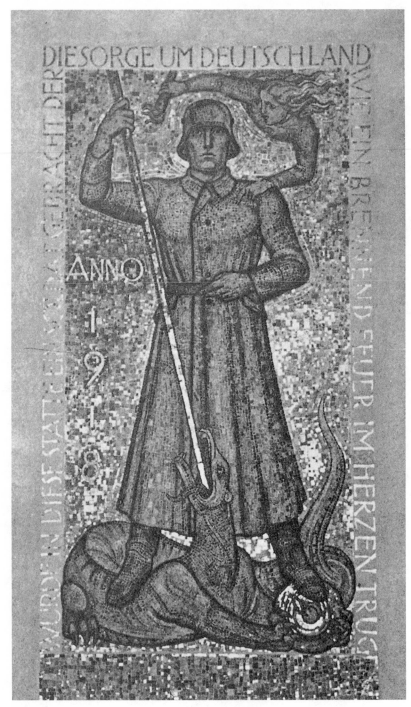

Gruber: Mosaic

Herrmann: This is your Victory

Khmelko: Triumph of our Fat[

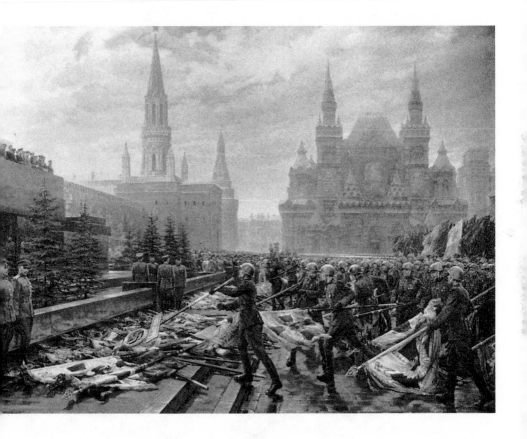

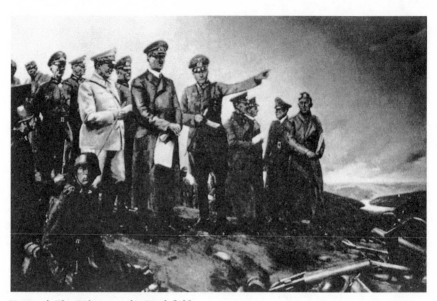

Hommel: The Führer on the Battlefield

Nalbandian: Novorossisk, Malaia Zemlia [Brezhnev at the Front]

Feinogenov: Stalin at the Front

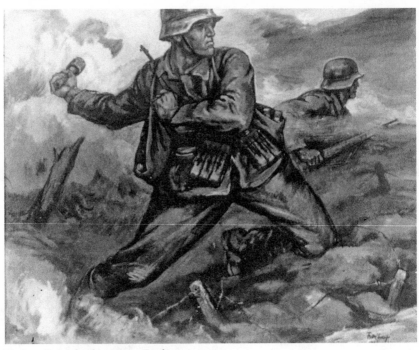

Freitag: Grenade Thrower in Battle

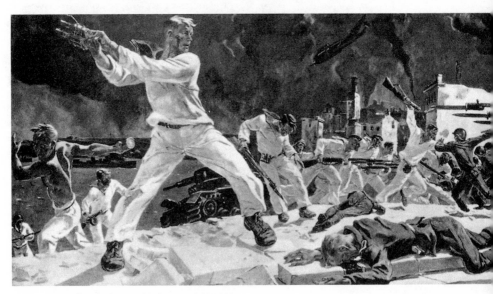

Deineka: Defence of Sebastopol (1942)

Neprintsev: Rest after Battle (1951)

Nordmann: Soldiers Listening to the Radio

Schmitz-Wiedenbrück: Workers, Peasants and Soldiers

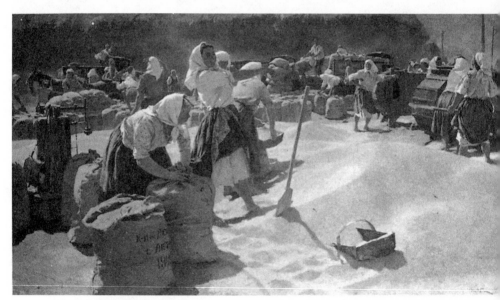

Iablonskaia: Bread

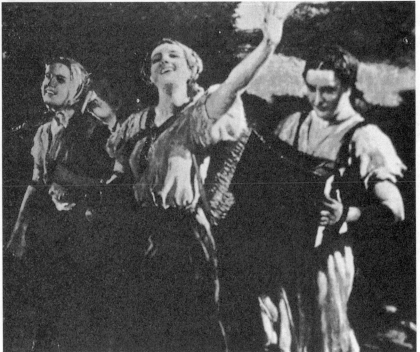

Schmutzler: Farm Girls Returning from the Fields

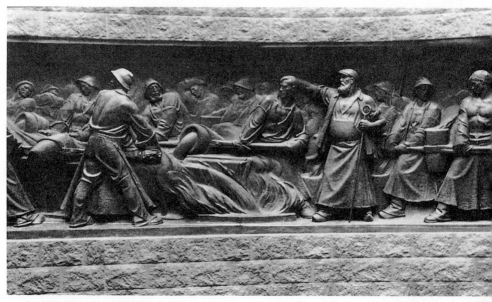

Hoffmann: Steel-rolling Mill

Shadr: Battle with the Soil

ina: Higher and Higher (1934)

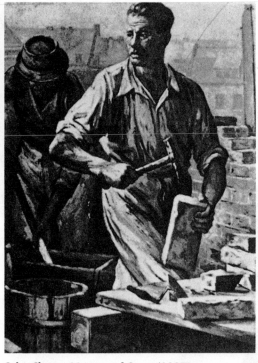

Sohn-Skuwa: Mortar and Stone (1937)

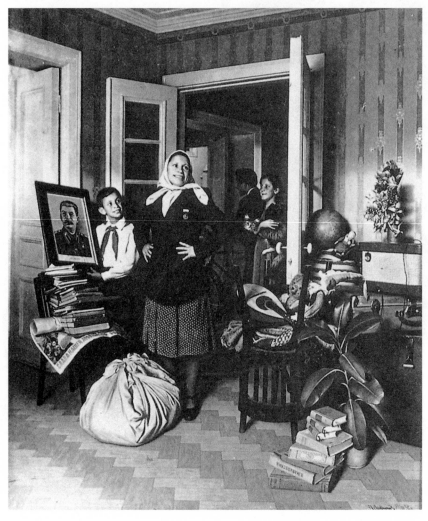

Laktenov: The New Flat

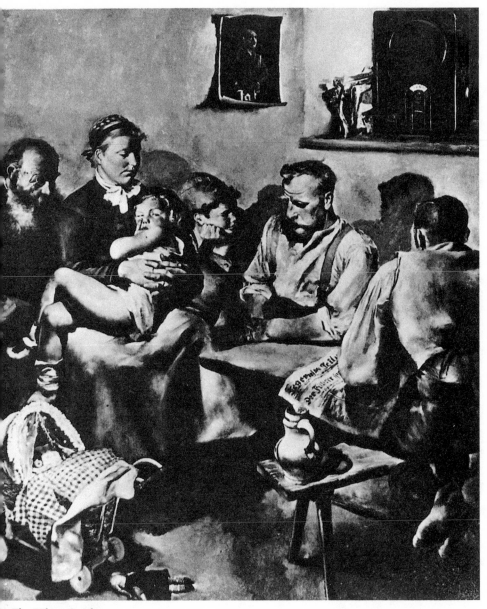

a: The Führer Speaks

Saliger: Country Engagement Party

ov: The Country Party

Orlova: Moscow Metro

rt: The Lovers

Grigorev: Enlisting in the Komsomol (1949)

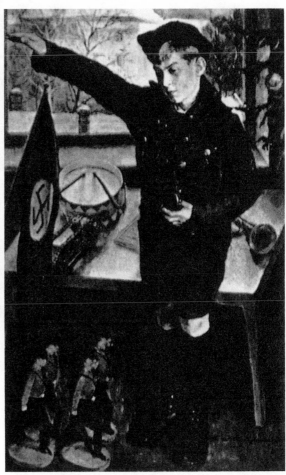

Dielmann: Boy from the Hitler Youth

Iakovlev: Head of an Old Partisan

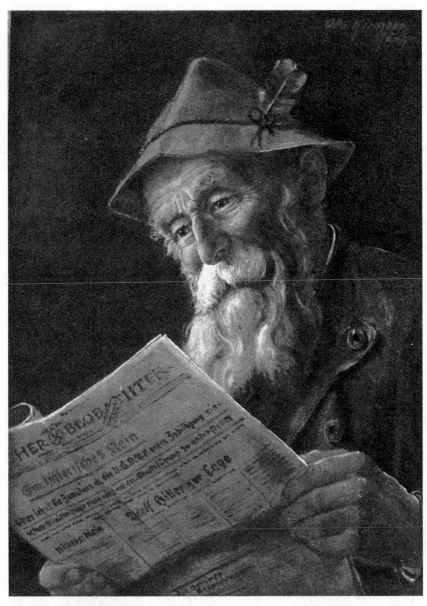

Kirchner: Old Man Reading a Newspaper

Riazhskii: The Woman Delegate (1927)

E. Schmitt: Girl from the Hitler Youth

Gessner: The Works

: Furnace No. 1

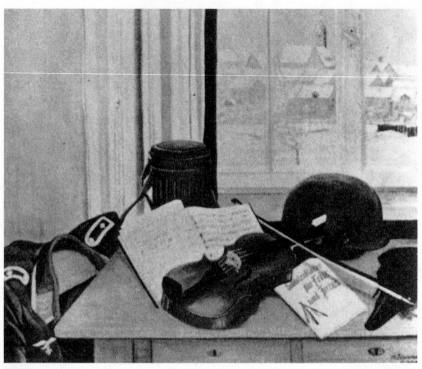

Zimmermann: Leisure

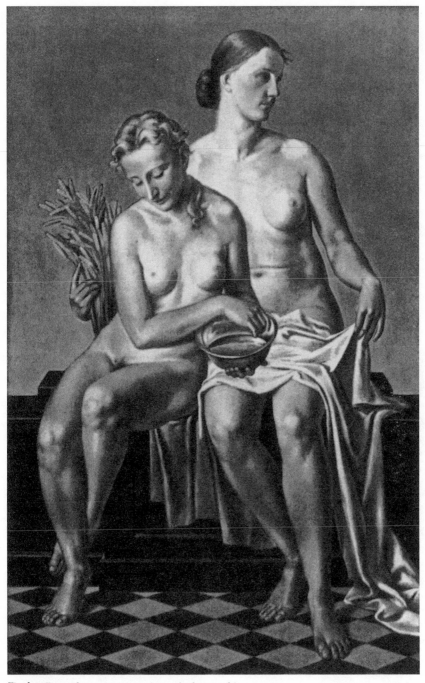

Ziegler: Four Elements (central panel of triptych)

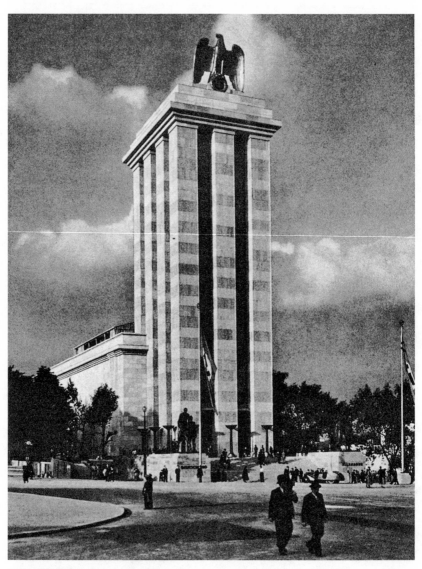

German Pavilion, Paris 1937

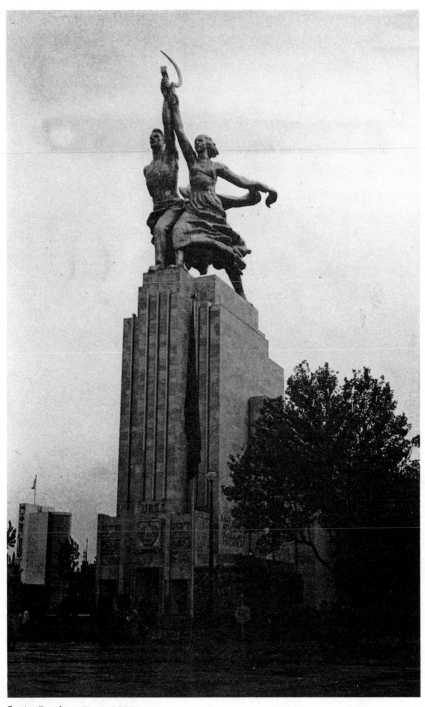

Soviet Pavilion, Paris 1937

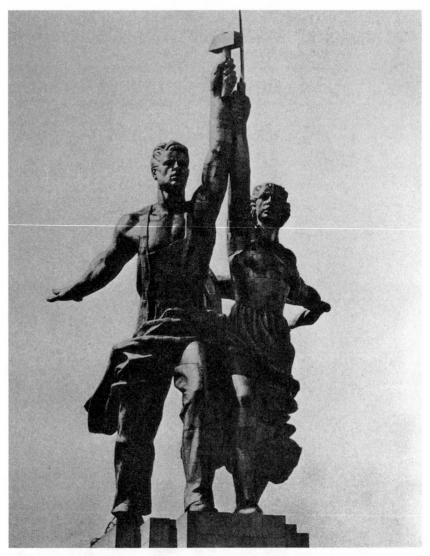

Mukhina: Worker and Collective Farm Woman (1937)

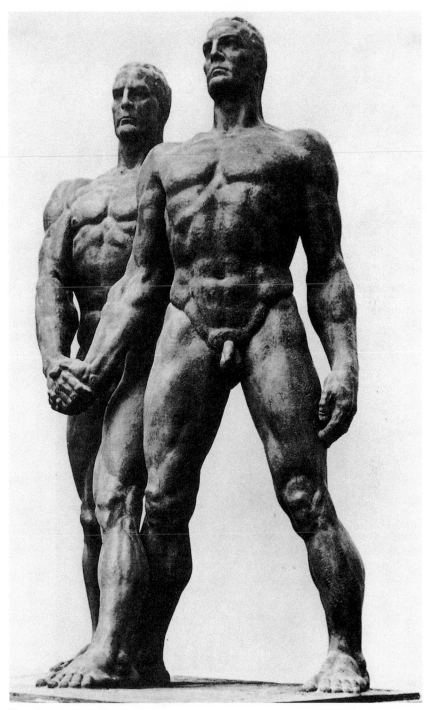

Thorak: Comradeship

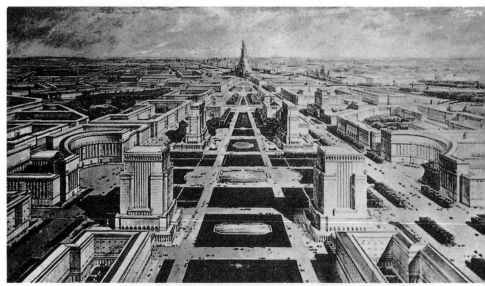

Plan for Moscow's
new centre

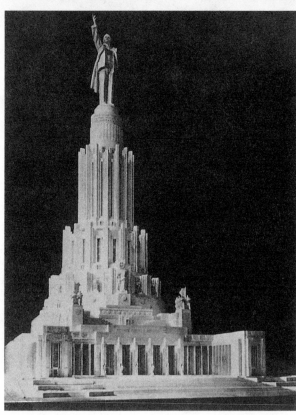

Iofan:
Palace of the
Soviets (193

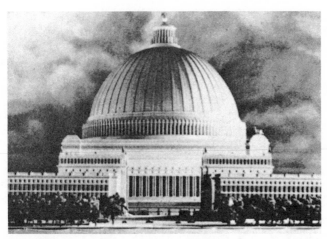

Speer: The Great Hall Planned for Berlin (1939)

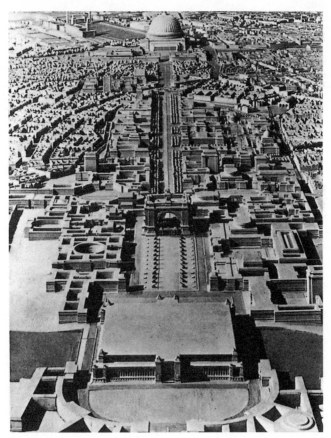

Plan for Berlin's new centre

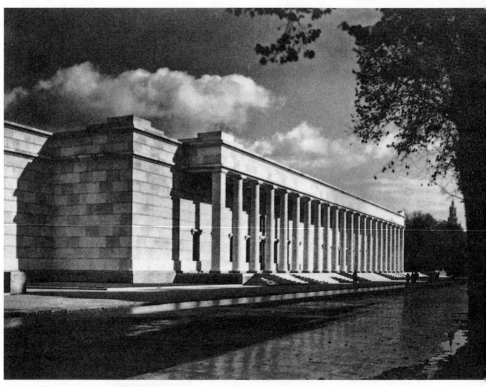

Troost: The House of German Art

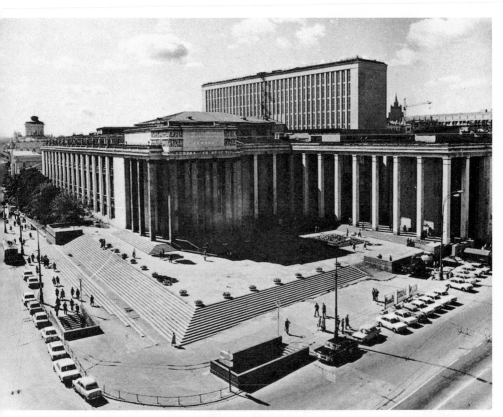

Lenin Library, Moscow

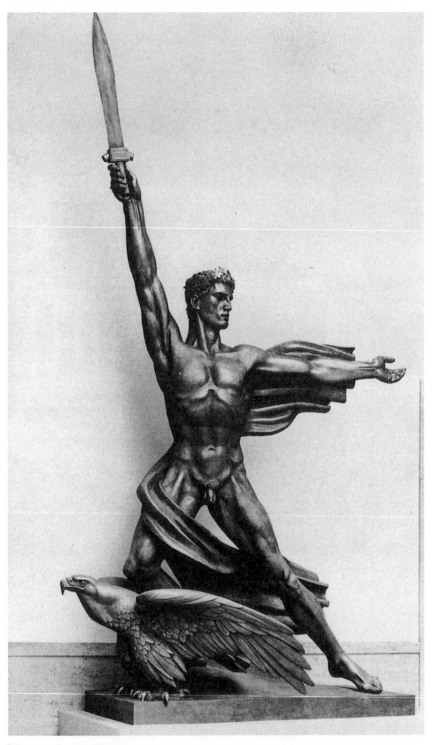

Wamper: Genius of Victory

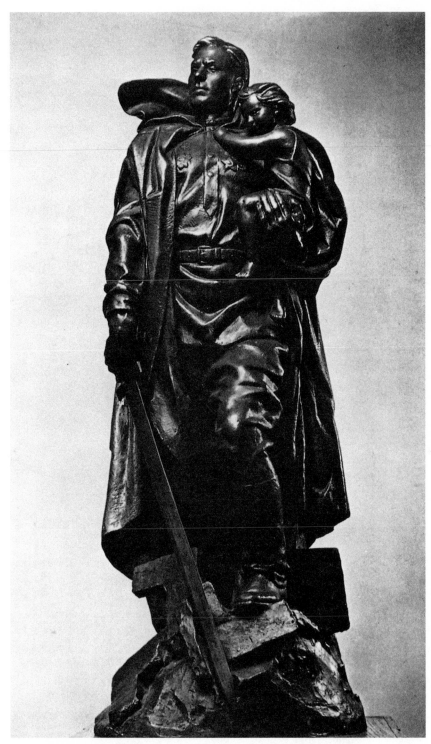

Vuchetich: The Soldier-Liberator (Maquette for the Victory Monument, Treptow Park, East Berlin) (1947–49)

View of Smolenskaia Embankment from the Ukraina hotel

Picture Sources

The colour illustrations fall within one unnumbered section and are credited separately and by illustration number. Black and white illustrations are indicated by page number and location – t.r. (top right), c.l. (centre left), b. (bottom), b.l. (bottom left), etc.

Colour

Department of Defence, Washington DC: 3, 6, 10, 11, 14
Edimedia, Paris: 7, 18, 19
Die Kunst im Dritten Reich (*Die Kunst im Deutschen Reich*): 16
Golomstock, London: 2, 5, 8, 9, 12, 13, 15
Iskusstvo: 4
Visual Arts Library, London: 1, 17

Black and white

Archiv für Kunst und Geschichte, Berlin: 206 (t.)
Bilderberg: 207 (b.)
Bilderdienst Süddeutscher, Munich: 96, 243 (b.), 340 (t.), 349
Chelkovskii, Igor, Paris: 188 (l.), 223 (r.), 267, 319 (t. and b.), 320, 321, 341, 368 (t.)
Das Bild: 229 (r.), 326, 350, 362
Department of Defence, Washington DC: 188 (r.), 195, 238 (l. and r.), 239, 240 (b.), 242, 248 (c.), 250, 293, 315 (b.), 328, 332 (t.l.), 342 (t.), 343 (b.), 359, 360
Die Kunst im Dritten Reich (*Die Kunst im Deutschen Reich*): 134 (b.), 172 (c.), 181 (b.), 191 (c.), 192 (c.), 214 (r.), 233 (l.), 248 (b.), 256 (l.), 258 (t. and b.l.), 263 (b.), 271 (r.), 279, 282, 303, 304 (l. and r.), 313, 323 (t.), 327 (t.), 337, 344 (t.), 346 (t.), 347 (c.r.), 353, 363, 364, 367, 370
Edimedia, Paris: 127, 128, 129, 130, 203, 221 (b.), 294 (r.)
Face of the Ruling Class, The, Allison & Busby, London: 59 (l. and r.)
Golomstock, London: 15, 37 (t.), 42 (b.), 45 (l.), 53 (b.), 73, 167 (b.), 177 (t.), 180 (b.), 192 (t. and b.), 221 (c.), 229 (l. and r.), 257, 268, 276 (t.), 298, 315 (t.), 316 (b.), 317, 319 (t. and b.), 320, 321, 322, 324, 325 (t.), 331, 335, 339, 340 (b.), 342 (b.), 346 (b.), 348, 352, 358, 368 (b.)
Hochschule der Künste, Berlin: 323 (t.)
Heinrich Hoffmann Presse-Illustrationen Zeitgeschichtliches Bildarchiv, Munich: 180 (t.)
Imperial War Museum, London: 25 (b.r.)
Iskusstvo: 25 (b.l.), 72 (t. and b.), 99, 177 (b.), 181 (t.), 197, 210, 212, 214 (l.), 229 (l.), 234 (l. and r.), 256 (l.), 263 (t.), 297, 312, 314, 316, 327 (b.), 329, 332 (b.l.), 336, 347 (t.l.), 351, 356, 361, 367
Novosti Press Agency, London: 42 (c.), 153 (t.), 160, 205, 211, 221 (t.), 222 (t.), 270 (b.), 279, 354, 371, 374

Papernii, Vladimir, Paris: 49 (r.), 222 (b.), 271 (t.), 276 (b.), 346 (b.)
Popperfoto, London:134 (t.), 365
Réalismes, Paris: 41 (r.)
Scala, Italy: 42 (t.)
Silva: *Kunst und Ideologie Fascismus*: 44 (l.), 49 (r.), 119 (c. and b.) 252 (t., c. and b.), 253 (t. and b.)
Society for Cultural Relations with the USSR, London: 50
Sovetskaia Arkhitektura za XXX let, Moscow: 279 (b.)
Speer, S: *Inside the Third Reich*, Weidenfeld & Nicolson, London: 369 (t. and b.)
TASS/Jürgens, Cologne: 167 (t.), 294 (l.), 318
Tretiakov Gallery, Moscow: 373
Ullstein GmbH Bilderdienst, Berlin: 207 (t.), 249 (b.l. and b.r.)
Victoria and Albert Museum, London: 119 (t.), 134 (b.), 363
Visual Arts Library, London: 5 (t., c. and b.), 7, 25 (t.), 37 (b.), 41 (l.), 44 (r.), 45 (r.), 53 (t.), 58, 121, 153 (b.), 167, 172 (b.), 333, 343 (t.), 344 (b.l.)
Zeitungsmagazin, Hamburg: 357
Zentralinstitut für Kunstgeschichte, Munich: 206 (b.), 240 (t.), 243 (t.), 258 (r.), 230, 334, 348 (l.), 345 (b.r.), 355 (c.r.), 372

Notes

Introduction

[1] Iu. Fel'shtinskii (ed.), *SSSR – Germaniia, 1939 Dokumenty i materialy oi Sovetsko-Germanskikh othosheniiakhiv Aprele-Sentiabre 1939*, 1983, pp. 21–22.
[2] F. Roh, *Geschichte der Deutschen Kunst von 1900 bis zur Gegenwart*, Munich, 1958, p. 151.
[3] Berthold Hinz, *Art in the Third Reich*, Oxford, 1980, p. xi.
[4] Norman Cohn, *The Pursuit of the Millennium*, London, 1970, p. 286.
[5] Lewis Mumford, *The Myth of the Machine*, New York, 1967, p. 189.
[6] See, for example, "V. I. Lenin i izobrazitel'noe iskusstvo. Khronika sobytii 1917–1923", *Iskusstvo*, 1975, No. 4, pp. 9–18.
[7] A. Teut, *Architectur im Dritten Reich 1933–1945*, Berlin, Frankfurt and Vienna, 1967, p. 13.
[8] H. Hoffmann, *Hitler Was My Friend*, London, 1955, p. 88.

Chapter One: Modernism and Totalitarianism

[1] Isaiah Berlin, *Personal Impressions*, London, 1980, p. 160.
[2] A. Hamilton, *The Appeal of Fascism*, London, 1971, p. 48.
[3] K. S. Malevich, "On New Systems in Art", Vitebsk, 1919 – quoted from T. Andersen (ed.), *Essays on Art*, London, 1969, Vol. 1, p. 94.
[4] S. Lissitzky-Küppers, *El Lissitzky: Life, Letters, Texts*, London, 1968, p. 327.
[5] Marc Chagall, *My Life*, London, 1965, p. 135.
[6] B. Lifshits, *Polutoroglazyi strelets*, New York, 1978, pp. 142ff.
[7] U. Apollonio (ed.), *Futurist Manifestos*, London, 1973, p. 22.
[8] Ibid., pp. 24–5.
[9] J. Joll, *Intellectuals in Politics*, New York, 1960, p. 141.
[10] Vladimir Markov (ed.), *Manifesty i Programmy russkikh Futuristov*, Munich [no date], pp. 50–1.
[11] C. Tisdall and A. Bozzolla, *Futurism*, London, 1977, p. 89.
[12] S. Tretiakov, "Otkuda i kuda?" in *LEF*, No. 2, 1923, p. 193.
[13] V. Maiakovskii, "Kaplia degtia", in *Manifesty i Programmy ...*, pp. 159–60.
[14] *LEF*, No. 1, 1923, p. 4.
[15] *LEF*, No. 2, 1923, p. 132.
[16] E. Nolte, *Three Faces of Fascism*, New York, Chicago, San Francisco, 1966, p. 150.
[17] D. Mack Smith, *Mussolini*, London, 1983, pp. 7–8.
[18] Nolte, op. cit., p. 152.
[19] Ibid, pp. 189–90.
[20] Ibid., p. 310.
[21] Mack Smith, op. cit., p. 41.
[22] C. J. Taylor, *Futurism, Politics, Painting and Performance*, Ann Arbor, 1979, p. 12.
[23] Mack Smith, op. cit., p. 42.
[24] F. T. Marinetti, "Beyond Communism" – quoted from *Marinetti: Selected Writings*, London, 1972, p. 153.

[25] Tisdall and Bozzolla, op. cit., p. 200.

[26] Ibid., p. 201.

[27] Ibid., p. 15.

[28] LEF, No. 3, 1923, pp. 158–9.

[29] LEF, No. 2, 1923, pp. 133–5.

[30] N. Gorlov, Futurizm i Revolutsiia, Moscow, 1924, p. 10.

[31] Ibid, p. 15.

[32] Ibid., p. 3.

[33] L. Hirschfeld-Mack, The Bauhaus, Victoria (Australia), Longman, 1963, pp. 2–3.

[34] K. Malevich, "O Muzee", in Iskusstvo kommuny, 23 February 1919, p. 2.

[35] N. Chuzhak, "Pod znakom zhiznestroyeniia", in LEF, No. 1, 1923, pp. 36–8.

[36] O. Brik, "Ot kartiny k sittsu", in LEF, No. 2/6, 1924, p. 27.

[37] Apollonio, op. cit., p. 24.

[38] V, Kandinskii, Stupeni, Moscow, 1918, p. 49.

[39] Chagall, op. cit., p. 109.

[40] C. Lodder, Russian Constructivism, Yale University Press, 1983, p. 100.

[41] Ibid.

[42] Ibid., p. 48.

[43] K. Malevich, Ot Kubizma k suprematizmu, Moscow, 1916, p. 1.

[44] Sovetskoe iskusstvo za 15 tet. Sbornik, Moscow, 1934, p. 143.

[45] Apollonio, op. cit., p. 148.

[46] Marinetti, op. cit., p. 155.

[47] J. Milner, Vladimir Tatlin and the Russian Avant-Garde, Yale University Press, 1983, p. 144.

[48] Isskustvo kommuny, No. 8, 26 January 1919.

[49] LEF, No. 1, 1923, p. 9.

[50] LEF, No. 4, 1924, p. 21.

[51] Lodder, op. cit., pp. 88–9.

[52] N. Misler and J. Bowlt, P. Filonov, A Hero and His Fate, Austin, Texas, 1983, p. 226.

[53] S. Fitzpatrick, The Commissariat of Enlightenment, Cambridge University Press, 1970, pp. 138–9.

[54] LEF, No. 4, 1924, p. 12.

[55] Marinetti, op. cit., p. 11.

[56] W. Haftmann, Painting in the Twentieth Century, London, 1960, p. 106.

[57] Lissitzky-Küppers, op. cit., p. 340.

[58] V. Maiakovskii, Sobr. soch., Vol. 12, p. 19.

[59] Sirena, Voronezh, 30 January 1919, No. 4.

[60] LEF, No. 1, 1923, pp. 199, 202.

[61] S. Tretiakov, "Standart" in Oktiabri mysli, Moscow, 1924, No. 2, pp. 30–3.

[62] A. Menshutin and A. Siniavskii, Poeziia pervykh let revoliutsii, Moscow, 1964, p. 154.

[63] LEF, No. 1, 1923, p. 201.

[64] Sbornik – "Modernizm", Moscow, 1980, p. 76.

Chapter Two: Between Modernizm and Realism

[1] L. Trotsky, Literature and Revolution, New York, 1957, pp. 145–7.

[2] Fitzpatrick, op. cit., p. 100–101.

[3] LEF, No. 1, 1923, p. 5.

[4] A. Lunacharskii, "Ob otdele izobrazitel'nykh Iskusstv", (written c. 1920), in Novy Mir, 1966, pp. 237–8.

[5] E. Valkenier, Russian Realist Art, The State and Society: The Peredvizhniki and their Tradition, Ann Arbor, 1977, p. 139.

[6] Fitzpatrick, op. cit., p. 188.

[7] Sovetskoie iskusstvo za 15 let, Moscow, 1934, p. 310.

[8] E. Katsman, 'Kak Sozdavalsva AKhRR' in 'AKhRR. Sbornik vospominanii, statec, dokumentov', Moscow, 1973, p. 81.

[9] L. Schapiro, *Totalitarianism*, London, 1972, p. 23.

[10] V. I. Lenin, *Partiinaia organizatsiia i partiinaia literatura*, Moscow, 1965, p. 5.

[11] Ibid., p. 6.

[12] L. Trotsky, op. cit., p. 221.

[13] S. Fitzpatrick, op. cit., p. 188.

[14] Ibid., p. 236.

[15] Ibid., pp. 244–5.

[16] C. Friedrich and Z. Brzezinski, *Totalitarian Dictatorship and Autocracy*, Frederic A. Praeger, New York, Washington, London, 1965, p. 29.

[17] A. Lunacharskii, *Sobr. soch.*, Moscow, 1964, Vol. 2, p. 613.

[18] G. Urban (ed.), *Stalinism*, London, 1982, p. 417.

[19] *Literaturnoe nasledie. V. I. Lenin i A. V. Lunacharskii, perepiska, doklady, dokumenty*, Moscow, 1971, p. 46.

[20] Trotsky op. cit., pp. 145–9.

[21] M. Drudy Gambillo and C. Brunni (eds), *Dopo Boccioni: Dipinti e Documenti Futuristi del 1915 al 1919*, Rome, Medusa, 1961, p. 29.

[22] Nolte, op. cit., p. 287.

[23] Joll, op. cit., p. 158.

[24] Apollonio, op. cit., p. 200.

[25] Joll, op. cit., pp. 146–7.

[26] Haftmann, op. cit., p. 216.

[27] E. Tannenbaum, *Fascism in Italy*, London, 1972, p. 304.

[28] K. Flint, "Art and the Fascist Regime in Italy", *Oxford Art Journal*, Vol. 3, No. 2 (1980), p. 50.

[29] U. Silva, *Kunst und Ideologie des Fascismus*, Milan, 1973, p. 133.

[30] Nolte, op. cit., p. 231.

[31] Urban, op. cit., p. 417.

[32] "Dialogo con Guttuso sulla Pittura" in *Quaderni Milanesi*, 1962, No. 4–5, p. 22.

[33] A. Pica, *Mario Sironi*, Milan, 1955, p. 18.

[34] M. Lifshits, *Iskusstvo i sovremennyi mir*, Moscow, 1978, p. 201.

[35] Tisdall and Bozzolla, op. cit., p. 199.

[36] Mack Smith, op. cit., p. 110.

[37] B. Ternovets, "Ital'yanskaia pressa i sovetskii otdelna XVI Mezhdunarodnoi vystavke v Venetsii", in *Isskustvo*, 1928, pp. 93, 98.

[38] Ibid., p. 105.

[39] Ibid., p. 104.

[40] Ibid.

[41] Iu. Kolpinskii, "Fashizm i monumental'noe Iskustvo", in *Iskusstvo*, 1934, No. 4, p. 197.

[42] Hitler, *Mein Kampf*, Boston, 1971, p. 258.

[43] J. Ritchie, *German Literature under National-Socialism*, London, 1983, p. 13.

[44] Hitler, *Mein Kampf*, pp. 496–7.

[45] *The Early Goebbels Diaries* (ed. H. Heiber), London, Weidenfeld & Nicolson, 1962, entries for 23 October 1925 and 31 January 1926, pp. 44, 63.

[46] Barbara M. Lane and Leila J. Rupp, *Nazi Ideology before 1923*, Manchester University Press, 1978, pp. 75, 78.

[47] Ritchie, op. cit., p. 40.

[48] D. Egbert, *Social Radicalism and the Arts in Western Europe. A Cultural History from the French Revolution to 1968*, New York, p. 633.

[49] Ibid.

[50] Ibid., p. 644.

[51] B. S. Myers, *The German Expressionists*, New York, 1957, p. 279.

[52] D. Pike, *German Writers in Soviet Exile, 1933–45*, University of North Carolina Press, 1982, p. 4.

[53] J. Willett, *The New Sobriety 1917–33 Art and Politics in the Weimar Period*, London, 1978, p. 70.

[54] Pike, op. cit., p. 21.

[55] Ibid., pp. 23–4.

[56] V. P. Lapshin, "Pervaia vystavka russkogo iskusstva. Berlin. 1922. Materialy k istorii sovetsko-germanskikh khudozhestvennykh sviazei", in *Sovetskoe iskusstvoznanie*, 1982, No. 1, p. 329.

[57] Ibid., p. 330.

[58] Ibid., p. 331.

[59] Lissitzky-Küppers, op. cit., p. 340.

[60] A. Speer, *Inside the Third Reich*, London, 1978, p. 264.

[61] P. Nisbet, "Some Facts of the Organizational History of the van Diemen Exhibition in *The First Russian Show* (exhibition catalogue), London, 1983, pp. 69–71.

[62] Archives of Stedelijk Museum, Amsterdam.

[63] Hinz, op. cit., p. 53.

[64] Willett, op. cit., p. 49.

[65] Egbert, op. cit., p. 649.

[66] C. Schnailt, *Hannes Meyer*, Taufen, Switzerland, 1965.

[67] *Arkhitektura SSSR*, 1933, No. 6.

[68] Pike, op. cit., p. 8.

[69] Ibid., p. 18.

[70] Willett, op. cit., p. 203.

[71] J. C. Fest, *Hitler*, Harmondsworth, 1977, p. 188.

[72] Ibid., p. 214.

[73] A. Bullock, *Hitler: A Study in Tyranny*, New York, 1964, p. 580.

[74] Haftmann, op. cit., p. 305.

[75] *Istoriia russkogo iskusstva*, Moscow, 1957, Vol. XI, p. 175.

[76] M. Geller, A. Nekrich, *Utopiia u vlasti*, London, 1982, Vol. 1, p. 210.

[77] E. Katsman in *AKhRR. Sbornik vospominanii, statei, dokumentov*, p. 81.

[78] V. Komar and A. Melamid, "Rol' voyennogo vedomstva v sovetsom iskusstve", in *A-Ya*, Paris, No. 2, p. 51.

[79] *Bor'ba za realizm v iskusstve 20kh godov*, Moscow, 1962, p. 127.

[80] Ibid.

[81] *Sovetskoe iskusstvo za 15 let*, p. 390.

[82] *Bor'ba za realizm*, p. 158.

[83] Lodder, op. cit., p. 184.

[84] *Iskusstvo*, 1933, No. 5, pp. 120–1.

[85] Ibid., p. 119.

[86] G. Griundig, *Mezhdu karnavalom i velikim, postom*, Moscow, 1963, p. 175.

[87] C. Brenner, *Die Kunstpolitik des National-Sozialismus*, Hamburg, 1963, pp. 7–10.

[88] Griundig, op. cit., pp. 184–5.

[89] A. Speer, *Spandau, The Secret Diaries*, New York, 1976, p. 261.

[90] Hinz, op. cit., p. 54.

[91] Ibid., p. 57.

[92] Barbara M. Lane, *Architecture and Politics in Germany, 1918–1945*, Harvard University Press, 1968, p. 176.

[93] Ibid., p. 178.

[94] Ia. Tugendkhol'd, "Vystavka germanskogo iskusstva v Moskve", in *Pechat' i revoliutsiia*, 1934, pp. 105–11.

[95] Pike, op. cit., p. 286.

[96] *Sovetskoe iskusstvo za 15 let*, pp. 383–90.

[97] Pike, op. cit., pp. 287–8.

[98] Nolte, op. cit., p. 8.

Chapter Three: From Words to Action

[1] Hinz, op. cit., p. 2.

[2] *Sovetskoe iskusstvo za 15 let*, Moscow, 1934, pp. 644–5.

[3] N. Baynes (ed.), *Speeches of Adolf Hitler*, Oxford University Press, 1942, Vol. 1, p. 568.

[4] Ibid., Vol. 1, p. 576.

[5] Ibid., Vol. 1, p. 572.

[6] *A Guide to the Exhibition of Degenerate Art*, translated by William C. Bunce, Silver Fox Press, Redding, Conn., 1972, pp. 24–6.

[7] Baynes, op. cit., pp. 591–2.

[8] Ibid., p. 586.

[9] Ibid., p. 571.

[10] Ibid., p. 579.

[11] *A Guide to the Exhibition of Degenerate Art*, pp. 28–30.

[12] Baynes, op. cit., pp. 606–7.

[13] *A Guide to the Exhibition of Degenerate Art*, p. 26.

[14] *Pervyi vsesoiuznyi s'ezd sovetskikh pisatelei*, Moscow, 1934, p. 4.

[15] Ibid., p. 19.

[16] Ibid., p. 1.

[17] Ibid., p. 12.

[18] *Hitler's Table Talk. 1941–1944*, London, 1953, pp. 370–1.

[19] *Pervyi vsesoyuznyi s'ezd sovetskikh pisatelei*, p. 498.

[20] G. Mosse, *Nazi Culture*, New York, p. 142.

[21] *Pervyi vsesoyuznyi s'ezd sovetskikh pisatelei*, p. 4.

[22] Mosse, op. cit., p. xxxi.

[23] *Pervyi vsesoyuznyi s'ezd sovetskikh pisatelei*, p. 151.

[24] Hellmut Lehmann-Haupt, *Art under a Dictatorship*, New York, 1954, p. 176.

[25] *Pervyi vsesoyuznyi s'ezd sovetskikh pisatelei*, p. 284.

[26] Ibid., p. 304.

[27] A. Agurskii, *Ideologiia natsional-bol'shevizma*, Paris, 1980, p. 194.

[28] *Pervyi vsesoyuznyi s'ezd sovetskikh pisatelei*, p. 302.

[29] Ibid., p. 304.

[30] Ibid., p. 680.

[31] R. Herzstein, *The War that Hitler Won: the Most Infamous Propaganda Campaign in History*, New York, 1978, p. 154.

[32] *Iskusstvo*, 1952, No. 1, p. 3.

[33] A. G. Hardy, *Hitler's Secret Weapon*, New York, Washington and Hollywood, 1967, p. 28.

[34] Ibid., p. 261.

[35] *The Goebbels Diaries, 1939–41*, ed. Fred Taylor, London, 1982, p. 255.

[36] *Pervyi vsesoyuznyi s'ezd sovetskikh pisatelei*, p. 716.

[37] K. F. Schrieber, *Das Reich der Reichskulturkammer*, Berlin, 1955.

[38] Hinz, op. cit., p. 32.

[39] *Hitler's Table Talk*, p. 603.

[40] H. Hoffmann, *Hitler Was My Friend*, London, 1955, p. 170.

[41] Mosse, op. cit., pp. 162–3.

[42] A. Hamilton, *The Appeal of Fascism*, London, 1971, p. 164.

[43] Mosse, op. cit., pp. 154–8.

[44] *Iskusstvo i ideologicheskaia rabota partii*, Moscow, 1976, p. 23.

[45] Hinz, op. cit., p. 13.

[46] *The Goebbels Diaries, 1939–1941*, entries for 24 November, 26 November, 3 December 1940; 21 May 1941.

[47] Hinz, op. cit., p. 12.

[48] Lehmann-Haupt, op. cit., p. 181.

[49] C. Brenner, *Die Kunstpolitik des National-Sozialismus*, Hamburg, 1963, p. 172.

[50] A. Gerasimov, *Moia Zhizn*, Moscow, 1963, p. 77.

[51] P. Rave, *Kunstdictatur im Dritten Reich*, Hamburg, 1949, p. 52.

[52] *Kunst im 3 Reich: Documente der Unterwerfung*, Frankfurt Kunstverein, 1977, p. 27.

[53] *A Guide to the Exhibition of Degenerate Art*, pp. 26–8.

[54] Ibid.

[55] *Iskusstvo*, 1933, No. 4, pp. 60–64.

[56] *Iskusstvo*, 1933, No. 1, p. 3.

[57] *Iskusstvo*, 1933, No. 3, p. 1.

[58] *Iskusstvo*, 1934, No. 6, p. 18.

[59] A. K. Lebedev, *Iskusstvo v okovakh*, Moscow, 1962, p. 21.

[60] *Iskusstvo*, 1936, No. 3.

[61] *Iskusstvo*, 1937, No. 6, p. 8.

[62] *Hitler's Table Talk*, p. 370.

[63] M. Domarus, *Hitler. Reden und Proklamationen, 1932–1945*, Munich, 1962, Band 1, p. 718.

[64] *Modernizm*, Moscow, 1980, p. 20.

[65] F. Roh, *German Art in the Twentieth Century*, London, 1968, p. 142.

[66] *Iskussto, kotoroe ne pokorilos. Nemetskie khudozhniki v periode fashizma*, Moscow, 1972, p. 105.

[67] Ibid., pp. 123, 132.

[68] *Iskusstvo kommuny*, No. 1, 7 December 1918.

[69] H. Grosshans, *Hitler and the Artists*, New York and London, 1983, p. 71.

[70] *Iskusstvo*, 1938, No. 4, p. 40.

[71] A. Rudenstine (ed.), *The George Costakis Collection: Russian Avant-Garde Art*, London, 1981, p. 36.

[72] Ibid., pp. 62–5.

[73] Nadezhda Mandel'stam, *Vtoraia kniga*, Paris, 1972, p. 253.

[74] Mack Smith, op. cit., p. 159.

[75] Ibid., p. 212.

[76] Ibid., p. 156.

[77] Ibid., p. 359.

[78] *Popolo d'Italia*, April 1933.

[79] *Sabavdia, citta nuova fascista*, London, 1982, p. 2.

[80] Mack Smith, op. cit., p. 198.

[81] Ibid., p. 369.

[82] Ibid., p. 155.

[83] M. Missoroli and O. Agresti, *The Organization of the Arts and Professions in the Fascist Guild State*, Rome, 1938, pp. 16–17.

[84] K. Flint, "Art and the Fascist Regime in Italy", *Oxford Art Journal*, Vol. 3, No. 2.

[85] O. Tadden and L. Mercante, *Arte Fasciste, arte per la massa*, Rome, 1935.

[86] *Matino*, 20 May 1934.

[87] Missoroli and Agresti, op. cit., pp. 5–6.

[88] Ibid., p. 58.

[89] *Studio*, London, December 1936, pp. 297–302.

[90] Mack Smith, op. cit., p. 252.

[91] K. Flint, op. cit., p. 50.

[92] Mack Smith, op. cit., p. 352.

[93] Mao Tse-tung, *On Literature and Art*, Peking, 1960, pp. 15–16.

[94] Ibid., p. 35.

[95] Chung Chao, *The Communist Programme for Literature and Art in China*, 1955, p. 4.

[96] *A Definitive Translation of Mao Tse-tung on Literature and Art: the Cultural Revolution in Context*, Washington, 1967, pp. 18, 22.

[97] Ibid., p. 21.

[98] Chung Chao, op. cit., p. 1.

[99] *A Definitive Translation of Mao Tse-tung on Literature and Art . . .*, p. 8.

[100] Ibid., p. 17.

[101] Chung Chao, op. cit., p. 24.

[102] Ibid., p. 25.

[103] Ibid., p. 26.

[104] Ibid., p. 4.

[105] J. Archer, *Mao Tse-tung*, New York, 1972, p. 136.

[106] Mao Tse-tung, *Let a Hundred Flowers Bloom*, New York, 1957, pp. 45–6.

[107] Ibid., pp. 49–50.

[108] P. Devillers, *Mao*, New York, 1969, p. 34.

[109] *A Definitive Translation of Mao Tse-tung on Literature and Art ...*, p. 34.

[110] Chung Chao, op. cit., p. 39.

[111] *China Viewpoints Mei nsu: New Art in China*, Hong Kong, n.d., pp. 18–20.

[112] *A Definitive Translation of Mao Tse-tung on Literature and Art ...*, p. 33.

PART TWO Prologue: Encounter in Paris (1937 and beyond)

[1] *Iskusstvo*, 1947, No. 5, p. 16.

[2] *Paris. Exhibition Internationale, 1937*. Deutsche Abteilung, Berlin, 1937, p. 7.

[3] *Iskusstvo*, 1937, No. 4, p. 149.

[4] *Paris. Exhibition Internationale. Pavilyon SSSR na Mezhdunarodnoi vystavke v Parizhe*, Moscow, 1938, p. 4.

[5] A. Speer, *Inside the Third Reich*, London, 1979, p. 130.

[6] *Die Kunst im Dritten Reich*, 1941, p. 103.

[7] *Iskusstvo*, 1950, No. 1, p. 64.

[8] G. Severini, "Marxism and Art", in *Seven Arts*, selected and edited by Fernando Puma, New York, 1956, pp. 88–9.

[9] *Art Digest*, 1 November 1937, p. 11.

[10] R. Taylor, *The World in Stone – The Role of Architecture in the National Socialist Ideology*, University of California Press, 1974, p. 110.

[11] L. Rempel', "Nemetskii formalizm i ego fashistskie kritiki!" in *Iskusstvo*, 1934, No. 3, p. 2.

[12] Severini, op. cit., p. 89.

[13] *Paris. Exhibition Internationale, 1937*, Deutsche Asteilung, pp. 46–50.

[14] *Iskusstvo*, 1937, No. 6.

[15] Bullock, op. cit., p. 530.

[16] Speer, op. cit., p. 243.

[17] Mosse, op. cit., p. xix.

Chapter Four: The Present, the Past and the Future (inheritance and tradition)

[1] *The Goebbels Diaries, 1939–45*, London, 1982, p. 49.

[2] W. Yenne and W. Keith, *German War Art, 1939–45*, New York, 1983, p. 23.

[3] *Soveshchanie deyatilei sovetskoi muzyki v Tsk VKPb*, Moscow, 1948, pp. 139–40.

[4] Ibid.

[5] *Sovetskoe iskusstvo za 15 let*, Moscow, 1934, p. 145.

[6] *Ocherki po istorii russkogo iskusstva*, Moscow, Akademia khudozhestv – SSSR, 1954, p. 80.

[7] Ibid., pp. 47, 141, 158, 249.

[8] Ibid., p. 46.

[9] Ibid., p. 47.

[10] Ibid., pp. 56, 68.

[11] Ibid., p. 94.

[12] *Iskusstvo*, 1949, No. 6, p. 14.

[13] *Iskusstvo*, 1949, No. 4, p. 16.

[14] *Iskusstvo*, 1949, No. 1, p. 15.

[15] Ibid., p. 9.

[16] Ibid., pp. 18–19.

[17] Ibid., p. 39.

[18] *Iskusstvo*, 1948, No. 2, p. 3.

[19] *Iskusstvo*, 1947, No. 7/8, p. 43.

[20] *Iskusstvo*, 1949, No. 5, p. 77.

[21] *Iskusstvo*, 1952, No. 1, p. 86.

[22] *Iskusstvo*, 1949, No. 1, p. 16.

[23] Ibid., p. 13.

[24] *Iskusstvo*, 1948, No. 5, p. 9.

[25] Ibid., p. 13.

[26] *Iskusstvo*, 1947, No. 7/8.

[27] *Voprosy teorii sovetskogo izobrazitel'nogo iskusstva*, Moscow, 1950, p. 64.

[28] *Iskusstvo*, 1947, No. 3, p. 4.

[29] Aldous Huxley, *The Devils of Loudon*, Panther Books, 1979, p. 235.

[30] *Literaturnoe nasledstvo. V. I. Lenin i A. V. Lunacharskii, perepiska, doklady, dokumenty*, Moscow, 1971, p. 46.

[31] *Iskusstvo kommuny*, No. 9, 23 February 1919.

[32] Trotsky, op. cit., p. 12.

[33] Baynes, op. cit., p. 597.

[34] V. I. Lenin, "Kriticheskie zametki po natsional'nomu voprosu", in *Sochineniia* (Collected Works), 4th edn, Vol. 20, p. 8.

[35] Baynes, op. cit., p. 567.

[36] G. Nedoshivin, *Ocherki teorii iskusstva*, Moscow, 1953, p. 164.

[37] Ibid., pp. 166, 177.

[38] Ibid., pp. 170–1.

[39] A. Rosenberg, *Selected Writings*, London, 1970, p. 35.

[40] *Die Kunst im Dritten Reich*, 1938, No. 8, p. 232.

[41] Lehmann-Haupt, op. cit., p. 97.

[42] *The Goebbels Diaries, 1939–41*, pp. 304–5.

[43] *Ocherki po istorii russkogo iskusstva*, p. 83.

[44] Nedoshivin, op. cit., p. 183.

[45] R. Cecil, *The Myth of the Master Race: Alfred Rosenberg and Nazi Ideology*, London, 1972, p. 128.

[46] Speer, *Spandau. The Secret Diaries*, New York, 1976, p. 96.

[47] Speer, *Inside the Third Reich*, p. 81.

[48] *Voprosy teorii* ..., pp. 29–30.

[49] A. Gerasimov, *Zhizn' khudozhnika*, Moscow, 1963, p. 216.

[50] Bullock, op. cit., p. 354.

[51] Lehmann-Haupt, op. cit., p. 216.

[52] Ibid., p. 91.

[53] G. Ritter, *The Third Reich*, London, 1955, p 386.

[54] Mosse, *The Nationalization of the Masses*, New York, 1975.

[55] With regard to the ideological sources of totalitarianism see: J. L. Radel, *The Roots of Totalitarianism: The Ideological Sources of Fascism, National Socialism and Communism*, New York, 1975: D. Gusman, *The Scientific Origins of National-Socialism*, New York, 1971.

[56] N. Berdiaev, *Russkaia ideia*, Paris, 1971, pp. 33, 35.

[57] Ibid., p. 249.

[58] G. Mosse, *The Crisis of German Ideology*, London, 1964, p. 1.

[59] G. Mosse, *The Culture of Western Europe. The Nineteenth and Twentieth Centuries*, London, 1963, p. 43.

[60] Mosse, *The Crisis of German Ideology*, p. 66.

[61] W. Laqueur, *Russia and Germany: A Century of Conflict*, London, 1965, p. 14.

[62] Radel, op. cit., p. 106.

[63] N. G. Chernyshevskii, *Esteticheskiye otnosheniya iskusstva k deisvitel'nosti*, Saint Petersburg, 1855, p. 102.

[64] V. G. Belinksii, *Izbr. soch.*, Moscow, 1947, p. 537.

[65] G. Obraztsov, *Estetika V. V. Stasova i razvitie russkogo natsional'nogo-realisticheskogo iskusstva*, Leningrad, 1975, p. 53.

[66] E. Valkenier, *Russian Realist Art. The State and Society: The Perezdhizniki and their Tradition*, Ann Arbor, 1977, pp. 172–93.

[67] V. V. Stasov, *Stat'i i zametki*, Moscow, 1959, Vol. 2, p. 5.

[68] Obraztsov, op. cit., p. 68.

[69] Valkenier, op. cit., p. 55.

[70] Chernyshevskii, op. cit., p. 66.

[71] Mosse, *The Crisis of German Ideology*, pp. 33, 282.

[72] V. V. Stasov, *Izbrannoe*, Moscow and Leningrad, 1950, Vol. 1, p. 9.

[73] V. V. Stasov, *Sobranie sochinenii*, Vol. 1, pp. 125–7.

[74] F. Stern, *The Politics of Cultural Despair – A Study in the Rise of Germanic Ideology*. University of California Press, 1961, p. 135.

[75] Georg Grosz, *A Little Yes and A Big No*, New York, 1946, p. 122.

[76] J. Ritchie, *German Literature under National-Socialism*, London, 1983, p. 11.

[77] H. Grosshans, *Hitler and the Artists*, New York and London, 1983, p. 68.

[78] "Nishchiye dukhom" and "Podvor'e prokazhennykh" (the titles of two articles by Stasov written in the nineties), *Izbrannoe*, Vol. 1, pp. 347, 353.

[79] Stasov, *Izbr. soch.*, Vol. 1, p. 218.

[80] Obraztsov, op. cit., p. 153.

[81] Stasov, *Izbr. soch.*, Vol. 2, pp. 418–19.

[82] R. Herzstein, op. cit., p. 54.

[83] A. Gerasimov, *Za sotsialisticheskii realizm*, Moscow, 1952, p. 21.

[84] Stern, op. cit., p. 133.

Chapter Five: Function and Language

[1] Yenne and Keith, op. cit., p. 17.

[2] Z. A. B. Zeman, *Nazi Propaganda*, London, 1964, p. 59.

[3] *The Goebbels Diaries, 1939–41*, London, 1982, p. 138.

[4] *Iskusstvo*, 1952, No. 1, p. 64.

[5] Hitler, *Mein Kampf*, Boston, 1971, p. 176.

[6] V. Reimann, *The Man Who Created Hitler: Joseph Goebbels*, London, 1977.

[7] V. Reimann, *Dr Joseph Goebbels*, Vienna, Munich and Zurich, 1971, p. 93.

[8] Hitler, op. cit., pp. 180–1.

[9] Baynes, op. cit., p. 571.

[10] Ibid., p. 574.

[11] *A Guide to the Exhibition of Degenerate Art*, p. 18.

[12] K. Tsetkin, *Vospominaniia o Lenine*, Moscow, 1955, p. 14.

[13] Ibid., p. 14.

[14] K. Zetkin, *Erinnerung an Lenin*, Vienna and Berlin, 1929, p. 14.

[15] *Sovetskoye iskusstvo za 15 let*, pp. 226, 351, 356, 367, 368, 375, 387, etc.

[16] *Bor'ba za realizm v sovetskom iskusstve 20kh godov*, Moscow, 1962, p. 157.

[17] For example: *Sovetskoe iskusstvo za 15 let*, p. 356; *Bor'ba za realizm ...*, p. 162; *AKhRR: Sbornik vospominanii, statei, dokumentov*, p. 320.

[18] *LEF*, 1924, No. 5.

[19] Lehmann-Haupt, op. cit., p. 144.

[20] Reimann, *The Man who Created Hitler*, p. 166.

[21] Baynes, op. cit., p. 578.

[22] G. Nedoshivin, *Ocherki teorii iskusstva*, Moscow, 1953, p. 132.

[23] Lehmann-Haupt, op. cit., p. 89.

[24] *Hitler's Table Talk*, pp. 370–1.

[25] *Iskusstvo*, 1948, No. 2, p. 4.

[26] *Iskusstvo*, 1952, No. 3, p. 5.

[27] *Soveshchanie deiatelei sovetskoi muzyki v TsK VKP/b*, Moscow, 1948, pp. 143–4.

[28] Ritchie, op. cit., p. 10.
[29] *Sovetskaia literatura*, Moscow, 1934, p. 20.
[30] *Pervyi vsesoiuznyi s'ezd sovetskikh pisatelei*, Moscow, 1934, p. 147.
[31] Ibid., p. 433.
[32] V. Frumkin, "Ran'she my byli marksisty: pesennye sviazi dvukh sozialismov", in *Obozrenie*, Paris, 1985, Nos. 16 and 17.
[33] Ritchie, op. cit., p. 92.
[34] Speer, *Spandau. The Secret Diaries*, p. 312.
[35] Baynes, op. cit., p. 574.
[36] *Iskusstvo*, 1949, No. 1, p. 5.
[37] *Iskusstvo*, 1952, No. 3, p. 8.
[38] Nedoshivin, op. cit., pp. 145–6.
[39] *Iskusstvo*, 1951, No. 1, p. 68.
[40] Domarus, op. cit., p. 447.
[41] Baynes, op. cit., p. 608.
[42] Ibid., p. 593.
[43] *Iskusstvo*, 1951, No. 6, p. 23.
[44] *Iskusstvo*, September 1951, p. 55.
[45] Mosse, *The Nationalization of the Masses*, p. 203.
[46] Iu. Fel'shtinskii (ed.), *SSSR – Germaniya, 1939–1941*, 1981, p. 186.
[47] Nedoshivin, op. cit., p. 203.
[48] Ibid., pp. 320–1.
[49] Ibid., p. 224.
[50] Ibid., p. 314.
[51] *Das Bild*, 1936, No. 6, p. 290.
[52] Hinz, op. cit., p. 77.
[53] *Iskusstvo*, 1950, No. 1, p. 23.
[54] *Iskusstvo*, 1951, No. 1, p. 69.
[55] Hinz, op. cit., p. 111.
[56] R. S. Kaufman, *Sovetskaia tematicheskaia kartina*, Moscow, 1951, p. 112.
[57] *Iskusstvo*, 1948, No. 2, p. 4.
[58] Hoffmann, op. cit., p. 107.
[59] Hinz, op. cit., p. 163.
[60] *The Goebbels Diaries, 1939–41*, p. 75.
[61] *Pervyi vsesoiuzni s'ezd, sovetskikh pisatelei*, pp. 303, 331, 370, 384.
[62] H. Buchheim, *Totalitarian Rule: its Nature and Characteristics*, Middletown, Conn., 1968, p. 14.
[63] Joachim Fest, *The Face of the First Reich*, Harmondsworth, 1972, p. 438.
[64] M. Geller, *Mashina i vintiki. Istoriia formirovaniia sovetskogo cheloveka*, London, 1985, p. 9.
[65] I. Stalin, "Marksizm i voprosy yazykoznaniia", *Pravda*, 1950, p. 7.
[66] *Iskusstvo*, 1951, No. 5, p. 73.
[67] Baynes, op. cit., p. 585.
[68] Ibid., p. 606.
[69] R. Herzstein, *The War that Hitler Won*, p. 50.
[70] Stalin, op. cit., pp. 7–8.
[71] Baynes, op. cit., p. 582.
[72] Stalin, op. cit., p. 32.
[73] V. Reimann, *Dr Joseph Goebbels*, p. 218.
[74] C. Friedrich and Z. Brzezinski, *Totalitarian Dictatorship and Autocracy*, New York, Washington and London, p. 127.
[75] Mosse, *Nazi Culture*, p. 127.
[76] Geller, op. cit., p. 180.
[77] Lenin, *Sochineniia*, 4th edition, Vol. 31, p. 270.
[78] Fest, op. cit., p. 117.
[79] Herzstein, *Adolf Hitler and the Third Reich, 1933–45*, Boston, 1971, p. 48.

[80] Fest, op. cit., p. 327.
[81] *Pervyi vsesoiuznyi s'ezd sovetskikh pisatelei*, pp. 315–16.
[82] Ibid.
[83] R. Manvell and H. Fraenkel, *Heinrich Himmler*, London, 1965, pp. 135–6.
[84] G. Urban (ed.), *Stalinism*, London, 1982, p. 137.
[85] Buchheim, op. cit., p. 47.
[86] Manvell and Fraenkel, op. cit., p. 62.
[87] *Pervyi vsesoiuznyi s'ezd sovetskikh pisatelei*, (Speeches by Vs. Vishnevskii and V. Shklovskii), pp. 285, 154.
[88] Mack Smith, op. cit., p. 174.
[89] Ibid., p. 210.
[90] Ibid., p. 174.
[91] *Kunst im Dritten Reich*, p. 125.
[92] *Iskusstvo*, 1947, No. 5, p. 22.
[93] Mosse, *Nazi Culture*, p. 108.
[94] Fest, op. cit., p. 338.
[95] Severini, op. cit., p. 43.
[96] Mosse, *Nazism*, Oxford, 1978, p. 43.
[97] Hannah Arendt, *The Origins of Totalitarianism*, London, 2nd edn., 1958, p. 474.

Chapter Six: Structure

[1] Peter Smith, "Soviet Art Reconsidered", *Art Monthly*, London, October 1981, p. 7.
[2] Hinz, op. cit., p. 16.
[3] Ibid., foreword.
[4] *A Guide to the Exhibition of Degenerate Art*, p. 24.
[5] *Iskusstvo*, 1934, No. 2, p. 6.
[6] *Iskusstvo*, 1938, No. 3, p. viii.
[7] *Iskusstvo*, 1938, No. 5, p. 85.
[8] *Vystavki sovetskogo izobrazitel'nogo iskusstva. Spravochnik*, Moscow, 1973, Vol. 2.
[9] *The Goebbels Diaries, 1939–41*, 21 November 1940, p. 181.
[10] *Iskusstvo*, 1947, May–June, p. 3.
[11] *30 let sovetskogo izobrazitel'nogo iskusstva*, pp. 30–7.
[12] Ibid., pp. 68–9.
[13] Reimann, *Dr Joseph Goebbels*, pp. 215–16.
[14] Arendt, op. cit., p. 374.
[15] V. Papernii, *Kul'tura "Dva"*, Ann Arbor, 1985, p. 132.
[16] The Himmler File in the Hoover Archives, folder 332.
[17] *Voprosy teorii sovetskogo izobrazitel'nogo iskusstva*, Moscow, 1950, p. 62.
[18] *Iskusstvo*, 1937, No. 6, p. 60.
[19] A. Gerasimov, *Za sotsialisticheskii realizm*, Moscow, 1952, p. 116.
[20] Lehmann-Haupt, op. cit., p. 57.
[21] Taylor, op. cit., p. 191.
[22] *Literaturnaia gazeta*, 29 January 1933, pp. 4–5.
[23] Papernii, op. cit., p. 34.
[24] *Iskusstvo*, 1938, No. 4, p. 181.
[25] Hoffmann, op. cit., p. 171.
[26] J. Fest, *Hitler*, Harmondsworth, 1974, p. 758.
[27] Hoffmann, op. cit., pp. 113–14.
[28] *Demokratiia i bolshevizm*, Berlin, 1938, pp. 8–9.
[29] *Iskusstvo*, 1937, No. 6, p. 61.
[30] R. Cecil, *The Myth of the Master Race: Alfred Rosenberg and Nazi Ideology*, London, 1972, p. 150.
[31] *Pervyi vsesoiuznyi s'ezd sovetskikh pisatelei*, p. 277.

[32] Ibid., p. 376.

[33] Hinz, op. cit., p. 2.

[34] V. Zimenko, *Sovetskaia istoricheskaia zhivopis'*, Moscow, 1970.

[35] Fest, *Hitler*, p. 415.

[36] *Iskusstvo*, 1950, No. 1, p. 8.

[37] A. Kuznetsov, "Sovetskaia istoricheskaia kartina", in *30 let sovetskogo izobrazitel'nogo iskusstva*, pp. 98–114.

[38] B. Mussolini, *My Autobiography*, New York, 1928, p. 297.

[39] *Voprosy teorii sovetskogo izobrazitel'nogo iskusstva*, p. 36.

[40] *30 let sovetskogo izobrazitel'nogo iskusstva*, p. 108.

[41] Yenne and Keith, op. cit., p. 18.

[42] Hitler, *Mein Kampf*, London, 1939, pp. 32, 116.

[43] Bullock, op. cit., p. 362.

[44] Fest, *The Face of the Third Reich*, p. 113.

[45] Apollonio, op. cit., p. 21.

[46] *30 let sovetskogo izobrazitel'nogo iskusstva*, p. 64.

[47] E. Vostokov, *Grekovtsy*, Moscow, 1983, p. 46.

[48] *Iskusstvo*, 1948, No. 5, p. 9; 1949, No. 1, p. 17; 1949, No. 5, pp. 3–4, etc.

[49] Mussolini, op. cit., p. 124.

[50] Mack Smith, op. cit., p. 143.

[51] Hinz, op. cit., p. 79.

[52] *Iskusstvo*, 1952, No. 3, p. 7.

[53] Mussolini, op. cit., p. 127.

[54] *Demokratiia i bol'shevizm*, p. 40.

[55] Mosse, *Nazi Culture*, pp. xxix, 3.

[56] *Kunst im Dritten Reich*, 1943, No. 1, p. 16.

[57] *30 let sovetskogo izobrazitel'nogo iskusstva*, p. 119.

[58] Hinz, op. cit., p. 111.

[59] *Kunst im Dritten Reich*, 1942, No. 6, p. 45.

[60] *Iskusstvo*, 1951, No. 4, p. 71.

[61] *Voprosy teorii sovetskogo izobrazitel'nogo iskusstva*, p. 40.

[62] R. A. Kauffmann, *Die neue Deutsche Malerei*, Berlin, 1941.

[63] Mosse, *Nazi Culture*, p. 163.

[64] *Iskusstvo*, 1950, No. 1, p. 78.

[65] *30 let sovetskogo izobrazitel'nogo iskusstva*, p. 119.

[66] Gerasimov, *Za sotsialisticheskii realizm*, p. 89.

[67] *Matino*, 20 May 1934.

[68] Speer, *Inside the Third Reich*, p. 329.

[69] Hinz, op. cit., foreword.

[70] *Voprosy teorii sovetskogo izobrazitel'nogo iskusstva*, pp. 93–4.

[71] Lehmann-Haupt, op. cit., p. 176.

Chapter Seven: Architecture and Style

[1] Hoffmann, op. cit., p. 184.

[2] *Arkhitektura SSSR*, 1935, No. 7, p. 1.

[3] *Sbornik, Arkhitektura SSSR*, Moscow, 1947, p. 3.

[4] The main sources on this are works by Albert Speer: his prison diaries and the memoirs, *Inside the Third Reich*.

[5] *Iskusstvo*, 1939, No. 6, p. 30.

[6] B. M. Lane, *Architecture and Politics in Germany, 1918–1945*, Harvard University Press, 1968, p. 142.

[7] Baynes, op. cit., p. 601.

[8] Ibid., p. 582.

[9] *Sbornik, Arkhitektura SSSR*, 1947, p. 5.

[10] Baynes, op. cit., p. 581.

[11] Ibid., p. 573.

[12] *Arkhitektura SSSR*, 1952, No. 1, p. 2.

[13] Ibid., 1952, No. 11, p. 14.

[14] Ibid., 1952, No. 4, p. 3.

[15] W. Rittich, *New German Architecture*, Berlin, 1944, pp. 24, 31, 33.

[16] Speer, *Inside the Third Reich*, p. 226.

[17] Ibid.

[18] Henry A. Miller, "Some New Towns in Italy in the 1930s", in H. A. Miller and L. Nochlin (eds.), *Art and Architecture in the Service of Politics*, Cambridge, Mass., and London, 1978, p. 332.

[19] *Sbornik, Arkhitektura SSSR*, 1947, p. 12.

[20] P. Schmittenner, *Baukunst in neuen Reich*, Munich, 1934, p. 21.

[21] Baynes, op. cit., p. 583.

[22] Rittich, op. cit., p. 5.

[23] Baynes, op. cit., p. 600.

[24] Speer, *Inside the Third Reich*, p. 199.

[25] *Gorodskoe khoziaistvio Moskvy*, 1949, No. 3, p. 2.

[26] Speer, *Inside the Third Reich*, p. 233.

[27] Ibid., p. 226.

[28] Ibid., p. 203.

[29] *The Goebbels Diaries, 1939–41*, p. 446.

[30] Speer, *Spandau. The Secret Diaries*, p. 93.

[31] Papernii, op. cit., p. 103.

[32] *Arkhitektura SSSR*, 1932, No. 1–2, p. 7.

[33] Papernii, op. cit., p. 37.

[34] *The Goebbels Diaries, 1939–41*, p. 305.

[35] Taylor, op. cit., p. 39.

[36] Speer, *Spandau. The Secret Diaries*, p. 360.

[37] Papernii, op. cit., p. 38.

[38] Baynes, op. cit., p. 600.

[39] Taylor, op. cit., p. 46.

[40] S. Kostof, "The Emperor and Duce: The Planning of Piazzale Augusto Imperatore in Rome", in H. A. Miller and L. Nochlin (eds.), *Art and Architecture in the Service of Politics*, pp. 279, 287.

[41] *Arkhitektura SSSR*, 1957, No. 11, p. 18.

[42] Baynes, op. cit., pp. 593–4.

[43] Grosshans, op. cit., p. 93.

[44] Papernii, op. cit., p. 34.

[45] Speer, *Inside the Third Reich*, p. 97.

[46] Robert Hughes, *The Shock of the New*, London, 1980, p. 99.

[47] *Arkhitektura SSSR*, 1938, No. 9, p. 6.

[48] To be convinced of this, one need only look at the illustrations in works on architecture, jubilee editions and propaganda brochures intended for internal and external consumption alike: for example, *30 let sovetskoi arkhitektury*, Moscow, 1958; W. Rittich, *Architectur und Bauplastic der Gegenwert*, Berlin, 1938; H. Schrude, *Bauten des Dritten Reich*, Leipzig, 1937; *A Nation Builds – Contemporary German Architecture*, German Library of Information, New York, 1940; the journals, *Arkhitektura SSSR*, and *Die Kunst*, Munich, et al.

[49] Speer, *Spandau. The Secret Diaries*, pp. 174–5.

[50] Rittich, op. cit., p. 44.

[51] A. Rabinbach, "The Aesthetics of Production in the Third Reich", in *Journal of Contemporary History*, London, Vol. 11, No. 4, p. 43.

[52] Ibid., p. 51.

[53] *Arkhitektura SSSR*, 1955, No. 12, p. 13.

[54] Speer, *Inside the Third Reich*, pp. 230–1.

[55] *Pravda*, 26 July 1964.

[56] R. Kaufman, *Sovetskaia tematicheskaia kartina*, Moscow, AKh SSSR, 1951, p. 5.

[57] R. Grunberger, *A Social History of the Third Reich*, Harmondsworth, 1974, p. 537.

[58] *Vsesoiuznaia khudozhestvennaia vystavka* (exhibition catalogue), 1952, Tbilisi, Baku, Kiev, Lvov, Vilnius, Riga, Tallin and Leningrad.

[59] Lehmann-Haupt, op. cit., p. 136.

[60] *Kunst im Dritten Reich*, 1942, No. 6, p. 268.

[61] Lane, op. cit., p. 50.

[62] W. Wingler, *Das Bauhaus*, 1962, p. 39.

[63] Lane, op. cit., p. 46.

[64] Nolte, op. cit., p. 258.

[65] Rittich, op. cit., pp. 12, 19.

[66] *Voprosy teorii sovetskogo izobrazitel'nogo iskusstva*, pp. 6–7.

[67] Mosse, *Nationalization of the Masses*, p. 10.

[68] Berdiaev, *Novoe srednevekov'e*, Berlin, 1924, p. 64.

[69] Berdiaev, *Istoki i smysl' russkogo kommunizma*, Paris, 1955, p. 136.

[70] Cecil, op. cit., p. 82.

[71] G. Mosse, *Nazi Culture*, p. 244.

[72] J. McGovern, *Martin Bormann*, London, 1968, pp. 181, 212–13.

[73] Bullock, op. cit., p. 356.

[74] Herzstein, op. cit., p. 121.

[75] Mosse, *Nazi Culture*, p. 245.

[76] Herzstein, op. cit., p. 249.

[77] Urban, *Stalinism*, London, 1982, pp. 21–2.

[78] Fest, *Hitler*, p. 422.

[79] Lehmann-Haupt, op. cit., pp. 138–9.

[80] Mosse, *Nazism*, 1978, p. 37.

[81] Herzstein, op. cit., pp. 50–1.

[82] *30 let sovetskogo izobrazitel'nogo iskusstva*, p. 28.

[83] *Kunst im Dritten Reich*, 1938, No. 1, p. 4.

[84] Hinz, op. cit., pp. 80–1.

[85] Taylor, op. cit., p. 72.

[86] Speer, *Inside the Third Reich*, p. 80.

[87] Rittich, op. cit., p. 35.

[88] Herzstein, *The War that Hitler Won*, p. 51.

Epilogue: Encounter in Berlin

[1] Lehmann-Haupt, op. cit., p. 201.

[2] Ibid.

[3] Ia. Kornfel'd, *Laureaty Stalinskikh premii v arkhitekture. 1941–50*, Moscow, 1953, p. 179.

[4] See: M. Damus, *Sozialistischer Realismus und Kunst im Nationsozialismus*, Fischer Taschenbuch Verlag, 1981.

[5] Lehmann-Haupt, op. cit., p. 189.

[6] Hinz, op. cit., p. 43.

[7] As an example of the presence of totalitarian tendencies in contemporary culture, one could adduce the example of Joseph Beuys. His concept of refashioning human consciousness through art in order to sculpt a new – democratic – man (Beuys's theory of Social Sculpture), his proclamation of the end of all previous artistic genres, his declaration that "everything that lies under the sun" is art – all these are totalitarian. And there is probably no artist since Picasso who has had so great an influence on the development of art.

Select Bibliography

1. General Works

H. Arendt, *The Origins of Totalitarianism*, London, 1958.

R. Aron, *Democracy and Totalitarianism*, London, 1968.

J. Brügel, *Stalin und Hitler. Pact gegen Europa*, Vienna, 1973.

H. Buchheim, *Totalitarian Rule: Its Nature and Characteristics*, Middletown, Conn. 1968.

B. Burch (ed.), *Dictatorship and Totalitarianism. Selected Reading*, New York, 1964.

P. Bürger, *Theory of the Avant-Garde*, Minneapolis, c. 1984.

N. Cohn, *The Pursuit of the Millennium*, London, 1970.

E. Crispoli, B. Hinz, *Arte e Fascismo in Italia e in Germania*, Milan, 1974.

M. Damus, *Sozialistischer Realismus und Kunst in Nationalsozialismus*, Frankfurt-am-Main, 1981.

F. Deakin, *The Brutal Friendship: Mussolini, Hitler and the Fall of Italian Fascism*, London, 1961.

W. Ebenstein, *Totalitarianism: New Perspective*, New York, 1962.

D. Egbert, *Social Radicalism and the Arts: Western Europe. A Cultural History from the French Revolution to 1968*, New York, 1968.

Iu. Fel'shtinskii (ed.), *SSSR i Germania. Dokumenty i materialy o Sovetsko-Germanskikh otnosheniiakh. Aprele–Sentyabre 1939*, 1983.

R. Fischer, *Stalin and German Communism*, 1948.

C. Friedrich (ed.), *Totalitarianism: Proceedings of a Conference Held at the American Academy of Arts and Science, March 1953*, Cambridge, Mass. and London, 1954.

C. Friedrich and Z. Brzezinski, *Totalitarian Dictatorship and Autocracy*, New York, Washington, London, 1965.

W. Haftmann, *Painting in the Twentieth Century*, London, 1976.

F. von Hayek, *The Road to Serfdom*, London, 1944.

R. Hughes, *The Shock of the New*, New York, 1981.

J. Joll, *Three Intellectuals in Politics*, New York, 1960.

S. King-Hall, *Three Dictators: Mussolini, Hitler, Stalin*, London, 1964.

C. Lane, *The Rite of Rulers*, New York, 1981.

W. Laqueur, *Russia and Germany: a Century of Conflict*, London, 1955.

H. Lehmann-Haupt, *Art under a Dictatorship*, New York, 1954.

G. Lehrmann, *De Marinetti à Maiakovski*, Fribourg, La Gaze, 1942.

M. Lifshits, *Iskusstvo i sovremennyi mir*, Moscow, 1978.

G. Mosse, *The Culture of Western Europe. The Nineteenth and Twentieth Centuries*, Chicago, 1966.

G. Mosse, *Nationalization of the Masses*, New York, 1975.

L. Mumford, *The Myth of the Machine*, New York, 1967.

E. Nolte, *Three Faces of Fascism: Maurras, Mussolini, Hitler*, New York, Chicago, San Francisco, 1965.

D. Pike, *German Writers in Soviet Exile: 1933–1945*, University of North Carolina Press, 1982.

J. L. Radel, *Roots of Totalitarianism: The Ideological Sources of Fascism, National Socialism and Communism*, New York, 1975.

H. Rosenberg, *Discovering the Present: Three Decades in Art, Culture and Politics*, Chicago, 1973.

L. Schapiro, *Totalitarianism*, London, 1972.

T. Schapiro, *Painters and Politics: the European Avant-Garde and Society*, New York, 1976.

W. Schlangen, *Theorie und Ideologie des Totalitarismus*, Bonn, 1972.

G. Severini, "Marxism and Art" in *Seven Arts*, selected and edited by F. Puma, New York, 1956.

J. Stephen, *The Russian Fascists: Tragedy and Farce in Exile, 1925–45*, New York, 1978.

J. Talmon, *The Origins of Totalitarian Democracy*, New York, 1960.

R. Taylor, *Film Propaganda: Soviet Russia and Nazi Germany*, London and New York, 1979.

A. Unger, *The Totalitarian Party: Party and People in Nazi Germany and Soviet Russia*, London and New York, 1971.

E. Weber, *Varieties of Fascism*, New York, 1965.

2. USSR

M. Agurskii, *Ideologiia natsional-bol'shevizma*, YMCA Press, 1980.

V. Belinskii, *Izbrannye sochineniia*, Vol. 1, Moscow, 1947.

N. Berdiaev, *Istoki i smysl' russkogo kommunizma*, Paris, 1955.

N. Berdiaev, *Novoe srednevekov'e*, Berlin, 1924.

N. Berdiaev, *Russkaia ideia*, YMCA Press, 1971.

N. Chernyshevskii, *Esteticheskie otnosheniia iskusstva k deistvitel'nosti*, St Petersburg, 1855.

Iu. Druzhnikov, *Voznesenie Pavlika Morozova*, London, 1988.

V. Frumkin, "Ran'she my byli marksisty: pesennye sviazi dvukh sotsialismov", *Obozrenie*, Paris, 1985, Nos 16, 17.

A. Gan, *Konstruktivizm*, Tver', 1922.

M. Geller, *Mashina i vintiki. Istoriia formirivaniia sovetskogo cheloveka*, London, 1985.

M. Geller, A. Nekrich, *Utopiia u vlasti*, Vol. 1–2, London, 1982.

A. Gerasimov, *Za sotsialisticheskii realizm*, Moscow, 1952.

A. Gerasimov, *Izbrannye proizvedeniia*, Moscow, 1951.

A. Gerasimov, *Moia zhizn'*, Moscow, 1963.

N. Gorlov, *Futurizm i revoliutsiia*, Moscow, 1924.

M. Kalinin, *Ob iskusstve i literature*, Moscow, 1957.

M. Kalinin, *O zadachakh sovetskoi intelligentsii*, Moscow, 1939.

V. Kandinskii, *Stupeni*, Moscow, 1918.

R. Kaufman, *Sovetskaia tematicheskaia kartina*, Moscow, 1951.

V. Kniazeva, *AKhRR*, Leningrad, 1967.

V. Komar, A. Melamid, "Rol' voennogo vedomstva v sovetskom iskusstve", *A-Ia*, No. 2, Paris.

Ia. Kornfel'd, *Laureaty Stalinskikh premii v arkhitekture, 1941–1950*. Moscow, 1953.

A. Kruchenykh, *Piatnadtsat' let russkogo futurizma, 1912–1927. Materialy i dokumenty*, Moscow, 1928.

V. Lapshin, "Pervaia vystavka russkogo iskusstva, Berlin, 1922. Materialy k istorii sovetsko-germanskikh khudozhestvennykh svyazei", *Sovetskoe iskusstvoznanie*, 1982, No. 1.

A. Lebedev, *Iskusstvo v okovakh*, Moscow, 1962.

P. Lebedev, *Sovetskoe iskusstvo v periode inostrannoi interventsii i grazhdanskoi voiny*. Moscow, 1949.

V. Lenin, "Kriticheskie zametki po natsional'nomu voprosu", in *Sochinenia*, izd. 4, vol. 20.

V. Lenin, *Partiinaia organizatsiia i partiinaia literatura*, Moscow, 1965.

B. Lifshits, *Polutoroglazyi strelets*, New York, 1978.

M. Lifshits (ed.), *Lenin o kul'ture i iskusstve*, Moscow, 1938.

V. Lobanov, *A. M. Gerasimov*, Moscow, Leningrad, 1943.

A. Lunacharskii, *Ob izobrazitel'nom iskusstve*, Vol. 1–2, Moscow, 1967.

A. Lunacharskii, "Ob otdele izobrazitel'nykh iskusstv", *Novyi mir*, 1966.

K. Malevich, *Ot kubizma k suprematizmu*, Moscow, 1916.

N. Mandel'shtam, *Vtoraia kniga*, Paris, 1972.

N. Mashkovtsev, *Kniga dlia chteniia po istorii russkogo iskusstva*, Moscow, 1949.

A. Men'shutin, A. Siniavskii, *Poeziia pervykh let revoliutsii*, Moscow, 1964.

G. Nedoshivin, *Ocherki teorii iskusstva*, Moscow, 1953.

B. Nikiforov, *Zhivopis'*. Moscow, Leningrad, 1948.

L. Novikova, *Iskusstvo i vospitaniie novogo cheloveka*, Moscow, 1964.

G. Obraztsov, *Estetika V. V. Stasova i razvitie russkogo natsional'no-realisticheskogo iskusstva*, Leningrad, 1975.

V. Papernii, *Kul'tura "Dva"*, Ardis, Ann Arbor, 1985.

N. Radlov, *O futurizme*, St Petersburg, 1923.

V. Razumnyi, *Problemy sotsialisticheskogo realizma*, Moscow, 1963.

V. Serov, *V bor'be za sotsialisticheskii realizm*, Moscow, 1963.

K. Simonov, "Glazami cheloveka moego pokoleniia", *Znamia*, March–May 1988.

K. Sitnik, *Lenin i Stalin v narodnom izobrazitel'nom iskusstve*, Moscow, Leningrad, 1940.

I. Stalin, *Marksism i voprosy iazykoznaniia*, "Pravda", Moscow, 1950.

V. Stasov, *Stat'i i zametki*, Vol. 1–2, Moscow, 1959.

V. Stasov, *Izbrannoye*, Moscow, Leningrad, 1950.

B. Ternovets, "Ital'ianskaia pressa i sovetskii otdel na XVI mezhdunarodnoi vystavke v Venetsii", *Iskusstvo*, 1928, No. 2.

K. Tikhova, "Sovetskie khudozhniki na XIX mezhdunarodnoi vystavke v Venetsii", *Iskusstvo*, 1935, No. 1.

M. Tsapenko, *O realisticheskikh osnovakh sovetskoi arkhitektury*, Moscow, 1952.

K. Tsetkin, *Vospominaniia o Lenine*, Moscow, 1955.

Ya. Tugendkhol'd, "Vystavka germanskogo iskusstva v Moskve" – *Pechat' i revoliutsiia*, 1934.

S. Varshavskii, *Upadnicheskoe iskusstvo zapada pered sudom russkikh khudozhnikov-realistov*, Moscow, Leningrad, 1949.

E. Vostokov, *Grekovtsy*, Moscow, 1983.

A. Zhdanov, "Vystuplenie na diskussii po knige G. F. Aleksandrova" – *Istoriia zapadno-evropeiskoi filosofii*, 14/VI/47, Moscow, 1947.

A. Zhdanov, *Doklad o zhurnalakh "Zvezda" i "Leningrad"*, Moscow, 1952.

A. Zhdanov, *Sovetskaia literatura – samaia ideinaia, samaia peredovaia literatura v mire*, Moscow, 1953.

V. Zimenko, *Sovetskaia istoricheskaia zhivopis'*, Moscow, 1970.

V. Zimenko, *Sovetskaia portretnaia zhivopis'*, Moscow, 1951.

Sborniki, spavochniki, postanovleniya i t.d.

AKhRR: *Sbornik vospominanii, statei, dokumentov*, Moscow, 1973.
Arkhitektura SSSR, Sbornik, Moscow, 1947.
Bor'ba za realizm v sovetskom iskusstve 20kh godov, Moscow, 1962.
Voprosy teorii i istorii iazyka v svete trudov I. V. Stalina po iazykoznaniiu, Moscow, 1952.
Voprosy teorii sovetskogo izobrazitel'nogo iskusstva, Moscow, 1950.
Vystavki sovetskogo izobrazitel'nogo iskusstva. Spravochnik, Vol. 1–4, Moscow, 1973.
Iskusstvo i ideologicheskaia rabota partii, Ak Obshchestvennykh Nauk pri TsKaKPSS, Moscow, 1976.
Istoriia russkogo iskusstva, Vol. 10–11, Moscow, 1953–1957.
Iz istorii sovetskogo iskusstvoznaniia i esteticheskoi mysli 30kh godov, Moscow, 1977.
Iz istorii sovetskoi arkhitektury 1941–1945 godov (dokumenty i materialy), Moscow, 1978.
Izobrazitel'noe iskusstvo v gody Velikoi Otechestvennoi voiny, Moscow, 1951.
Literaturnoe nasledie. V. I. Lenin i A. V. Lunacharskii, perepiska, doklady, dokumenty, Moscow, 1971.
Manifesty i programmy russkikh futuristov, München.
Mastera sovetskogo izobrazitel'nogo iskusstva, Moscow, 1951.
Modernizm: Analiz i kritika osnovnykh napravlenii, Moscow, 1980.
O sovetskoi sotsialisticheskoi kul'ture, Moscow, 1948.
Ocherki po istorii russkogo iskusstva, Moscow, 1954.
Paris. Exposition Internationale. Pavil'on SSSR na mezhdunarodnoi vystavke v Parizhe, Moscow, 1938.
Pervyi vsesoyuznyi s'ezd sovetskikh pisatelei (stenograficheskii otchet), Moscow, 1934.
Postanovlenie TsKaVKP(b) o zhurnalakh "Zvezda" i "Leningrad", Strathcona Publication, 1978.
Postanovlenie TsKa VKP(b) "Ob opere 'Velikaia druzhba' V. Muradeli", Moscow, 1950.
Protiv formalizma i naturalizma v iskusstve, Moscow, 1937.
Sovetskaia arkhitektura za XXX let, Moscow, 1950.

Soveshchaniie deiatelei sovetskoi muzyki v TsKaVKP(b), Moscow, 1948.
Sovetskoie iskusstvo za 15 let, Moscow, 1934.
Stanovleniye sotsialisticheskogo realizma v sovetskom izobrazitel'nom iskusstve, Moscow, 1960.
Tvorcheskiie voprosy sovetskoi arkhitektury, Moscow, 1940.
Tridtsat' let sovetskogo izobrazitel'nogo iskusstva, Moscow, 1947.

Periodicals
Arkhitektura SSSR, Moscow, 1933– .
Iskusstvo kommuny.
LEF, Moscow, 1923–25.
Novyi LEF, Moscow, 1927–8.
Iskusstvo, Moscow, 1933– .
Tvorchestvo, Moscow, 1933– .

T. Andersen (ed.), *K. Malevich, Essays on Art*, Vol. 1–2, London, 1969.
S. Bann and J. Bowlt, *Russian Formalism: a Collection of Articles and Texts in Translation*, London, 1973.
I. Berlin, *Personal Impressions*, London, 1980.
O. Beskin, *The Place of Art in the Soviet Union*. The American-Russian Institute for Cultural Relations with the Soviet Union, New York, 1936.
J. Billington, *The Icon and the Axe*, New York, 1966.
L. Blomquist, "Some Utopian Elements in Stalinist Art", *Russian History*, No. 11, 1984.
J. Bowlt (ed.), *Russian Art of the Avant-Garde: Theory and Criticism 1902–34*, New York, 1976.
M. Chagall, *My Life*, London, 1965.
K. Clark, *The Soviet Novel*, Chicago and London, 1983.
A. De Jonge, *Stalin and the Shaping of the Soviet Union*, New York, 1986.
I. Deutscher, *Stalin, a Political Biography*, London and New York, 1966.
D. Elliott, *New Worlds. Russian Art and Society 1900–1937*, London, 1986.
S. Fitzpatrick, *The Commissariat of Enlightenment. Soviet Organization of Education and the Arts under Lunacharsky. October 1917–1921*, Cambridge, 1970.
S. Fitzpatrick, *Cultural Revolution in Russia 1928–31*, Indiana University Press, 1977.
G. Fothergill, *Stalinist Communism and Fascism*, Ann Arbor, Mich., 1966.
H. Gassner and E. Gillen (eds), *Zwischen Revolution . . .? Kunst und Sozialistischen Realismus. Dokumente und Kommentare*. Köln, 1979.
C. Gray, *The Great Experiment in Russian Art*, London, 1970.
R. Hingley, *Joseph Stalin: Man and Legend*, London, 1974.
C. James, *Soviet Socialist Realism*, Macmillan, 1973.
L. Kleberg and S. Ringholm, "V. I. Lenin in Smolnyi and the Second Coming", *Russian History*, No. 11, 1984.
A. Kopp, *Architecture et urbanisme sovietiques des années vingt*, Paris, 1967.
El Lissitzky, *Russia and Architecture for World Revolution*, Cambridge (M. I. T. Press), Mass., 1970.
C. Lodder, *Russian Constructivism*, New Haven and London, 1983.
J. Milner, *Vladimir Tatlin and the Russian Avant-Garde*, New Haven and London, 1983.
N. Misler and J. Bowlt, *Pavel Filonov: a Hero and his Fate*, Austin, Texas, 1983.
P. Nisbet, "Some Facts on the Organizational History of the van Diemen Exhibition", *The First Russian Show*, London, 1983.
A. Nove, *Was Stalin Really Necessary?*, London, 1965.
F. Starr, *Melnikov. Solo Architect in a Mass Society*, Princeton, 1978.
A. Rudenstine (ed.), *The George Costakis Collection*, London, 1981.
L. Trotsky, *Literature and Revolution*, Ann Arbor, 1957.
L. Trotsky, *On Literature and Art*, New York, 1970.
L. Trotsky, *The Struggle against Fascism in Germany*, New York, 1971.
R. Tucker, *Stalin as Revolutionary, 1879–1929*, New York, 1973.
K. Umansky, *Neue Kunst in Russland, 1914–19*, Potsdam, 1920.

G. Urban (ed.), *Stalinism*, London, 1982.

E. Valkenier, *Russian Realist Art. The State and Society: the Peredvizhniki and their Tradition*, Ann Arbor, 1977.

A. Voyce, *Russian Architecture. Trends in Nationalism and Modernism*, New York, 197?.

R. Williams, *Russian Art and American Money*, Harvard, 1980.

B. Wolfe, *Communist Totalitarianism. Key to the Soviet System*, Boston, 1956.

3. Germany

L. Baird, *The Mythical World of Nazi War Propaganda, 1939–45*, Minneapolis, 1974.

N. Baynes, (ed.), *Speeches of Adolf Hitler*, Vol. 1, Oxford, 1948.

W. Betz, *The Third Reich*, London, 1955.

K. Bracher, *The German Dictatorship. The Origins, Structure and Effects of National Socialism*, London, 1970.

C. Brenner, *Die Kunstpolitik des National-Sozialismus*, London, 1970.

H. Buhheim, *The Third Reich. Its Beginnings, Its Development, Its End*, London, 1961.

A. Bullock, *Hitler: a Study in Tyranny*, New York, Harper & Bros, 1964.

K. Bullwant (ed.), *Culture and Society in the Weimar Republic*, Manchester, 1978.

R. Cecil, *The Myth of the Master Race: Alfred Rosenberg and Nazi Ideology*, London, 1972.

A. Churchill (ed.), *Eyewitness: Hitler. The Nazi Führer and his Times as seen by Contemporaries, 1930–45*, New York, 1979.

M. Domarus, *Hitler: Reden und Proklamationen 1932–45*, Vols. 1–2, Munich, 1962.

D. Ellis, *Music in the Third Reich: National Socialist Aesthetic Theory as Governmental Policy*, Ann Arbor, c. 1970.

J. Fest, *The Face of the Third Reich*, Harmondsworth, 1970.

J. Fest, *Hitler*, Harmondsworth, 1974.

P. Gay, *Weimar Culture: the Outsider as Insider*, London, 1968.

J. Goebbels, *Bolshevism in Theory and Practice*, Berlin, 1936.

The Early Goebbels Diaries. 1925–56, H. Heiber (ed.), London, 1962.

The Goebbels Diaries, 1939–1941, F. Taylor (ed.), New York and London, 1982.

The Goebbels Diaries, 1942–43, L. Lochner (ed.), New York, 1968.

E. Gombrich, *Myth and Reality in German War-Time Broadcasts*, London, 1970.

H. Grosshans, *Hitler and the Artists*, New York, 1983.

G. Grosz, *A Small Yes and a Big No* (new translation), London, 1982.

H. Gruber, "Willi Münzenberg: Propaganda for and against the Comintern", *International Review of Social History*, Vol. 10, 1965.

R. Grunberger, *A Social History of the Third Reich*, Harmondsworth, 1974.

F. Grunfield, *The Hitler File. A Social History of Germany and the Nazis, 1918–45*, New York, 1974.

D. Gusmen, *The Scientific Origins of National Socialism*, New York, 1971.

E. Hadamovsky, *Propaganda and National Power. The Organization of Public Opinion for National Politic*, New York, 1954.

A. Hardy, *Hitler's Secret Weapon*, New York, 1967.

R. Herzstein, *Adolf Hitler and the Third Reich, 1933–45*, Boston, 1971.

R. Herzstein, *The War that Hitler Won: the Most Infamous Propaganda Campaign in History*, New York, 1978.

B. Hinz, *Art in the Third Reich*, Oxford, 1980.

A. Hitler, *Mein Kampf*, Boston, 1971.

Hitler's Table Talk: 1941–1944, London, 1953.

H. Hoffmann, *Hitler Was My Friend*, London, 1955.

C. de Jaeger, *The Linz File*, London, 1981.

S. Kacaner, *From Caligula to Hitler. A Psychological History of the German Film*, Princeton, 1974.

F. Kauffmann, *Die neue Deutsche Malerei*, Berlin, 1941.

F. Kauffmann, *Deutsches Wohnen*, Berlin, 1940.

R. Königsberg, *Hitler's Ideology*, New York, 197?.

A. Kubizek, *The Young Hitler I Knew*, Boston, 1955.

B. Lane, *Architecture and Politics in Germany 1918–1945*, Cambridge, Mass., 1968.

B. Lane and L. Rupp, *Nazi Ideology before 1933*, Manchester, 1978.

W. Laqueur, *Fascism: a Reader's Guide*, Berkeley, 1976.

W. Laqueur, *Young Germany*, New York, 1962.

W. Laqueur, *Weimar: a Cultural History 1918–1933*, New York, 1980.

E. Leiser, *Nazi Cinema*, London, 1974.

B. Lewis, *George Grosz: Art and Politics in the Weimar Republic*, Madison, Wis., 1971.

J. McGovern, *Martin Bormann*, London, 1968.

H. von Maltiz, *The Evolution of Hitler's Germany*, 1973.

R. Manvell, *Doctor Goebbels, his Life and Death*, London, 1960.

R. Manvell and H. Fraenkel, *Heinrich Himmler*, London, 1965.

M. Marmin, *Arno Breker. El Miguel-Angelo del siglo XX*, Barcelona [no date].

W. Maser, *Hitler: Legend, Myth and Reality*, London, 1973.

V. Miesel, *Voices of German Expressionism*, New York, 1970.

G. Mosse, *The Crisis of German Ideology: Intellectual Origins of the Third Reich*, London, 1964.

G. Mosse, *Nazi Culture*, London, 1966.

G. Mosse, *Nazism. A Historical and Comparative Analysis of National Socialism*, Oxford, 1978.

B. Myers, *The German Expressionists*, New York, 1957.

F. Neumann, *Behemoth. The Structure and Practice of National Socialism*, London, 1944.

F. Pick, *The Art of Dr Goebbels*, London, 1942.

R. Pois, "German Expressionism in the Plastic Arts and the Nazi: a Confrontation of Idealists", German Life and Letters, Vol. XXI, No. 3, April, 1968.

Z. Ponti, *Critical Analysis of the Implementation of Rosenbergian National-Socialism in the Field of the History of Culture*, USA.

V. Prostler, *Die Ursprünge der Nationalsozialistischen Kunsttheorie*, Munich, 1982.

A. Rabinbach, "The Aesthetics of Production in the Third Reich", *Journal of Contemporary History*, Vol. 11, No. 4, London, 1976.

P. Rave, *Kunstdictatur im Dritten Reich*, Hamburg, 1949.

V. Reimann, *The Man who Created Hitler*, London, 1977.

G. Reiss, *Josef Goebbels, A Biography*, New York, 1948.

J. Ritchie, *German Literature under National-Socialism*, London, 1983.

G. Ritter, *The Third Reich*, London, 1955.

W. Rittich, *Deutsche Kunst der Gegenwart*, Breslau, 1943.

W. Rittich, *New German Architecture*, Berlin, 1941.

F. Roh, *Geschichte der Deutschen Kunst von 1900 bis zur Gegenwart*, Munich, 1958.

F. Roh, *German Art in Twentieth Century Painting, Sculpture, Architecture*, London, 1968.

F. Roh, *"Entartete" Kunst; Kunstbarbarein im Dritten Reich*, Hanover, 1962.

A. Rosenberg, *The Myth of the Twentieth Century: an Evaluation of the Spiritual-Intellectual Confrontations of Our Age*, Torrance, Calif., 1982.

A. Rosenberg, *Race and Race History, and other Essays*, New York, 1971.

D. Rousset, *The Other Kingdom*, New York, 1947.

D. Roxan and K. Wanstall, *Jackdaw of Linz: the Story of Hitler's Art Thieves*, London, 1964.

P. Salz, *Emil Nolde*, USA, 1963.

J. Schleimann, "The Organization Man: the Life and Work of Willi Münzenberg", *Survey*, No. 55, 1965.

P. Schmittenner, *Baukunst im neuen Reich*, Munich, 1934.

C. Schnaidt, *Hannes Meyer*, Tanfen (Switzerland), 1965.

H. Schrade, *Bauter des Dritten Reiches*, Leipzig, 1937.

K. Schrieber, *Das Reich der Reichkulturkammer*, Berlin, 1935.

R. Schroeder, *Modern Art in the Third Reich. Documents*, Oggenburg, 1952.

W. Shirer, *The Rise and Fall of the Third Reich*, New York, 1960.

W. Soxel, *The Writer in Extremis: Expressionism in Twentieth Century German Literature*, Stanford, 1959.

A. Speer, *Architektur: Arbeiten. 1933–42*, Munich, 1942.

A. Speer, *Inside the Third Reich*, London, 1979.

A. Speer, *Spandau. The Secret Diaries*, New York, 1976.

F. Stern, *The Politics of Cultural Despair – A Study in the Rise of Germanic Ideology*, Berkeley, 1961.

R. Taylor, *The Word in Stone: the Role of Architecture in the National Socialist Ideology*, Berkeley and Los Angeles, 1974.

A. Teut, *Architectur im Dritten Reich, 1933–45*, Berlin, Frankfurt-am-Main, Vienna, 1967.

J. Willett, *The New Sobriety. 1917–33. Art and Politics in the Weimar Period*, London, 1978.

W. Wingler, *Das Bauhaus*, 1962.

J. Wulf, *Die Bildenden Künste im Dritten Reich. Eine Dokumentation*, Berlin, 1966.

W. Yenne and W. Keith, *German War Art 1939–45*, New York, 1983.

Z. Zeman, *Nazi Propaganda*, 1964.

B. Zortman, *Hitler's Theatre: Ideological Drama in Nazi Germany*, El Paso, Texas, c. 1984.

A Guide to the Exhibition of Degenerate Art, Redding, Conn., 1972.

Kunst im Dritten Reich: Documente der Unter Werfung. Frankfurt Kunstverein, 1974.

Paris. Exposition Internationale, 1937, Deutsche Abteilung, Berlin, 1937.

A Nation Builds. Contemporary German Architecture. German Library of Information, New York, 1940.

The Third Reich. International Council for Philosophy and Humanistic Studies, New York, London and Toronto, 1940.

Kunst dem Volk, Munich, 1939–43.

Die Kunst im Dritten Reich (from 1939, *Die Kunst im Deutschen Reich*), 1937–1945.

Kunstkammer, 1935–6.

G. Griundig, *Mezhdu karnavalom i velikim postom*, Moscow, 1963.

L. Rempel', "Nemetskii formalizm i ego fashistskie kritiki", *Iskusstvo*, 1934, No. 3.

Demokratiia i Bol'shevism. Rechi Gitlera, Rosenberga i Geringa, Berlin, 1938.

Iskusstvo, kotoroe ne pokorilos'; nemetskie khudozhniki v periode fashizma, Moscow, 1972

4. Italy

U. Apollonio (ed.), *Futurist Manifestos*, London and New York, 1973.

G. Armellini, *Le immagini del fascismo nelle arti figurativi*, Milan, 1980.

G. Ballo, *Modern Italian Painting from Futurism to the Present Day*, New York and London, 1958.

P. Bardi, *Rapporto sull' Architettura*, Roma, 1931.

E. Crispoli, *Il secondo futurismo*, Turin, 1962.

L. Damiani, "Arte del Novecento", *Frinli*, Vols. 1–2, Del Bianco Editore, 1978 and 1982.

R. de Felice, *Interpretation of Fascism*, Milan, 1955.

M. Drudi Gandrillo and G. Bruni, *After Boccioni: Futurist Painting and Documents from 1915 to 1919*, Rome, 1961.

K. Flint, "Art and the Fascist Regime in Italy", *Oxford Art Journal*, Vol. 3, No. 2, 1980.

J. Gregor, *The Ideology of Fascism*, New York, London, 1969.

A. Hamilton, *The Appeal of Fascism*, London, 1971.

A. Lancelotti, *L'arte e il fascismo*, Rome, 1940.

D. Mack Smith, *Mussolini*, London, 1973.

D. Mack Smith, *Italy, a Modern History*, London, 1959.

A. Maraini, "Italian Art under Fascism", *The Studio*, London, December 1936.

T. Marinetti, *Selected Writings*, London, 1972.

H. Millon and L. Nochlin (eds), *Art and Architecture in Service of Politics*, M.I.T., Cambridge, Mass., 1981.

M. Missoroli and O. Agresti, *The Organization of the Arts and Professions in the Fascist Guild State*, Rome, 1938.

B. Mussolini, *My Autobiography*, New York, 1928.

B. Mussolini, *Fascism: Doctrine and Institutions*, Rome, 1935.
A. Pica, *Mario Sironi*, Milan, 1955.
U. Silva, *Kunst und Ideologie des Fascismus*, Milan, 1973.
J. Soby and A. Barr, *Twentieth-century Italian Art*, New York, 1949.
O. Tadden and L. Mercante, *Arte Fascista, arte per la massa*, Rome, 1935.
E. Tannenbaum, *Fascism in Italy*, London, 1972.
F. Tempest, *Arte dell' Italia Fascista*, Milan, 1976.
C. Tisdall and A. Bozzolla, *Futurism*, London, 1977.
P. Vergani, *Achille Funi*, Milan, 1949.
Sabavdia, citta nuova fascista, London, 1982.
Il Premio Cremona, Cremona, 1940.

5. China

J. Archer, *Mao Tse-tung*, New York, 1972.
Chao Chung, *The Communist Programme for Literature and Art in China*, New York, 1955.
J. Ch'ēn, *Mao and Chinese Revolution*, London, New York, 1965.
P. Devilliers, *Mao*, New York, 1969.
R. Eunson, *Mao Tse-tung: the Man who Conquered China*, New York, 1973.
Mao Tse-tung, *A Definitive Translation of Mao Tse-tung on Literature and Art: the Cultural Revolution in Context*, Washington D.C., 1967.
Mao Tse-tung, *On Art and Architecture*, Peking, 1960.
Mao Tse-tung, *Let a Hundred Flowers Bloom*, New York, 1957.
Su Gin-Djih, *Chinese Architecture – Past and Contemporary*, Hong Kong, 1964.
Yang Chen, *China's New Literature and Art: Essays and Addresses*, Peking, 1954.

China in Black and White, New York, 1945.
China Viewpoints, Mei nsu: New Art in China, Hong Kong [undated, but from the 1950s]

O. Gluhareva, *Iskusstvo narodnogo Kitaia*, Moscow, 1958.
K. Kravchenko, *U kitaiskikh druzei*, Moscow, 1959.
Sovetskie ckhudozhniki o Kitaie, Moscow, 1959.

Index

"Military Collection", Washington, x, 247n.
millenarianism, xi, 280–1, 285
Miller, Richard: "Himmler", 233
Minin, Kuzma, 244
Ministry of Aviation building, Berlin, 282
Ministry of Culture, USSR, 97, 100, 101–2, 306
Ministry of Foreign Affairs building, Moscow, 270, 270, 275, 282
Ministry of Light Industry building, Moscow, 284
Ministry of Popular Enlightenment and Propaganda (Germany), 92, 101, 139, 170, 176, 202
Minkus, Mikhail, 270, 278
Minsk, 277n., 278
Miró, Joan, 132
Mjolnir, pseud. of G. Schweitzer, 104
Misler, N., 23n.
mobile constructions, 19
Mochalskii, Dmitrii: "They Saw Stalin", 286
Modernism, x, 3, 21, 39, 40, 56, 58, 60, 76, 77, 102, 103, 105, 107, 109, 110 and n., 111, 115, 126, 132, 144, 145, 146, 151, 176, 182, 302, 305, 306; and Fascist art, 218n.; and National Socialist art, 218n.; German, 57, 58, 93, 94, 104, 193, 218; Italian, 120; Russian, 88
modernist architecture, 268
Mogne, 142
Moholy-Nagy, Laszlo, 17, 67
Molotov, Viacheslav, 196, 223, 224, 232, 305
"Molotov and Stalin Walking in a Glade in the Forest with Children" (Efanov), 232
"Molotov on the Tribune" (A. Gerasimov), 232
Molotov–Ribbentrop pact, 57
Mondrian, Piet, 4
Monet, Claude, 144
"Monument to the Third International" (Tatlin), 2, 36, 37, 112
monuments, German: destroyed, 111; erected, 170, 224, 227–8
monuments, Russian: destroyed, x, 112, 148; erected, 34, 87, 111–12, 170; see also Album 4
Moore, Henry, 145, 245, 246; "Family Group", 146
Morandi, Giorgio, 41
Moravov, Aleksandr: "The Country Registry Office", 73; "Stalin Speaks in the Dynamo Factory", 325
Mordvinov, Arkadii, 268
"Morning in the Pinewoods" (Shishkin), 160
"Morning of our Fatherland" (Shurpin), 4, 128, 195, 312
Morozov, Pavlik, 87, 111, 210–11, 241
Morris, William, 301
"Mortar and Stone" (Sohn-Skuwa), 343

Mosaic (Gruber). 333
Moscow: Lusinov Street model, 276; reconstruction, 267, 273, 274–5, 283, 364; siege, German, 170
Moscow College of Painting and Architecture, 14
Moscow Historical Museum, 219n.
"Moscow Metro" (Orlova), 348
"Moscow painters", 43, 51
Moscow Regional Union of Soviet Artists, 93
Moscow State Museum of Modern Western Art, 111, 144–5
Moscow University, 275, 276, 285
Moscow–Volga canal, 267
Mosse, George, 156, 157, 158, 214, 290, 293
Mosselprom (Moscow Agricultural Industry), 50
motherhood in art, 44, 217, 259
Motovilov, Georgi: "The Stonebreaker", 256
"Mountain Landscape" (Handel-Mazzetti), 287
MPR (Association of International Aid for Workers), 62–3, 64, 66
Mukhina, Vera, vii; "Worker and Collective Farm Woman", 132, 133, 191, 223, 362
Müller, Gestapo chief, 207
Mumford, Lewis, xii
Munch, Edvard, 140
Munich painters, 196
Munich putsch (1923), 62, 187, 238, 328; memorial, 279, 282, 282
Munich Soviet Republic, 62
Munster commune, xi
Münzenberg, Willi, 62–3, 63n., 64 and n., 65, 66, 70, 74, 76, 79
Muradeli, Vano, 141
mural painting, 45, 47, 242
museums of art, 293; German, 80, 81, 102; Russian, xiv, 14, 29, 100, 111, 219, 302
music, 179, 223–4
Mussolini, Benito: admiration for Lenin, 51; on architecture, 114; and art, xiii; and avant-garde, 29; as Bolshevik, 51, 115; bust of, 252; control of culture, 32, 41; coup, 3, 4, 13; cult of the leader, 226, 251; cultural policies, 3; on democracy, 290; and Fascism, 10; on Fascism, 115–16, 209–10, 292; and Futurism, 10, 11, 38, 40, 227, 245; Goebbels on, 114; grandiose projects, x, 301; on Hitler, 114; hyperactive, 114; image of, in art, 187; iron will of, 194; on labour, 255; lack of iconography, 251; leader of former Marxists, 9; liberal attitude of, 46; "March on Rome", 187, 251; and Marinetti, 9, 40; and Marxism, 10; and "new man", 43, 213; and Novecento, 55; portrayals of, 2, 41, 49, 228, 251, 252, 253; posters of, 49, 49, 252, 253; preserver of institutions, 120–1; reconstruction of Rome, 273, 280; and role of the Party, 34;